**HERE ARE JUST SOME
OF THE FASCINATING INSIGHTS IN
STEPHEN KING'S OWN WORDS FROM**

STEPHEN KING
The Art of Darkness

On CARRIE: ". . . *Carrie* is largely about how women find their own channels of power, and what men fear about women and women's sexuality. . ."

On 'SALEM'S LOT: "There are so many small towns in Maine, towns which remain so isolated that almost anything could happen there. People could drop out of sight, disappear, perhaps even come back as the living dead."

On THE SHINING: "There is no horror without love and feeling . . . because horror is contrasting emotion to our understanding of all things that are good and normal. Without a concept of normality, there is no horror."

DOUGLAS E. WINTER, an honor graduate of Harvard Law School, is a leading critic of fantasy, horror, and science fiction. His criticism, reviews, and interviews have appeared in publications ranging from the *Washington Post* and *Philadelphia Inquirer* to *Gallery, Harper's Bazaar*, and *Twilight Zone Magazine*. He is the author of three other books on supernatural fiction and film. Winter practices law in Washington, D.C.

STEPHEN KING:
THE ART OF DARKNESS

BY
DOUGLAS E. WINTER

REVISED AND EXPANDED

A PLUME BOOK

NEW AMERICAN LIBRARY

NEW YORK AND SCARBOROUGH, ONTARIO

A hardcover edition of *Stephen King: The Art of Darkness* was published by
New American Library and simultaneously in Canada by The New American Library of Canada Limited.

An earlier version of this work was published by Starmont House in a
limited edition.

Acknowledgments

"Sleepless" by King Crimson (lyrics by Adrian Belew). Copyright © 1984
E. G. Music, Inc. Used by permission. All rights reserved.

"Instant Karma" by John Lennon. Copyright © 1970 Northern Songs, Ltd.
All rights for the United States and Mexico controlled by Maclen Music,
Inc., c/o ATV Music Corp. Used by permission. All rights reserved.

PLUME TRADEMARK REG. U.S. PAT. OFF. AND FOREIGN COUNTRIES
REGISTERED TRADEMARK—MARCA REGISTRADA
HECHO EN FORGE VILLAGE, MASS., U.S.A.

SIGNET, SIGNET CLASSIC, MENTOR, PLUME, MERIDIAN AND NAL BOOKS
are published *in the United States* by New American Library,
1633 Broadway, New York, New York 10019,
in Canada by The New American Library of Canada Limited,
81 Mack Avenue, Scarborough, Ontario M1L 1M8

Library of Congress Cataloging in Publication Data

Winter, Douglas E.
 Stephen King, the art of darkness.

 Bibliography
 Includes index.
 1. King, Stephen, 1947- —Criticism and interpretation. 2. Horror
tales, American—History and criticism.
I. Title.
PS3561.I483Z95 1984 813'.54 84-1167
ISBN 0-453-00476-8
ISBN 0-452-25804-9 (pbk)

First Plume Printing, June, 1986

1 2 3 4 5 6 7 8 9

PRINTED IN THE UNITED STATES OF AMERICA

for my mother, who knew that I could,
and for Lynne, who knew that I would . . .

"It's all right to feel a little fear . . ."
—Adrian Belew/King Crimson

Contents

Foreword

I first met Stephen King in a shoeshine parlor.

It was like finding a Woodrow Wilson dime or a Maine roadmap with a town named Jerusalem's Lot. It was like . . . well, it was like a story by Stephen King.

St. Louis, Missouri, the fall of 1975: I was sitting in a nameless storefront near the federal courthouse with my friend Adrian Steel, two brand-spanking new lawyers waiting for what was probably the last twenty-five-cent shoeshine in America. The place was deserted but for the two of us and the bent-backed, ancient black man who silently, caringly polished shoe after shoe after shoe. We sat at his thrift-shop bench, just across from a dusty repair counter and advertising displays that surely dated from the 1950s. On the seat next to me, for the pleasure of waiting patrons, was a stack of reading material—week-old newspapers and a collection of skin magazines, all bearing a wrinkled, irrevocably *used* look. The magazine covers and most of the revealing photographs had been torn away, leaving the customer with the even more dubious textual content. But being neither proud nor likely to sit idle in the presence of reading matter, I reached into the stack. So it happened that I plucked forth an issue of *Cavalier*, and as I meandered through its ruined

pages, the words "Springheel Jack" caught my eye. And I began to read a peculiar short story—peculiar at first because it was neither about sex nor written with the tiresome, obsessive leer that passes for American eroticism; but primarily because it captured me, there in a decaying (and now long-ago demolished) shoeshine parlor in downtown St. Louis, taking me away to a strawberry spring in New England where horror waited in every shadow. So I reciprocated—with a modicum of stealth, I tore its pages from the crumpled magazine.

That the writer of the story was named Stephen King was meaningless to me, as it would have been to most other readers; if anything, I assumed that the name was a pseudonym. But the story was packed away in a thin manila folder that has since expanded to fill four file drawers in my office. And the name was filed away into the less reliable drawer of my subconscious, from which it happily reemerged several months later when a paperback called 'Salem's Lot appeared on the newsstands. As I looked at the book, the name clicked in my memory, and I had a sudden feeling that I wouldn't be disappointed.

I haven't been yet.

Stephen King and I did not meet personally until 1980, at an annual gathering of writers, editors, publishers, and fans of horror and fantasy fiction called the World Fantasy Convention, held that year in Baltimore, Maryland. By that time, seemingly everyone knew his name, but I was somewhat startled to learn that he knew mine, from my review of *Firestarter*. And in our moments of conversation across a gauntlet of autograph-seekers, a circle began to turn, and this book was drawn from a stack much as I had found that tattered copy of *Cavalier* five years before.

I received a letter from Stephen King a few weeks later; it was nearly as long as my review, telling me that I had heard his words with an understanding ear. If that was true, it was because I had been listening for such words nearly all of my life. I grew up with horror fiction—finding my first real terror, at seven years of age, in the motion picture *Invasion of the Body Snatchers*, and reading and writing horror stories ever since. Throughout my childhood and adolescence, I read just about everything I could lay my hands on, but horror fiction was always my first choice. I would prowl the spinning wire racks of Reese's Drugstore in Granite City, Illinois, on the lookout for the books with lurid covers—that's where I found Rob-

ert Bloch, Ray Bradbury, H. P. Lovecraft, Richard Matheson . . . the list goes on and on. I pawed E. C. Comics in the basement of a friend's house, sat through endless American International matinees, collected *Famous Monsters of Filmland* magazine—those early years were really a prolonged swim in the myth-pool of things horrific. It was perhaps inevitable, then, that as an adult prone to thinking about the things that I read, I would turn to writing about horror fiction. It's an honorable undertaking, one that I've pursued at least since college, when one of my English professors told me that my thoughts on Ira Levin's *Rosemary's Baby* were intelligent and interesting, but it was a shame that I had not applied my abilities to "real" literature, rather than this "horror stuff." It was her loss. I have always held with Raymond Chandler that "the only fiction of any moment in any age is that which does magic with words."

Since that first letter from Stephen King, we've talked often, drunk a lot of beer, seen some perfectly awful horror films, tried our hand at fishing—we were even nearly charbroiled together one August night in Center Lovell, Maine, when a sheet of lightning ripsawed over our heads and into the ground fifty yards away from the porch where we sat. ("It's an omen," he said. "Guess we shouldn't have had that last beer.") And somewhere along the way, this book was written.

What you hold in your hands, then, is best described as a critical appreciation; it is an intermingling of biography, literary analysis, and unabashed enthusiasm, spiced with commentary by Stephen King transcribed from our more than twelve hours of recorded conversations—including the only interview that he intends to give on the subject of his novel *Pet Sematary.* Although the principal text is devoted to Stephen King's novels and major short stories, I have included, in the Appendices, detailed surveys of his pseudonymous "Richard Bachman" books, all his published short fiction, and the motion picture and television adaptations of his work. For those interested in bibliographic information, I have also provided a detailed checklist of King's published writing, as well as a sampling of major interviews and critical reviews of his writing.

A principal theme of this book is journey, and its writing has been a personal odyssey of sorts—beginning with penciled notes on scratch paper and ending on an IBM word processor, it has been written in three different houses and has crossed the continent five-

and-a-half times. It has been preceded by my short "reader's guide" to King's work, published by Starmont House in 1982, an excerpt from which, "The Night Journeys of Stephen King," appeared in *Fear Itself: The Horror Fiction of Stephen King,* a recent trade paperback from New American Library's Plume Books. Several people have made important contributions along the way, and to each of them I express my appreciation and grateful thanks:

To Paul C. Allen, who started it all;

To Tim Underwood and Chuck Miller, who asked for more;

To Roger Schlobin and Ted Dikty of Starmont House;

To my editor at New American Library, Hilary Ross;

To several fine writers of horror fiction—Ramsey Campbell, Charles L. Grant, David Morrell, Alan Ryan, and Peter Straub—for their encouragement and support;

To Brooks Landon of the University of Iowa Department of English, for his insightful comments on an early version of the manuscript;

To Stephanie Leonard, for her bibliographic assistance;

To Howard Morhaim, for his sound business practices;

To Ronald L. Weston, talking post and conscience;

To my wife, Lynne, my toughest critic and truest friend;

And most of all, to Steve and Tabby, for caring.

—Douglas E. Winter
Alexandria, Virginia
March 1984

revised edition
November 1985

Chronology

1947 Stephen Edwin King is born on September 21 in Portland, Maine, the second son of Donald and Nellie Ruth King

1949 King's parents separate, and Donald King is not heard from or seen again by his family

1949–58 Middle years of childhood are spent in Fort Wayne, Indiana, and Stratford, Connecticut; frequent visits are made to his mother's relatives in Malden, Massachusetts, and Pownal, Maine

1953 Hears Ray Bradbury's "Mars is Heaven" on the *Dimension X* radio program

1954 Sees the first motion picture that he can remember, *The Creature from the Black Lagoon*

1954–55 Writes first stories, emulating the science fiction and adventure books that he reads

1957 On October 4, sees *Earth vs. the Flying Saucers* at a theater in Stratford, Connecticut; the motion picture is interrupted with the announcement that the satellite Sputnik has been launched by the Russians

1958 Nellie King moves her family to Durham, Maine, in order to care for her parents, incapacitated by old age

1959–60 Discovers a box of his father's books—fantasy and horror fiction that proves a major influence; also obtains a typewriter, and begins to submit short stories to science fiction magazines

1962–66 Attends Lisbon Falls, Maine, high school

1965 Has first story published: "I Was a Teenage Grave Robber," in a comic book fan magazine

1965–66 Writes first novel-length manuscript, *The Aftermath*; begins writing *Getting It On* (*Rage*)

1966–70 Attends University of Maine at Orono, where he is active on the school newspaper, in student politics, serving as a member of the student senate, and in the antiwar movement; meets faculty member Burton Hatlen, who provides him with much-needed support

1967 Publishes first professional story, "The Glass Floor," in *Startling Mystery Stories*
Completes first true novel, *The Long Walk*, at age nineteen; when it is rejected by a first-novel competition, he is discouraged from offering it for publication

1968 Completes second novel, *Sword in the Darkness*; it is rejected by twelve publishers
Publications: "Cain Rose Up," "Here There Be Tygers," and "Strawberry Spring"

1969 Meets Tabitha Jane Spruce while working in university library; completes a one-act play, "The Accident"
Publications: "The Reaper's Image," "Night Surf," and "Stud City"

1970 Graduates from the University of Maine with Bachelor of Science degree in English; unable to find a teaching position, works as a laborer in an industrial laundry
Publications: "Graveyard Shift"

1971–73 Teacher of English at Hampden Academy, Hampden, Maine

1971 Marries Tabitha Spruce
Completes third novel, *Getting It On* (*Rage*), which is almost purchased by Doubleday
Publications: "The Blue Air Compressor" and "I Am the Doorway"

1972　Completes fourth novel, *The Running Man*, which is immediately rejected by Doubleday and Ace Books
Begins a short story entitled "Carrie"; later, desperate for ideas, expands manuscript to novel length
Publications: "Battleground," "The Fifth Quarter" (as John Swithen), "The Mangler," and "Suffer the Little Children"

1973　Submits manuscript of *Carrie* to Doubleday, which purchases it; sale of paperback rights to New American Library permits him to quit teaching and write full-time; writes *Blaze*; moves family to North Windham, Maine, while writing a novel entitled *Second Coming*, which becomes *'Salem's Lot*
Nellie Ruth King dies of cancer
Publications: "The Boogeyman," "Gray Matter," and "Trucks"

1974　Writes *Roadwork*; moves to Boulder, Colorado; begins to write *The House on Value Street*, which will become *The Stand*; writes first draft of *The Shining*
Publications: *Carrie*, revised "Night Surf," and "Sometimes They Come Back"

1975　Returns to Maine, purchasing a house in Bridgton; completes first draft of *The Stand*
Publications: *'Salem's Lot*, "It Grows on You," "The Lawnmower Man," "The Revenge of Lard Ass Hogan," and revised "Strawberry Spring"

1976　Begins, then abandons, novels *Welcome to Clearwater* and *The Corner*; receives World Fantasy Award nomination for *'Salem's Lot*
Release of motion picture version of *Carrie*, directed by Brian De Palma
Publications: "I Know What You Need" and "The Ledge"

1977　Completes first drafts of *The Dead Zone* and *Firestarter*; travels to England for projected year-long stay, where he meets Peter Straub and completes first draft of *Cujo*; returns to Maine after three months, purchasing a home in Center Lovell; adopts the "Richard Bachman" pseudonym for publication of *Getting It On* as *Rage*
Publications: *The Shining*, *Rage* (as Richard Bachman), "The Cat from Hell," "Children of the Corn," "The Man Who Loved Flowers," "One for the Road," and "Weeds"

1978 Moves to Orrington, Maine, to serve as writer-in-residence and instructor at the University of Maine at Orono; changes hardcover publisher from Doubleday to Viking Press; serves as judge for 1977 World Fantasy Awards
Publications: *The Stand, Night Shift* (including the original appearances of "Jerusalem's Lot," "The Last Rung on the Ladder," "Quitters, Inc.," and "The Woman in the Room"), "Man with a Belly," "The Night of the Tiger," and "Nona"

1979 Completes first drafts of *Christine, Pet Sematary,* and *Danse Macabre,* and of screenplay for *Creepshow;* returns to Center Lovell; guest of honor, World Fantasy Convention, Providence, Rhode Island; receives World Fantasy Award nominations for *The Stand* and *Night Shift*
Release of television miniseries version of *'Salem's Lot,* directed by Tobe Hooper
Publications: *The Dead Zone, The Long Walk* (as Richard Bachman), and "The Crate"

1980 Purchases home in Bangor, Maine, retaining Center Lovell house as a summer residence; completes first draft of *IT;* receives World Fantasy Award nomination for *The Dead Zone;* receives special World Fantasy Award for contributions to the field; makes cameo appearance in George A. Romero's motion picture *Knightriders*
Release of motion picture version of *The Shining,* directed by Stanley Kubrick
Publications: *Firestarter,* "The Mist," "Big Wheels," "Crouch End," "The Gunslinger," "The Monkey," "The Way Station," and "The Wedding Gig"

1981 Participates, as screenwriter and actor, in filming of *Creepshow;* receives Career Alumni Award from the University of Maine; receives World Fantasy Award nomination for "The Mist" and Nebula Award nomination for "The Way Station"; receives special British Fantasy Award for contributions to the field
Tabitha King publishes *Small World* and "The Blue Chair"
Publications: *Danse Macabre, Cujo, Roadwork* (as Richard Bachman), "The Bird and the Album," revised

"The Blue Air Compressor," "Do the Dead Sing?," "The Gunslinger and the Dark Man," "The Jaunt," "The Man Who Would Not Shake Hands," "The Oracle and the Mountains," and "The Slow Mutants"

1982 Begins writing *The Talisman* with Peter Straub; begins writing *The Cannibals*; receives World Fantasy Award for "Do the Dead Sing?," Hugo Award for *Danse Macabre*, and British Fantasy Award for *Cujo*

Release of motion picture *Creepshow*, directed by George A. Romero

Publications: *The Dark Tower: The Gunslinger*, *Different Seasons*, *Creepshow* (with Berni Wrightson), *The Running Man* (as Richard Bachman), "Before the Play," revised "It Grows on You," "The Raft," "Skybar," and "Survivor Type"

1983 Completes first drafts of *The Talisman*, *The Tommyknockers*, and *The Eyes of the Dragon*, and of screenplay for *Cat's Eye*; receives World Fantasy Award nominations for *Different Seasons* and "The Breathing Method"

Release of motion picture versions of *Cujo*, directed by Lewis Teague; *The Dead Zone*, directed by David Cronenberg; and *Christine*, directed by John Carpenter

Tabitha King publishes *Caretakers*

Publications: *Christine*, *Pet Sematary*, *Cycle of the Werewolf* (with Berni Wrightson), "Uncle Otto's Truck," and "The Word Processor"

1984 Completes *Thinner* and *Misery*, and screenplay of *Silver Bullet*

Release of motion picture versions of *Children of the Corn*, directed by Fritz Kiersch, and *Firestarter*, directed by Mark Lester

Publications: *The Talisman* (with Peter Straub), *Thinner* (as Richard Bachman), *The Eyes of the Dragon* (in limited edition), "The Ballad of the Flexible Bullet," "Gramma," and "Mrs. Todd's Shortcut"

1985 Discloses "Richard Bachman" pseudonym; completes screenplay of *Overdrive* and moves to Wilmington, North Carolina, to direct that motion picture; receives World Fantasy Award nomination for *The Talisman*

Release of motion pictures *Cat's Eye*, directed by Lewis

Teague, and *Silver Bullet*, directed by Daniel Attias; videocassette *Two Mini-Features from . . . Stephen King's Night Shift Collection;* and television adaptation of "The Word Processor of the Gods"

Tabitha King publishes *The Trap* and "The Demonstration"

Debut of Stephen King fan magazine *Castle Rock* Publications: *Skeleton Crew* (including the original appearance of "Morning Deliveries"), *The Bachman Books*, "Beachworld," and "Dolan's Cadillac"

1986 Publication of *Silver Bullet* and *IT*

Release of motion picture *Overdrive*, directed by Stephen King; and television adaptation of "Gramma"

Scheduled release of motion pictures *The Body*, directed by Bob Reiner, and *The Running Man*, directed by George Pan Cosmatos

Tabitha King publishes "Road Kill"

1987 Publication of *Misery*, *The Eyes of the Dragon*, *The Tommyknockers*, and the short story "Popsy"

Scheduled release of motion picture *Pet Sematary*, directed by George A. Romero

1989 Scheduled publication of the unexpurgated edition of *The Stand*

· 1 ·

Introduction:
Do the Dead Sing?

"To the three Ds—death, destruction and destiny. Where would we be without them?"

—Stephen King

"The Reach was wider in those days," says Stella Flanders, the oldest resident of Goat Island, Maine. Ninety-five years old and dying of cancer, Stella Flanders has decided to take a walk. It is winter, the Reach has frozen over for the first time in forty years, and Stella Flanders has begun to see ghosts. And she has decided that, having never before left Goat Island, it is time for a walk across the Reach. The inland coast of Maine is a mile and a half distant, and so far as we know, neither the coast nor Goat Island has had occasion to move. But Stella Flanders is nevertheless right—the Reach *was* wider in those days.

The storyteller's name is Stephen King, and although he asks "Do the dead sing?" his story, "The Reach,"[1] is about a journey. Stella Flanders, having left her home behind, sets forth on an odyssey of discovery that, paradoxically, looks homeward with every step. The lonely crossing of the dark, frozen waters of the Reach means death for Stella Flanders; and the question "Do the dead sing?" asks what really lies upon the far side of the Reach.

That question, asked and answered in different guises, resounds throughout the fiction of Stephen King. Not very far from Goat Island, but in another version of reality called *The Stand*, Fran Gold-

smith waits in expectation on the mainland coast at Ogunquit, Maine. She is pregnant, alone, and one of the few people left alive in a world decimated by the flu. Further south, in the fictional hall of mirrors known as *The Talisman*, twelve-year-old Jack Sawyer stands at Arcadia Beach on the tiny seacoast of New Hampshire. His mother is dying, and he senses that her fate—and perhaps the fate of the world—may soon be held in his young hands. Both Fran Goldsmith and Jack Sawyer have also decided to take a walk, and although the distances they must travel are considerable in miles, their journeys cross a Reach no different in meaning than that facing Stella Flanders—although each of them will return, for a time, to the near side of the Reach.

That Stella Flanders' journey is westward may be a fluke of geography, but that west is the prevailing movement of the travelers of *The Stand* and *The Talisman* is not. These stories enact the recurrent American nightmare—the terror-trip experienced by Edgar Allan Poe's Arthur Gordon Pym, Herman Melville's Ishmael, and a host of fellow journeyers: the search for a utopia of meaning while glancing backward in idyllic reverie to lost innocence.[2] It is a journey taken by Jack Torrance in *The Shining*, driving west to the promise of a new life at the Overlook Hotel; by Johnny Smith in *The Dead Zone*, who crosses time, if not space; by Louis Creed in *Pet Sematary*, carrying the body of his dead son along the uphill path to a secret burial ground; by character after character in Stephen King's fiction, all trapped between fear of the past's deadly embrace and fear of future progress in a world that placidly accepts the possibility of total war. It is a night journey, both literally and symbolically, and Stephen King is its foremost practitioner in contemporary fiction.

The story of Stella Flanders' crossing of the Reach provides an appropriate introduction to the night journeys of Stephen King. As an archetype of American nightmare, "The Reach" (originally published as "Do the Dead Sing?") suggests the principal reasons for the importance and popularity of modern horror fiction, and the writings of Stephen King in particular. It will serve as a roadmap of context, by which we will travel through ten years of Stephen King novels, from *Carrie* to his recent collaboration with Peter Straub, *The Talisman*. And the question "Do the dead sing?" will haunt us throughout these novels in literal and symbolic manifestations that may prove more frightening than the face of fear itself.

Asking whether the dead sing is much like offering Johnny Smith's rhetorical toast in *The Dead Zone*: "To the three Ds—death, destruction and destiny. Where would we be without them?" These questions have been asked since the first horror story was told by firelight, and they are as inevitable—and as unanswerable—as the question of why we tell and listen to horror stories. To suggest that the tale of terror is an inextricable element of the human condition—a guilty fascination with darkness and irrationality, with the potential for expanding human consciousness and perception, with the understanding of our mortality and our universe—would be true but insufficient. More pragmatic answers seem to be in order. Western society is obsessed with horror fiction and film—the past fifteen years have seen an eruption of interest in horror stories rivaled only by the halcyon days of the ghost story at the close of the nineteenth century.

To ask why we read horror fiction is to ask why Stella Flanders took that walk on that cold winter's day of the storyteller's imagination. Death stalks Stella Flanders, and her faltering steps onto the Reach are an adventure, an escape from a mundane life—and a mundane death. At a minimum, horror fiction is a means of escape, sublimating the very real and often overpowering horrors of everyday life in favor of surreal, exotic, and visionary realms. Escapism is not, of course, necessarily a rewarding experience; indeed, horror fiction's focus upon morbidity and mortality suggests a masochistic or exploitative experience, conjuring subjective fantasies in which our worst fears or darkest desires are brought into tangible existence. "It was the way things worked," says Officer Hunton in King's short story "The Mangler"—"the human animal had a built-in urge to view the remains."[3] But conscientious fiction of escape provides something more—an art of mimesis, a counterfeiting of reality whose inducement to imagination gives the reader access to truths beyond the scope of reason. As D. H. Lawrence would write of Poe's horror fiction: "It is lurid and melodramatic, but it is true."[4]

The escapist quality of horror stories and other popular fiction speaks in a conditional future voice. As King has observed: "Literature asks 'What next?' while popular fiction asks 'What if?' "[5] Despite its intrinsic unreality, the horror story remains credible—or at least sufficiently credible to exert an influence that may last long beyond the act of reading. One does not easily forget the thing that

waits inside "The Crate,"[6] or the grinning, cymbal-clashing toy of "The Monkey."[7] This credibility is possible because horror's truths are judged not by the real fulfillment of its promises, but by the relevance of its fantasies to those of the reader or viewer. Although horror fiction appeals to the source of daydreams—and of nightmares—its context is waking reality.

The tensions between fantasy and reality, wanderlust and nostalgia, produce an intriguing paradox. Stella Flanders' escape across the Reach is a search for the ghosts of her past—the lives, and years, that have departed; it can lead only to her death. In the stories "The Ballad of the Flexible Bullet"[8] and "The Jaunt,"[9] King even more forcefully portrays how the active pursuit of the uncanny leads, with whirlpool inevitability, to destruction. As in many of the stories of the early-twentieth-century master of horror, H. P. Lovecraft, the uncanny provokes a self-destructive impulse, reflecting the alternately repulsive and seductive nature of horror fiction. "[W]hat is sought after—the otherworldly—makes us realize how much we need the worldly," writes critic Jack Sullivan, "but the more we know of the world, the more we need to be rid of it."[10]

The six o'clock news is sufficient to show our need to be rid of the world: assassination, rampant crime, political wrongdoing, social upheaval, and war are as much a part of our daily lives as the very air we breathe. And we can no longer trust that air—or the water that we drink, the food that we eat, our machines, or our neighbors. Just ask Richie Grenadine, who popped the top on a funky can of beer in "Gray Matter"[11]; or Harold Parkette, who employed "The Lawnmower Man"[12]; or the young woman who met "The Man Who Loved Flowers"[13]; or the characters of *Cujo*, whose reality is, in the final trumps, as inescapable as our own. And we live in the shadow of the atomic bomb, harbinger of our total destruction and the ultimate proof that we can no longer trust even ourselves.

Psychoanalyst and sleep researcher Charles Fisher once observed that "Dreaming permits each and every one of us to be quietly and safely insane every night of our lives."[14] His words apply as well to the waking dreams of horror fiction. In the tale of horror, we can breach our foremost taboos, allow ourselves to lose control, experience the same emotions—terror, revulsion, helplessness—that besiege us daily. If we fear heights, we can step out on "The Ledge"[15]; or if rats are our phobia, we can work "The Graveyard Shift."[16] The confinement of the action to the printed page or motion picture

screen renders the irrationality safe, lending our fears the appearance of being controllable. The achievement of horror's conditional future is endlessly deferred; except within the closed environment of the fiction or film, the fantasy does not—and, perhaps more important, cannot—become reality. Our sensibilities are offered a simple escape from escapism: wanderlust fulfilled, we can leave horror's pages and shadowed theaters with the conviction that the horror was not true and cannot be true. Every horror novel, like every nightmare, has a happy ending, just so long as we can wake up, and we can say, with Herman Melville's *Pierre* (1852), that "It is all a dream—we dreamed that we dreamed we dream."

But horror fiction is not simply an unquiet place that we may visit in moments of need. Along with its obvious cathartic value, horror fiction has a cognitive value, helping us to understand ourselves and our existential situation. Its essential element is the clash between prosaic everyday life and a mysterious, irrational, and potentially supernatural universe. The mundane existence of Stella Flanders is never the same after she first sees the ghost of her long-dead husband. Her haunting is a traditional one, and Stephen King conjures an atmosphere of suspended disbelief by his very reliance upon the traditions of the supernatural tale. Just like settling into a comfortable chair, King's conscientious use of such traditions—both in terms of theme (as in the vampire lore of *'Salem's Lot* and the Gothic castle/hotels of *The Shining* and *The Talisman*) and of narrative technique (as in the Lovecraftian epistolary tale of "Jerusalem's Lot"[17] and the smoking room reminiscence of "The Man Who Would Not Shake Hands"[18])—lends credibility to the otherwise unbelievable. The supernatural need not creep across the floorboards of each and every horror story, however; reality itself often is sufficiently frightening—and certainly credible—as short stories like King's "Strawberry Spring"[19] and "Survivor Type"[20] prove through themes of psychological distress and aberration.

Then there are the stories that fall somewhere in between. Although Stella Flanders sees ghosts in "The Reach," these ghosts are no more adequately proved than the aliens who schoolmarm Emily Sidley believes have replaced her third-graders in "Suffer the Little Children."[21] To be sure, Stella Flanders follows the ghosts (just as Miss Sidley takes the little children, one by one, to the mimeograph room, where she kills them), but there is no extrinsic evidence of

their reality. Do the dead sing? The question is not simply one of faith—how close does it come to reality?

The pursuit of realism suggests that horror fiction should follow a consequential pattern: that some semblance of reason, however vague, should underlie seemingly irrational or supernatural events. The leap of faith necessary to persuade the purblind skeptic that zombies can walk is made slightly easier by a springboard based in voodoo or—as in the classic zombie film, *Night of the Living Dead* (1968)—the strange radiation of a returning Venus probe, even if these explanations are themselves intrinsically illogical. And once that leap of faith is made, the reader may as well shout that the water's fine: if zombies can walk, then we have little additional trouble in accepting that they will feast upon the flesh of the living rather than serve as ideal elevator operators. The fact that the typical reader of horror fiction is willing to believe should render the author's task that much easier. There is a secret self—the eternal child, perhaps—lurking somewhere within each of us who yearns to be shown that the worst is true: that zombies can walk, that ghosts really beckon to Stella Flanders.

When the printed tale of terror was young—in those days of the "penny dreadfuls" and their more respectable kin, the Gothic novel—a rigid dichotomy was observed between fiction based in supernatural events and that based in rational explanation. The latter form, best exemplified by the novels of Ann Radcliffe—such as *The Mysteries of Udolpho* (1794)—and reprised briefly in the "shudder pulps" of the 1930s and the "Baby Jane" maniac films of the 1960s, proposed apparently supernatural events that were explained rationally at the story's end. As the modern horror story emerged in the late 1800s, however, neither a rational nor a supernatural explanation of events needed ultimately to be endorsed. Even formalist M. R. James would write: "It is not amiss sometimes to leave a loophole for a natural explanation, but I would say, let the loophole be so narrow as not to be quite practicable." Indeed, the archetypal ghost story, J. Sheridan LeFanu's "Green Tea" (1869), posed a mystifying dual explanation of its events, using the inevitable tension between the rational and the irrational to exacerbate its horror—a tension replicated nearly one hundred years later in the wholly inadequate interpretation of the psychiatrist at the conclusion of Alfred Hitchcock's *Psycho* (1960) and the straight-faced recommendation

of exorcism by the physicians in the motion picture of *The Exorcist* (1973).

Stephen King's most pervasive short story, "The Boogeyman,"[22] suggests that explanation, whether supernatural or rational, may simply not be the business of horror fiction—that the very fact that the question "Do the dead sing?" is unanswerable draws us inexorably to his night journeys.

"I came to you because I want to tell my story," says Lester Billings, comfortably enthroned on the psychiatric couch of Dr. Harper. "All I did was kill my kids. One at a time. Killed them all."[23] So begins Lester Billings' journey through the retrospective corridors of psychoanalysis. He quickly explains that he did not actually kill his three children, but that he is "responsible" for their deaths because he has left certain closet doors open at night, and "the boogeyman" has come out. A rational mind must reject such a confessional, and Billings is an abrasive personality—cold, insensitive, filled with hatred for the human condition. Immediately, we doubt his credibility and his sanity. By the story's close, Billings has made it clear that it is he who fears "the boogeyman," and the reader can only conclude that he has murdered his children. Dr. Harper states that therapy will be necessary, but when Billings returns to the psychiatrist's office, he notices that the closet door is open—first, just by a crack, but it quickly swings wide: " 'So nice,' the boogeyman said as it shambled out. It still held its Dr. Harper mask in one rotted, spade-claw hand."[24]

On a metaphorical level, the boogeyman's appearance may be an affirmation of Billings' psychosis—this is the loophole for a rational explanation. Symbolically, we see psychiatry, the supposedly rational science of mind—and, indeed, the science that explained as disease what earlier beliefs had held to be the workings of supernatural forces—succumb to the slavering irrationality of a "boogeyman." The retrogression to childhood, so intrinsic to Freudian solution, ironically affirms the correctness of childhood fears. And this very image is revisited again and again in King's fiction. When Father Callahan confronts "Mr. Barlow," the king vampire of *'Salem's Lot*, he recognizes the face: it is that of "Mr. Flip," the boogeyman who haunted the closets of his youth. The thing that haunts Tad Trenton's closet in *Cujo* prefigures that rabid dog, the nightmare unleashed in daylight. And the Overlook Hotel of *The Shining* is

revealed in the end as the quintessential haunted closet, from which the boogeyman shambles:

> A long and nightmarish masquerade party went on here, and had gone on for years. Little by little a force had accrued, as secret and silent as interest in a bank account. Force, presence, shape, they were all only words and none of them mattered. It wore many masks, but it was all one. Now, somewhere, it was coming for him. It was hiding behind Daddy's face, it was imitating Daddy's voice, it was wearing Daddy's clothes.
>
> But it was not his Daddy.[25]

On both the literal and symbolic levels, "The Boogeyman" shattered the distinction between the supernatural and the empirical, offering the chilling possibility that there is no difference. In its wake, King put forward a theme of "rational supernaturalism" in his novels—first seeded in *Carrie*, but brought to fruition in *The Stand*, *The Dead Zone*, and *Firestarter*—granting credence to unnatural phenomena through elaborate rationalizations not unlike those of science fiction, and simultaneously suggesting a dark truth that we all suspect: that rationality and order are facades, mere illusions of control imposed upon a reality of chaos.

Like the mask worn by the boogeyman, what Stella Flanders has left behind in the small community of Goat Island is deceptive. Surface appearances are not to be trusted, as two young men learn when they test the fledgling ice of the Reach on a snowmobile. The apparent serenity and pastoral simplicity of Goat Island are stripped away through Stella Flanders' memories of the town's complicity in the deaths of a mongoloid baby and a child molester. Artifice and masquerade are recurring themes in Stephen King's fiction, reminding us that evil works from within as well as from without— that, like the ravaged hulk of the 1958 Plymouth Fury that sits at the roadside at the beginning of *Christine*, we are clothed with the thin veneer of civilization, beneath which waits the beast, eager to emerge.

Horror fiction is thus an intrinsically subversive art, which seeks the true face of reality by striking through the pasteboard masks of appearance. That the lifting of the mask may reveal the face of the boogeyman, the new world of *The Stand*, or the nothingness of *Cujo* is our existential dilemma, the eternal tension between doubt

and belief that will haunt us to our grave, when we surely must learn. But the lifting of the mask also strikes at the artifices of control that we erect against this dilemma—our science, religion, materialism, and civilization. That horror fiction evokes current events and religious and sociopolitical concerns should thus come as no surprise. The masterpieces of "yellow Gothic"—Robert Louis Stevenson's *Dr. Jekyll and Mr. Hyde* (1886), Oscar Wilde's *The Picture of Dorian Gray* (1891), H. G. Wells's *The Island of Dr. Moreau* (1896), and Bram Stoker's *Dracula* (1897)—reflected the fears of an age of imperial decline. More recently, the "technohorror" films of the 1950s were obvious analogs of the doomsday mentality created by the atomic bomb and the cold war. As we shall see, the novels and stories of Stephen King exploit this subversive potential, consciously creating sociopolitical subtexts that add timely depth and meaning to their horrifying premises.

Stella Flanders does not read a horror story in "The Reach," but she does the next best thing—attend a funeral. Its ritual is not unlike a horror tale, organizing and packaging fears, giving meaning and value to death (and, in so doing, to life). And Stella Flanders helps us see something more; her attendance is compelled not so much by mere inquisitiveness, escape, catharsis, or the demands of society as by her memories of the past. Things were better then; after all, the Reach—indeed, the whole world—was wider in those days. When Stella Flanders embarks upon her journey, she understands what she is leaving behind in the "small world" on this side of the Reach: "a way of being and a way of living; a feeling."[26] Her glance backward is a fundamental aspect of all horror fiction; thus, Philip Van Doren Stern described the ghost stories of the early twentieth century as "singing the swan song of an earlier way of life."[27]

In an era of continuous social and technological revolution, however, contemporary horror fiction lacks a pretechnological culture to sentimentalize. Indeed, the horror lurking within certain of Stephen King's novels—particularly *The Stand*—is precisely the lack of an "earlier way of life" worthy of our sentiment.[28] Rather than indulge in a spurious attempt to recapture a social milieu, King's fiction often looks to our youth as the earlier way of life whose "swan song" must be sung. His stories are songs of innocence and experience, juxtaposing childhood and adulthood—effectively completing the wheel whose turn began in childhood by reexperiencing those days from a mature perspective. Indeed, several of his novels

suggest that horror fiction performs the role of the modern fairy tale—*Cujo* begins with the words "Once upon a time," while *Carrie* and *Firestarter* respectively evoke the traditions of "Cinderella" and "Beauty and the Beast."

This is a powerful motif; it may cause the reader to look to his or her life as well as that of the characters. In King's works, we experience again those occasions in our lives when it has seemed important to understand what a person really is—to perceive the genuine identity beneath the social exterior of manner, habits, clothes, and job. Such moments are most common in childhood, when no one's identity is certain and when any exterior is likely to be impermanent or false. Uncertainty in our own sense of self renders the processes of knowing and communicating with others difficult and intense. We live in a world of emotion and moral significance, in which the business of life is the process of social relation and social judgment; we constantly attempt to fix our view of others, to do justice to emotions and judgments, yet language always seems inadequate to express what we *know*. We leave this world behind as we mature. As King wryly notes, "the only cure is the eventual ossification of the imaginary faculties, and this is called adulthood."[29] We lose our sense of the mysticism of life—of fear and fantasy, of unhindered and yet inexplicable vision, of unscalable heights and limitless possibilities. This lost world is sought by Ben Mears of *'Salem's Lot* in his nostalgic journey to the haunted house of his childhood, and found by Stella Flanders on the far side of the Reach. It is the world that we recapture in the fiction of horror.

Our haunted past offers one truth, one answer, that is often obscured by the countless rationalizations, psychological interpretations, and critical insights offered to explain the reading and writing of horror fiction. We knew that truth as children, on those nights when we feared the dark, the slightly open closet door, the certain abyss beneath our bed, yet we were drawn to the darkness and dread. It is the truth that anyone who steps upon a roller coaster—and anyone who reads a horror story—must recognize.

The truth is that it was fun—frightening ourselves, having nightmares, realizing that there is something that we do not and may not ever understand. The Reach was wider in those days, and the question "Do the dead sing?" did not need to be asked. Now that we are

older, we may ask that question and offer explanations, but that one truth, that one answer, prevails throughout the night journeys of Stephen King: "We all had some fun tonight," says comedian Steve Martin, "considering that we're all gonna die."

Notes Toward
a Biography: Living
with the Boogeyman

"As to whether he was warped as a child or just born that way, the answer is as obvious as it is ultimately insignificant. Of course he was, and you better watch out."

—*Tabitha King*

"Nobody was really surprised when it happened, not really, not at the subconscious level where evil things dwell."[1] In retrospect, these words, which began the narrative of Stephen King's first published novel, *Carrie* (1974), ring with undeniable truth. With the publication in the fall of 1984 of the paperback edition of King's ninth novel, *Pet Sematary,* and the hardcover edition of his collaboration with Peter Straub, *The Talisman,* more than fifty million copies of the books of Stephen King have seen print worldwide. In the space of only ten years, King has become the most popular writer of horror fiction of all time, a publishing phenomenon whose success, a conjoining of talent and timing, was seemingly inevitable.

King's meteoric rise began in 1976, with the release of Brian De Palma's motion picture adaptation of *Carrie* and the substantial sales of the paperback editions of that book and King's second novel, *'Salem's Lot* (1975). With the publication of King's first hardcover bestseller, *The Shining* (1977), and of *The Stand* (1978) and the short story collection *Night Shift* (1978), King's reputation as the modern master of the macabre was firmly established. His next novel, *The Dead Zone* (1979), perched for more than six months on the *New York Times* bestseller lists and was followed by the similar

popular successes of the novels *Firestarter* (1980) and *Cujo* (1981), a nonfictional reminiscence of the past three decades of horror, *Danse Macabre* (1981), and a collection of four novellas, *Different Seasons* (1982). In 1983, two King novels—*Christine* and *Pet Sematary*— saw print, and at the end of that year, they respectively occupied first positions in *Publishers Weekly's* listings of bestselling paperback and hardcover books. His collaboration with Peter Straub, *The Talisman*, had hardcover sales of nearly one million copies in 1984, and a new collection of short stories, *Skeleton Crew*, topped the bestseller lists in 1985.

In addition, King has published five novels—including two written while in college—under the pseudonym "Richard Bachman": *Rage* (1977), *The Long Walk* (1979), *Roadwork* (1981), *The Running Man* (1982), and *Thinner* (1984). The pseudonym was used, he notes, "to publish stuff when I didn't want to be Stephen King. Paul McCartney used to talk about the idea of the Beatles going around to small clubs, playing gigs in masks or something—anything but as the Beatles. That's what Richard Bachman tried to do."

By the close of 1985, six of King's novels—and one of his short stories, "The Children of the Corn"— had been produced as feature films, and *'Salem's Lot* had appeared as a four-hour television miniseries. *The Talisman* was under development as a motion picture by Steven Spielberg, while "The Body" (from *Different Seasons*) and *The Running Man* were also being adapted for the silver screen. King himself had collaborated with director George A. Romero on an original film anthology, *Creepshow* (1982), and on pending productions of *Creepshow II*, *The Stand*, and *Pet Sematary*. He had also written the screenplays for the original motion picture *Cat's Eye* (1985) and an adaptation of his novelette *Cycle of the Werewolf* entitled *Silver Bullet* (1985). In 1986, his debut as a film director, *Overdrive*, would have its premier, and his long-awaited *magnum opus*, *IT*, would be published.

The man whom *Time* magazine has termed "the Downeast Disney"[3] lives his quiet and staggeringly productive life in rural Maine. With his wife, Tabitha (herself an accomplished writer, as witness her novels *Small World*, *Caretakers*, and *The Trap*),[4] and their three children—Naomi Rachel, Joe Hill and Owen Philip—he moves seasonally between a contemporary summer home on Kezar Lake in Center Lovell and a large Victorian house in Bangor. Stephen King is of Scots-Irish ancestry; he stands six feet, four inches

tall—hunching his shoulders slightly as if shy of showing his height—and weighs just over two hundred pounds. He is blue-eyed, fair-skinned, and has thick black hair; in winter, he usually grows a heavy beard. He has worn glasses since he was a young child, although he occasionally uses contact lenses. King plays tennis and softball in the summer, swims and takes long walks, and watches baseball in season, favoring the Boston Red Sox. He likes beer in quantity and loud rock and roll, does battle with a cigarette habit, and has been known to eat Excedrin dry when he has a headache. He tries to write every day except for his birthday, Christmas, and the Fourth of July, and he writes for an audience of one: himself. His stories exist "because it occurred to me to write them. I have a marketable obsession."[5]

Looking backward over the ten years since *Carrie* was published, it is all too easy to suggest that Stephen King's success should have come as no surprise. But to characterize Stephen King as an "overnight sensation" would be far from the truth. Preceding *Carrie* were more than two thousand pages of unpublished manuscripts, and years of collecting rejection slips and publishing short fiction in obscure or unnoticed magazines. Indeed, the story of his success, and how he has turned horror into a national pastime, has the elements of legend.

Stephen Edwin King was born on September 21, 1947, in Portland, Maine, the second son of Donald and Nellie Ruth Pillsbury King. He was a midlife child, and something of a surprise—his older brother, David, had been adopted earlier when Nellie King was told by doctors that she could not bear a child. If one considers childhood trauma to be formative in the life of a writer—a superficial but inevitable inquiry, particularly when the subject is a writer of horror fiction—then two events in King's early years are noteworthy. In 1949, when he was two years old, his parents separated, and Donald King was never seen or heard from again by his family. Two years later, according to King's mother, the four-year-old Stephen went to play at a neighbor's house—a house that was near a set of railroad tracks:

About an hour after I left I came back (she said), as white as a ghost. I would not speak for the rest of that day; I would not tell her why I'd not waited to be picked up or phoned that I wanted to come home; I would

not tell her why my chum's mom hadn't walked me back but had al-
lowed me to come alone.

It turned out that the kid I had been playing with had been run over
by a freight train while playing on or crossing the tracks (years later, my
mother told me they had picked up the pieces in a wicker basket). My
mom never knew if I had been near him when it happened, if it had oc-
curred before I even arrived, or if I had wandered away after it hap-
pened . . . I have no memory of the incident at all.[6]

King doubts that his genesis as a horror writer can be attributed
to such events: "People always want to know what happened in
your childhood. . . . In truth, the urge to make up unreality seems
inborn, innate, something that was sunk into the creative part of my
mind like a great big meteor full of metallic alloys, large enough to
cause a compass needle to swing away from true north. . . . "[7] In
King's memory, the first time that the needle swung toward that
buried meteor was in 1953, when he crept from his bed, cuddling a
pillow, and placed his ear to the crack of his closed bedroom door,
eavesdropping as his mother listened to the broadcast adaptation of
Ray Bradbury's chilling short story "Mars Is Heaven" on the *Dimen-*
sion X radio program. "When it was over," King recalls, "I tried to
crawl in bed with my brother. He pushed me out and told me to go
to sleep in my own bed, but I wouldn't do that. I'm not sure I *could*
have done that. So instead, I slept under his bed, on my pillow."[8]

Stephen and David King had a conservative upbringing: "There
was a high premium on maintaining a pleasant exterior—saying
'please' and 'thank you' even if you're on the Titanic and it's going
down, because that was the way you were supposed to behave."[9]
Nellie King was a religious woman, with relatively fundamentalist
perspectives; throughout his youth, Stephen King attended Method-
ist church two to three times a week. "We had Thursday night Bible
School, and there was a big poster that read 'Methodists say, *No,*
thank you.' " He often read the Bible, entranced by its stories:

Part of me will always be that Methodist kid who was told that you were
not saved by work alone, and that hellfire was very long—the idea that the
pigeon comes to polish his beak on the top of the iron mountain once every
ten thousand years, and by the time that mountain is worn down, that's
the first second of your stay in Hell. When you are six or seven years old,
that kind of stuff bends your mind a little. So it keeps coming back in my
fiction. And the major reason, I think, is that I still believe that most of the

ideas expressed by Christianity—particularly the progression from the Old Testament ideas to the New Testament ideas—are morally valid.

My religious feelings have not changed very much over the years— they are as traditional as the stuff that I write. They are not complete. I believe in God; I believe what I write when I say that I think we live in the center of a mystery. Believing that there is just life, and that's the end of it, seems to me as primitive as believing that the entire universe revolves around the earth. [10]

The tale of terror became a constant companion—the first motion picture that King can recall seeing was *The Creature from the Black Lagoon* (1954). Nellie King read Classics Comics—illustrated adaptations of world literature—to her sons, and young Stephen felt a "dreadful appreciation" for the tales of horror and science fiction, so much so that individual panels from the comic book versions of H.G. Wells's *The Time Machine* and *The War of the Worlds* remain vivid in his mind to this day. "Because my brother and I loved to have stories read to us, or to be close to her, or both, my mother read to us over the course of four years, from 1953 to 1957 or so, more books that I can remember. . . . [T]he ones I remember most clearly are the scary ones. And I think, although I'm not sure, that they were her favorites as well." [11] King soon began reading on his own, and his appetite for the written word was voracious. "I can remember being caught by Mrs. Taylor, my second grade teacher, reading Jack London's *The Call of the Wild* and being accused of pretending to read it and having to read aloud to her after school before being allowed to go." [12]

The two brothers were raised by their mother in a succession of small towns. Parts of King's childhood were spent in Fort Wayne, Indiana, where his father's family lived, and in Stratford, Connecticut. It was in Stratford that, on October 4, 1957, at age ten, he attended a local movie house to see *Earth vs. the Flying Saucers*. In the middle of the film, the theater lights came on and the manager informed the audience that the Russians had launched the satellite Sputnik. At that moment, recalls King, "the cradle was rudely opened and all of us fell out. It was the end of the sweet dream . . . and the beginning of a nightmare." [13]

Stephen and his brother also paid frequent visits to members of his mother's family in Malden, Massachusetts, and Pownal, Maine. In 1958, when King was eleven years old, his mother settled her

little family in Durham, Maine, so that she could care for her parents, who had become incapacitated with old age: "We lived mostly on the largesse of the other relatives, who were working. So my mother was like a sharecropper, only her crop was these two dying people in their eighties."[14] About three years later, King entered his grandmother's bedroom to find that she had died in her sleep: "I remember sitting on the bed beside her, holding my mother's compact near to her mouth because it was something I had seen in the movies. And there was nothing."[15] Nearly twenty years later, King would write of this experience in the short story "Gramma."[16]

Stephen King had begun to write at about age seven, emulating the adventure and science fiction stories that he read. He was often sick as a child, and illness once kept him out of school for an entire year. Bedridden, he wrote stories for amusement, at first copying from his *Bomba the Jungle Boy* and *Tom Swift* books, then creating his own adventures:

> *I can remember the first real horror story that I wrote. I was about seven years old, and I had internalized the idea from the movies that, when everything looked blackest, the scientists would come up with some off-the-wall solution that would take care of things. I wrote about this big dinosaur that was really ripping ass all over everything, and finally one guy said, "Wait, I have a theory—the old dinosaurs used to be allergic to leather." So they went out and they threw leather boots and leather shoes and leather vests at it, and it went away.*[17]

As he neared adolescence, he knew that he wanted to be a writer:

> *If there was any turning point, it was when I got a typewriter. I got an office model Underwood, and it took me to the place where the physical act of writing wasn't uncomfortable any longer—from the stage of taking five minutes to write out a sentence to that of being able to keep up with the run of my thoughts. I also finally had the means to prepare manuscripts that people might actually look at for publication—at least until the n key broke on it. And even then I would kid myself—they won't notice if I'm really good—but I used to hate that. I would sit down with a finished manuscript and just fill in every n by hand. And then the e broke, and then the t. . . .*[18]

At age twelve, he began to submit stories for sale, choosing his favorite science fiction magazines, *Fantastic* and *The Magazine of*

Fantasy and Science Fiction, as his principal targets; but he received only form rejection slips in reply. His first responsive communication was a "crusty" but supportive rejection note from Avram Davidson, then editor of *The Magazine of Fantasy and Science Fiction.* King recalls those early stories with undisguised fondness:

> These stories had the trappings of science fiction—they were set in outer space—but they were really horror stories. One of the few good ones was about an asteroid miner who discovered a pink cube, and all this stuff started to come out of the cube and drive him back further and further into his little space hut, breaching the airlocks one after the other. And the thing got him in the end. All of the science fiction magazines sent it back, because they knew goddamn well there was no science in it—there were no aliens trying to communicate using psionic talents, or anything like that. There was just this big pink thing that was going to eat someone, and it ate him.[19]

At about this time, King had also discovered the reality of evil. As recounted in the short story "The Revenge of Lard Ass Hogan,"[20] the young Stephen kept a scrapbook of newspaper clippings on the murder spree of Charles Starkweather. "It was a young boy's first glimpse of the face of evil," he recalls. "I loved that guy. I thought that he was 'cool as a moose,' as we used to say; but at the same time, he scared me shitless. My mother was ready to have me placed in analysis."[21]

In Durham in the fall of 1959 or 1960, King's fledgling writing career received a strange legacy from his departed father, who, according to King's mother, had himself tried a hand at writing fiction. In the attic above his aunt and uncle's garage, King discovered a box of his father's old books; inside were Avon paperbacks from the 1940s that included a sampler of stories from *Weird Tales* magazine and a collection of stories by H. P. Lovecraft.[22] This encounter with serious fantasy and horror fiction exerted a profound influence upon his writing efforts, as did his exposure during the same time period to E. C. Comics that he found in secondhand book stores. King began to read horror stories constantly, and soon came upon the fiction of Richard Matheson, which probably had the greatest impact upon him as a writer:

> I had read Poe and I had read a lot of Gothic novelists, and even with Lovecraft I felt as though I were in Europe somewhere. I knew instinc-

tively that I was trying to find a way to get back home, to where I belonged. And then I read Richard Matheson's I Am Legend, *where this fellow is blockading himself in his house every night—and it wasn't a castle, it was a tract house in Los Angeles. He was going out and staking vampires every day, finding them at the cold counter at Stop and Shop, laid out like lamb chops or something. And I realized then that horror didn't have to happen in a haunted castle; it could happen in the suburbs, on your street, maybe right next door.*[23]

King completed grammar school in Durham and then attended Lisbon Falls High School. Undaunted by his collection of rejection slips from science fiction magazines, King began publishing his own stories:

My brother had an offset printing press in the basement of our house— something that he had picked up. He used to publish his own little newspaper on it, called "Dave's Rag." People would telephone for Dave and my mother, in all innocence, would say, "Well, Dave can't come to the phone right now, he's down in the basement on the rag." Someone finally suggested a better description to her.

One day I went to Brunswick to see the American International film of The Pit and the Pendulum *with Vincent Price, and I was very impressed by it—very, very scared. And when I went home, I got a bunch of stencils, and I wrote a novelization of that movie, with chapters and everything—although it was only twelve pages long. I bought a ream of typewriter paper, and I bought a stapler and some staples, and I printed, on Dave's machine, about two hundred and fifty copies of this book. I slugged in a price of a dime on them, and when I took them to school, I was just flabbergasted. In three days, I sold something like seventy of these things. And all of a sudden, I was in the black—it was like a license to steal. That was my first experience with bestsellerdom.*

But they shut me down. They took me to the principal's office and told me to stop, although there didn't seem to be any real reason. My aunt taught in that school, and it just was not seemly; it wasn't right. So I had to quit.[24]

There were several of such self-published "books," but copies of only two exist today: "People, Places, and Things—Volume I," a 1963 collection of eighteen one-page horror and science fiction stories created by King and his friend Chris Chesley; and an "AA Gaslight Book" written and printed by King in 1964 entitled "The Star Invaders," an imaginative science fiction story evocative of the

motion picture *Earth vs. the Flying Saucers*, which had so affected him seven years before.

King's teenage years were introspective; his family placed an emphasis "on keeping yourself to yourself." Although he had many friends, worked on cars, played organized sports, it was his private side that was important:

> *Inside, I felt different and unhappy a lot of times. I felt violent a lot of times. But I kept that part of myself to myself. I never wanted to let anybody get at it. I figured that they'd steal it, if they knew what I thought about this or that or the other thing. It wasn't the same as being embarrassed about it, so much as wanting to keep it and sort of work it out for myself.*
>
> *I could write, and that was the way I defined myself, even as a kid. Maybe I couldn't put one past the centerfielder, and maybe all I was good for in football was left tackle. You know, I used to get cleat marks up my back.*
>
> *But I could write. . . .*[25]

Looking back on his youth, he assesses it as a happy time: "My memories of childhood are that it was a good one, a quite happy one—in a lonely or a solitary way. If I had really been unhappy, it would come out in what I've written."[26]

During high school, King saw his first story published by another hand: "I Was a Teenage Grave Robber,"[27] which appeared in 1965 in the comics fan magazine *Comics Review*. He also completed his first novel-length manuscript, *The Aftermath*, which is the story of Talman, one of the survivors of a nuclear holocaust. Talman is a loner, and something of a Jonah; ultimately he joins the Sun Corps, a paramilitary organization seeking to restore order to crippled America. He learns of a Godlike computer that ordains the increasingly fascist policies of the Corps, and sets out to destroy the machine. The novel is remarkably mature, and demonstrates King's storytelling talents even at an early age. But King's major writing success during high school was probably his production of a send-up of the school newspaper called *The Village Vomit*, which earned him a three-day suspension from school:

> *It was difficult for anybody to conceive of someone getting a suspension not for fighting or for smoking, but for something you had actually writ-*

ten. It demonstrated that it really was true that the pen could be very powerful.[28]

In the summer of 1966, after his graduation from high school, King began work on a psychological suspense novel entitled *Getting It On*. He had been accepted at Drew University, a liberal arts college near New York City associated with the United Methodist Church, but his family's finances were insufficient to enable him to attend; he entered the University of Maine at Orono, just north of Bangor, in the fall of 1966. In his freshman year, he made his first professional sale—a short story, "The Glass Floor," which appeared in Robert A. W. Lowndes' *Startling Mystery Stories*.[29] He also completed his first truly adult novel, *The Long Walk*, a dystopian fantasy set in a parallel world. Although he submitted the book to a first-novel competition, "[i]t was rejected with a 'Dear Contributor' note, and I was too crushed to show that book to any publisher in New York."[30]

During his sophomore year, he completed another novel, *Sword in the Darkness*. Heavily indebted to the "Harrison High" novels of sometime horror novelist John Farris—who, along with Don Robertson, author of *The Greatest Thing Since Sliced Bread* (1965), *Paradise Falls* (1968), and other novels, was a major influence upon the maturing King—this lengthy tale of a race riot at an urban high school was rejected an even dozen times on Publishers' Row. King reflects: "I had lost my girlfriend of four years, and this book seemed to be constantly, ceaselessly pawing over that relationship and trying to make some sense of it. And that doesn't make for good fiction."[31]

Although King reworked *Getting It On* during his junior year, he completed no further novel-length works in college after *Sword in the Darkness*. Ironically, his participation in creative writing courses during the last two years of college stifled his output: "[I]t was a constipating experience; it was the worst thing I could have done to myself. And it really muffled everything for a while. Once I got out of the writers' workshops and I could stop worrying about what felt right and just *do* what felt right, everything was fine."[32]

His studies produced two lasting influences, however; first was his exposure to the naturalist writers:

Thomas Hardy, Jack London, Theodore Dreiser—the list goes on and on. I was always impressed with the naturalists. Their stories would

suggest to me that almost everything that we do has a history. No matter where you come in on any situation, you are not coming in at the beginning. James Clavell says that the most difficult thing for him is to end a book, because the story always goes on. And the story always does go on. The hardest thing for me is to start a book, because the minute that I come in, I want to say to you, "But you don't understand, this is what her father was like; and his father, wait until I tell you about him—and look over here, this is how things happened before World War Two." And how do you fit all of this history into a book?[33]

The second influence was a poetry seminar taught by Burton Hatlen, who was interested in contemporary American mythology. In those years, the concept of "black soul" was prominent in the wake of Eldridge Cleaver's *Soul on Ice* (1967). Hatlen, rather than lecture on traditional aspects of poetry, asked his students: "Is there such a thing as white soul? Is there suburban soul?" King recalls:

Something in all of that reached out to me, because I liked McDonald's and Dairy Queen and things like that. You'd see people bopping in there, and it seemed to me they did have white soul.[34]

When King showed his work to Hatlen, he took it seriously, as literature, and encouraged King to explore the mythic elements of fiction. "He was a sophomore at the time," says Hatlen:

And he said, "I've written this novel—would you read it?" I took the manuscript home. It was sitting on the dining room table, and my wife picked it up, started reading it, and literally did not stop. And then I read it, and I was simply stunned. There was an immediate sense of plot and pace; the control of narrative seemed instinctive. There was no suggestion that he needed to learn any of that. At about the same time, he showed it to a creative writing teacher, Ted Holmes. And I remember running into Ted in the office right afterward; he just said, ecstatically, "I think we've got a writer."[35]

The serious reception given his work by Hatlen, Holmes, and a few other faculty members bolstered King's ambition to write professionally. "You've got to have some support," King notes. "If you listen to enough people say what you're doing is not important, then you begin to think, 'What I'm doing *isn't* important.' "[36] In retro-

spect, Hatlen recognizes that the interaction of certain faculty members with King provided the young writer with more than moral support:

> *It suggested to him that there was not an absolute, unbridgeable gulf between the academic culture and popular culture, and that he could move back and forth between the two, which was, in some ways, a key discovery for him. Because I think it enabled him to become what he wanted to be—a serious writer in American literature as well as a best-seller—and that's kind of unique.* [37]

King published a number of short stories in college literary magazines, including early versions of "Strawberry Spring"[38] and "Night Surf,"[39] and won an award for his one-act play "The Accident." He was actively involved in the school newspaper, *The Maine Campus,* writing a weekly opinion column, "King's Garbage Truck," in which he offered highly personalized commentary on subjects ranging from record reviews to the first moon landing. He also began a political pilgrimage: his conservative upbringing fell away with a sudden rage, and he became active in the campus antiwar movement and in student politics, serving as a member of the student senate. During his senior year, he co-taught a course in American popular fiction—perhaps the only time that an undergraduate has served as a teacher at the University of Maine.

Also during his senior year, while working at a part-time job in the stacks of the university library, King met Tabitha Jane Spruce. Born in 1949 in Old Town, Maine, Tabitha was the third of eight children; like King, she had written since her childhood, but she intended to pursue a career in archaeology and history. Her plans to attend the University of New Mexico were dashed by a lack of money, and in 1967, she entered the University of Maine at Orono in a work-study program. She soon encountered the "King's Garbage Truck" column in the school newspaper: "I remember reading it and getting furious," she says, "thinking 'Who's this joker who just moved in?' "[40] One day, she was crossing the campus to the library with a friend. "He pointed ahead of us to this enormous, shambling person in cut-off gum rubbers. Talk about hippie—this was serious hippiedom in front of me. My friend said, 'Do you know who that is? That's Steve King, and he is going to be working with you this summer.' And I said, sarcastically, 'I think I'm in love.' "[41]

When they eventually met in the library stacks, it was not exactly love at first sight. "I was a lot more impressed with him than he was with me," she recalls:

> He thought I had all the makings of a fine waitress. I thought he needed a haircut, but I revised my opinion. He was the only one I knew who was serious about writing.
>
> And he needed more than a haircut; he was really living under dreadful circumstances. Talk about going to college poor—this guy was going to college the way that people did in the twenties and thirties. He had nothing to eat, he had no money, he had no clothes; it was just incredible that anybody was going to school under those circumstances, and even more incredible that he didn't care. All he cared about was the education. It didn't matter to him at all that there was no money for him to get into the fraternity system or to have a car to impress the girls. All he cared about was getting everything he could out of school and writing his head off.[42]

In 1970, King graduated from the University of Maine at Orono with a Bachelor of Science degree in English and certification to teach on the high school level. The parting installment of his "Garbage Truck" column for *The Maine Campus* was a mock announcement of his "birth" into the "real" world; it included the following self-assessment:

> This boy has shown evidences of some talent, although at this point it is impossible to tell if he is just a flash in the pan or if he has real possibilities. It seems obvious that he has learned a great deal at the University of Maine at Orono, although a great deal has contributed to a lessening of idealistic fervor rather than a heightening of that characteristic. If a speaker at his birth into the real world mentions "changing the world with the bright-eyed vigor of youth" this young man is apt to flip him the bird and walk out, as he does not feel very bright-eyed by this time; in fact, he feels about two thousand years old.[43]

King then set out on the difficult course of writing for a living:

> I . . . packed all my worldly possessions into a pair of shopping bags, moved into a sleazy Orono, Maine, apartment and started what I hoped would be a very long fantasy novel called The Dark Tower. I had recently seen a bigger-than-life Sergio Leone western, and it had gotten

*me wondering what would happen if you brought two very distinct gen-
res together: heroic fantasy and the Western. . . .*[44]

But the fruits of his efforts—the first stories of his "Gunslinger"
cycle—would not see publication for several years.[45]

Shortly after his graduation, he sold his first story to a mass mar-
ket magazine—"Graveyard Shift"[46] to *Cavalier*, which, under the
editorship of Nye Willden in the late 1960s and early 1970s, pub-
lished a great deal of quality horror and science fiction. Throughout
the next several years, King would sharpen his talents in many short
stories sold primarily to men's magazines, the majority of which
were collected in *Night Shift* (1978).

Stephen King married Tabitha Spruce in January 1971, during
Tabitha's last year of college. Unable to find placement as a teacher
upon his graduation, King took work as a laborer in an industrial
laundry, where he earned sixty dollars a week—an experience that
he would use in at least two short stories, "The Mangler"[47] and "Big
Wheels."[48] Tabitha took a job as a waitress: "I was devastated to get
out of college and find that no one wanted to hire me. I had man-
aged to work all of the way through college and make money, only
to discover suddenly that my B.A. was worth absolutely nothing."[49]

Writing at night, King completed the novel *Getting It On* early in
1971. At about the time that he was preparing to offer the novel to a
publisher, he borrowed Loren Singer's *The Parallax View* (1970)
from the Bangor Public Library. The "slightly surrealistic flavor" of
Singer's book reminded King of his own work, and he sent a query
letter addressed to "The Editor of *The Parallax View*" at its pub-
lisher, Doubleday. On the day the letter arrived at Doubleday, the
editor of *The Parallax View* was ill, and the letter was referred to
another editor, Bill Thompson. Thompson replied with, in King's
words, "an open-minded sort of letter from a man who obviously
thought that there just might still be a good unsolicited novel some-
where out there in America."[50]

King sent the book to Thompson, who liked it a great deal; after
further rewriting, it appeared that Doubleday would publish *Get-
ting It On*. King reflects:

If Doubleday had published Getting It On, *it would be easy to say that
it would have changed everything, because the book was not a horror*

novel. But it really wouldn't have changed anything; because in the long run, the monster would have come out.[51]

Doubleday eventually decided not to publish the book, however, and it would lay dormant for six more years, only to become King's first "Richard Bachman" novel, *Rage*. When a teaching position became available at Hampden Academy in Hampden, Maine, King applied for the job and was hired—"taking the first step down the other road and entertaining half-bitter, half-morbid thoughts about all the potential Plaths and Updikes and Mailers and Ross MacDonalds who had ended up spending the 40 years following their graduation teaching the difference between participles and gerunds . . ."[52] In the fall of 1971, he began teaching high school English at Hampden Academy.

The Kings, with their first child, Naomi, took up residence in a trailer in nearby Hermon. King wrote in the furnace room of the trailer, his wife's Olivetti typewriter perched upon a child's desk. During one weekend in the winter of 1971, he wrote *The Running Man*, a near-future science fiction novel that was immediately rejected by Bill Thompson at Doubleday; it was also declined by Donald A. Wollheim at Ace Books, who responded that he was "not interested in negative Utopias."[53]

For the King family, the situation, already difficult, grew perilous. King's teaching workload cut back sharply on his writing time. A second child, Joe, was born, and King's salary as a teacher was insufficient to meet the bills; "financially it was always very, very tight," notes Tabitha King. "We lived from hand to mouth. My kids' clothes were all borrowed or given. Joe cost about three hundred dollars because I didn't stay in the hospital after giving birth—there was just no money to pay those bills."[54] The Kings had their telephone removed in a "pitiful act of defiance. It was quitting before the Credit Department fired us." King was drinking heavily: "I began to have long talks with myself at night about whether or not I was chasing a fool's dream."[55] As the winter of 1972 descended and snowmobiles buzzed across the fields outside the trailer, King's writing was roadblocked; he lacked ideas for a story or a novel. For want of anything else to write, he began revising a short story called "Carrie" that he had tinkered with the previous summer.

At that point, even though almost all of King's short story sales were horror fiction, he had not considered writing a horror novel.

After a fitful start, during which Tabitha King literally rescued the manuscript from the wastebasket, this short story grew into a novel. King felt that the finished manuscript was "a certified loser"; it sat for a month before he dispatched it to Bill Thompson at Doubleday. But Thompson was enthusiastic; after substantial revisions to the book's last fifty pages, Stephen King became a *bona fide* "first novelist."

Doubleday purchased *Carrie* in the spring of 1973 for an advance against royalties of $2,500. On Mother's Day of that year, Bill Thompson called King with the news that New American Library had bought the paperback rights to the novel for a staggering sum of money:

> *My wife was not at home. I hung up, and I walked around the house, running my hands through my hair, stopping, then sitting down for a minute and looking blankly out of the window. Then I would get up and walk around the house, running my hands through my hair some more. The thought going through my mind was that I had to do something—I had to mark this. After about twenty minutes, I finally decided that I was going to get Tabby a present. I was going to do it right now, and as I crossed the street, a drunk would come along in a car and he would kill me, and things would be put back in perspective.*
>
> *I went downtown and bought her a hair dryer for twenty-nine dollars—and I scuttled across those streets, looking both ways.*[56]

The paperback sale allowed King to leave teaching and write full-time. He moved his family from Hermon to southern Maine. Renting a summer house on Sebago Lake in North Windham for the winter, he pressed ahead with work on another novel. As the family waited for his first book's publication, Nellie Ruth King died of cancer; her son would write about her, and about his feelings at her death, in "The Woman in the Room."[57]

Then, in the spring of 1974, a $5.95 hardcover book called *Carrie* appeared in the bookstores.

Stephen King's reign of terror had begun.

Carrie

"The dark spot by the road that you might not notice at all is, you see, the beginning of everything."
—*Sherwood Anderson*

Stephen King's first published novel, *Carrie* (1974),[1] is also his most eccentric. It is streamlined and uses an epistolary structure—only about half of the novel is written in a traditional narrative style, with the remainder presented in bogus items of documentation: newspaper clippings, letters, excerpts from books, transcripts of legislative hearings, teletype news reports.[2] The result is an appealing chronicle that presents a cacophony of perspectives on an otherwise brief and simplistic story with a balanced moral precept. A great deal of dramatic irony (not to mention stylistic parody) is contained in the spillover of the documentary portions of the book.

In the principal narrative, however, the unassuming prose and truthful characterizations that would become trademarks of King's later novels are present. He writes in what E. B. White once called the "plain style"—what King himself has termed "the literary equivalent of a Big Mac and a large fries from McDonald's."[3] This seemingly offhand, conversational style, when combined with his appealing characters, produces an almost immediate intimacy with the reader—an intimacy that King savors:

In most of the books, I think, there's a kind of Steve King hammock that you fall into—and you feel really comfortable in that hammock, be-

cause you know the people and you feel good about them. You don't have unease about who they are—you have unease about the circumstances that they find themselves in.[4]

As early as the second page of *Carrie,* the observation of schooldesk graffiti—"Carrie White eats shit"—ambitiously evokes the visceral, bringing the reader down to the gut level at which King operates best. "I recognize terror as the finest emotion," he has written. "So I try to terrorize the reader. . . . But if I find I cannot terrify, I will try to horrify. And if I cannot horrify, I'll go for the gross-out. I'm not proud."[5] No better summation of these endearingly excessive elements of King's prose can be written than Peter Straub's reaction to his first exposure to the novels of Stephen King:

Good taste had no role in his thinking: he was unafraid of being loud and vulgar, of presenting horrors head-on, and because he was able to abandon notions of good taste he could push his ambition into sheer and delightful gaudiness—into the garish beauty of the gaudy. . . .
 . . . [His] was not at all a literary style, but rather the reverse. It made a virtue of colloquialism and transparency. The style could slide into jokes and coarseness, could lift into lyricism, but what was really striking about it was that it moved like the mind itself. It was an unprecedentedly direct style . . ., and like a lightning rod to the inner lives of his characters.[6]

Carrie is the story of a teenaged ugly duckling, a fractured fairy tale based in part upon two schoolgirls whom King had known. Carrie White is seventeen years old, trapped between childhood and womanhood, and caught up in the ageless battle between identity and her mother's beliefs and experience. She can find comfort and understanding neither at home nor in the "ant farm" microcosm of high school. Her mother's fundamentalist religious mania has tied short apron-strings, denying Carrie even rudimentary social contacts and insisting that womanhood is sinful. Carrie's ostracization at school is inevitable, not simply because of her appearance and upbringing, but because of the nature of high school itself. As King summarized the book in *Danse Macabre* nearly a decade after its creation:

[T]he book tries to deal with the loneliness of one girl, her desperate effort to become a part of the peer society in which she must exist, and

how her effort fails. If it had any thesis to offer, this deliberate updating of High School Confidential, *it was that high school is a place of almost bottomless conservatism and bigotry, a place where the adolescents who attend are no more allowed to rise "above their station" than a Hindu would be allowed to rise above his or her caste.*[7]

Carrie is alone, awkward, different. No one befriends her—no one seems to understand her, to be able to communicate with her. She is the victim of the mindless, almost unfocused, hatred of her peers. Even her body is alien to her, undergoing its strange transformation toward womanhood—and toward something more. She is telekinetic, gifted (or damned) by a genetic mutation—the ability to move objects merely by thought. Her belated first menstruation intensifies the power, bringing it within her conscious control. When fully unleashed, her "wild talent" will demolish her home, her high school, and her small hometown of Chamberlain, Maine; but only after Carrie's brief journey to womanhood has rendered the innocent, unattractive, and slightly backward schoolgirl into a powerful and beautiful angel of destruction.

The fairy tale resonances of Carrie are undeniable. Stephen King casts a warped Cinderella story of an ugly duckling, ground beneath the heels of a wicked stepmother and tormenting stepsisters. One of the schoolgirls, Susan Snell, takes on the role of fairy godmother when, ashamed at the latest humiliation wreaked upon Carrie, she persuades her boyfriend, handsome Tommy Ross, to escort Carrie to the prom. A magical transformation occurs—makeup and new clothes, and even the pleasure of spiting mother, are insufficient to explain realistically Carrie's conversion into a beautiful swan at the axis of the book. For a few moments, in the dreamworld of the high school prom, Carrie attains the acceptance of her society. The Cinderella imagery is made explicit when she loses her slippers fleeing the ball. It is not the midnight chime that calls Carrie home, however, but a cruel practical joke—a shower of pig's blood, mirroring her first, humiliating menstruation in the girl's shower room. Fairy tales do not always come true, and there is always something dark lurking behind the beauty:

They were all still beautiful and there was still enchantment and wonder, but she had crossed a line and now the fairy tale was green with corruption and evil.[8]

The result is revolution—violent revolution, tearing apart the society that she longed to embrace: "Her only thought was to run, to get out of the light, to let the darkness have her and hide her."[9] Carrie strikes out with her powers and brings down a holocaust upon Chamberlain, Maine; but her act is not revenge—nor is it evil.

Popular entertainment finds it convenient to stereotype children. Misguided sentiment often sees children portrayed in a wholly innocent—and mindless—sense. In the realm of horror fiction, a tried and true device—typified *ad nauseam* by the novels of John Saul—is the inversion of innocence, rendering children into agents of darkness for no reason other than exploitation. The wellspring of horror's spate of evil children was, ironically, a conscientious novel—William Peter Blatty's *The Exorcist* (1971), which depicted an adolescent girl possessed by a demon without her complicity and for reasons only vaguely comprehensible. The book, as well as the resulting motion picture, was working a motherlode of social fear emergent at the time of its writing: a "generation gap" that had widened to a violent chasm. On a rather blatant level, *The Exorcist* rehearsed the very sudden and very real alienation of parents from their children. And what better explanation could be offered for rebellious youth than possession by demons? Perhaps only that of the motion picture drudgery called *The Omen* (1976), in which the child is the Antichrist itself.[10]

It is true that Carrie's rebellious obscenities echo Regan MacNeil's marathon blasphemies in *The Exorcist,* and that the climactic bloodbath of the "Black Prom" and the destruction of Chamberlain, Maine, produce images of a ruthless child-juggernaut—enhanced, perhaps, by the intense visual imagery of Brian De Palma's motion picture adaptation of the novel. It is also true that the popular success of the book and film of *Carrie* benefited from the fallout of *The Exorcist.* Yet the reader of *Carrie* should understand that evil lies not in Carrie White but in her tormentors—and, more important, in the traps of society and religious mania in which her tormentors are confined. "I never viewed Carrie as evil," notes King. "I saw her as good. When she pulls down the house at the end, she is not responsible."[11] As we shall see, Carrie White is the first of many King protagonists who reflect his naturalistic stance—she starts nothing of her own free will. The fault—the evil—is that of nature itself, and of the artificial constructs of nature (here, society and religion) that civilization has erected.

Stephen King is also a romantic; he believes in the innate good-
ness of children. There have been exceptions in his fiction, to be
sure; but even the explicit evil of the young characters of "Children
of the Corn"[12] and "I Know What You Need"[13] is steeped in King's
thematic concern with childhood, the nature of corruption, and the
rite of passage to adulthood. As fellow horror novelist Charles L.
Grant has observed, King's fiction posits that "[t]he struggle toward
adolescence and adulthood is as fraught with terror as the worst
possible nightmare, and as meaningful as anything a grown-up has
to contend with."[14]

That journey, the coming of age, is an important underpinning of
all of King's novels, and in *Carrie*, we see glimpses of the true dan-
ger that King perceives along its path. It is impossible to escape the
feeling of deep unease that presides over Carrie White. She is the
archetypal teenager, grappling with the weight of misunderstand-
ing and feelings of impotence and paranoia, needing ever so badly
the cathartic release from adolescence. She is at the center of an
ever-tightening circle of control, of a society laden with traps that
demand conformity and the loss of identity. Her mother is trapped
by fanatic religious fundamentalism and guilt. The schoolgirls who
torment her are trapped by the demands of their peer groups—and
Chris Hargensen, the evil stepsister of the drama, is in dark rebel-
lion against the trap of parental expectations, while Susan Snell
flinches from the traps of American womanhood:

> *The word she was avoiding was expressed* To Conform, *in the infinitive,
> and it conjured up miserable images of hair rollers, long afternoons in
> front of the ironing board in front of soap operas while hubby was off
> busting heavies in an anonymous Office; of joining the P.T.A. and then
> the country club when their income moved into five figures; of pills in
> circular yellow cases without number to insure against having to move
> out of the misses' sizes before it became absolutely necessary and against
> the intrusion of repulsive little strangers who shat in their pants and
> screamed for help at two in the morning. . . .*[15]

And the high school boys—Chris's macho greaser Billy Nolan and
Susan's All-American Tommy Ross—are, at least early in the book,
cat's paws, trapped by the manipulations of their girlfriends.

In the book's undercurrent of social commentary, a feminist ele-
ment is pervasive, although unobtrusive. The "curse" of menstrua-

tion intertwines with the "curse" of Carrie's telekinesis, as well as with the nightmare passage to womanhood. The blood imagery of *Carrie* has sexual significance, not as an extension of erotic power as in the traditional vampire novel, but of feminine power. King has written:

> Carrie *is largely about how women find their own channels of power, and what men fear about women and women's sexuality. . . . The book is, in its more adult implications, an uneasy masculine shrinking from a future of female equality. For me, Carrie White is a sadly misused teenager, an example of the sort of person whose spirit is so often broken for good in that pit of man- and woman-eaters that is your normal suburban high school. But she's also Woman, feeling her powers for the first time and, like Samson, pulling down the temple on everyone in sight at the end of the book.*[16]

For Carrie White, the circle of control and conformity tightens to the breaking point, but the violent catharsis that it provokes nevertheless fails to break its nooselike grip. Most of the novel's documentary elements concern the inevitable aftermath of her acts—a government investigation that tidily packages the incident with an acceptable explanation and offers up a scapegoat. At the novel's end, King's wry interjection of an excerpt from a book of slang shows that Carrie has been defined away as a comfortable colloquialism, memorialized for her act rather than herself.

In the traditional fairy tale, the heroine masters the trials set before her and becomes the ruler of a kingdom—symbolizing autonomy and the ability to rule her own life. In Stephen King's dark modernization of the Cinderella story, those childhood dreams are dashed. Carrie is pushed to a brink where there is no alternative but violence; and without her wild talent, there would be no alternative at all—life would crush her. King reflects on the pessimism of his conclusion:

> The fundamental unfairness of naturalistic storytelling is that it doesn't really admit for much optimism—for the lucky break, for things going right instead of wrong for a change. The happy ending is not the contrivance that a lot of existential writers would have us believe it is—we know from our own lives that happy endings are often the natural order of things.
> . . . At one point, Carrie thinks about some fashion magazines—that

she could make nice dresses like in the magazines, and that she could go away, she could start again. But when I wrote the story, I felt that I was her God, her fate, driving her down this cattle chute toward the end. In the real world, perhaps she would have gone away—except that the girl who was a prototype for Carrie did just that, and she had an epileptic seizure alone in her apartment, and strangled on her own tongue.

So there isn't always a happy ending.[17]

Even death, we learn, offers no solace for Carrie White. Susan Snell, drawn to the dying Carrie, witnesses that journey toward night—a rehearsal of her own death—through Carrie's ebbing power:

> *For a moment Sue felt as if she were watching a candle flame disappear down a long, black tunnel at a tremendous speed.*
> *(she's dying o my god i'm feeling her die)*
> *And then the light was gone, and the last conscious thought had been*
> *(momma i'm sorry where)*
> *and it broke up and Sue was tuned in only on the blank, idiot frequency of the physical nerve endings. . . .*
> *She began to run, breathing deep in her chest, running from Tommy, from the fires and explosions, from Carrie, but mostly from the final horror—that last lighted thought carried swiftly down into the black tunnel of eternity, followed by the blank, idiot hum of prosaic electricity.*[18]

The blackness at the end of Carrie's journey is indeed the final horror, a dire affirmation of the futility of her desperate life; but Carrie has reached, at last, a kind of peace. The horror is that of Susan Snell—and, vicariously, of the reader—who must live in the memory of the blackness and its death song. Susan's vision is of that blinding mystery that the horror story embraces—the impenetrable mystery of death, toward which we move closer every day; in the words of Stephen King: "We fall from womb to tomb, from one blackness and toward another, remembering little of the one and knowing nothing of the other . . . except through faith."[19]

The hardcover edition of *Carrie* sold a modest thirteen thousand copies. Its paperback edition, released in April 1975, would initially sell over a million copies; but well before that time, the process by

which Stephen King has become a "brand name" horror novelist was irretrievably in motion.

After *Carrie* had been accepted for publication by Doubleday, King went through a prolific six months of writing, producing the first drafts of two novels—a suspense melodrama entitled *Blaze*, which concerned "a huge, almost retarded criminal who kidnaps a baby, planning to ransom it back to the child's rich parents . . . and then falls in love with it"[20]; and a horror novel called *Second Coming*. After Bill Thompson at Doubleday read both books, he and King decided that the horror novel—later retitled *Jerusalem's Lot* and, finally, *'Salem's Lot*—should be published next. Before its publication, and before *Carrie* was released in paperback, King completed *Roadwork*, a novel that sought "to make some sense of my mother's painful death the year before"[21]; it proved too painful to offer for publication, and King set it aside. He turned then to the first draft of *The Shine*, which would ultimately be retitled as *The Shining*. After reading this manuscript, Thompson voiced his concern that King would become typecast as a horror writer. The problem had been considered before by King, but this time he took it more seriously:

> [A]nd then I thought about all the people who had been typed as horror writers, and who had given me such great pleasure over the years— Lovecraft, Clark Ashton Smith, Frank Belknap Long, Fritz Leiber, Robert Bloch, Richard Matheson, and Shirley Jackson. . . . And I decided . . . that I could be in worse company. . . .
>
> "That's okay, Bill," I said, "I'll be a horror writer if that's what people want. That's just fine."
>
> We never had the discussion again. Bill's still editing and I'm still writing horror stories, and neither of us is in analysis. It's a good deal.[22]

In the spring of 1976, *'Salem's Lot* was published in paperback; about ten weeks later, Brian De Palma's motion picture adaptation of *Carrie* was released, along with a "movie tie-in" paperback edition of *Carrie*. The two paperbacks promptly sold some three-and-a-half million copies; and, in 1977, *The Shining* became Stephen King's first hardcover bestseller.

Stephen King was here to stay.

'Salem's Lot

"You know what there is down there in 'Salem's Lot? Want me to tell you? Want me to tell you?"

—*Stephen King*

In the early pages of *'Salem's Lot* (1975),[1] haunted writer Ben Mears sees a copy of his second novel in the hands of Susan Norton, the woman who will become his lover—and the woman whom he will kill. And he says: "Of such inconsequential beginnings dynasties are begun."[2] This was an ironic prophecy, to be sure, for Stephen King, who would see his second published novel sell a respectable twenty-six thousand copies in hardcover and then top the *New York Times* bestseller list in paperback, the springboard for his dynasty of terror.

Whether these beginnings were "inconsequential" is another matter. *'Salem's Lot* saw little critical attention at the time of its publication. Retrospective analysis has seen too many critics willing to dismiss the book prematurely as "just another vampire story."[3] But the novel has remained, over the years, King's personal favorite; and it is the single most influential of his books upon other writers of horror fiction.[4]

'Salem's Lot was written in 1973; the idea resulted from a dinner conversation in which King, his wife, and his long-time friend Chris Chesley discussed what might happen if Dracula returned in modern times, not to London, but to rural America. When King jok-

ingly said that the FBI would quickly put him to rest, a victim of wiretaps and covert surveillance, his companions noted that almost anything could occur unnoticed in the small towns of Maine. King reflects:

> There are so many small towns in Maine, towns which remain so isolated that almost anything could happen there. People could drop out of sight, disappear, perhaps even come back as the living dead.
>
> I began to turn the idea over in my mind, and it began to coalesce into a possible novel. I thought it would make a good one, if I could create a fictional town with enough prosaic reality about it to offset the comic-book menace of a bunch of vampires.[5]

'Salem's Lot was thus modeled upon the most enduring of all horror novels, Bram Stoker's Dracula (1897). As a mere comparison of titles will suggest, however, the focus of King's novel is not vampirism but its victim, a small town in southern Maine.[6] Indeed, "Mr. Barlow"—the king vampire of 'Salem's Lot—does not even appear until page 157 of the hardcover edition of the book. His physical presence in the remainder of the narrative is rare, reserved primarily for two climactic scenes of confrontation. This depiction resulted, in part, from a lesson King had learned from Dracula: "More than anything else I was impressed by the way [Stoker] made the Count seem more fearsome by keeping him offstage. . . ."[7] But equally important, and easily overlooked, is the fact that King's use of the vampire in 'Salem's Lot is not simply literal—behind the bared teeth of the undead lie important metaphors for the seductiveness of evil and the dehumanizing pall of modern society.

In Jerusalem's Lot, King created an archetype of the small, insular Maine towns of his youth—towns that he would return to again and again in his fiction, particularly in Castle Rock, the setting for The Dead Zone, Cujo, "The Body" in Different Seasons, and several short stories. In the story "It Grows on You," King suggested the appeal of these towns to a writer of horror fiction:

> Outsiders think they are always the same, these small towns—that they don't change. It's a kind of death the outsiders believe in, although they call it "tradition" simply because it sounds more polite.
>
> It's those inside the town who know the difference—they know it but they don't see it. It's only the outsiders who believe you can't know what you can't see. There is such a thing as feeling, and as some of them grow

*older they do feel the town; they feel its cooling rhythms, and they dis-
cuss them in pauses and in silences. . . .*

*But there are, of course, many things the outsiders don't know, and
even when there is something to see, they don't see it.*[8]

Fear of the city has long been echoed in popular entertainment—
consider the continued efficacy of the "true life mythology" of Jack
the Ripper; the urban horror story masterpieces of Ramsey Camp-
bell; and motion pictures as early as Fritz Lang's *Metropolis*
(1927) and as recent as John Carpenter's *Escape from New York*
(1981). We need look no further than the daily newspaper to sample
both the real and the realistically imaginable dangers of the urban
environment. Paradoxically, the city's man-made landscape is an
obvious symbol of our social and technological development, whose
goal was to supplant the chaos of nature with an ordered society.
The urban sprawl has been likened to the very jungle that it sought
to replace. Personified by aged structures and mazelike streets,
overcrowded, dirty, chaotic, and crime-infested, the city struggles
to adapt to modern needs while under cancerous siege from within.

The frightening nature of the city stands in stark distinction to our
belief in the peaceful, rustic charm of rural communities—smiling
landscapes unshadowed by the daily crime and claustrophobic fears
of urban areas. Fostered by sources as diverse as Thornton Wilder
and cereal commercials, we view these one-stoplight towns as exud-
ing an air of innocence, creating a picturesque setting to juxtapose
to the monolithic greed and guilt of the American city. Even wild
nature has come to be considered as a source of inspiration rather
than as a minacious presence.[9]

This sentimental antithesis between country and city serves as the
underlying premise of *'Salem's Lot*. That *Our Town* can be ren-
dered into Jerusalem's Lot is a jackhammer blow at the psychological
firmament of the pastoral myth, tearing away the small town fa-
cade to expose dark truths that the outsider cannot or will not see.

From the outset of *'Salem's Lot*, King brings this theme home
through a sense of detail and imagery that has matured consider-
ably from the sparse landscapes of *Carrie*. After a flashback pro-
logue that seeds the sense of horror to come, we witness the arrival
of Ben Mears at Jerusalem's Lot, and through his eyes become the
outsider, looking in. These opening passages build an *Our Town*
feeling while hinting that something supernatural, some dire sea-

change, lurks just beneath placid surface appearances; but King's style seduces the reader through suggestion and understatement, bringing us, like Ben Mears, slowly into the undercurrent of the town.[10]

Mears has returned to Jerusalem's Lot, where he spent four idyllic childhood years, in retreat from the "sudden blackness" of his wife's death in a motorcycle accident. He seeks to recapture what he has lost by walking the roads of his youth, and by writing about the town and his childhood fears. For a brief moment, he seemingly passes back through time—falling in love with a town girl, Susan Norton, and becoming part of the town's close-knit society—but the blackness, the darkness, settles upon the town:

> *The town knew about darkness.*
> *It knew about the darkness that comes on the land when rotation hides the land from the sun, and about the darkness of the human soul. The town is an accumulation of three parts which, in sum, are greater than the sections. The town is the people who live there, the buildings which they have erected to den or do business in, and it is the land.*
> *. . . [M]ost of the stores are false-fronted, although no one could have said why. The people know there is nothing behind those false fa-cades. . . . There is no life here but the slow death of days, and so when evil falls on the town, its coming seems almost preordained, sweet and morphic. It is almost as though the town knows the evil was coming and the shape it would take.*
> *The town has its secrets, and keeps them well. . . . [S]ome will later be known and some will never be known. The town keeps them all with the ultimate poker face.*
> *The town cares for devil's work no more than it cares for God's or man's. It knew darkness. And darkness was enough.*[11]

King first wrote of the shadowed town in "Jerusalem's Lot,"[12] a college short story imbued with Lovecraftian allusions and sugges-tions of faceless powers beyond the fabric of space and time. That story, set in the 1800s, developed some of the early history of the Lot, recounting the heritage of a family taken in bondage as *nosferatu.* "Blood calls to blood" is its refrain, and a great house—a desecrated church—is the locus of the summons.

In *'Salem's Lot,* another great house becomes the central symbol of the town—the Marsten House. King quotes the first paragraph of Shirley Jackson's *The Haunting of Hill House* (1954) as an epigraph

to the novel, and his narrative describes the Marsten House in like terms, treating it as a living, sentient structure—one that definitely is not sane: "It stared back at him with idiot indifference."[13] The Marsten House is the town's "dark idol," its character made whole—a silent house, secretive, slowly deteriorating . . . and haunted:

> ". . . The Marsten House has looked down on us all for almost fifty years, at all our little peccadilloes and sins and lies. Like an idol."
> "Maybe it's seen the good, too," Ben said.
> "There's little good in sedentary small towns. Mostly indifference spiced with an occasional vapid evil—or worse, a conscious one. . . ."[14]

"You asked what my book was about," says Ben Mears, walking with his doomed lover, Susan Norton, in the shadow of the Marsten House. "Essentially, it's about the recurrent power of evil."[15] And the haunted hill house, overlooking the town, is the lodestar of evil. Built by gangland murderer Hubert Marsten, the house has stood empty for the nearly forty years since Marsten shotgunned his wife to death, then climbed to an upper room to hang himself. An evil house calls evil men, suggests King, and "Mr. Barlow" has answered the call of the Marsten House.

That evil should revisit Jerusalem's Lot in the form of vampirism is not an accident. 'Salem's Lot contains a veritable catalog of vampire iconography—from a single, sublime quotation of Dracula to a copy of Vampirella magazine—with an intent less to instill fear than to reinforce the pervasive recognition and acceptance of the vampire in twentieth-century American culture that has reduced the vampire, as King acknowledges, to a "comic book menace." King vests his undead with the trappings of traditional vampire myth: blood-lusting creatures unable to function in sunlight, repulsed by garlic, and vulnerable to the sign of the cross. His innovations are few and subtle—thus, Ben Mears creates a cross from two tongue depressors, bound together with tape, to repel one of the nosferatu; yet, in a test of faith, the Catholic priest Father Callahan fails to resist Barlow despite a blessed cross.

The telling variation is the manner in which King downplays the strong sexual element of vampire myth. Like the vampire immortalized by Bram Stoker—who, in turn, was inspired by J. Sheridan

LeFanu's sensual "Carmilla" (1870)—Barlow instills a mixture of terror and desire, yet the desire invoked is not one of sexual surrender but of submersion of identity. The shift in focus was intentional. In writing about *Dracula*, King has emphasized the time of its creation—the close of the Victorian era, when a sexual double standard thrived, even to the extent of Victorian gentlemen maintaining secret rooms in their houses for sexual liaisons, erotic books, and paraphernalia: "In a sense, *Dracula* was the secret room of Victorian literature. Besides being a ripping good monster story, it is a highly charged tale of abnormal sex, resounding most strongly with dark notes of necrophilia."[16]

That the sexual undercurrents of *Dracula* have remained effective today despite the "sexual revolution" is a tribute more to the book's appeal to a lost sense of the forbidden than to a real breach of modern sexual taboos. In writing *'Salem's Lot*, King discovered that "there was not much steam left in the sexy underclothing of *Dracula*. . . . I sensed that, whatever the secret room was, its contents were not sexual impedimenta."[17] The "secret room" of the early 1970s, when a sociopolitical double standard thrived, was far more pervasive:

> I wrote 'Salem's Lot *during the period when the Ervin committee was sitting. That was also the period when we first learned of the Ellsberg break-in, the White House tapes, the shadowy, ominous connection between the CIA and Gordon Liddy, the news of enemies' lists, of tax audits on antiwar protestors and other fearful intelligence. During the spring, summer and fall of 1973, it seemed that the Federal Government had been involved in so much subterfuge and so many covert operations that, like the bodies of the faceless wetbacks that Juan Corona was convicted of slaughtering in California, the horror would never end. You'd say to yourself, "It must be over now," and then someone would produce another mangled freedom from the ditch of tapes, burnbags, shredding machines and studied answers of "At this point in time I cannot recall."*
>
> *Every novel is to some extent an inadvertent psychological portrait of the novelist, and I think that the unspeakable obscenity in* 'Salem's Lot *has to do with my own disillusionment and consequent fear for the future. The secret room in* 'Salem's Lot *is paranoia, the prevailing spirit of [those] years. It's a book about vampires; it's also a book about all those silent houses, all those drawn shades, all those people who are no longer what they seem. In a way, it is more closely related to* The Invasion of

the Body Snatchers *than it is to* Dracula. *The fear behind* 'Salem's Lot *seems to be that the Government has invaded everybody.*[18]

There are literal "secret rooms" in *'Salem's Lot*. One stands on the upper floor of the Marsten House—the room where Hubie Marsten had hung himself and where, years later, nine-year-old Ben Mears entered on a dare. Mears had ascended the creaking stairs of the deserted house to that upper room, and when he crossed its threshold, he confronted death for the first time: the apparition of Hubie Marsten, hanging from a ceiling beam. When the novel opens twenty-five years later, Mears's life is under siege from guilt and helplessness stemming from his wife's death. He has been drawn instinctively on the journey back to Jerusalem's Lot at the very moment that the town itself is under siege. And when he finally returns to the Marsten House with Father Callahan, to the threshold of the second "secret room"—the cellar lair of the king vampire—the descent is incomplete:

> *For a moment they just looked at each other, and then at the cellar door that led downward, just as twenty-five odd years ago he had taken a set of stairs upward, to face an overwhelming question.*[19]

While Carrie White teetered at the edge of an unwelcome childhood, Ben Mears has fled from adulthood, descending to his childhood memories to seek the answer to that "overwhelming question" that only death can provide. Like many of King's adult protagonists (and like King himself), Mears is romantic, individualistic, and assuredly nostalgic. His journey is not one of regression but, as Richard Gid Powers has written about the comparable journey of Jack Finney's *The Body Snatchers* (1955), "an adult refusal to be infantilized by a puerile present."[20] What Mears finds in his shrinking from experience to innocence is a mirror-image of himself, the child Mark Petrie, who is beginning the dark outward path from innocence to experience.

Like Thomas Wolfe's George Webber, Mears mourns for the past, and he learns that he cannot go home again. Indeed, Mears must lay the "blackness" of his past to rest by driving a stake through the heart of undead Susan Norton (and, symbolically, of the undead specter of his wife) and by starting the fire that will consume Jerusalem's Lot.

King's plague of vampires, like that of Jack Finney's "body snatchers," is less an invasion than a sudden confirmation of what we have silently suspected all along: that we are taking over ourselves, individuals succumbing to the whole. The relentless process of fragmentation and isolation—a progressive degradation of individuals to a one-dimensional, spiritless mass—has seen the moral disintegration of an entire town. The population of Jerusalem's Lot is reduced to a zombie-like state—pale, staggering effigies with eyes locked in thousand-yard stares—as penetrable as the "idiot indifference" of the Marsten House. Therein lies the root of paranoia—a fear and mistrust not simply of those around us, but of our very own identities. For if control and self-determination are lost to others, our turn surely cannot be far away.

The theme is an ominous and depressing one, but brought home subtly in the novel, avoiding a preachment. The strength of King's conviction is perhaps best measured by the fact that *everyone* died in the original conception: "I thought that it would be the perfect balance to *Dracula*. And I just got to like the kid and the man, and I let them get away."[21] Nevertheless, the vampires do triumph, for all intents and purposes, and it is worth noting that Ben Mears and Mark Petrie escape by leaving not simply Jerusalem's Lot, but the country.

A coda to *'Salem's Lot*—the short story "One for the Road"[22]— was published in 1977. In it, we learn that the fire set by Ben Mears in the novel's final page has burned out of control for three days, flattening the town. Yet what we learn next seems as inevitable as night following day:

> *After that, for a time, things were better. And then they started again. . . . Whatever you do, don't go up that road to Jerusalem's Lot. Especially not after dark.*[23]

But one day—and assuredly after dark—we will return to that road, along with the survivors, living and undead. For, according to King, there will be a sequel to *'Salem's Lot:*

> *. . . I know what the sequel will be. It's just a question of when I find the time. . . .*
>
> *Should I give you a preview? Ben Mears and [Mark Petrie] are now living in England, where Ben is doing the screenplay to one of his*

books. . . . *[Mark's] in school. While Ben is in his studio, [Mark] comes home, makes dinner and begins to get calls via transatlantic cable— from his mother.*

"I'm still alive. . ." she says. "You must come back to the Lot. . . . They're hurting me." And eventually he does go back. Ben follows him.

Father Callahan will come back, too. He's working in a Detroit soup kitchen, and this dying bum comes in: "Father, you've got to bless me." "I'm not a priest anymore," he says. The bum is gurgling out his last words, "It's not over in 'Salem's Lot yet." And believe me, it isn't![24]

The Shining

"We all shine on, like the moon and the stars and the sun. . . ."

—*John Lennon*

The haunted house that loomed eternally in the background of *'Salem's Lot* became the centerpiece of Stephen King's third published novel, *The Shining* (1977).[1] The Overlook Hotel has become, in the public mind, a premier archetype of the *genius loci* or "Bad Place"—outdistancing its conscious inspirations, Shirley Jackson's Hill House and Edgar Allan Poe's haunted palace in "The Masque of the Red Death" (1842).

Upon completing the manuscript of *'Salem's Lot,* King wrote the novella "The Body" (which would later appear in *Different Seasons*) before turning to *Roadwork.* He then moved his family to Colorado in the late summer of 1974 for an extended vacation. There, he began to write a novel loosely based upon the Patricia Hearst kidnapping, tentatively entitled *The House on Value Street* and destined ultimately to become *The Stand.* The book was not progressing well, and one night in early fall, the setting for *The Shining* presented itself:

In late September of 1974, Tabby and I spent a night at a grand old hotel in Estes Park, the Stanley. We were the only guests as it turned out; the following day they were going to close the place down for the winter. Wandering through its corridors, I thought that it seemed to be the perfect—maybe the archetypical—setting for a ghost story.[2]

The seed of the novel had been planted nearly ten years before, however, when a teenaged King had been inspired by Ray Bradbury's story "The Veldt" to consider writing about a person whose dreams could become real. In 1972, King toyed with the idea for a novel called *Darkshine*, when it occurred to him that the power to make dreams—or nightmares—become real might reside in a place as well as a person; the novel would involve a boy who was a psychic receptor—its setting would be an amusement park. On the night of his stay at the Stanley, the puzzle pieces fitted together in a dream:

> *That night I dreamed of my three-year-old son running through the corridors, looking back over his shoulder, eyes wide, screaming. He was being chased by a fire-hose. I woke up with a tremendous jerk, sweating all over, within an inch of falling out of bed. I got up, lit a cigarette, sat in the chair looking out the window at the Rockies, and by the time the cigarette was done, I had the bones of the book firmly set in my mind.*[3]

The Overlook Hotel stands high in the Rocky Mountains, forty miles from the nearest town over roads that are impassable through six months of bitter winter. This great, isolated house, with its dignified architecture and accumulation of history, creates the suggestion of a settled order. Upon closer inspection, however, the Overlook is the ruined castle of Gothic literature, replete with labyrinthine corridors, forbidden books and rooms, rattling chains (in the elevator shaft), and a company of ghosts. And like its Gothic predecessors, the Overlook symbolizes the pride and guilt of authentic tragedy.

The Marsten House overlooked Jerusalem's Lot, a "dark idol" of the evil that thrived in that small country town. The Overlook Hotel, as its name implies, watches over a great deal more—it sits at the highest populated location in the United States. Built at the turn of the century and beset by scandal and financial problems ever since, the resort hotel fulfills what King describes as the truest definition of the haunted house: "a house with an unsavory history."[4] That history has left an equally unsavory residue that, for certain special guests, plays on like a supernatural newsreel:

> *[H]ere in the Overlook things just went on and on. Here in the Overlook all times were one. There was an endless night in August of 1945, with laughter and drinks and a chosen shining few going up and coming*

down in the elevator, drinking champagne and popping party favors in each other's faces. It was a not-yet-light morning in June some twenty years later and the organization hitters endlessly pumped shotgun shells into the torn and bleeding bodies of three men who went through their agony endlessly. In a room on the second floor, a woman lolled in her tub and waited for visitors.

In the Overlook all things had a sort of life. It was as if the whole place had been wound up with a silver key. The clock was running. The clock was running.[5]

"*This inhuman place makes human monsters,*"[6] and it calls Jack Torrance to its doorstep as the new winter caretaker, just as it has called a parade of evil men before him. But its supernatural setting is subordinate to the human drama played out in the foreground. King reflects: "The book . . . seemed to be primarily a story about a miserable, damned man who is very slowly losing his grip on his life, a man who is being driven to destroy all the things he loves."[7]

King holds that the most essential element of an effective horror story is love of characters:

> *You have got to love the people. That's the real paradox. There has to be love involved, because the more you love . . . then that allows the horror to be possible. There is no horror without love and feeling. . ., because horror is the contrasting emotion to our understanding of all the things that are good and normal. Without a concept of normality, there is no horror.*[8]

Jack Torrance and his family, who are the characters that King brings to confront his archetypal haunted house, are imbued with an endearing humanity, comfortably worthy of the reader's love and thus the reader's horror. Their struggle is identifiable, clothed in the trappings of daily life: a shopworn automobile, dwindling bank accounts, diffuse thoughts of divorce. They have fled west to the Overlook and the hope of a better future from New England and a past of dark memories.

Jack Torrance had taught at a prestigious preparatory school in Vermont, and he was slowly blooming into a successful writer. His childhood had been clouded by a father whose drunken viciousness included wife and child abuse, and his father's shadow has fallen over him: alcoholism, reinforcing the roadblock that his writing could not shake, and an uncontrollable temper that once caused

him to break his son's arm, and later, to hit a student, ruining his teaching career. Clutching at the job of caretaker at the Overlook as a last chance, an escape in which he can rekindle the once bright flames of his writing, "his pride was all that was left"[9]; but pride, as we soon learn, is also a sin. Yet despite his shortcomings—indeed, in part because of them—Jack is intensely human, sympathetic, and forgivable.

The Shining was the easiest of King's novels to write ("A very erotic experience," he has said),[10] and it is also his most nervously alive. For good reason, perhaps—the doomed character of Jack Torrance is an amalgam of King's personal fears at the turning point of his career:

> For much of the three or four months it took me to write the first draft of the novel I was calling The Shine, I seemed to be back in that trailer in Hermon, Maine, with no company but the buzzing sound of the snowmobiles and my own fears—fears that my chance to be a writer had come and gone, fears that I had gotten into a teaching job that was completely wrong for me, fears most of all that my marriage was edging onto marshy ground and that there might be quicksand anyplace ahead.[11]

Jack's wife, Wendy, is attractive, fragile, threatened—a modernized Gothic heroine. Like Jack, she cowers in the shadow of a parent, in her case, a voracious mother. It is not Wendy, however, but Danny, their five-year-old son, who is burdened with the mantle of innocence and whose seduction by evil is at issue. Danny is possessed of the "shining," a wild talent of telepathy and imperfect precognition that is both a catalyst and the goal of the haunting of the Overlook.

In writing about the role of the haunted house in horror fiction, King has noted: "When we go home and shoot the bolt on the door, we like to think we're locking trouble out. The good horror story about the Bad Place whispers that we are not locking the world out; we are locking ourselves in . . . with them."[12] In The Shining, he takes us one step further, reminding us that we are also locking ourselves in with ourselves.

Ben Mears, the haunted writer of 'Salem's Lot, was possessed of a homing instinct, while Jack Torrance strives mightily to escape the past. Yet their eastward and westward paths converge at the cross-

roads that is the modern American nightmare, recognized by Wendy Torrance at the outset of *The Shining:* "In grief and loss for the past, and terror of the future."[13] The Overlook Hotel, like the Marsten House, is that crossroads—the house on the borderland of past and future. The nightmare only dreamed by Mears—of being trapped within the haunted house of his past—becomes real for Jack Torrance. The Overlook, like his father's blood, is Jack's inheritance, inextricably linked to the darkest secret of his past: a drunken automobile accident on a deserted country road in Vermont, where he and his drinking buddy, Al Shockley, can find only the bicycle that they hit, and not a trace of a body. The incident, their "secret shared," underlies Jack's employment as caretaker of the Overlook, which Shockley owns in part.

The "unsavory history" of the Overlook mirrors the equally "unsavory history" of Jack Torrance, revealing the true ghost of *The Shining.* As King wrote in *Danse Macabre,* "the past is a ghost which haunts our present lives constantly."[14] Although ostensibly in flight from the past, when Jack Torrance arrives at the Overlook, he becomes obsessed with it. His descent into the basement of the Overlook is also a descent into the uneasily buried past, as he discovers a scrapbook filled with news clippings about the resort's "unsavory history"—an index of the post-World War Two American character. Thoroughly captivated, unwilling to leave the past alone, he fixates upon the idea of writing an exposé of the Overlook. "He would write it for the reason he felt that all great literature, fiction and nonfiction, was written: truth comes out, in the end it always comes out."[15] He absorbs and is absorbed by the hotel, and the truths of the past, repressed in the dark basement of the unconscious, begin to emerge.

The Overlook Hotel is a symbol of unexpiated sin: it is the house that Jack built. For in *The Shining,* the ruined Gothic castle has become the haunted mind itself. Just as the violent elements of the Overlook's past drone on like an eternal film loop, the hotel produces a closed loop of character. The entire world has shrunk to its snow-encased, isolated boundaries, and the winding corridors, as well as the weather, mimic Jack Torrance's inward-looking, twisted, claustrophobic obsession with his past. The haunter becomes the haunted and, in King's words, "the Overlook Hotel becomes the microcosm where universal forces collide."[16]

Although *The Shining* explicitly invokes the name of Edgar Allan

Poe, its themes parallel those of America's guiltmaster, Nathaniel Hawthorne.[17] As in *The House of Seven Gables* (1851), a family's blood has descended as a curse. The "universal forces" in collision are portrayed with Christian dualism—good and evil, matter and spirit—and when these incompatible realms impinge in the hotel, something leaks through. There is a stain, a sensation of the overlapping of past and present, that betrays itself in the best tradition of Hawthorne. Jack Torrance scrubs at his stain—symbolized so well by his nervous wiping of his mouth when in desire of drink— but for King, again like his New England ancestor, providence is balanced too delicately to offer absolution. When the specter of Delbert Grady, a former caretaker who had murdered his family in the Overlook, says those chilling words to Jack Torrance—"You've *always* been the caretaker"[18]—he gives voice to the themes of responsibility and guilt that overshadow *The Shining.* Jack has failed in his responsibilities—to his family, to his writing, to himself. Ironically, it is a final failure of responsibility—to look after the creeping pressure of the hotel furnace—that causes the destruction of the Overlook.

The degree to which King saturates his imagery with an uneasy symbolism is itself a form of staining. A recurring image is the wasps' nest—like Jack Torrance and the Overlook, a placid exterior whose insides are maddeningly afire. When Jack begins repair work on the hotel, he finds a wasps' nest in the roof. Initially, he views the nest as a symbol of his past and an omen for a better future:

> *He felt that he had unwittingly stuck his hand into The Great Wasps' Nest of Life. . . . He had stuck his hand through some rotted flashing in high summer and that hand and his whole arm had been consumed in holy, righteous fire, destroying conscious thought, making the concept of civilized behavior obsolete. Could you be expected to behave as a thinking human being when your hand was being impaled on red-hot darning needles? Could you be expected to live in the love of your nearest and dearest when the brown, furious cloud rose out of the hole in the fabric of things (the fabric you thought was so innocent) and arrowed straight at you? . . . When you unwittingly stuck your hand into the wasps' nest, you hadn't made a covenant with the devil to give up your civilized self with its trappings of love and respect and honor. It just happened to you. Passively, with no say, you ceased to be a creature of the mind and became a creature of the nerve endings. . . .[19]*

But the wasps' nest, like the past, is inescapable: "Jack . . . knew about wasps from his childhood."[20] The nest found in the roof is fumigated, but when it is placed in Danny's room, wasps emerge in the night and sting him. Jack reacts:

> One thought played over and over in his mind, echoing with
> (You lost your temper. You lost your temper. You lost your temper.)
> an almost superstitious dread. They had come back. He had killed the
> wasps but they had come back.[21]

The frightening thought of spontaneous regeneration flickers through Jack's mind, the first inkling of the supernatural puppetry that will descend upon the Overlook. The stain is not passive, but symbolically animates the inanimate, including the snakelike fire hose and the eerie animal topiary, harkening to Hawthorne's *The Marble Faun* (1860).

In his childhood, Jack had learned from his father what would happen when the wasps' nest is placed into fire. The "shining" is the flame lit beneath the Overlook—Danny's inheritance from his father, who possesses the power but rejects it as a sign of madness. On one level, the heightened perception of the "shine" is simply a subtle exaggeration of every child's perspective. King believes that it is "important for the reader to cultivate the child's point of view. . . . [Y]ou must have a child's ability to believe in everything."[22] The surreal structure of nightmare results: the distortion of linear time, the constant shifting of reality, the intense animism of the physical environment—all serving to heighten the suggestive power of the horrors involved.

On another level, the "shining" serves, as its name implies, as a lamp in the darkness of the haunted castle. The mystery of the Overlook is one of time. In the hotel, as in Prince Prospero's castle, time stops with the stroke of midnight, suggesting that the future, like the past, is already determined. Thus, Jack Torrance is doomed to stalk the hotel's seemingly endless corridors, raging against a past he cannot transcend—"Come and take your medicine" being the shout of *his* father, calling for his punishment as well as Danny's. While Jack is haunted by the past, Danny is haunted by the future. His imperfect precognition alone shines into an uncertain future, reading not only its terror, but its hope. His power is linked to an imaginary playmate, "Tony," who is revealed as an older version of Danny,

one who has experienced the fall from innocence, surviving the sins of his parents.

As Jack Torrance is absorbed by the Overlook, the fourth, surrogate member of the Torrance family, Dick Hallorann—who had been introduced briefly at the novel's outset—reappears, assuming many fatherly characteristics. Hallorann, the black, sixty-year-old cook for the hotel, is also possessed of the "shining," and Danny's desperate psychic summons brings him back to the hotel from his winter venue in Florida to rescue Wendy and Danny. As frequently occurs in fairy tales, *The Shining* splits its father character into two figures, representative of both limiting and supporting aspects of fatherhood: the blighted Jack, heir of the alcoholism and violence of his father, the "irrational white ghost-god"; and the benevolent Hallorann, the very color of his skin a positive symbol against the negating whiteness that shrouds the hotel.

It is through Hallorann that we recognize that the destruction of the Overlook Hotel is not a triumph over evil. The stain remains, as we learn when he glances back at the burning structure to see the final image of the wasps' nest:

From the window of the Presidential Suite he thought he saw a huge dark shape issue, blotting out the snowfield behind it. For a moment it assumed the shape of a huge, obscene manta, and then the wind seemed to catch it, to tear it and shred it like old dark paper. It fragmented, was caught in a whirling eddy of smoke, and a moment later it was gone as if it had never been. But in those few seconds . . . he remembered something from his childhood. . . . He and his brother had come upon a huge nest of ground wasps just north of their farm. . . . His brother had had a big old niggerchaser in the band of his hat, saved all the way from the Fourth of July. . . . It had exploded with a loud bang, and an angry, rising hum—almost a low shriek—had risen from the blasted nest. . . . And looking back over his shoulder, as he was now, he had on that day seen a large dark cloud of hornets rising in the hot air, swirling together, breaking apart, looking for whatever enemy had done this to their home so that they—the single group intelligence— could sting it to death.[23]

This image is recurrent in King's early novels, where good and evil are depicted as relatively rigid dualities. In *'Salem's Lot*, it occurs when Susan Norton is laid to rest ("In the faint light it was only a suggestion, a shadow, of something leaping up and out, cheated

and ruined. It merged with the darkness and was gone") and again when the king vampire is staked ("he felt the passage of something which buffeted past him like a strong wind").[24] The image reappears at the climax of *The Stand* ("He had a bare impression of something monstrous standing *in front* of where Flagg had been. . . . Then it was gone.")[25] King's novels recount only the skirmishes between good and evil, not the final conflict. Life goes on—an uncertain future awaits; and even momentary triumphs are underscored with melancholy. Dick Hallorann's closing words to Danny Torrance are the best explication of that fundamental message of King's fiction:

> ". . . There's some things no six-year-old boy in the world should have to be told, but the way things should be and the way things are hardly ever get together. The world's a hard place, Danny. It don't care. It don't hate you and me, but it don't love us, either. Terrible things happen in the world, and they're things no one can explain. Good people die in bad, painful ways and leave the folks that love them all alone. Sometimes it seems like it's only the bad people who stay healthy and prosper. The world don't love you. . . . You grieve for your daddy. . . . That's what a good son has to do. But see that you get on. That's your job in this hard world, to keep your love alive and see that you get on, no matter what. Pull your act together and just go on."[26]

Our journey from innocence to experience will never be complete; for we cannot escape the past, just as we cannot forsake the future. We move on, for better or worse—and sometimes the world moves on with us, as we would learn in *The Stand*.

The Stand
♦
The Dark Tower:
The Gunslinger

"Underneath this reality in which we live and have our being, another and altogether different reality lies concealed."

—*Friedrich Nietzsche*

Stephen King's novel of journey, *The Stand* (1978),[1] signaled a definite turning point in his fiction. Prior to this work, his published novels and short stories were structured, for the most part, within the boundaries of traditional horror fiction. *The Stand* was the first of several highly successful novels that transcended the *genre* and that also explicitly grappled with sociopolitical themes.

When King finished the first draft of *The Shining*, he spent two weeks writing "Apt Pupil" (which would appear years later in *Different Seasons*), and then rested for a time; early in 1975, he returned to the novel that he called *The House on Value Street*:

> It was going to be a roman à clef *about the kidnapping of Patty Hearst, her brainwashing (or her sociopolitical awakening, depending on your point of view, I guess), her participation in the bank robbery, the shootout at the SLA hideout in Los Angeles—in my book, the hideout was on Value Street, natch—the fugitive run across the country, the whole ball of wax. It seemed to me to be a highly potent subject, and while I was aware that lots of non-fiction books were sure to be written on the subject, it seemed to me that only a novel might really succeed in explaining all the contradictions. . . .*[2]

The book was never written; King attacked it for six weeks, but nothing seemed to work. He was haunted by a news story that he had read about an accidental chemical/biological warfare spill in Utah that had nearly endangered Salt Lake City; it reminded him of George R. Stewart's science fiction novel *Earth Abides* (1949), in which a plague decimates the world. One day, while listening to a gospel radio station, he heard a preacher repeat the phrase "Once in every generation a plague will fall among them." King liked the sound of the phrase so much that he tacked it above his typewriter:

> *This phrase and the story about the CBW spill in Utah and my memories of Stewart's fine book all became entwined in my thoughts about Patty Hearst and the SLA, and one day while sitting at my typewriter . . . I wrote—just to write something:* The world comes to an end but everybody in the SLA is somehow immune. . . . *[Later] I wrote* Donald DeFreeze is a dark man. *I did not mean that DeFreeze was black; it had suddenly occurred to me that, in the photos taken during the bank robbery in which Patty Hearst participated, you could barely see De Freeze's face. He was wearing a big badass hat, and what he looked like was mostly guesswork. I wrote* A dark man with no face *and then glanced up and saw that grisly little motto again:* Once in every generation a plague will fall among them. *And that was that. I spent the next two years writing an apparently endless book called* The Stand. *It got to the point where I began describing it to friends as my own little Vietnam, because I kept telling myself that in another hundred pages or so I would begin to see light at the end of the tunnel.*[3]

If one must pigeonhole *The Stand* (which was packaged both in hardcover and paperback as a horror novel), it is best described as epic fantasy. Such a description refers not simply to its length—over eight hundred printed pages, and cut significantly from the original manuscript[4]—but to its affinity with the fantasy novels of J. R. R. Tolkien and E. R. Eddison, as well as the classical epics in a tradition spanning from Homer to Milton's *Paradise Lost* and to Thomas Mann's *The Magic Mountain* and *Doctor Faustus*.

Like Tolkien's popular *The Lord of the Rings*, *The Stand* takes the form of a noble quest and employs a host of characters, some heroic, some darker and indeed monstrous. King does not set his epic in an imaginary Elfland, however, but—with more chilling impact—in the world we know. *The Stand* creates a modern mythology, portraying the timeless struggle between good and evil in terms

and geography distinctly American: evil haunts not dark, clammy caverns or mist-laden mountains, but the cornfields of Nebraska, the backroads of Montana, and the oil refineries of Indiana. Its seat of power is not Mordor but Las Vegas. Evil does not strike with sorcerous spells, bat-winged nightriders, or flame-breathing dragons, but with .45 caliber pistols, radio-controlled explosives, Phantom jets, and nuclear warheads—its victims lie in the crowded corridors of overworked hospitals, in the vomit of drug overdose, in pools of bullet-rendered blood, and even in a bowl of Campbell's Chunky Beef Soup.

In the brief introductory note to his American epic poem *Paterson*, William Carlos Williams described the essential qualities of the modern epic: "A taking up of slack; a dispersal and a metamorphosis." And these are the essential qualities of *The Stand*. The novel's first third is a creation myth involving the "taking up of slack": the birth of a new world through the destruction of our modern society. The motive force is an experimental biological weapon, a "superflu" that escapes from a secret military installation. Called "Captain Trips" (ironically, the nickname of Jerry Garcia of The Grateful Dead), the superflu is 99.4 percent pure, not unlike Ivory Soap, and its infection is always fatal. Only six-tenths of one percent of the world's population, who are inexplicably immune to the superflu, survive its cleansing onslaught.

The new world is a haunted one. King's short story "Night Surf,"[5] which first considered the concept of the superflu, vividly distills the horror of the reign of Captain Trips. Its focus is upon a group of teenagers who grimly frolic along the resort beaches of southern Maine on a brief holiday, waiting for seemingly inevitable death from the disease. A first-person narrative, "Night Surf" is concerned with subjectivity, inviting the reader to interpret the narrator not simply by what he says, but by what he chooses to say. What we see is bitterness, alienation, and defeat. King exposes the tragicomedy of regret: a childhood—and a world—that the narrator cannot regain, buried beneath the ironic epitaph "Just the flu." And omnipresent is the sea—traditionally a symbol of journey and death—its night surf creeping inexorably to shore.

Much of the power of *The Stand* draws upon the juxtaposition of the world that was with the postapocalypse wasteland. The Gothic tradition has always played a major, but unspoken role in apocalyptic fiction, and *The Stand*, much like Mary Shelley's *The Last Man*

(1826) and Shirley Jackson's *The Sundial* (1958), brings that tradition to the foreground. In particular, apocalyptic fiction implicitly invokes the "dual life" or "dual landscape" theme present in most Gothic fiction and, indeed, used as a touchstone for much criticism of all nineteenth-century literature.[6] This portrayal of duality attempts to burrow beneath surface illusions to reach the inevitably dark reality below. Thus, in Bram Stoker's *Dracula* (1897), the king vampire's castle is schizoid: its upper levels include a Victorian library and well-furnished apartments, while underneath lie labyrinthine vaults; likewise, Dr. Seward's mansion encloses an insane asylum. Similar landscapes are presented in *The Stand*—for example, the Disease Center in Vermont is a bright, sterile environment that exudes order and authority but is transmuted into a mazelike chaos, filled with death and dread. In *Heart of Darkness* (1902), Joseph Conrad described a similar duality as the "whited sepulcher,"[7] and perhaps no better description exists for Las Vegas, where the evil forces of *The Stand* congregate.

This duality of life and landscape is the central metaphor of *The Stand;* indeed, it was central to King's life at the time the novel was written, as he attempted, like his character Larry Underwood, to come to terms with his sudden success: "[T]he America I had grown up in seemed to be crumbling beneath my feet . . . it began to seem like an elaborate castle of sand unfortunately built well below the high-tide line."[8] Superimposing the illusions of our modern world upon the ravished landscape of catastrophe, King explores the strange mixture of myth and reality that comprises our perception of America.

From the colonial years, Americans have seen themselves as a people of great mission—of destiny. The westward urge of "manifest destiny" inspired the conquest of a continent and the creation of the very imperialism that we sought to escape. We see ourselves as independent and democratic, even though two political machines control the electoral process, many of us never vote, and the spirit of independence is likeliest to be manifested by dissent. Our heroes typically have been cowboys and rugged individualists—only recently have we embraced our martyrs. We think of ourselves as nonviolent and peace-loving, but we cannot even successfully regulate, let alone ban, the sale of handguns. We have conquered ruthlessly when our destiny has been challenged; and we have found war to be a cleansing experience. Our science created the atomic

bomb to end a great war, and we must live in its shadow evermore. We romanticize small towns, yet flock to our crowded cities. "All men are created equal," but this may not include women, gays, blacks, chicanos. . . . "In God We Trust," but missile silos and chemical/biological warfare hedge our bets.

We pursue happiness, believe in progress, materialism, and the infallibility of science, but we doubt our success, our power, ourselves. As we watch the evening news, if we reflect even momentarily upon our social fabric, we begin to question the validity of the engine of progress. Our position as a society is a precarious one—and principally because of our misguided belief in the divinity of civilization and technology. When crime and inflation run rampant, when our nuclear reactors threaten meltdown, when our diplomats are held hostage in foreign lands, our doubts intensify. And these are the precise fears that Stephen King explores in *The Stand*.[9]

These dual landscapes, psychological and geographical, provide the setting for the remainder of the novel, which takes the form of the quest so common in epic literature. The "dispersal" and "metamorphosis" quickly focus upon the traditional epic struggle of man against monster: Odysseus confronting Scylla and Polyphemus, Beowulf squaring off with the Dragon. By the Fourth of July, less than three weeks after the epidemic begins, only the immune remain, and a new America rises purposefully from the human rubble. The survivors are visited with strange and often highly personalized dreams involving two recurring images: a dark, faceless man offering enticement and threat, and an ancient black woman who exudes peace and sanctuary. These images form the parameters of a choice between good and evil in which each individual's intrinsic predisposition plays an important role. That choice divides the survivors into opposing camps: the evil forces at Las Vegas, the forces of good at Boulder, Colorado.

The embodiment of good is Abagail Freemantle, a one-hundred-and-eight-year-old black woman from Nebraska, affectionately called Mother Abagail. Her image is that of an Earth mother, spawned from the fertile cornfields and imbued with a frontier Christianity; she is less an active force than a vessel through which courses of action are revealed. Around her gathers an incongruous collection of folk heroes, consciously paralleling the multiracial band of adventurers of Tolkien's epic fantasy: Stu Redman, a Texas blue-collar worker; the mute Nick Andros, a self-educated orphan;

Fran Goldsmith, a pregnant Maine college student; overnight rock-and-roll sensation Larry Underwood; a retarded Oklahoma man, Tom Cullen; New Hampshire sociology professor Glen Bateman; and what may be the last surviving dog.

The protagonist of *The Stand* is Stu Redman, the factory worker from Arnette, Texas, his soft-spoken, stoic reliability evoking the archetypal American cowboy hero roles played by Gary Cooper and Clint Eastwood. He is the character to whom we are first introduced, and he is one of the few major characters to survive the novel; as his last name suggests, he is the new native American. Yet despite his traditional heroic and American qualities, his role is one of continuum—he does not change through the course of the novel, but is instead a celebration of ordinary human existence. The critical character is burned-out rock musician Larry Underwood, whose internal strife places him, as his last name hints, on the knife-edge between good and evil. As his mother ironically realizes before dying of the superflu that Underwood may have communicated to her: "[T]here was good in Larry, great good. It was there, but this late on it would take catastrophe to bring it out."[10] Underwood is particularly interesting because he lacks Redman's traditional heroic qualities; he is self-destructive and avoids taking personal responsibility until it is thrust upon him. But in the final trumps, his refusal to give up the good inside himself transforms him into a person capable of self-sacrifice.

The entwined fates of Redman and Underwood are played out in the novel's final third, when "the stand"—the confrontation between good and evil—occurs. Foreshadowed in the novel's early pages, their destinies become increasingly clear as the story progresses. As Captain Trips ravages the nation, Redman is locked in the isolation of a government laboratory by authorities desperate to understand his immunity; Underwood meanwhile experiences the mass graveyard of New York City. When Redman, Underwood, Glen Bateman, and Ralph Brentner go to take "the stand," Redman's leg is broken *en route;* he must be left alone in the desert while the others proceed to Las Vegas. His "stand" must take place in isolation, as if it were a reaffirmance of his individualism. Underwood, the rock performer, must again take the center stage, this time to die before the masses.

An effective counterpoint to Larry Underwood is Harold Lauder, who also wrestles with impossible self-demands but makes a con-

scious decision to reject good in favor of evil. Lauder is never a truly sympathetic character. Initially obese, neurotic, and self-pitying, he matures outwardly, repressing his repulsiveness and lack of understanding to the breaking point, when he is used and cruelly cast aside by the forces of evil. Lauder's fate is dictated not only by selfishness but by the American dream; he is unwilling or unable to exist within the postapocalypse society. His response is extreme, but eminently logical—to cause death by casting the runes of chaos into the budding order of the Free Zone. Lauder shows us that the choice for evil is less than a free one, but the moment of self-recognition at his death suggests that this choice is never irrevocable.

The focal point of the wrong—west—side of the Rocky Mountains is Randall Flagg, the Dark Man, the "Walkin Dude." His earliest memory is of attending school with Charles Starkweather, but he also recalls meeting Lee Harvey Oswald in 1962, riding with the Ku Klux Klan, cop-killing with black men in New York City, and whispering plans to Donald DeFreeze about Patty Hearst. One almost expects him to cry out, like the narrator of The Rolling Stones' "Sympathy for the Devil": "Pleased to meet you, hope you guess my name."

Yet Randall Flagg is neither Satan nor his demonic spawn; King, who first wrote of him in a college poem, "The Dark Man,"[11] comments: "He's the Outsider; he is Colin Wilson's Outsider. He is not very bright—he not only doesn't understand us, he hates us. And he's real—I think he is real, and that as a symbol, he is a wonderful thing to have around."[12] Flagg is an atavistic embodiment of evil, the "last magician of rational thought."[13] He is the epitome of the Gothic villain: his appearance is indistinct, malleable, a collection of masks. Phantom-like, he wanders the corridors of the haunted castle of the American landscape, symbolizing the inexplicable fear of the return of bygone powers—both technological and, as his last name intimates, sociopolitical. He is a Miltonic superman whose strength originates in dark mystery, the distant successor of Eblis, ruler of the realm of despair in William Beckford's Vathek (1786). At his right hand is Donald Merwin Elbert, the "Trashcan Man," whose pyromania is matched only by his instinctive technical wizardry at finding and operating the machinery of death—symbolic of blind science. At his left hand is Lloyd Henreid, street wise and stir

crazy, the two-bit criminal gone big time—symbolic of the moral weakness at the heart of Flagg's empire.

Like many Gothic villains, Flagg is curiously inept, helplessly watching his well-laid plans go awry at every turn. He is a rhetorician of self, seemingly obsessed with convincing himself and others of his importance and destiny. And as the novel's climax discloses, Flagg, like Tolkien's Sauron, is a straw man who literally collapses when confronted. Thus, Glen Bateman explodes into laughter when he faces Flagg, even though he is entirely at his mercy:

> *"You're* nothing!" *Glen said, wiping his streaming eyes and still chuckling. "Oh pardon me . . . it's just that we were all so frightened . . . we made such a* business *out of you . . . I'm laughing as much at our own foolishness as at your regrettable lack of substance."*[14]

There is almost a compulsion to view *The Stand* as a sustained allegory, but its climax produces instead a sense of brooding mystery. The quest to Las Vegas does not simply seek the safety to rebuild what was lost; the survivors are searching for an unknown gnosis, a redemption for the desolation of the world. In counterpoint to typical postapocalypse fiction, whose journeys are structured by the acquisition of material things, King's quest is marked by the stripping away of possessions. It is a heroic show of faith, a sacrifice of the flesh toward an uncertain end. When Larry Underwood is brought before the city's populace for execution, it is with lightning-rod effect. Out of the desert emerges the Trashcan Man, an atomic bomb in tow. His countenance reflects the horror:

> *He was in the last stages of radiation sickness. His hair was gone. His arms, poking out of the tatters of his shirt, were covered with open running sores. His face was a cratered red soup from which one desert-faded blue eye peered with pitiful intelligence. His teeth were gone. His nails were gone. His eyes were frayed flaps.*
>
> *. . . Flagg watched him come, frozen. His smile was gone. His high, rich color was gone. His face was suddenly a window made of pale clear glass.*[15]

The "last magician of rational thought" has exceeded the bounds of his pentacle. The powers that he invoked have escaped his control, and the face of evil has passed to another. Flagg's clothes suddenly are empty:

> *. . . Flagg was no longer there. He had a bare impression of something monstrous standing* in front *of where Flagg had been. Something slumped and hunched and almost without shape—something with enormous yellow eyes slit by dark cat's pupils.*
> *Then it was gone.*[16]

Above Las Vegas stands a vision of the "Hand of God." Then the bomb explodes, vivifying Glen Bateman's explosion of laughter: "And the righteous and unrighteous alike were consumed in that holy fire."[17] We are reminded of the last appearance of the great seabeast in *Moby Dick*, or of the primitive, unexplained world of Grendel's lake—the source of poetry. The Biblical imagery only heightens the sense of destiny and mysticism. King refuses to accede to the typical demand that horror fiction tie and knot all loose ends. Beyond the novel's conclusion, mystery and horror remain—the mystery of the human condition, of life and death in a universe of good and evil, of destiny and chance—and of hope.

The climactic destruction of Las Vegas also reechoes the Gothic themes present in *The Stand*, harkening to the exploding walls and collapsing turrets at the denouement of the grandaddy of all Gothic novels, Horace Walpole's *The Castle of Otranto* (1764). Ruins, the central metaphor and repetitive prop of Gothic fiction, express a triumph, a movement toward freedom and away from control and discipline, much as the Gothic movement was itself, at least in origin.[18] *The Stand* glories in these ruins, as King admits in *Danse Macabre*: "Yes, folks, in *The Stand* I got a chance to scrub the whole human race, and *it was fun!*"[19]

Although the most mystical of King's novels, *The Stand* is also his most explicitly didactic book. The paradoxes of myth and reality that seemingly riddle the fabric of American society are the Gordian Knot, split and unwinding in the ruins. This sociopolitical subtext poses difficult questions about the nature of order and authority. Humans need companionship, but companionship produces a society, which in turn seemingly requires some semblance of order. As King's sociologist, Glen Bateman, argues:

> *"Show me a man or woman alone and I'll show you a saint. Give me two and they'll fall in love. Give me three and they'll invent that charming thing we call 'society.' Give me four and they'll build a pyramid. Give me five and they'll make one an outcast. Give me six and they'll*

re-invent prejudice. Give me seven and in seven years they'll reinvent warfare. Man may have been made in the image of God, but human society was made in the image of His opposite number and is always trying to get back home."[20]

The problems of order and authority recur throughout Stephen King's novels, and provide one explanation for his consistent concentration upon children and the dynamics of growing up. King depicts children with a sympathetic aura of recapitulation: the child literally as "father to the man," a miniature rehearsal of the development of the adult race unrestrained by the illusions and realities of order and authority. Perception is heightened; passionate feelings and animistic thoughts abound:

None of us adults remember childhood. We think we remember it, which is even more dangerous. Colors are brighter. The sky looks bigger. It's impossible to remember exactly how it was. Kids live in a constant state of shock. The input is so fresh and so strong that it's bound to be frightening.[21]

King's fiction accordingly characterizes children with a more open attitude to the supernatural and a wider range of responses to their environment than the "rational" adult. Implicit in this characterization—and explicit in such adult characters as Jack Torrance of *The Shining* and in the siegelike scenarios of *Firestarter* and *Cujo*—is the observation that the process of maturation and socialization in modern America is incomplete and, indeed, stultifying. Thus, both Leo "Joe" Rockaway, the backward child of *The Stand*, and Tad Trenton in *Cujo* instinctually recognize evil, but their warnings are fruitless because of the inability of adults to understand.

King similarly attributes such heightened powers of perception to the alcoholic, the feeble-minded, and the insane. A drunk in *Carrie* is the first to "know" who is responsible for the destruction of Chamberlain, Maine; and Tom Cullen of *The Stand*, forever simple-mindedly assuring us that M-O-O-N spells something, displays precognitive fugues under hypnosis and ultimately receives guidance through visions of the dead Nick Andros.

In *The Stand*, King's message is clear. Freed from the yoke of civ-

ilization, the survivors of the superflu epidemic begin to experience a heightened perception:

> As the gigantic quiet of the nearly empty country accumulated on you day by day, imprinting its truth on you by its very weight, the sun—the moon too, for that matter—began to seem bigger and more important. More personal. Those bright skyships began to look to you as they had when you were a child.[22]

Indeed, the narrative structure of the novel emphasizes this theme, beginning with a disjointed multiple viewpoint technique that subtly collapses inward until even the consciousness of characters is interwoven in the book's final pages.

King holds that "the curse of civilization is its chumminess."[23] One senses a gleeful sarcasm as King recounts the antics of the Free Zone citizenry in developing a reconstruction democracy. The organizers stress the need to reaffirm the Constitution and the Declaration of Independence, while at the same time conspiring to assure that hand-picked individuals assume leadership positions. Committees and town meetings, census-taking and jails spring weedlike into existence as if a natural function of togetherness. The Free Zone, so focused upon ordering its lives, literally fiddles with matches while the totalitarian regime of Randall Flagg readies napalm for its Phantom jets. Only a final visionary experience by Mother Abagail rouses the Free Zone from the comfortable sleep of socialization, provoking "the stand."

The problem posed by *The Stand* may be insoluble: the malignancy of order seems to balance the social benefits of the lack of chaos. At the conclusion of the book, it is clear that the destruction of Flagg's threat provides only a respite. Redman returns to the Free Zone to find that its police have been given authority to bear arms—and the possibility remains that other societies will hold interests adverse to the Free Zone. King's characters ask and answer the novel's ultimate question: "[D]o you think people ever learn anything? . . . *I don't know.*"[24] That question is posed continually in postapocalypse fiction, as in the classic *A Canticle for Leibowitz* (1960) by Walter M. Miller, Jr.: "Are we doomed to do it again and again and again? Have we no choice but to play the Phoenix in an unending sequence of rise and fall? . . . *Are we doomed to it, Lord, chained to the pendulum of our own mad clockwork, helpless to halt its swing?*"[25]

Stephen King offers no pat answer: "My own lesson in writing *The Stand* was that cutting the Gordian Knot simply destroys the riddle instead of solving it, and the book's last line is an admission that the riddle still remains."[26] King shares Miller's existential dread, but *The Stand* does not present a dystopian vision. Although antiscientific, *The Stand* disavows scientific ignorance as the answer. Instead, King is assured by a faith in faith—he does not despair of man. As in all of King's novels, *The Stand* tells us that the need for action is on the individual level—that an individual can still make a difference in his or her society. Its conclusion finds Stu Redman and Fran Goldsmith, mother of the first postapocalypse baby, retreating to Maine from the renascent civilization of the Free Zone, an Adam and Eve cast out of the wilderness and into a temporary Eden. Hope remains, even if the worst is expected or indeed has occurred; as King has written, *"The Stand . . .* echoes Albert Camus's remark that happiness, too, is inevitable."[27]

Almost simultaneous with the hardcover publication of *The Stand*, Stephen King's short story "The Gunslinger" appeared in *The Magazine of Fantasy and Science Fiction*, with this lyrical introduction:

> *The man in black fled across the desert, and the gunslinger followed.*
> *The desert was the apotheosis of all deserts, huge, standing to the sky for what might have been parsecs in all directions. White; blinding; waterless; without feature save for the faint, cloudy haze of the mountains which sketched themselves on the horizon and the devil-grass which brought sweet dreams, nightmares, death. An occasional tombstone sign pointed the way, for once the drifted track that cut its way through the thick crust of alkali had been a highway and coaches had followed it. The world had moved on since then.*
> *The world had emptied.*[28]

This story of Roland the gunslinger and his pursuit of the man in black began an epic story-cycle whose first five installments have been collected in a limited and now out-of-print hardcover edition, *The Dark Tower: The Gunslinger* (1982),[29] with illustrations by Michael Whelan. Inspired in part by Robert Browning's poem "Childe Roland to the Dark Tower Came," the cycle was conceived, and its first story drafted, while King was still in college; in final form,

King estimates that the completed epic of *The Dark Tower* will constitute twenty-five interlocking short stories.[30]

Although set in a postapocalypse wasteland like *The Stand*, Roland's saga magnifies that novel's mysticism, creating an enigmatic landscape whose creation and destiny are equally obscure. Whereas the postapocalypse world of *The Stand* is purged and purified, expectant, ready for anything, *The Dark Tower* presents a barren, scorched earth where the only beauty is grisly—and the only certainty, death. The world is moving on, perhaps for the final time, and Roland becomes a living metaphor for its passage.

Roland is the last gunslinger, a knight-errant on the endless quest for an unknown grail: "He was like something out of a fairy tale or myth, the last of his breed in a world that was writing the last page of its book."[31] He is a simulacrum of the classic elements of heroic mythology: a lone, relatively amoral seeker wandering a dark wasteland for a purpose he has not yet realized. The remains of gasoline pumps, highways, and railroads mark not only the world's passage, but the dwindling of mechanistic power before the spiritualistic strength—indeed, magic—that has risen as civilization wanes. Hope seems to be a forgotten commodity, but because of an ancient skill—talent with the gun—Roland is able to give to a new order.

Although Roland pursues the man in black, much as the forces of white marched relentlessly to confrontation with the dark man in *The Stand*, the battle lines are not so clearly drawn: "He found himself thinking more and more about Cort, who had taught him to shoot. . . . Cort had known black from white."[32] Roland's journey seeks this elusive knowledge. In his path lie the huddled, cowering remains of mankind—and the creatures of darkness: the Speaking Demon buried beneath "The Way Station"[33]; a vampiric seer, trapped within a circle of stones, in "The Oracle and the Mountains"[34]; and "The Slow Mutants,"[35] troglodytes whose subhumanity seems a chillingly short distance away. Roland is joined by the inevitable child-companion, Jake, whom he must sacrifice—much as his own youth was sacrificed to become a gunslinger. And finally, in "The Gunslinger and the Dark Man,"[36] he must confront the man in black himself. But equally important, the tales of Roland traverse his past in fragmentary flashback sequences that disclose murky secrets of his quest.

In the five stories of *The Dark Tower: The Gunslinger*, Roland's

journey has only begun. Although he finds the man in black, there are few answers, and many questions. His quest for the grail—the Dark Tower itself—continues:

> *The gunslinger waited for the time of the* drawing *and dreamed his long dreams of the Dark Tower, to which he would some day come at dusk and approach, winding his horn, to do some unimaginable battle.*[37]

The second sequence of five stories, *The Dark Tower: The Drawing of the Three,* has been written in part, and King's afterword to *The Dark Tower: The Gunslinger* offers enticing glimpses of the tales of Roland to come. Yet that final battle is "unimaginable" even for Stephen King, at least for the present; he is writing Roland's saga, as he writes most of his books, without an outline or notes, holding its secrets "somewhere inside."[38] Although he promises that one day the story will be fully told, until then, like Roland, we can only wait.

·7·

The Dead Zone

"... but that would be wrong."
— *Richard Milhous Nixon*

The wheel of fortune is the central symbol of *The Dead Zone* (1979).[1] It is blind chance, whirling hypnotically, the bright colors and numbers blurring. All bets have been laid, and we wait, breathless, for our number to come up. At the wheel's side, the carnival barker patiently smiles—the odds are with him, and perhaps a small lever assures his take. And if we look closely at the spinning wheel, the colors and numbers alter for an instant, revealing a second disc. At its heart is an eagle, but its edges are slotted as if, like the wheel of fortune, it awaits the silvered ball. It is the Presidential Seal, a symbol of a different game of chance—politics—and its paradoxes: of martyrdom and tyranny, impotency and incompetency, power and ambition; of idealism and peacefulness, corruption and warmongering, truth and lies; and of peanut farmers and B-movie actors. As *The Dead Zone* reminds us, fate, chance, and politics are intermingled in modern America.

American literature has produced countless political horror novels—Jack London's *The Iron Heel* (1908) and Robert Penn Warren's *All the King's Men* (1946) eminent among them—but few of these books have concerned the supernatural, perhaps because their realities alone were sufficiently terrifying. Since the 1950s, novels from

writers such as Allen Drury and Fletcher Knebel have echoed recurring fears that the game of politics has vanquished our democratic system of government in favor of a conspiratorial totalitarianism. At heart, these novels probe the individual's feeling of helplessness in the face of our recent political history, in which candidacies for even our highest office have been decided not so much by the exercise of choice, but by factors as diverse as video images and rampaging policemen, media access and dirty tricks, untimely remarks and assassins' bullets. In such a system, the impact of the individual seems nil; he or she becomes an observer, and choice seems a meaningless myth.

The Dead Zone explores the nature of choice, political and personal, in modern America. It is the story of Johnny Smith, whose intended resemblance to Everyman is signaled in the prosaic simplicity of his name. At age twenty-two, Smith seems primed to live a full, happy, productive life. He is successfully employed as a high school teacher and he is in love with Sarah Bracknell. That love reaches an epiphany in October 1970, when Johnny and Sarah visit a carnival. As they prepare to depart, Johnny is drawn to a sideshow wheel of fortune game. With unerring and uncanny accuracy—and despite heavily biased odds—he defeats the wheel and its brassy sideshow barker, while Sarah becomes alarmed and ultimately ill at this sudden obsessive change in Johnny's character.

As he returns home by taxicab from Sarah's apartment, life's wheel of fortune spins, and Johnny's number comes up: a drag-racing automobile crashes head-on with the taxi, instantly killing the driver. Johnny Smith is rendered comatose and vegetates for five years. The world drifts swiftly past: people die, the named few (Jimi Hendrix and Harry Truman) and the nameless millions; the war in Vietnam ends; a Vice-President and President resign; and Sarah Bracknell marries and bears a child, while Johnny's mother develops a religious fanaticism to the point of insanity.

And then, one day in May 1975, Johnny Smith regains consciousness, but brings with him something more—a "secret strangeness" that is a staggeringly powerful cognitive ability. With a mere touch of the hand, Smith can *see* into people or objects, glimpsing their past, present, or future. Ultimately, he will shake the hand of Greg Stillson, an unlikely Congressional candidate, at a New Hampshire political rally. Johnny perceives a strangely clouded vision of Stillson as the President of the United States, in which Stillson, riddled

with madness, provokes a nuclear holocaust. That perception demands that Johnny choose whether or not to stop Stillson, even if assassination must be the result.

Stephen King's fiction posits the existence of two broad categories of evil: internal evil—whose classic depiction is in the quintessential werewolf story, Robert Louis Stevenson's *Dr. Jekyll and Mr. Hyde* (1886), where unknown drugs release an evil being repressed within the self—and external evil, symbolized by the wheel of fortune.[2]

The evil within is a traditional horror theme, often expressed in the form of a logical insistence that unpleasant consequences await those who meddle in matters best left undisturbed. Its archetypes include the myth of Pandora, the "true life fairy tale" of Bluebeard, and the powerful allegory of Faust. In *The Dead Zone*, the symbolic device of the masquerade is used to depict the internal element of evil omnipresent in humanity. One cannot help but recall the cry of Ahab in *Moby Dick* (1851): "All visible objects, man, are but as pasteboard masks. But in each event—in the living act, the undoubted deed—there, some unknown but still reasoning thing puts forth the moulding of its features from behind the unreasoning mask." Or in the words of Robert Bloch, author of *Psycho* (1959): "Horror is the removal of masks."[3]

We are introduced to the masquerade on the night of Johnny Smith's fateful trip to the carnival, when he dons a bizarre mask as a Halloween prank to frighten Sarah:

> [T]he face appeared before her, floating in the darkness, a horrible face out of a nightmare. It glowed a spectral, rotting green. One eye was wide open, seeming to stare at her in wounded fear. The other was squeezed shut in a sinister leer. The left half of the face, the half with the open eye, appeared to be normal. But the right half was the face of a monster, drawn and inhuman. . . .[4]

This one-eyed, bifurcated visage is recurrent in King's novels. It is worn by Donald Merwin Elbert, the "Trashcan Man" of *The Stand*, dying of radiation sickness as he wheels his atomic bomb through the streets of Las Vegas; it is also the face of Rainbird, the haunting assassin of *Firestarter*; and, at the climax of *The Talisman*, it becomes the countenance of mad Sunlight Gardener.[5] The visage is highly symbolic: in *The Dead Zone*, Sarah identifies it as a Jekyll-Hyde appearance, invoking the duality of good and evil competing

within each of us. For the Trashcan Man, Rainbird, and Sunlight Gardener, the monstrous face is seemingly the explicit externalization of their surrender to evil. But in the case of Johnny Smith, the face is but a mask that may be removed with the flick of a wrist: it is an externalization of Everyman's *possible* evil—one that Johnny, who still has a choice, may wear or discard.

The masquerade also pervades the novel's subplot of the "Castle Rock Rapist," whose identity is withheld until one of Johnny Smith's psychic revelations. When Johnny is asked to undertake a Peter Hurkos role in attempting to determine the identity of the rapist, he succeeds—it is an evil that has hidden for years behind the mask of one of the town's trusted police deputies, Frank Dodd. Yet the discovery comes too late; Dodd commits suicide. And Johnny and the sheriff are greeted with the sickening image of Dodd's slashed throat—as if he had attempted, in expiation, to remove his mask.

It is the masquerade of politics, however, that is the prominent focus of *The Dead Zone*. Greg Stillson has taken the Vietnamese masquerade-game of the "Laughing Tiger" one step further: ". . . inside the beast-skin, a man. . . . But inside the man-skin, a beast."[6] King's political commentary is unmistakably clear—the many faces of Stillson are no less real than those demonstrated by the politicians of Watergate, Koreagate, and Abscam infamy. That an actor should become President in 1980 is an affirmation of what the 1970s have taught us (or failed to teach us) about the nature of politics, and a disturbing warning of the power of the mask echoing King's portrayal of Greg Stillson.[7]

Ironically, when Stillson is confronted with his masquerade by Johnny Smith's assassination attempt, it is Stillson's effort to mask himself—to hide behind a small child—that discloses his true nature to the public and brings about his downfall.

The second form of evil addressed by King's fiction may be called chance or, if one holds a rigidly deterministic view of the universe, predestination. It is lightning from a clear sky; it is the fate of the child whose mother was prescribed thalidomide or the stand-by passenger whose flight went belly-up on takeoff. It is an evil we cannot—and indeed, do not—dwell upon because of its frightening implications; it awaits us at every turn of the spinning wheel of fortune, every toss of the dice, without apparent logic or motivation. It

cannot be changed and it cannot be avoided. As King wrote in his compelling short story "The Monkey":

> *It might be . . . that some evil—maybe even most evil—isn't even senti-*
> *ent and aware of what it is. It might be that most evil is very much like a*
> *monkey full of clockwork that you wind up; the clockwork turns, the*
> *cymbals begin to beat, the teeth grin, the stupid glass eyes laugh . . . or*
> *appear to laugh. . . .*[8]

From *Carrie* through *Pet Sematary*—and most dramatically in *The Dead Zone*—Stephen King's protagonists face "the monkey" involuntarily and accidentally, victims of the spinning wheel of fortune. These characters are extraordinarily ordinary people, lacking hubris or even the innocent curiosity of Bluebeard's wife, let alone the Faustian hunger for forbidden knowledge that possesses the likes of Victor Frankenstein. They have such prosaic names as Johnny Smith.

These King protagonists have much in common with the lamented Reverend Jennings of J. Sheridan LeFanu's "Green Tea" (1869), whose sole offense, as the story's title suggests, is the consumption of green tea—a theme modernized by King in his short story "Gray Matter,"[9] in which a layabout suffers for his consumption of beer. In his seminal study of the English ghost story, Jack Sullivan describes the world view expressed by "Green Tea":

> *The very title of the tale registers the fundamental irony: the awful dis-*
> *juncture between cause and effect, crime and punishment. What*
> *emerges is an irrational, almost Kafka-esque feeling of guilt and perse-*
> *cution . . . Jennings never experiences even a flash of tragic recogni-*
> *tion; on the contrary, he never knows why this horrible thing is*
> *happening. There is no insignt, no justice and therefore no tragedy.*
> *There is only absurd cruelty, a grim world view which endures in the*
> *reader's mind long after the hairs have settled on the back of the neck.*[10]

Although this horrifying aesthetic is principal in King's novels, he does not embrace entirely the grim world view espoused by LeFanu. An enigmatic element is present, lurking in the twilight intersection of rationalism and supernaturalism—a hint of insight and of justice in the workings of the wheel of fortune that does not sacrifice the horror and foreboding sense of doom inherent in its spin. It is the element of *destiny*. "In the wheel," King says, "I wanted to

show that everything is fate—everything is chance; and that fate and chance are the same thing. That when we say that nothing is predestined, and when we say that everything is predestined, we are really saying the same thing."[11]

When one of *The Dead Zone*'s characters describes Greg Stillson as a "cynical carnival pitchman,"[12] the import is not simply literal. Destiny links the internal and external elements of evil. In *The Stand,* the imagery of destiny is focused in religious terms: four leading characters—Stu Redman, Larry Underwood, Fran Goldsmith, and Nick Andros—are said by Mother Abagail to be touched by the "finger" of God[13]; presumably she represents the hand's fifth finger. Later, when retarded Tom Cullen flees from his espionage mission in Las Vegas, he is instructed by a vision of the dead Andros to seek "God's Finger," a geographical landmark on a trail that leads ultimately to Cullen's discovery of the injured Redman, who otherwise would have died in the desert. In the lonely jail cell where Glen Bateman will meet his death, fearing no evil, he writes: "I am not the potter nor the potter's wheel, but the potter's clay. . . ."[14] And at the climactic confrontation between the forces of good and evil in Las Vegas, when "the stand" finally is taken, it is all of the fingers—the "Hand of God"—that descend to obliterate the den of iniquity.

In *The Dead Zone,* this image of the touch of destiny is also explicit, principally through the raving religious mania of Johnny Smith's mother, who can rationalize her version of God with the spin of the wheel of fortune—the tragic accident that has befallen her son—only by the notion of predestination: "Not the potter but the potter's clay. . . . You'll know the voice when it comes. It'll tell you what to do. . . . And when it does, Johnny . . . *do your duty.*"[15] Again we see the image of the hand of God, its touch molding the clay of humanity to the service of destiny.

Touch is, of course, the means by which Johnny Smith's awesome power is exercised. The implications of his touch are highlighted in the first moments after Johnny awakens from the coma. In a strikingly disturbing scene, Johnny touches his doctor's hand:

> *When Smith had grabbed his hand, he had felt a sudden onrush of bad feelings, childlike in their intensity; crude images of revulsion had assaulted him. He found himself remembering a picnic in the country when he had been seven or eight, sitting down and putting his hand in*

> *something warm and slippery. He had looked around and had seen that*
> *he had put his hands into the maggoty remains of a woodchuck that had*
> *lain under the laurel bush all that hot August. He had screamed then,*
> *and he felt a little bit like screaming now. . . .*[16]

This touch serves as the opening parenthesis to the "life between deaths" of Johnny Smith, and it signals the horrors that will be visited upon him because of his strange powers.

The Dead Zone explicitly raises two interpretations of its title. When Johnny emerges from his marathon coma, intensive medical testing discloses a modicum of brain damage. Johnny is occasionally unable to visualize certain common items, and he describes such items as being "in the dead zone." It is the landscape of the forgotten: the memories—and symbolically, the life—that Johnny cannot retrieve. From this perspective, it is Johnny's coma—Latin for "sleep of death"—that is the "dead zone." Johnny Smith is a Rip Van Winkle who awakens not to the thunder of 1970, but the silent yawn of 1975. His five years of sleep have brought him to an alien world:

> *. . . [T]here are still times when it's hard for me to believe that there*
> *ever was such a year as 1970 and upheaval on the campuses and Nixon*
> *was president, no pocket calculators, no home video tape recorders, no*
> *Bruce Springsteen or punk-rock bands either. And at other times it*
> *seems like that time is only a handsbreadth away. . . .*[17]

The Dead Zone is a novel about the 1970s, and the isolation and alienation experienced by Johnny Smith find ready equation to that experienced by people maturing in the early seventies, including Stephen King. Johnny is besieged by an elusive sense of loss, an ennui beyond the simple explanation of his missing five years. He has lost more than just time; he has lost his youth and, with it, his idealism. That the woman he loved has married another man, and that his mother has died, are but elements of that loss.

The closing section of the novel provides a brief glimpse into the aftermath of Johnny Smith's assassination attempt and death, in both the macrocosm of a Congressional investigation and the microcosm of letters from Johnny to his father and Sarah. It is entitled "Notes from the Dead Zone," suggesting that the "dead zone" holds a literal meaning, referring to death and the "dead zone" of human memory to which Johnny Smith has been committed. Yet Johnny is

not really "in the dead zone"; he is remembered within the alternate history of the novel, and the epilogue juxtaposes those memories. In both *Carrie* and *The Dead Zone,* King provides apt commentary on American myth-making. Both Carrie White and Johnny Smith are subjected to the *post hoc* rationalizations of a disbelieving civilization, whose single-minded obsession with a "suitable explanation" of events obscures reality in favor of a palatable myth. One cannot help but draw comparisons with our national obsession with the death of John F. Kennedy, and with the Congressional committees organized fifteen years after that assassination in an attempt to apply a salvelike placebo to this wound in the American psyche.

King also uses these examples of American myth-making to increase the thematic tensions of his exploration of the powers of heightened perception. The selective perception of events is vividly portrayed as an inevitable attribute of civilization and its tenants, be they investigative committees, news media, or less institutionalized rumor-mongers. Susan Snell, whose instant of heightened perception at the fading moments of Carrie's death renders her the only person fully to understand—to *see*—the tragedy of Carrie White, becomes the scapegoat of the selective perception of civilization. Likewise, Johnny Smith, the only person who has glimpsed completely behind the mask of Greg Stillson, ironically fits the profile of the mad lone assassin, as if packaged for comfortable consumption by the six o'clock news.

The parentheses opened by Johnny's touch of his doctor's hand are closed in the book's final scene with imagery so similar as not to be coincidental. Sarah visits Johnny Smith's grave, and there is considerable *frisson* as an unexpected hand descends to touch her; she turns to find that no one is there. The scene is not simply theatrics or an *hommage* to Brian De Palma's nightmare ending to the motion picture of *Carrie.* This closing touch signals both release and reassurance. Sarah's emotions spin from horror to an uplifting understanding; she *knows*, despite all the tragedy: "Same old Johnny."[18] For beyond the horror, beyond the masquerades, beyond the possibility that purblind chaos lurks behind the wheel of fortune—and despite the heavy odds—perhaps time *is* only a handsbreadth away.

The Dead Zone was written in 1976 and 1977, but only after a period during which King's work seemed roadblocked. His struggle to

find the "light at the end of the tunnel" with *The Stand* had finally ended with a complete first draft in 1976. The massive book had taken something out of him; he was able to write "Rita Hayworth and Shawshank Redemption" (which would appear several years later in *Different Seasons*), but little else. The result would be that *The Dead Zone* and *Firestarter* were written in tandem:

> *I had a bad year in 1976—it was a very depressing time. I started a book called* Welcome to Clearwater, *but it was busted. Then, for a time, I worked on something called* The Corner; *it didn't turn out, either. That was when I wrote a trial cut on* The Dead Zone. *It was a small town story about a child-killer.*
>
> *The germ of* The Dead Zone *never really made it into the novel. I had an idea about a high school teacher. I wanted to write about a high school teacher, because that was a profession I knew quite well, but had never used in a novel. I saw him giving an examination to his class—it becomes very quiet, everyone's head is bent over their papers, and a girl comes up and hands him the test. Their hands touch, and he says into this quiet: "You must go home at once, your house is on fire." And I could see everyone in the room looking at him—all the eyes, staring. . . .*
>
> *After a point, I couldn't work on* The Dead Zone *anymore, and I laid it aside and wrote the first third of* Firestarter. *I felt slightly desperate to finish something, and I think that, subconsciously, I returned to what I had written before. When I reached the scene of the shoot-out at Manders' farm, I realized how much of* Carrie *that I was reworking, so I fulminated for a while and went back to* The Dead Zone.
>
> *I had this depressing feeling that I was a thirty-year-old man who had already lapsed into self-imitation. And once that begins, then self-parody cannot be far away. The only way that I could return to* Firestarter *was upon rereading what I had written, and realizing that, not only was it less like* Carrie *than I had thought—it was also better than* Carrie. *And I realized that it should be possible for a writer to revisit themes if it betters his work. I thought that critics might claim that Steve King had started to eat himself; but I recognized that they would do no such thing if I were a "serious" novelist—they would say, as you have, that Stephen King is attempting to amplify themes that are intrinsic to his work. And, with that in mind, I made my peace with* Firestarter.[19]

Firestarter

"In the Country of the Blind, the One-Eyed Man is King."
—*H. G. Wells*

Stephen King introduces *Firestarter* (1980)[1] with a quotation from Ray Bradbury's *Fahrenheit 451* (1953): "It was a pleasure to burn." The reference is two-sided: it is a recognition of *Firestarter*'s affinity with *Fahrenheit 451* in its concern with individual freedoms, but it is also a wryly succinct expression of the moral dilemma at the heart of King's sixth published novel. *Firestarter* is not a traditional horror novel, but a further breeding of the suspense, supernatural, and science fiction forms earlier explored by King in *The Stand* and most fully realized in *The Dead Zone*. It follows a pursuit and confrontation pattern native to the espionage novel; the important difference is the nature of the quarry.

The "firestarter" is a seven-year-old girl named Charlie McGee. Her parents had once needed two hundred dollars. It was 1969, and they were newly acquainted college students; marriage and a child were as yet uncontemplated. The money was easily obtained, by participating in a faculty experiment with a low-grade hallucinogenic called "Lot Six." Only two days were required, under the auspices of Dr. Wanless—who conducted his research for the Department of Scientific Intelligence (otherwise known as "The Shop"), an ephemeral CIA-style agency dedicated to scientific de-

velopments "bearing on national security." That Lot Six might develop extraordinary psychic talents in the unwitting subjects of the experiment was known to The Shop. That its long-term effects could be lethal to the subjects was an acceptable risk that could be anticipated. But that two of the participants should subsequently marry and procreate was a possibility so inconceivable as to escape safeguards. Yet a child is born—of a mother who had residual telekinesis and of a father who had developed an awesome power of suggestion that he calls "pushing." Charlie McGee inherits not her parents' abilities, but a mutated effect of Lot Six that produces pyrokinesis: mentally controlled combustion. And when this firestarter is aged seven, The Shop wants her; they kill Charlie's mother, and drive Charlie and her father underground—penniless, paranoid outlaws who may have nowhere left to hide.

Many of Stephen King's early novels feature principal characters who are societal aberrations, typically because of their psychic abilities. King's genius as a prose stylist is his portrayal of these characters in strikingly real, *human* terms. His works repeatedly dramatize the compelling human consequences of the possession of strange talents, by developing a sympathetic reader identification with the protagonist and then producing an intense conflict on both physical and emotional levels that culminates in a confrontation with the person (or, in the case of *The Shining*, with the nearly sentient Overlook Hotel) who has evoked their talents. In both *The Dead Zone* and *Firestarter*, this confrontation plays a climactic role, but it is secondary to a moral choice that precedes it—a choice that offers an interesting reflection on the nature of good and evil in King's fiction.

In the King tradition, Charlie McGee is very much an ordinary little girl despite her extraordinary talent. Starkly conscious that she is the target of a relentless pursuit because she possesses a power that she can neither understand nor fully control, she is a vulnerable creature of reaction, maneuvered again and again by circumstances that intensify her inner conflicts to the breaking point. She is King's "quintessential naturalistic character":

> Until the end, there isn't anything in the book that is original with her— that she isn't asked to do, or forced or coerced into doing. There are very few good characters in my books who start things as a matter of free will.[2]

Charlie is torn by the pressure to use her power to save her father and herself from capture and, indeed, death; by the guilt instilled by her parents' careful training that the power is a "bad thing"; and by the realization of a growing pleasure in the use of the power. Yet despite the book's title, its key character is Charlie's father, Andy McGee. Lacking Charlie's childhood state of grace, it is Andy who must confront the moral consequences of their collective talents— including the grim knowledge that Charlie's power is growing, while continued use of his "push" will likely cause his death.

The forces of evil arrayed against Andy and Charlie McGee are depicted with an intriguing cyclopean imagery. Dr. Wanless, the chief proponent of the experimental drug program, has a mien said to be reminiscent of the "Dr. Cyclops" of motion picture infamy.[3] The Shop is a monolithic bureaucracy conceived in cold war perspectives; it has grown conspiratorially pervasive, ruthlessly immoral, and nightmarishly inept. Both The Shop and its epitome and leader, Cap Hollister, are creatures whose time has passed, much as the mythical cyclopes were the stranded remnants of an earlier time. (The cyclopes are described in Edith Hamilton's classic *Mythology* with apt comparison to The Shop: "Their fierceness and savage temper . . . did not grow less; they had no laws or courts of justice, but each one did as he pleased. It was not a good country for strangers."[4])

At the heart of the sociopolitical commentary of *Firestarter* is a sense of informational bleed-through—The Shop, like Big Brother of George Orwell's *1984* (1949), is able to penetrate any secret, but it never truly understands the information it has obtained. When the McGees are finally captured by The Shop, King offers a sardonic view of the cold war, arms-race mentality:

> *In a marvelous story by Fredric Brown, a man who is obviously insane visits the home of a scientist and begs him to stop working on the latest nuclear weapon. The scientist, whose only son is mentally retarded, replies that he is merely advancing science and that any responsibility lies with the government. The visitor says that he will leave, but he asks for a drink. And the scientist, who is delighted to be rid of him, goes to the next room to get the drink. When he returns, the man is gone, but the scientist's son is sitting on the floor playing with a pistol. The scientist snatches it away from him and wonders what sort of madman would put a loaded gun in the hands of a mentally retarded child.*

> *And that, obviously, is an element of* Firestarter: *Charlie is the idiot child and the loaded gun is in her head. And The Shop is only encouraging her to shoot it.*[5]

Completing King's pantheon of evil is a literal cyclops, Rainbird—"a troll, an orc, a balrog of a man":

> *[He] stood two inches shy of seven feet tall, and he wore his glossy black hair drawn back and tied in a curt ponytail. Ten years before, a Claymore had blown up in his face during his second tour of Vietnam, and now his countenance was a horror show of scar tissue and runneled flesh. His left eye was gone.*[6]

Rainbird is the Polyphemus who entraps the McGees in the underground chambers of The Shop's Virginia headquarters. He is obsessed with death, an assassin whose motive is neither greed nor revenge, but a patient quest for an understanding of his own inevitable demise. Although obviously psychopathic, Rainbird's character has precedent in "Mr. Barlow," the elusive king vampire of *'Salem's Lot:* both offer an almost amoral view of death as a form of sustenance. King tends to identify the internal element of evil with moral weakness—such characters as Lloyd Henreid of *The Stand*, Greg Stillson of *The Dead Zone*, Roland D. LeBay of *Christine*, Morgan Sloat of *The Talisman*, and, of course, the townspeople victims of *'Salem's Lot* are ready examples. Rainbird is no exception, but his seeming stance of moral ambivalence in the matter of his own fate adds a subtle twist, creating a frighteningly real, yet curiously opaque, villain.

Firestarter is Stephen King's most sexual novel, even though it contains not a single scene involving explicit sex. The triangle of Rainbird, Charlie McGee, and her father verges on the sexual in an understated yet powerful sense (suggested most strongly through dream sequences) and evokes the highly symbolic fairy tale "Beauty and the Beast."[7] Beauty's father is menaced by the Beast in a design to capture Beauty—and eventually to obtain her love and thereby release the Beast from his gruesome appearance. The parallels follow rather scrupulously until the ending: when Charlie McGee is reunited with her father at the climax of *Firestarter*, she realizes that she has been deceived by Rainbird. The "marriage" he seeks is a joining in death, and the ending is anything but a happy one. In the

fairy tale, Beauty resolves the conflict between her love for her father and the Beast's needs in a beautiful manner. In *Firestarter*, as is elsewhere clear in Stephen King's fiction, the world is not a fairy tale where the good live in happiness. The good are subjected to death, to all forms of strife, for no apparent reason—other than that they are human. King has stated:

> Horror . . . deals inevitably with a conflict between good and evil; both sides must be well represented. The monster doesn't always have to die (take Rosemary's Baby, for example), but when a horror novel has no moment of reintegration, there is often no real emotional satisfaction. . . . On the other hand, a happy ending can't be Boy Scout stuff. There needs to be a pay-out as well as a pay-off. Good isn't free.[8]

The term "night journey" has been used earlier in this book to describe the literal descent into horror that occurs throughout Stephen King's fiction; but the "night journey" is also a critical perspective, derived from cultural anthropology, that offers significant symbolic insights into King's fiction.[9] The "night journey" is an archetypal myth dramatized in much great literature, from the Old Testament's Book of Jonah to Joseph Conrad's symbolist masterpiece, *Heart of Darkness* (1902), with its most memorable portrayal in James Joyce's *Ulysses* (1922). It is an essentially solitary passage through darkness involving profound spiritual change in the voyager. In its classical form, the night journey is a descent into the underworld, followed by a return to light.[10] A familiar variant, omnipresent in Gothic fiction, is the passage through a tunnel or other dark, enclosed space. A powerful rendition of this variant in King's fiction is the crossing of the Lincoln Tunnel in *The Stand:* a claustrophobic groping through a dreamlike landscape from the teeming island of humanity's past to the bright freedom of an uncertain future—a stunning, microcosmic enactment of that novel's principal theme. Similarly, Jack Sawyer's crossing of the Oatley Tunnel in *The Talisman* vividly encapsulates his nervous transition from the freedom of childhood to the traps and responsibilities of adulthood.

The night journey need not represent more than literal adventure, and this is particularly true in horror fiction, whose essence is the experiencing of mystery and evil, which is most often depicted with an element of darkness. Although horror fiction rarely relates

the archetypal myth in a symbolic manner—the night journey into one's own unconscious, and confrontation with an entity *within the self*—such symbolic usages seem unusually apparent among the works of the field's premier writers, including those of Stephen King.

For Russell Kirk, whose supernatural tales bear a very Christian intent, the night journey is an effective allegory for Christian redemption that "penetrates to spiritual depths and spiritual heights."[11] For his philosophical opposite, H. P. Lovecraft, whose mechanistic materialism tended to transcend ultimate notions of "good" and "evil," the night journey had no end; it was a downward, irreversible spiral into the abyss of oblivion.[12] King's fiction seems to strike a middle ground; unlike Lovecraft, he offers an element of choice: men and women are moral beings capable of right or wrong, good or evil, and the existence of that choice is both the source and the solution of the night journey. Yet King also embraces the notion of an inherent predisposition for good or for evil, most obviously depicted in *The Stand*, where the final remnants of humanity are divided by some nonconscious obsession into two rivaling groups representative of good and evil. Although this view, similar to that of Kirk, suggests spiritual depths and heights, King does not propose an overt religious allegory.

In both *The Dead Zone* and *Firestarter*, the element of choice is paramount, and it is echoed in haunting and unequivocal depictions of the night journey. In *The Dead Zone*, Johnny Smith's decision to assassinate Greg Stillson is presaged by the obvious night journey of his coma:

> It was a dream, he guessed. He was in a dark, gloomy place—a hallway of some kind. . . . Something else crept in: a feeling that he had changed. . . . He had gone into the darkness with everything, and now it felt to him that he was coming out of it with nothing at all—except for some secret strangeness.[13]

This "secret strangeness" is Johnny Smith's second sight, which will reveal Stillson's potential destiny and confront Johnny with the moral dilemma of whether he should commit murder to avoid fulfillment of that vision of destiny.

In *Firestarter*, a similar dilemma is presented to Andy McGee. Confined in the underground Shop installation, forcibly addicted to

Thorazine, apparently bereft of his "push," Andy undertakes the night journey in a claustrophobe's ultimate nightmare. Storms disable The Shop's electrical systems, leaving Andy's small cell-like chamber locked and in absolute darkness. He is sent reeling into the depths of his unconscious, where he must face the decision whether to concede his impotency against The Shop or to resist despite the likelihood that his death will result and that Charlie's powers will be unleashed. He dreams of a sojourn through dark labyrinthine corridors "until there was no light . . . a living dark,"[14] in which he overcomes his addiction, restoring his mental power; and he faces for the final time the image of a riderless black horse and its beating hoofs—the inescapable aftereffect of a strenuous "push." The image is profound—intensely evocative of Andy's pain, but further pairing Andy with the horse in The Shop's stables that Charlie has come to love as a surrogate for her father; it is also ironically suggestive of the final confrontation between Andy, Charlie, and Rainbird, which occurs in the stables. Like Johnny Smith, Andy McGee must face himself before he will face the antagonist; he must recognize the ultimate evil within himself. And just as Johnny Smith's choice preserved others from a likely holocaust, Andy McGee's choice frees Charlie to face herself and to make her moral choices in the novel's closing pages.

The climax of *Firestarter* confirms the power that King attributes to knowledge and moral choice. That Rainbird should fail in the face of Andy's sacrifice—and in the wake of Charlie's awesome power—is presaged in the defeats of Randall Flagg and Greg Stillson. Likewise, that The Shop should prove to be a house of cards should not surprise the devoted King reader:

The Shop is presented as a monolithic authority, but there is a very real sense that it is simply filled with bureaucrats who are running out of control. To me, the most horrifying scene in the book is the outright terrorism that goes on in a lunchroom when The Shop is looking for Andy and Charlie; this Shop agent terrorizes first a waitress and then a short-order cook—it's an awful piece of work. To suggest that there aren't guys like that who are actually getting their salaries from the taxpayers is to claim that there aren't guys like Gordon Liddy who ever worked for the CIA. And they love their work, man. They love their fucking work.[15]

The thing that worries me more than monolithic authority is that there may be no such thing, and that if you could meet Hitler, at the end you would find this [harried] little bureaucrat saying, "Where are my maps? Where are my armies? Gee whiz, gang, what happened?"[16]

For King, the strength of evil often lies in the element of secrecy and masquerade—of an existence beyond our knowledge. In *Firestarter*, as in *The Stand* and *The Dead Zone*, the night journey forces evil from the shadows into the daylight of confrontation and open conflict, where it cannot survive.

All told, *Firestarter* has the hallmarks of a transitional work; King's revisiting of concepts and themes explored in *Carrie*, *The Stand*, and *The Dead Zone* suggests a tying up of loose ends. Perhaps most striking is the manner in which the lingering pessimism of the apocalyptic, self-destructive use of strange talents in *Carrie* and *The Dead Zone* is again invoked in the climax of *Firestarter* and then resolved in the clear optimism of its conclusion. "It was a pleasure to burn," King reminds us:

I have always felt a real dichotomy between the way that I know I am supposed to act and the way that I really feel. It's shameful of me even to admit that, because you are not supposed to say that, a lot of times, you feel a little crazy. I have always had tremendous feelings of aggression that it seemed necessary to cover up, to hide. And my writing was a clear channel for that—I think that that is why there is so much destruction in my early books, because it was a way of ridding myself of a lot of that energy that couldn't be drained in day-to-day life. In Firestarter, there is justified destruction—I have never been interested in destruction simply for the sake of destruction—but there is also a great, outward-turning catharsis.[17]

The cathartic optimism of *Firestarter* produces an interesting counterpoint to the imploding "technohorror" pessimism of the short novel "The Mist," which was written at roughly the same time. In the wake of these novels, King would produce more insular, less explicitly sociopolitical books—*Cujo*, *Christine*, and *Pet Sematary*—structured primarily around the family unit. He comments:

I am always going to be a social novelist, in the sense that there will always be novels like The Dead Zone *and* Firestarter—*in fact,* The Tommyknockers *will be one of them.*

I am a social creature; I am a creature of my time. The consistent beat that comes through a lot of the reviews is my use of brand names, and the "mass-cult" surface of my novels. But that's because these things are part of my life, and because I refuse to deny either my times or my interest in my times.

As the next novels would make clear, I am also interested in people who interact on a smaller social and political framework—particularly that of the family. The politics of the family. The social ethics of the family. The individual.[18]

The optimism of *Firestarter* fulfills the traditional night journey—it is the "return to light," overcoming the dark night of the soul and ascending to redemption or salvation. That outcome is not inevitable, however, as the classical myth of Orpheus makes clear; his descent into the underworld in search of his dead wife, Eurydice, failed when, at the very instant of success, he looked backward. In the words of Nietzsche in *Beyond Good and Evil* (1886): "[I]f you gaze long into an abyss, the abyss will gaze back into you." Such a night journey would form the basis of King's next publication of length—the chilling horror novella "The Mist."

The Mist

"Where there are no gods, demons will hold sway."
—*Novalis*

In "The Mist,"[1] Stephen King conjures the quintessential faceless horror: a white opaque mist that enshrouds the northeastern United States (if not the world) as the apparent result of an accident at a secret government facility. This short novel is a paradigm of the complicated metaphors of Faustian experimentation and technological horror consistently woven into the fiction of Stephen King. Those who read "The Mist" will not likely forget the haunting inability of its characters to comprehend, let alone explain, what is happening to them. It has been claimed that the central fantasy of horror fiction is "that the unknowable can be known and related to in some meaningful fashion."[2] "The Mist" completely belies that view, presenting a chilling dislocation in which horror and mystery are no less adequate than science, religion, or materialism to explain the human condition. As in Kafka's *The Metamorphosis* (1937), the whys and wherefores are secondary, even tertiary, as King unveils a reality that cannot be solved and, indeed, that cannot even be understood. In so doing, he demolishes the artifices through which we perceive reality, noting how much science, religion, and materialism shape our thinking and our lives, and questioning whether these shapes are desirable.

The technological horror theme is an obvious exploitation of the subversive tendencies of horror fiction. The common interpretation of the massive interest in supernatural fiction in the late 1800s, when many classic ghost stories were published, is that these stories represented the "swan song" of an earlier, pre-technological way of life.[3] That view is put forward often to explain the current upsurge of interest in macabre fiction and film. Charles L. Grant has noted that horror fiction serves as "the dark side of Romanticism,"[4] not simply a medium of escape but a rejection of the real horror and skepticism generated by our technological civilization in favor of a sentimental vision that confirms the possibility of the unknown. It thus seems quite logical that the contemporary horror story often utilizes an exaggeration or extrapolation of modern technology as its surrogate for the unknown, operating as a cautionary tale that simultaneously rejects technology while reassuring the reader that things could nevertheless be worse.

The halcyon years of "technohorror" were the 1950s, when fear of the ultimate possibilities of mankind's technology, omened by the nuclear devastation of Hiroshima and Nagasaki, was exposed at the visceral and readily dismissed level of the grade B science fiction movie. As the 1960s and 1970s progressed, celluloid unrealities called *Them* (1954) and *The Beginning of the End* (1957) were hauntingly evoked in grim realities with equally colorful names like Agent Orange, Three Mile Island, and Love Canal. Our belated awareness of the negative implications of technology, coupled with growing doubts about the ability of technology to solve the complex problems of modern society, has rendered "technohorror" a theme of undeniable currency, requiring the horror writer to take but a simple step beyond front-page news.

As a child of the fifties whose anxieties were fed by B movies and whose "fall from the cradle" occurred with the sublime intersection of *Earth vs. the Flying Saucers* and the launching of the Soviet Sputnik satellite, it seems only natural that Stephen King has written about "technohorror" since his earliest efforts at fiction. His high school story "I Was a Teenage Grave Robber"[5] concerned the monstrous results of secret experiments with corpses, while his first serious attempt at a novel, "The Aftermath"—also written during high school—depicted a post-holocaust world molded by the directives of a computer that scientists could no longer control. Although *Carrie* included a suggestion of genetic mutation, *The Stand* was King's

first published novel to probe in depth the fears generated by technological civilization. Both *The Stand* and *Firestarter* linked science and authority in an amoral tryst, yet concluded with an optimistic hope for new beginnings. In "The Mist," King posits only the end.

David Drayton, the narrator of "The Mist," is a commercial artist—a person whose career is devoted to creating artificial representations of human life. With his wife, Stephanie, and five-year-old son, Billy, Drayton leads an almost idyllic existence at a lakefront home near Bridgton, Maine—a replica of the home where King and his family lived from the summer of 1975 to the summer of 1977. Their life is shattered by a freakish summer storm that sends the Draytons to their cellar, where David has a remarkable precognitive dream—the very same dream, in fact, that caused Stephen King, after weathering such a storm, to write the story:

> *I had a dream that I saw God walking across Harrison on the far side of the lake, a God so gigantic that above the waist He was lost in a clear blue sky. In the dream I could hear the rending crack and splinter of breaking trees as God stamped the woods into the shape of His footsteps. He was circling the lake, coming toward the Bridgton side, toward us, and behind Him everything that had been green turned a bad gray and all the houses and cottages and summer places were bursting into purple-white flame like lightning, and soon the smoke covered everything. The smoke covered everything like a mist.*[6]

In the morning, a peculiar mist brews over the lake. It is moving across the water toward Bridgton—moving against the wind. When Drayton's wife asks what it is, Drayton thinks: ". . . the word that nearly jumped first from my mouth was *God*."[7]

Drayton drives his son and a neighbor into town to report downed electrical lines and to obtain grocery supplies. They find the Federal Foods Supermarket jammed with people. Speculation is rampant that something has gone wrong at the government's secret "Arrowhead Project" across the lake. As Drayton waits in the checkout line, he is distracted by an intangible concern. Billy interrupts his reverie, and Drayton observes: ". . . suddenly, briefly, the mist of disquiet that had settled over me rifted, and something terrible peered through from the other side—the bright and metallic face of pure terror."[8]

The mist settles over the supermarket, and although many people rush out to view the peculiar phenomenon, none returns. Gradually, with fever-dream intensity, the "pure terror" infecting Drayton is animated as the monstrous inhabitants of the mist are divulged. Tentacles writhe out of the mist to snatch away a bagboy; bug-things stretching four feet in length flop along the store windows, only to be gobbled up by pterodactyl-like monstrosities that plummet out of the mist. Huge spidery creepy-crawlers spin corrosive webs, and segmented parodies of lobsters crawl across the parking lot. The spawn of the mist seem endless in horrifying variety; but the mist, and what it signifies, is more important than its monsters: "It wasn't so much the monstrous creatures that lurked in the mist. . . . It was the mist itself that sapped the strength and robbed the will."[9] The mist takes on a symbolic significance—it is the unknown, not only in a physical sense but as the realm of experimentation.

Conspicuous by its absence from "The Mist" is a stock character of the "technohorror" nightmare—the scientist. We are offered only straw men: two young soldiers trapped within the supermarket who commit gruesome suicide in confirmation of the feared source of the disaster. The culprits of the Arrowhead Project remain as faceless and opaque as the mist itself. And this only increases our unease; there is no patent lunatic or misguided zealot on which to foist our responsibility.

"The Mist" takes the form of a nightmarish, surreal disaster film. The besieged occupants of the supermarket are a representative sample of humanity, put to the test of the external threat of the mist and the internal claustrophobia—and madness—of the supermarket. They undergo hysteria and fragmentation, and acts of courage and of stupidity result only in bloodshed while the inevitable leadership struggles take place.

King deftly creates the tension between illogic, religion, and materialism that is his forte. Drayton's neighbor, a vacationing New York City attorney, proves not to be a pillar of objectivity or calm; rather, he heads a group of people—wryly described by Drayton as the "Flat Earth Society"—which simply refuses to believe in the disaster despite quite tangible evidence. They walk into the mist, to their deaths. Another group, which grows in number as time passes, believes perhaps too strongly in the disaster, interpreting it as God's punishment. They are headed by Mrs. Carmody, an otherwise in-

nocuous old lady given to folk tales and remedies, who seemingly thrives on the disaster. This group soon demands a human sacrifice in appeasement of the mist. A third group, including Drayton, attempts a rational, pragmatic solution to the horror. They construct defenses, fight off the intrusions of monsters, and ultimately undertake an ill-fated expedition to a neighboring pharmacy. Their failure gives credence to the increasing zealotry of Mrs. Carmody and leads Drayton to organize an escape effort.

Readily apparent in "The Mist" is the influence of George A. Romero, virtuoso director of the classic low-budget horror film *Night of the Living Dead* (1968) and its powerful sequels, *Dawn of the Dead* (1979)[10] and *Day of the Dead* (1985). On one level, Romero's films plunder our dire unease with death and decay, hypothesizing that the dead will return to life with a singular hunger for human flesh. On another level, however, these films consider, in an intelligent and ironic sense, the horrific siege of reality. Romero terms his masterwork "an allegory meant to draw a parallel between what people are becoming and the idea that people are operating on many levels of insanity that are only clear to themselves."[11]

In *Night of the Living Dead,* Romero's zombies trap a group of strangers within a deserted farmhouse. Romero inverts the commercially successful disaster film, supplanting melodrama with nihilistic abandon: the young, attractive lovers are killed in an escape attempt; the older businessman becomes a raving coward rather than a calculating, take-charge leader; the little girl turns on her mother, butchering her with a garden tool and then devouring her; the "token" black becomes the leader—and only survivor—of the defense, only to emerge the next morning so shattered by the experience that he is mistakenly shot as a zombie. The theme is replayed to an almost absurdist premise in *Dawn of the Dead* (which was produced after "The Mist" had been written, but before it was published), in which a similar band of survivors barricades itself within a suburban shopping mall.

The thematic parallels between "The Mist" and Romero's "Living Dead" films are numerous; perhaps more striking is the manner in which the imagery of "The Mist" evokes the intensely visual and visceral quality of film. "You're supposed to visualize the story in grainy black and white," notes King.[12] Unlike any of King's earlier fiction of length, it is written entirely in first-person singular and structured on a scene-by-scene basis. And its narrator consistently

repeats, as if in self-assurance, that the creatures of the mist are the stuff of grade B horror movies. Not only does King thereby reinforce the several levels of perspective; he presents an irony equal to that of the "just the flu" epitaph of his short story "Night Surf"[13]—that the end of the world, when it comes, should indeed resemble a grade B horror movie.

The defense of the Federal Foods Supermarket takes on surreal aspects that intermingle shock and sardonic humor, paralleling the shopping mall confrontations of *Dawn of the Dead.* One of the pterodactyl-like creatures breaches the defenses, savaging a bystander before being set aflame. King recounts the incident with delightful imagery and an obvious send-up of the gravely serious narrator of traditional Gothic fiction:

> *I think that nothing in the entire business stands in my memory so strongly as that bird-thing from hell blazing a zigzagging course above the aisles of the Federal Supermarket, dropping charred and smoking bits of itself here and there. It finally crashed into the spaghetti sauces, splattering Ragu and Prince and Prima Salsa everywhere like gouts of blood.*[14]

A bug-thing immediately clambers through the broken window, but before the male defenders can act, a sixty-year-old school teacher, Mrs. Reppler, charges with a can of Raid in each hand and sprays it to death.

Although clearly self-conscious, "The Mist" is not parody. Like George Romero, King attempts—and succeeds—in balancing a pandemonium seesaw whose ends are occupied by pure horror and outrageous black humor. We are disturbed by "The Mist" because, like its narrator, we do not know exactly what to do when confronted by its horrors: "I was making some sound. Laughing. Crying. Screaming. I don't know."[15]

The typical disaster film produces a fascist answer—strong leadership will persevere, while the weak are dispensible. In "The Mist," Stephen King, again like George Romero, holds differently: horror produces not the best but the worst in people, and when it does produce a semblance of good, that good is usually unrecognizable to the world outside.[16] Drayton is less than a heroic figure; uncertain of the fate of his wife, he nevertheless feels compelled to have sex with another of the survivors, and he is drawn into the

doomed expedition to the drugstore. Finally, under the compulsion of the growing religious mania of Mrs. Carmody and her followers—and of the simple urge to see the sun again—Drayton leads a tiny group to his Land Rover, again suffering the loss of two companions. By the novel's close, Drayton and his comrades are barricaded within a Howard Johnson's; only then does he ponder the difficulty of refueling—and only then does he face the possibility that the mist may go on forever.

The flight from the supermarket is Stephen King's most literal and most Lovecraftian night journey. Drayton's narrative has no ending in the traditional sense. His group is heading south, hoping for refuge from the dark and seemingly endless tunnel of the mist, but they find only a surreal landscape of desolation and monstrosity. Yet the ultimate horror is nearly unseen, and it is all the more horrible given Drayton's dream on the night before the coming of the mist:

> *Something came; again, that is all I can say for sure. It may have been the fact that the mist only allowed us to glimpse things briefly, but I think it just as likely that there are certain things that your brain simply disallows. There are things of such darkness and horror—just, I suppose, as there are things of such great beauty—that they will not fit through the puny doors of human perception. . . .*
>
> *I don't know how big it actually was, but it passed directly over us. . . . Mrs. Reppler said later she could not see the underside of its body, although she craned her neck up to look. She saw only two Cyclopean legs going up and up into the mist like living towers until they were lost to sight.* [17]

This numinous vision, a nonrational confrontation with the apparently divine, omens the impossibility of escape. The growing sense of a mysterious profanity, latent in the religious hysteria of Mrs. Carmody, is manifest in this dark mirror-image of the God of Drayton's dream. Like *The Stand*, "The Mist" explicitly evokes Biblical stories of plagues embodying the wrath of God—and, of course, the archetypal story of the great flood. Although *The Stand* confirms the power of faith, "The Mist" refuses to offer a rainbow signaling man's triumph over adversity and the promise of a new day. As if animating Novalis's aphorism—"Where there are no gods, demons will hold sway"—King offers a universe without sal-

vation, imbued with the feeling of one's own submergence—of being antlike, trivial, before the footsteps of an unseeable God-thing.

For many readers, horror fiction is meaningful because its acceptance of the existence of evil implies the existence of good. Indeed, Russell Kirk contends that supernatural fiction confirms "hierarchical" Christian values.[18] "The Mist" is particularly terrifying because it proposes a transcendence of notions of good and evil, right and wrong; King moves his characters and readers through an ever-darkening universe of chaos and hostility. The line separating civilization from chaos—and indeed, life from extinction—has parted like the mist, and only "pure terror" remains.

The fiction of Stephen King offers no theological polemic, although—the aesthetics of "The Mist" notwithstanding—it does not embrace entirely the "cosmic pessimism" of H. P. Lovecraft. King's stories typically celebrate the existence of good, while graphically demonstrating its cost. In *Carrie, The Stand,* and *The Dead Zone,* King offers the intervention of God as a potential—and indeed, persuasive—explanation of events. His version of God harkens less to modern Christian values and their source, the New Testament, than to those of the Old Testament, and particularly the Book of Job. On the other hand, King's most optimistic and pessimistic novels, *Firestarter* and *Cujo,* ironically lack any explicit religious elements.

In "The Mist," King uses religion as well as materialism not as a dramatic foil to horror, but as its counterpoint. Just as he pushes the aesthetics of horror to the limit, so too are the aesthetics of religion and materialism tested in the extreme. In "The Mist," as in several of his novels—*Carrie, The Dead Zone,* and *The Talisman*—religious fanaticism is an artifice of control, the means by which its proponents impose the illusion of order upon a situation virulent with chaos. Similarly, the seeming obsession of David Drayton in "The Mist" with brand names and products—from an opening comparison of power saws to the final resting place at Howard Johnson's—reflects materialism as an artifice of control. The numinous vision climaxing "The Mist" profoundly disintegrates any remaining illusions of order—and indeed, suggests horribly that order may lie at the heart of chaos. King's lesson seems clear: that order—or at least release from chaos—cannot be imposed; if it exists, and to the degree that it exists, it will be discovered.

Writing about the horror story, King has noted:

The best tales in the genre make one point over and over again—that the rational world both within us and without us is small, that our under-standing is smaller yet, and that much of the universe in which we exist is, so far as we are able to tell, chaotic. So the horror story makes us ap-preciate our own well-lighted corner of that chaotic universe, and per-haps allows a moment of warm and grateful wonder that we should be allowed to exist in that fragile space of light at all.[19]

Although the dark, apocalyptic quality of "The Mist" suggests that our "fragile space of light" may be dwindling, David Drayton's night journey through the mist has not yet reached its end. The nov-el's final word is "hope," even if this hope is clouded by ambiguity and despair. And unlike Drayton, the reader has the protection of perspective. The setting of "The Mist," so reminiscent of the grade B horror film, is one of total security; we can leave at any moment, the lights will flicker on, and we can step safely into a more familiar world.

Or can we? That is the question posed by Stephen King's most pessimistic novel, *Cujo.*

·10·

Cujo

"Nope, nothing wrong here."
 —*The Sharp Cereal Professor*

Cujo was a good dog: a two-hundred-pound Saint Bernard with sad eyes and an intrinsic love for a life that demanded little more than playing with children and chasing an occasional rabbit. But one day, he followed a rabbit down a hole, and what he found was most definitely not Alice's Wonderland.

"Once upon a time," begins *Cujo* (1981),[1] Stephen King's seventh published novel, but it is not the sort of fairy tale to which we have grown accustomed. There is no ogre or dragon or evil witch, no thinly veiled childhood lesson and, most important, no happy ending. *Cujo* is steeped instead in a reality that is as inescapable as it is frightening, emphasizing not only the role of horror fiction as the modern fairy tale but the importance of realism in creating effective horror fiction.

Cujo is set in the spring of 1980 in the fictitious town of Castle Rock, Maine, which earlier served as the stalking ground of Frank Dodd, the "Castle Rock Rapist" of *The Dead Zone*.[2] Its storyline evolves about two marriages: Donna and Vic Trenton, whose son Tad is wracked with night fears concerning a monster that he swears is haunting his closet, and Joe and Charity Camber, whose son Brett has a dog named Cujo—inexplicably the *nom de guerre*

used by William Wolfe of Symbionese Liberation Army infamy.[3] For the two children, dreams echo with nightmarish reality; for the adults, reality itself has become the stuff of bad dreams.

The two marriages are in jeopardy. Vic Trenton has fulfilled the dream of a lifetime by escaping from New York City to found a small advertising agency in Castle Rock. The move was made possible by a major client, the Sharp Cereal Company, for whom Vic has created an advertising campaign featuring the "Sharp Cereal Professor," whose reassuring words—"Nope, nothing wrong here"— have won the hearts of children across the land. But when a disastrous chemical error renders Sharp's "Red Raspberry Zingers" cereal into the laughingstock of the nation, the account (and the Trentons' retreat to Maine) is imperiled. Donna Trenton, uncomfortable with the move to Maine, bored and overly conscious of aging, has drifted into an extramarital affair that disgusts her. Joe Camber—a brutal, selfish, stubbornly independent backwoods-Maine automobile mechanic—seemingly enjoys keeping his wife "in her place"; while Charity Camber, hoping to better her son, strives belatedly to assert her independence from Joe, who sinks deeper and deeper into indolence and alcoholism. And through this slice of everyday life in modern America walks a dog who has fallen into a dark hole, succumbing to the bites of rabid bats.

Like so much of King's fiction, *Cujo* had its origin in a real incident in King's life. In the spring of 1977, his motorcycle was not running well, and a friend told him about a mechanic who lived outside of Bridgton, Maine, "in the middle of nowhere":

> *I took the bike out there, and I just barely made it. And this huge Saint Bernard came out of the barn, growling. Then this guy came out and, I mean, he was Joe Camber—he looked almost like one of those guys out of Deliverance. And I was retreating, and wishing that I was not on my motorcycle, when the guy said, "Don't worry. He don't bite." And so I reached out to pet him, and the dog started to go for me. And the guy walked over and said, "Down Gonzo," or whatever the dog's name was, and gave him this huge whack on the rump, and the dog yelped and sat down.*
>
> *The guy said, "Gonzo never done that before. I guess he don't like your face." And that became the central situation of the book, mixed with those old "Movies of the Week," the made-for-television movies that they used to have on ABC. I thought to myself, what if you could have a situation that was an extension of one scene. It would be the ulti-*

mate TV movie. There would be one set, there would be one room.
You'd never even have to change the camera angle. So there was one
very small place, and it became Donna's Pinto—and everything just
flowed from that situation . . . the big dog and the Pinto.[4]

The horror of *Cujo* is not supernatural; nor does it take the form
of the demonic juggernaut-animal of *Jaws* (1975) and its imitators.
It is entirely predestinate and unequivocally real. King suggests, in
the opening pages of the novel, that the evil represented by Frank
Dodd has descended again upon Castle Rock. The implications are
twofold: first, the insinuation of the presence of a supernatural ele-
ment, perhaps to assuage the expectations of readers about to swal-
low the bitter pill of a novel framed with an unforgiving realism;
second, and more important, the confirmation that the evil of *Cujo*
emanated from an outside source, and not from the act of any
mortal being:

> *[P]eople will ask me, "Well, is that dog Frank Dodd?" And yes, he is,*
> *but only in the sense that there's something evil happening here, and it's*
> *outside evil; it's a visitation.*
> *. . . It isn't anything that these people have brought on themselves. I*
> *never intended that to happen in the book. The presence of Frank Dodd*
> *came only in a redraft, because it's the only way to balance off the*
> *unattractive idea that the visitation is a God-sent punishment of Donna*
> *Trenton for her adultery. And I never intended that.*[5]

The big dog is not intrinsically evil, but is the victim of a natural, if
loathsome, disease—struck down, like Johnny Smith of *The Dead*
Zone, by the spinning wheel of fortune. King's naturalistic stance is
made clear in the closing pages of the novel:

> *Shortly following those mortal events in the Camber dooryard, Cujo's*
> *remains were cremated. The ashes went out with the trash and were*
> *disposed of at the Augusta waste-treatment plant. It would perhaps not*
> *be amiss to point out that he had always tried to be a good dog. He had*
> *tried to do all the things his MAN and his WOMAN, and most of all his*
> *BOY, had asked or expected of him. He would have died for them, if*
> *that had been required. He had never wanted to kill anybody. He had*
> *been struck by something, possibly destiny, or fate, or only a degenera-*
> *tive nerve disease called rabies. Free will was not a factor.*[6]

Cujo kills both Joe Camber and his drinking buddy, Gary Pervier, while Charity and Brett Camber are visiting relatives in Connecticut; then he lays siege to Donna and Tad Trenton, trapped within Donna's crippled Ford Pinto for nearly two days when she brings it to Camber's farm for repairs. The rabid dog, struck down by a fate implicit in nature, becomes, in turn, a symbol of nature— and particularly the alternately beautiful and frightening nature of Maine, a nature that Donna, the outsider, must confront in order to come to terms with her life there.[7]

The big dog is thus a personification, a cumulation, of our everyday fears—horrors woven from the dark strands of the American social fabric: decaying marriages, economic woes, malfunctioning automobiles, and junk food. *Cujo* affirms the irony of Stephen King's popular success: we are obsessed with fear, running scared of our daily lives, where we can no longer trust the food we eat, our machines, our neighbor's dog, or even ourselves. Money, love, and death are the framework of fear, and King reminds us of their everyday presence with incisive and relentless effect.

Fear strikes at the supermarket:

> *They went to the Agway Market and Donna bought forty dollars' worth of groceries. . . . It was a busy trip, but she still had time for bitter reflection as she waited in the checkout line . . . on how much three lousy bags of groceries went for these days. It wasn't just depressing; it was scary.*[8]

And at our jobs:

> *Since the Zingers fiasco, two clients . . . had canceled their arrangements with I-E, and if Ad Worx lost the Sharp account, Rob would lose other accounts in addition to Sharp. It left him feeling angry and scared. . . .*[9]

It invades our personal relationships:

> *Now things could be admitted. How he had wanted to kill her when she called him a son of a bitch, her spittle spraying on his face. How he had wanted to kill her for making him feel old and scared and not able to keep on top of the situation any more.*[10]

And it is with us always, if only implicit in the passage of time:

There was no personal mail for her; these days there rarely was. Most of the people she knew who had been able to write were now dead. She would follow soon enough, she suspected. The oncoming summer gave her a bad feeling, a scary feeling.[11]

These are the big leagues of fear, the actualities behind the masks of the ghoulies and ghosties that normally inhabit horror fiction. They cannot be laughed away—they won't ever meet Abbott and Costello—and in *Cujo's* pages, we find that even horror fiction provides no respite.

The function of realism in horror fiction has always been paradoxical. We have noted that horror fiction serves as a means of escape for its readers, suppressing the very real and often overpowering horrors of everyday life in favor of surreal, exotic, and visionary realms. In "The Mist," King described this escapist function in explicit terms:

When the machines fail . . ., when the technologies fail, when the conventional religious systems fail, people have got to have something. Even a zombie lurching into the night can seem pretty cheerful compared to the existential comedy/horror of the ozone layer dissolving under the combined assault of a million fluorocarbon spray cans of deodorant.[12]

Yet horror fiction is not simply a place to which we seek to escape; it is also a place to which we are drawn seductively by a hidden need. As Joseph Conrad wrote in *Lord Jim* (1900), "to the destructive element submit yourself. . . . In the destructive element immerse"; or in Stephen King's colloquial, but no less telling rendition, we must "keep the gators fed."[13] Horror fiction not only vents emotions that run counter to "civilized" society, allowing us to air our innermost fears and to breach our foremost taboos; at its most extreme, it acts as a surrogate "night journey" for its readers, which Stephen King consciously seeks to fulfill:

I think that all horror fiction (all of the good stuff, anyway) is an attempt to carry the reader from the land of the living to the land of the dead, and that this journey becomes a kind of easily graspable, but nevertheless surreal mythic allegory for our own life passage toward death. Seen in this light, the writer of horror fiction is a little like the boatman ferrying people across the river Styx. . . .[14]

And as for Cujo, the novel speaks clearly: "Wasn't there a dog in the front of the boat in that story about the boatman . . . ? The boat-man's dog. Just call me Cujo."[15]

Horror fiction is indeed alternatively repulsive and seductive; in seeking to escape within its irrationality, we understand our need for reality—yet the closer our familiarity with reality, the greater our need for escape. Stephen King's fiction is conscious of this para-dox, operating with at least one foot firmly within waking reality—and indeed, at odds with allowing its escapist tendencies to divorce the reader from reality. If anything, his horror fiction draws the reader *closer* to reality, as he readily acknowledges:

> [T]he tale of horror and the supernatural is an escape, but the reader must never believe that it is only an escape outward, into a kind of never-never land . . . ; the tale of terror and supernatural is also an es-cape inward, toward the very center of our perceived humanity.[16]

In this context, the intrinsically subversive art of King's horror fic-tion proposes what H. P. Lovecraft called "an absolute and stupen-dous invasion of the natural order,"[17] while forcing the reader to consider whether, in fact, there is order and, indeed, whether any-thing is natural.

In *Danse Macabre*, King described the manner in which the best horror fiction is a dark analog of reality, its authors consciously or unconsciously expounding fantasy fears that are a reflection or sub-tle variation of actual fears. As we have seen, King's own novels seem to demonstrate several evolving subtexts for which *Cujo* pro-vides an apt climax. His early books were inward-looking, claustro-phobic expositions of the fears and guilt latent in interpersonal relationships. *Carrie* concerned the problems of maturation in con-temporary society, effectively juxtaposing the dark side of adoles-cence with the consequences of attempting to ignore or to suppress the dark side of the psyche. In *'Salem's Lot*, King subverted—or, the cynic might suggest, modernized—Thornton Wilder's *Our Town*, depicting a microcosmic small town whose moral disintegration is distilled in a clutch of vampires. In *The Shining*, the real terrors of alcoholism, child abuse, and familial breakdown were translated into a surreal Gothic atmosphere. The latter two novels, particu-larly, set forth scenarios in which the unknown may well represent an evasion of responsibility on the part of their protagonists. In very

real terms, these three initial novels, whose principal characters were either students or writers, find King often working out in print the personal fears that haunted his early writing efforts, when a short story sale literally meant that his family could have heat for another month.

With *The Stand*, *The Dead Zone*, and *Firestarter*, King's novels began a more outward-looking perspective, covering broader canvasses of space and time, and bringing sociopolitical fears—the curses of civilization—to the forefront. King's concern with this theme seems rooted both in lessons about our social and political processes taught in the 1960s and 1970s, and in the end of America's romance with technology. His first six novels produce a pattern of increasingly monolithic evil, culminating in the cyclopean imagery of *Firestarter* and climaxing in "The Mist," whose quintessential faceless evil spews forth a flurry of creepy-crawling monsters like an endless, insane "Creature Feature" from late-night television.

What could be worse? Only one thing, responds King in *Cujo:* reality.

Written in King's most visceral prose, *Cujo* reexamines these earlier themes, stripping away the veneer of supernaturalism to confront us with the mundane here-and-now of Cocoa Bears and Ford Pintos, baseball games and bake sales, farting and fucking, and says: reality *is* an unnatural order. You cannot explain it away as madness or drunkenness or, indeed, the stuff of horror fiction.[18] And this reality, in turn, has created our need for the horror story as a modern fairy tale, a land of "Once upon a time" that grants us escape or reassurance, simply confirming our worst expectations or giving a good look at the scene of the accident. Like Donna and Tad Trenton, trapped in their malfunctioning Pinto by the rabid Cujo, we are under siege from forces that we simply cannot understand. We are trapped by a reality as loathsome and ambiguous as the good dog gone bad—trapped between an uncertain future and an unreachable past, unable to tell guilt from innocence or true identity from false, unable to believe or to be comfortable in our unbelief. And the Sharp Cereal Professor's oft-repeated epigram— "Nope, nothing wrong here"—is not only a summing-up of the bitter irony of *Cujo* and its model, our reality; it also serves as a wry commentary on what we seek in horror fiction.

Cujo is an intensely written novel; it moves with seemingly instinctive pace, sustaining a relentless, and often disagreeable, ten-

sion. It is a harrowing reading experience, uncompromising in its terror and suspense, yet imbued with humor, warmth, and a deep sense of the human condition, of which fear is, after all, only an element. As in his earlier novels, King evokes the horror of *Cujo* not by a concatenation of circumstances but by the exposition and understanding of characters. The aesthetics of horror—"death, destruction and destiny," in the words of Johnny Smith in *The Dead Zone*—are matters of the greatest intensity and importance; they make the most rigorous demands for full expression of the human personality. King brings his characters to trial in a court of fear and asks each of them a question simultaneously simplistic and unreachably complex: who is this person?

He asks that question of us as well. The dark hole that snared Cujo awaits us all; when the novel's human antagonist—Steve Kemp, the layabout poet whom Donna Trenton unfortunately chooses as a lover—finally unleashes his psychotic anger upon the Trenton household, King writes: "He was down a dark hole."[19] And when Vic Trenton learns of his wife's affair with Kemp, the image is brought home with painful clarity:

> [W]hat you didn't know couldn't hurt you. Wasn't that right? If a man is crossing a darkened room with a deep, open hole in the middle of it, and if he passes within inches of it, he doesn't need to know that he almost fell in. There is no need for fear. Not if the lights are off.[20]

The hole is there, waiting, for each of us—whether we are drawn in like Cujo, or descend willingly like Steve Kemp, or are pushed like Vic Trenton. And this is the most chilling element of Stephen King's most pessimistic novel—not the tortured lives of its characters or the violent horror of its climax, but the stark yet inevitable final image, that we are not unlike small animals who have died down the dark hole.

Although *Cujo* is one of King's best novels, he has never been comfortable with its pessimism—and particularly with the death of Tad Trenton in its closing pages. Indeed, King has said that if he were ever to rewrite one of his published novels, it would be *Cujo;* and his original screenplay adaptation of the book saw Tad survive—an ending that was adopted in the 1983 motion picture directed by Lewis Teague. But the pessimistic stance of the novel was, in King's words, "almost demanded":

You can't continue to write this kind of thing over and over again and finish up by saying, "Oh, yes, and the kid was all right. God took care of him again, folks. Go to bed. Go to sleep. Don't worry." Because they die. Kids get run over, they get knocked out of their cowboy boots. People pick them up and take them away forever. Crib death. Leukemia. It isn't a large percentage—most of them do fine. But it has to be put into the equation: the possibility that there is no God and nothing works for the best. I don't necessarily subscribe to that view, but I don't know what I do subscribe to. Why do I have to have a world view? I mean, when I wrote Cujo, *I wasn't even old enough to be President. Maybe I will when I'm forty, or when I'm forty-five, but I don't now. I'm just trying on all of these hats.*[21]

The death of Tad Trenton nevertheless weighed upon King. He would soon revisit the death of a child, one of his greatest personal fears, in *Pet Sematary,* a novel that so affected him that he did not wish to see it published; but not surprisingly, he would first turn to lighter subject matter, writing an original screenplay for the darkly comic motion picture *Creepshow* and his most humorous novel, *Christine.* But his next writing project was "The Breathing Method," the final novella of *Different Seasons,* a collection that would confirm the horrific power of the realistic premises of *Cujo.*

· 11 ·

Different Seasons

"It is the tale, not he who tells it."

—*Stephen King*

At 249B East Thirty-fifth Street in New York City, we are told, there stands a nondescript brownstone house to which only certain people are invited. Inside meets a curious, informal club whose common thread is a penchant for the telling of tales. Toward the close of an evening, the club members will gather their chairs in a semicircle before the massive fireplace in the library. A story will be told; then a toast will be raised, echoing the words engraved upon the keystone of the fireplace mantel: *"It is the tale, not he who tells it."*

You will not find that brownstone in New York City, but it stands at the heart of Stephen King's collection of four short novels, *Different Seasons* (1982).[1] The members of the club at 249B East Thirty-fifth Street have a special fondness for the tale of the uncanny, but "[m]any tales have been spun out in the main room . . . tales of every sort, from the comic to the tragic to the ironic to the sentimental."[2] In *Different Seasons*, King moves beyond the horror fiction on which his fame is securely based to present those "tales of every sort," told through an array of fictional storytellers, all of whom ask the reader to judge the tale, not he who tells it.

The four novellas of *Different Seasons* were written between 1974

and 1980, each immediately after King completed a book-length novel, but they were offered for publication for the first time in this collection.[3] Their different tones and textures reflect the "different seasons" of the title, yet beneath each lurks a decidedly macabre quality. "Sooner or later," King notes, "my mind always seems to turn back in that direction. . . ."[4]

The opening novella, "Rita Hayworth and Shawshank Redemption," finds King working the theme of innocence as effectively as he considered the theme of guilt in *The Shining*. Set in the fictional Shawshank state penitentiary in southwestern Maine, it is the first-person narrative of an inmate identified only by the nickname Red. Serving triple life sentences for murder, Red has become the prison's entrepreneur—"I'm the guy who can get it for you"[5]—but his story is less about himself than another lifer whom he meets and befriends in the prison yard. Andy Dufresne is a former banker, convicted of the murder of his wife, and he makes curious purchases from Red's black market enterprise: a rock hammer and a poster of Rita Hayworth. Dufresne insists upon his innocence, and Red's story tells of how the irresistible force of that innocence succeeds against the seemingly immovable object of Shawshank. In challenging the constricting, dehumanizing environment of the prison—from the sexual brutality of the "sisters" to the corrupt prison overseers to the ever-present walls of stone—Dufresne displays a quality that is symbolized for Red in his seeming dedication to a form of art, the shaping and polishing of stones taken from the yard:

> First the chipping and shaping, and then the almost endless polishing and finishing with those rock-blankets. Looking at them, I felt the warmth that any man or woman feels when he or she is looking at something pretty, something that has been worked and made—that's the thing that really separates us from the animals, I think—and I felt something else, too. A sense of awe for the man's brute persistence.[6]

"Hope Springs Eternal" is the subtitle of the novella, and in it, King extols the power of hope: "[H]ope is a good thing . . ., maybe the best of things, and no good thing ever dies."[7] But hope, we learn, is nothing without persistence—and in the end, Dufresne's persistence is the only vindication of his innocence, as his years of chipping a hole through the wall of his cell, hidden by the poster of

Rita Hayworth and her pin-up queen successors, provide the only avenue to freedom.

"Apt Pupil," the second and longest installment of the volume, is subtitled "Summer of Corruption," and it is a tale of demons by daylight: the corruption of "the total all-American kid," Todd Bowden, through his fascination with an aging Nazi war criminal, Kurt Dussander. On the novella's first page, we meet thirteen-year-old Todd—blond, blue-eyed, and "smiling a summer vacation smile."[8] Ever the perfect student, Todd discovers Dussander living out his final, impoverished days hidden in Todd's idyllic California hometown. He is not shocked by Dussander's role as death-camp commandant, but intrigued; he blackmails Dussander, promising not to reveal Dussander's identity if the former S.S. officer will tell him stories of the camps: "I want to hear about it. . . . Everything. All the gooshy stuff."[9]

The telling of tales of past horrors produces a nightmare symbiosis, in which Todd becomes the "apt pupil" to Dussander's reluctant tutelage.[10] The placid, plastic modernity of sunny California—captured wryly through snapshot glimpses of suburban life—crumbles before dark memories of the Holocaust. The partnership inexorably takes on a pathological bent as Dussander, haunted by the specters of his past, embraces again his murderous ways, while Todd sets out upon the painfully familiar path of American violence. His smile has changed; on the story's last page, it has become "the excited smile of tow-headed boys going off to war."[11]

King's message is simple and chilling; in the words of his Nazi-hunter, Weiskopf (who himself is identified as a storyteller):

> "[M]aybe there is something about what the Germans did that exercises a deadly fascination over us—something that opens the catacombs of the imagination. Maybe part of our dread and horror comes from a secret knowledge that under the right—or wrong—set of circumstances, we ourselves would be willing to build such places and staff them. Black serendipity. Maybe we know that under the right set of circumstances the things that live in the catacombs would be glad to crawl out. And what do you think they would look like? Like mad Fuehrers with forelocks and shoe-polish moustaches, heil-ing all over the place? Like red devils, or demons, or the dragon that floats on its stinking reptile wings?"

> *"I don't know," Richler said.*
> *"I think most of them would look like ordinary accountants. . . .*
> *And some of them might look like Todd Bowden."*[12]

The centerpiece of *Different Seasons* is its third novella, "The Body." It is patently autobiographical, told by a narrator, Gordon Lachance, who is a *doppelgänger* for Stephen King—a bestselling writer of horror fiction "who is more apt to have his paperback contracts reviewed than his books."[13] Subtitled "Fall from Innocence," it is the story of Lachance's first, childhood view of a dead human being.

Stephen King's first confrontation with death occurred at age four, according to his mother, when one of his playmates was killed by a passing train.[14] In "The Body," Lachance tells of an adventure that he had at age twelve, to which he attributes his evolution as a writer: an overnight quest with three friends through the woods outside Castle Rock, Maine, in search of the body of a boy purportedly killed by a train. The story unfolds through stories—indeed, two of Lachance's early short stories are reprinted in the text ("Stud City" and "The Revenge of Lard Ass Hogan," both of which, in fact, are early King short stories originally published in college magazines).[15]

"The only reason anyone writes stories," King tells us here, "is so they can understand the past and get ready for some future mortality."[16] A recurrent theme of King's fiction is the completion of the wheel whose turn begins in childhood. "The idea," he has said, "is to go back and confront your childhood, in a sense relive it if you can, so that you can be whole."[17] We are haunted by our childhoods, by the important things we lost on the long walk to adulthood: the intensity of loves and fears, the talismanic rituals and objects of affection, and the moments of certain comprehension of our place in the scheme of things. To tell of these things now, as adults, exacts a high price:

> *The most important things lie too close to wherever your secret heart is buried, like landmarks to a treasure your enemies would love to steal away. And you may make revelations that cost you dearly only to have people look at you in a funny way, not understanding what you've said at all, or why you thought it was so important that you almost cried while you were saying it. That's the worst, I think. When the secret*

stays locked within not for the want of a teller but for want of an under-standing ear.[18]

Unlocking that secret is difficult, as King laments: "The most important things are the hardest to say, because words diminish them."[19] In "The Body," he reaches out to his past more directly than in any other story—crossing a bridge of time not unlike the railroad trestle that is the setting for the novella's most frightening scene. What he finds are memories of childhood friendships, of laughter and bravado, of tears and pain, all tinged with a wistful nostalgia. When he returns to the present, that bridge (again like the trestle) is gone, but the storyteller—and his story—endure.

The final novella of *Different Seasons* is set in that mysterious brownstone at 249B East Thirty-fifth Street. "A Winter's Tale" for the collection, "The Breathing Method" answers the question "Who will bring us a tale for Christmas, then?"[20] Christmas, the traditional time for the telling of ghostly tales,[21] offers the visitants to 249B East Thirty-fifth Street (and the readers of *Different Seasons*) the horror tale expected of Stephen King, written in a framework evocative of both Jorge Luis Borges and Peter Straub (to whom the story is dedicated).

The narrator of "The Breathing Method" is a middle-aged, unambitious attorney whose foremost love is books. He tells the story of his introduction to the club at 249B East Thirty-fifth Street and, in turn, of the Christmas tale that is told there one night. This story within the story is the reminiscence of an elderly, genteel doctor whose experiments in the 1930s with a predecessor of the Lamaze "breathing method" of childbirth produce a frightening result when the mother dies in labor.

As these levels upon levels of narration suggest, "The Breathing Method" serves as a fitting conclusion for King's collection of stories about storytelling. That imaginary brownstone at 249B East Thirty-fifth Street encompasses the jail cell where Red begins his tale of Andy Dufresne, the small bungalow where Kurt Dussander recalls the crimes of an uneasily buried past, and the room where Gordon Lachance taps out his sentimental retrospective on an IBM keyboard. The stories all flow from that brownstone—a metaphor for the storyteller's mind—whose keeper, appropriately enough, is named "Stevens":

[T]he question that came out was: "Are there many more rooms upstairs?"

"Oh, yes, sir," [Stevens] said, his eyes never leaving mine. "A great many. A man could become lost. In fact, men have become lost. Sometimes it seems to me that they go on for miles. Rooms and corridors. . . . Entrances and exits." . . .

"There will be more tales?"

"Here, sir, there are always more tales."[22]

Sandra Stansfield—the doomed, husbandless mother of "The Breathing Method"—completes the cycle of King's seasonal protagonists. Each faces the rite of passage—from childhood to adulthood, innocence to experience, life to death—as inevitable as the change of seasons. When Gordon Lachance describes the railroad tracks that defined his journey, he pinpoints King's obsession with the theme:

There's a high ritual to all fundamental events, the rites of passage, the magic corridor where the change happens. Buying the condoms. Standing before the minister. Raising your hand and taking the oath. Or, if you please, walking down the railroad tracks to meet a fellow your own age halfway. . . . It seemed right to do it this way, because the rite of passage is a magic corridor and so we always provide an aisle—it's what you walk down when you get married, what they carry you down when you get buried.[23]

In the night journeys of *Different Seasons*, we find a "brute persistence" as relentless as the rite of passage, the change of seasons—and in that persistence, the dilemma and a final horror. When Sandra Stansfield refuses to allow even her own death to prevent her from giving birth, King offers a parting image of a stone statue as timeless as the stone walls of Shawshank in which the collection of stories began:

[T]he statue . . . stood, looking stonily away . . ., as if nothing of particular note had happened, as if such determination in a world as hard and as senseless as this one meant nothing . . . or worse still, that it was perhaps the only thing which meant anything, the only thing that made any difference at all.[24]

The four short novels of *Different Seasons* thus form a fitting coda to the uncompromising, unforgiving stasis of *Cujo*, confirming that

novel's dark truth that the deepest horrors are those that are real. Indeed, the very reality of "Apt Pupil" caused some concern at King's paperback publishing company, New American Library, which initially asked that the novella not be used. As King recalls:

They were very disturbed by the piece. Extremely disturbed. It was too real. If the same story had been set in outer space, it would have been okay, because then you would have had that comforting layer of "Well, this is just make-believe, so we can dismiss it."

And I thought to myself, "Gee, I've done it again. I've written something that has really gotten under someone's skin." And I do like that. I like the feeling that I reached between somebody's legs like that. There has always been that primitive impulse as part of my writing.

I don't really care for psychoanalyzing myself. All I care about is when I find out what it is that scares me. That way, I can discover a theme, and then I can magnify that effect and make the reader even more frightened than I am.

I think I can really scare people, to the point where they will say, "I'm really sorry I bought this." It's as if I'm the dentist, and I'm uncovering a nerve not to fix it, but to drill on it.[25]

As these comments suggest, in answering the question of whether Stephen King can write more than horror fiction, *Different Seasons* did not presage a change in the direction of King's writing. John D. MacDonald's prediction in the "Introduction" to *Night Shift*—"Stephen King is not going to restrict himself to his present field of intense interest"[26]—has proved correct, but only to a point—a point on which King is highly vocal:

[T]here are a lot of people who are convinced that, as soon as I have made enough money, I will just leave this silly bullshit behind and go on to write Brideshead Revisited *and spy novels and things like that. I don't know why people think that. This is all I've ever wanted to write; and if I go out and I write a novel about baseball or about a plumber who's having an affair with some other guy's wife—which I have written, by the way—that is just because it occurred to me at the time to write that story. And I don't think anybody would want me deliberately to reject an idea that really excited me.*[27]

As if to make his point certain, the projects that followed *Different Seasons* have proved decidedly horrific. Close on the heels of its

publication came the release of *Creepshow*, the first motion picture created specifically for the screen by Stephen King, and two flat-out horror novels, *Christine* and *Pet Sematary*.

King's collaboration with *Creepshow* director George A. Romero was seemingly inevitable. Romero, undoubtedly America's most successful independent filmmaker, is best known for his "Living Dead" films—*Night of the Living Dead* (1968), *Dawn of the Dead* (1979), and *Day of the Dead* (1985)—which, as we have seen, have had an acknowledged influence upon King; but his other films should not be overlooked, particularly the surreal witchcraft of *Jack's Wife* (1972); a sardonic study in paranoia and ecological horror, *The Crazies* (1973); the modern vampire classic *Martin* (1977); and the contemporary, motorcycle-borne retelling of Arthurian myth, *Knightriders* (1981), in which Stephen and Tabitha King make a brief appearance.

In 1977, after a studio executive had seen *Martin*, King and Romero were brought together by Warner Brothers, which offered Romero the director's chair for a feature-length version of *'Salem's Lot*. But concern about the competition of other vampire films then in production—including John Badham's adaptation of the stage play of *Dracula* (1979) and Werner Herzog's *Nosferatu* (1979)—saw Warner Brothers convert the project to the smaller screen; *'Salem's Lot* was ultimately produced as a television miniseries, directed by Tobe Hooper. Nevertheless, King and Romero remained eager to work together, and in 1979 began development of *The Stand* as a feature film. Because of the expansive scope of the novel, and the substantial budget that its adaptation would require—which, in turn, would likely demand the backing of a major studio—they decided to attempt a smaller, independent project first. The result was *Creepshow*.

Creepshow

"I want my cake!"

—Nathan Grantham, deceased

"I want my cake!" growls the slimy corpse of Nathan Grantham, clawing up from its grave seven years after the Father's Day on which Grantham was murdered by his daughter. At once comically absurd and chillingly real, its demand is the battle-cry of *Creepshow* (1982),[1] the motion picture collaboration by Stephen King and director George A. Romero, also adapted in comic book form by King and artist Berni Wrightson.[2] The film is a studied tribute to E. C. Comics, an anniversary cake celebrating the resurrection of those marvelous horror comics, like the corpse of Nathan Grantham, from the grave of an uneasy burial almost four-times-seven years to the date of *Creepshow*'s release.

It was in the fall of 1954 that the last issue of a ten-cent comic book entitled *Tales from the Crypt* appeared on the very few newsstands that continued to sell it.[3] Inside the front cover was an editorial, written under the gravestone caption "In Memoriam," announcing the demise of E. C.'s "new trend" comics: five magazines of horror, crime, and suspense, including *Tales from the Crypt, Vault of Horror,* and *Haunt of Fear.* Although the Congressional witch-hunts of the 1950s failed to eradicate Communism or organized crime, they did manage to drive E. C. Comics out of

business for the heinous offense of publishing material said to pollute the minds of children (including, ironically after the fact of censorship, a grade-schooler named Steve King). The forces of self-righteousness did not stop there, however, but caused the remaining comic book publishers, wary of the example made of E. C., to accept the puerile self-regulation of the Comic Books Code, which called for the avoidance of excessive violence, curse words, sex, drugs, poor grammar, and nearly every controversial subject. The senselessness of this censorship was underscored by the wry sentiment of that parting editorial in *Tales from the Crypt:* "We at E. C. look forward to an immediate drop in the crime and juvenile delinquency rate of the United States. We trust there will be fewer robberies, fewer murders, fewer rapes!"[4]

At this late date, it is all too easy to pontificate about the paranoia and latent totalitarianism of the 1950s. It is equally easy to ignore the lessons of the past with the smug assuredness that it can't happen here—even as political forces as diverse as the so-called Moral Majority, the American Medical Association, and the "progressive" defenders of ethnic and women's rights join in nightmare alliances whose explicit purpose is to suppress freedom of expression. As I write these words, scattered before me on the desk are newspaper clippings of bannings and burnings galore in the 1980s: of "immoral" books like *Tarzan of the Apes*, of "racist" books like *The Adventures of Huckleberry Finn*, of "sexist" films like *Dressed to Kill*, but particularly of "blasphemous" books like *The Exorcist* and of "violent" films like *The Texas Chainsaw Massacre* and *Dawn of the Dead*. Most pertinent, and only one of several examples, is a series of articles concerning the efforts of school officials in Waukesha, Wisconsin, to ban Stephen King's *Firestarter* from school libraries and book fairs.[5]

The tale of horror has always had a lion's share of moral opposition. The case of E. C. Comics has seemed special, however—not simply because these comics had a major influence upon Stephen King[6] and other leading horror writers, but because of the overwhelming success of a sudden, steam-rolling opposition to something as mundane as comic books. The E. C. "new trend" comics were anything but innocuous, of course. Imagine the scene when one of E. C.'s most memorable covers—"Foul Play," depicting a baseball diamond spread with disembodied remains—was flourished before a Congressional investigative committee. In few other

forms of expression before or since have our most repressed and dangerous tendencies been so flagrantly exposed and offered for viewing to people of all ages. And for those Eisenhower-era censors, the excuse lay in those words "all ages." The E. C. audience was composed primarily of children, who, not surprisingly, embraced the tales of terror in a way that their elders could not understand. Indeed, it was common to hear the suggestion that comic books were "the marijuana of the children."

Creepshow opens with a framing story that echoes the demise of E. C. Comics; it is set on Maple Street in Centerville, U.S.A.—a timeless place, equally at home in the fifties and the eighties. A young boy (played by Stephen King's son Joe) is caught reading a "Creepshow" comic book by his father (Tom Atkins), who violently disapproves: "This crap! . . . You want to know where this is going, Billy? In the garbage. Right in the frigging garbage."[7] And as Billy is sent upstairs to bed, the comic book is indeed consigned to the trash can outside; when its pages are ruffled by an ominous, rising wind, its cartoon stories seemingly come to life as the five episodes of *Creepshow*.

The first episode, "Father's Day," chronicles the return of Nathan Grantham from his untimely grave. We are introduced to cigar-smoking, whiskey-swigging Bedelia Grantham (Viveca Lindfors)—the "patriarch" of the Grantham clan—as she makes her annual visit to the family home to pay her Father's Day respects at the grave of her father, Nathan. Seven years before, Bedelia had murdered Nathan (Jon Lormer) when he demanded his Father's Day cake. A vicious, selfish man who built the family fortune by bootlegging, Nathan had kept Bedelia at his side by arranging for her fiancé to suffer a hunting accident. As Bedelia drinks in these memories through a bottle of whiskey at her father's graveside, her jaded, snobbish niece, Sylvia (Carrie Nye), gossips about Nathan and Bedelia to a younger generation of Granthams (including Ed Harris). As if summoned by this curious outpouring of sentiment, Nathan rises from his grave. He still wants his cake, and when no one appears willing to satisfy his request, he constructs his own confection, using Sylvia's head—precisely the kind of satiric recapitulation that was the trademark of E. C. Comics.

The second episode, "The Lonesome Death of Jordy Verrill," is based upon the King short story "Weeds."[8] A likeable, dull-witted Maine farmer (played by Stephen King who, in his words, felt that

he had the talent to "give good idiot") finds a meteor on his remote property. Jordy's dreams of earning a fortune by selling the meteor to the university are dashed when he inadvertently breaks the sizzling hunk of rock; but he soon is rolling in another kind of green stuff. After he touches the strange substance that oozes from the meteor's core, fuzzy green tendrils begin to sprout from his fingers. The alien plant life suffocates the entire farmhouse and literally turns Jordy into a vegetable (while watching television, it should be noted). Jordy can find release only through suicide—but the weeds live on, growing hungrily toward civilization.

In "Something to Tide You Over," television executive Richard Vickers (Leslie Nielsen) devises a torturous murder for his unfaithful young wife, Becky (Gaylen Ross), and her paramour, Harry Wentworth (Ted Danson). He lures Wentworth to a deserted beach, and buries him to his neck in the sand. A television monitor shows that Vickers has given Becky a similar burial further down the beach. As Wentworth watches in horror, the tide closes in on her. Vickers claims that, if Wentworth can hold his breath and not panic, he might be able to work himself free. Then he retires to his beach house, where his remote cameras allow him to watch his private "snuff" video in the comfort of his living room. That night, he receives a unique pair of house guests—the ocean-rotted corpses of his victims return in an elaborate montage sequence edited personally by Romero. We next see Vickers, buried to his neck in the sand, his eyes gleaming with mad hilarity; the incoming tide engulfs him as he screams: "I can hold my breath for a long, long time!"[9]

The fourth episode is an adaptation of King's popular short story "The Crate."[10] Dexter Stanley (Fritz Weaver), head of a university zoology department, is called away from a faculty party by a janitor who has found a strange crate hidden beneath the basement stairs at the zoology building. The crate bears the date 1834 and a label referring to an Arctic expedition; inside, we soon learn, is a voracious creature—a cross between Tasmanian devil and jack-in-the-box that promptly dines upon the janitor and a graduate student. Stanley seeks the aid of his best friend and chess companion, English professor Henry Northrup (Hal Holbrook). But Henry is besieged by his own monster—a shrewish, castrating wife/mother, Wilma (Adrienne Barbeau), who forever brays, "Just call me Billie."[11] Northrup lures Wilma to the crate and forces her upon the monster

inside; then he locks the crate and dumps it in a remote quarry, thus disposing of both monsters.

In the final episode, "They're Creeping Up on You," elderly, reclusive, and utterly ruthless business tycoon Upson Pratt (E. G. Marshall) has an obsession with personal cleanliness—fostered, perhaps, by his singularly unclean approach to business dealings. He squashes rival businessmen and roaches with the same fanaticism: "Bugs. That's all they are. All of them. And . . . you have to watch them, because they creep up on you."[12] After his latest corporate takeover has prompted the suicide of a competitor, the gloating tycoon is visited by a crawling horde of roaches. When an electrical blackout descends upon the city, his antiseptic high-tech penthouse offers no protection against the vengeful invaders. In a stunning finale, Pratt is literally engorged with roaches—symbolic of the putrefaction of his soul, and an apt fate for a man who is convinced that human beings are no different from bugs.

The fantasies of *Creepshow*, like those of E. C. Comics, revel in our unconscious impulses toward chaos, touching the alienated immortal child in each of us who constantly rebels against itself and its society. The mentality of those comics—a calculated appeal to that immortal child—should not lead us to dismiss their horrors as "juvenile," but to accept them as universal. *Creepshow* thus works on at least three levels. Its consistent theme is the uncertainty of human relationships—its five stories devoted to patricide, suicide, the murder of an unfaithful wife, the murder of a shrewish wife, and the death of an ultraxenophobic business tycoon, in that order. Omnipresent is a deliberate regressiveness—a child's point of view is implied in the structure of each segment, even though the only child to appear in the film is the "Creepshow" reader of its framing story. Reinforcing the child's perspective is the film's obsession with authority figures, and with taking revenge upon such figures—indeed, in the closing return to the framing story, the father who so vehemently reviled the "Creepshow" comic receives his comeuppance.[13] On a second level, the film is a relentless pursuit of phobias, taboos, and fears—graveyard disturbances, cannibalism, burial alive, dark and enclosed spaces, dead-end marriages, racial and sexual strife, bugs, plants, drowning, disease . . . and death in endless variations. But on its most explicit level, *Creepshow* is a comedy.

In depicting its horrors, *Creepshow* successfully replicates the

heady, yet decidedly innocent, liberation of the postwar, pre-Code comics. The film's violence, presided over by special effects genius Tom Savini, is garish, although never excessive—a welcome relief from the "slice-and-dice" subgenre so prevalent today. Even the most grotesque mayhem is presented with the weight of a "Road-runner" cartoon and, perhaps more important, with clear-cut moral implications. Characters are drawn in black and white. Violence is not random. There is no difficulty in distinguishing between good and evil, right and wrong. The polarity is intentional, as is an omnipresent theme of retribution and poetic justice. King explains:

> *The concept of retribution is highly moral. The E. C. Comics were like the last gasp of a more gentle romanticism. It was as though these people came out of World War Two saying, "We know now that all this bullshit we used to believe about knights in shining armor and the good guy always winning is not true." All it took was a look at those bodies. And yet at the same time, they still wanted to believe it. So you get stories where the corpse comes back from the grave and murders the people who killed him. The first half of the story, where the murder happened and the people got away with it, was an admission that the world is a terrible place—that horrible things happen, that good people are hurt and that the bad people who hurt them are not punished. And then, when the corpse came back, it was as though they were saying, "We know all this is true, but we don't really believe that it is true. We think that there is a just God who administers rough justice and puts everything to right in the end."*
>
> *Horror fiction has always been, in that sense, very romantic fiction. That's why I like it at the end of* Firestarter *when Rainbird gets his head blown off, when the fire hits him and he just sort of melts. That is a good moment—very cheerful. It made me very cheerful to write that, because that man was so awful.*[14]

In *Creepshow*, King and Romero push beyond a merely "cheerful" element to the true essence of the E. C. Comics—the striking ability to walk the tightrope of humor and horror. The humor of *Creepshow* lies not simply in black and often vicious irony or in grimly unforgettable punch lines (both of which were E. C.'s forte), but also in its gaudiness, both visual and verbal. The five episodes are introduced and linked by captivating animation sequences designed by Jack Kamen, the master illustrator of the original E. C. Comics. In each episode, Romero forces his camera angles and uti-

lizes stylized color overlays in an effort to capture the exaggerated aesthetics of comic book art. His actors assume broad gestures, and indulge in antic, overwrought performances. The film's language is calculatedly crude, each and every one of its numerous expletives—including Jordy Verrill's memorable "Meteorshit!"—present in King's original screenplay.

As *Creepshow* so capably reminds us, the original E. C. magazines were *comic* books in the truest sense of the word. They exposed and then laughed at our darkest fears and most repressed fantasies. Those who damned E. C. sadly refused to believe that the comics could be only what they purported to be—no more, no less. There are some people, you see, in whom that immortal child in us all has been given, like Nathan Grantham, a premature burial.

The message of *Creepshow* is clear. What was really disturbing about E. C. Comics to those 1950s literary prohibitionists (and what, ironically, was equally disturbing to some critics of *Creepshow*) was not that the comics were directed to the child in each of us. The real problem was not violence or profanity or even that vague bugaboo, tastelessness.

The objection—and the reason that the forces of censorship prevailed—was that the comic books were "trash." Thus, in the opening segment of *Creepshow*, the comic book created as the framing device for the film suffers the same fate as E. C. Comics; it is thrown into the garbage—where, we are told, it belongs.

Neither today nor in Eisenhower yesterdays has the tale of horror climbed from the Hefty bag of "trash" entertainment to the lofty heights of "acceptable" literature. *Creepshow*, like the E. C. Comics, cares little for the distinction. The important thing, King and Romero remind us, is that the horrors just keep on coming, no matter how deeply we seek to repress them. Like the *Creepshow* comic book, flying upward on the wind out of the garbage, and like the corpse of Nathan Grantham, rising from the grave with single-minded purpose, the horror story will not be buried.

It wants its cake.[15]

Christine

♦

Cycle of the Werewolf

*"America was a V/8 country, gas-driven and water cooled
. . . it belonged to men who belonged to cars."*
— Harry Crews

"He was a loser, you know. Every high school has to have at least two; it's like a national law."[1] In *Carrie*, Stephen King introduced one of these high school losers, Carrie White; and in his eighth published novel, *Christine* (1983), we meet the second, Arnie Cunningham. Although two vastly different characters, their fundamental qualities are identical—they are unattractive, despairing teenagers who stumble through the nightmare journey to adulthood with little solace at home or at school. Both find a romance of sorts that uplifts them, if only momentarily, from their loser's world: for Carrie, it was the fairy tale of Tommy Ross and the high school prom; for Arnie, it is a car—a 1958 Plymouth Fury, to be exact. The car's name is Christine, and she is haunted.

Christine begins on a late August day in 1978, as Arnie and his only friend—handsome, level-headed jock Dennis Guilder—cruise suburban Pittsburgh in the lull before their final year of high school. In a moment of black serendipity, Arnie sees an ancient Fury parked at the roadside. Although it is little more than a ravaged hulk, he falls in love with the car, perhaps because it mirrors his loser's image. Arnie and Dennis meet the car's owner, an aged, bitter cripple named Roland D. LeBay, late of the U.S. Army and soon to

be late of this world—but not until he sells the car, which he had nicknamed Christine, to Arnie, thereby sealing the fate of all concerned.

Christine, not unlike the Overlook Hotel of *The Shining*, has an unsavory history—it had been LeBay's obsession, the only thing he ever truly loved, a customized dream machine in whose roomy interior both his daughter and wife had died. When Arnie attempts to rebuild her, the storyteller brings in all the King's horses and all the King's men—nothing natural can account for the sudden gleaming grille, the pristine bodywork and new windshield, let alone the radio's propensity to play only songs from the 1950s, or the odometer's steady *backward* roll. Christine is alive, apparently immortal, animated by Le Bay's single-minded rage against life—the Plymouth is thus, both literally and symbolically, "his unending fury."

Christine had its genesis in the summer of 1978, when King began to think strange thoughts about the old red Cadillac that he owned:

> *It was a short-story idea. I thought that I would write a really funny story about a kid and a car whose odometer ran backwards. The car would repair itself, and the kid would get younger and younger, and the kicker would be that, when the odometer returned to zero, the car, at the height of its beauty, would spontaneously fall into component parts. It would echo that Lewis Padgett story, "The Twonky"—really funny, but maybe a little sinister, too.*[2]

But when King began to write the story, "the same thing happened as with *Carrie*"[3]: the "loser" character began to take over, and the short story became a book. Defying one of Mario Puzo's rules on how to write a bestselling novel, the opening and closing sections of *Christine* are written in first-person as the narrative of Dennis Guilder, looking backward from his twenty-second year across a seeming abyss to his high school days. His point of view produces not only King's most colloquial novel, but also his most humorous. The middle section of *Christine*, however, is written in third-person after Dennis is hospitalized with a football injury. Just as Dennis's broken leg ensures the end of his friendship with Arnie, King's breaking of narrative, a device particularly common in the early Gothic novel, likewise ensures the reader's alienation from Arnie's initially sympathetic character.[4]

In *Christine*, King repaid a major debt to Henry Gregor Felsen,

whose young adult novels—including *Hot Rod* (1950), *Street Rod* (1953), and *Crash Club* (1959)—had influenced him as a teenager. Felsen's writing captured what the automobile meant to the child of the fifties, and what Christine symbolizes for Arnie Cunningham: the end of adolescence and the coming of age—sex, power, speed, freedom . . . and death. It is through Christine that Arnie first asserts his independence from his parents, first gains a sense of autonomy, and first falls in love. And although he finds his first girlfriend in teen angel Leigh Cabot, his first love is Christine; "Leigh came later," Dennis tells us on page one. "I just wanted you to understand that."[5] And as Roland D. LeBay's brother cynically tells Dennis:

> [L]ove is the enemy. . . . The poets continually and sometimes willfully mistake love. Love is the old slaughterer. Love is not blind. Love is a cannibal with extremely acute vision. Love is insectile; it is always hungry.[6]

When Dennis asks, "What does it eat?" he already knows—it consumes people like Arnie. Seduced by Christine, and by what she symbolizes, Arnie soon becomes uncomfortable, estranged outside the protective cocoon of her interior, which smells decidedly fine to him, but reeks of death and decay to others. When Leigh offers the possibility of mature love, it is too late. Arnie's passion for Christine is reciprocated—she is a jealous lover, conducting nighttime search-and-destroy missions against her rivals and exacting revenge upon Arnie's enemies, real and imagined. In "The Mist" and *Cujo*, King's characters found nowhere left to hide from horror and death but their automobiles. In *Christine*, the automobile literally becomes the boat on the River Styx, a hungry ferry between the land of the living and the land of the dead.

That King should write at novel length about the threat of a supernatural machine is not a surprise, given the technohorror premises of his most political novels—particularly *The Stand* and *Firestarter*, where the gadgetry of man's love-hate relationship with science and technology assumed mythic dimensions. He has long been fascinated with the notion of imputing life to mundane mechanical objects, as witness the snakelike fire hose of *The Shining* and the somewhat sensual garbage disposal of *Firestarter*. In his early short story "The Mangler,"[7] an electric speed iron in a commercial laundry maims and kills workers, apparently of its own vo-

lition. A policeman and an English professor, believing that the machine must be possessed by some demonic force, attempt an exorcism, but it actually tears itself from the floor and stalks the streets in search of prey. In "The Monkey,"[8] a wind-up, cymbal-clashing toy brings death with each turn of its clockwork, while in "Battleground,"[9] a box of toy soldiers mounts an assault upon a Syndicate hit man.

"Uncle Otto's Truck"[10] concerns an abandoned truck that creeps, year by year, to the object of its revenge—the man who used it to kill his business partner. King's narrator describes the truck's countenance in terms distinctly intended for something that is alive: "But what I remember best is the truck looming up, getting bigger and bigger—the toothy snarl of its radiator, the blood red of its paint, the bleary gaze of the windshield." But the true precursor to *Christine* is one of King's favorite short stories, "Trucks,"[11] in which a growing horde of driverless trucks lays siege to an interstate truck stop. When the occupants of the eatery speculate on the cause of this sudden supernatural puppetry, the protagonist, prefiguring *Christine*, drolly suggests: "Maybe they're mad."

King obviously enjoys the ironic humor of granting life to the inanimate ("Imagine," he laughs, pointing to a magazine cartoon. "A werewolf toaster"),[12] but the threat implicit in these stories is humanity's vulnerability to dehumanization. King thus uses the metaphor of the machine to describe adolescence. "Engines," Dennis Guilder observes:

> That's something else about being a teenager. . . . There are all these engines, and somehow you end up with the ignition keys to some of them and you start them up but you don't know what the fuck they are or what they're supposed to do. . . . Engines. They give you the keys and some clues and they say, Start it up, see what it will do, and sometimes what it does is pull you along into a life that's really good and fulfilling, and sometimes what it does is pull you down the highway to hell. . . .[13]

The machine age—whose first modern icon was the automobile—has garnered a system in which humans have had to adapt to the pace of machines; individual lives and emotions have become the fuel that services the engines of technology. Thus, in the denouement of "Trucks," King shows us the literal enslavement of humans

by their machines through a dark inversion of the scene we see each day at the fuel pumps of our gasoline stations. The seemingly inevitable result of technological progress is that we are unable wholly to understand the products that we have created. Whether the "engine" is one of internal combustion or nuclear fission, few of us understand precisely why or how it works; and when things go wrong, our fears are intensified:

> *Because nobody really knows* why *it happened. That is sometimes the worst part of horror fiction: the need to know why something happened. It's a holdover from the rational fifties: "We have* got *to have an explanation, Doc." But maybe they're mad. Maybe they're mad, that's all.*[14]

In *Dawn of the Dead* (1979), George A. Romero—to whom *Christine* is dedicated—proposed a bleakly humorous connection between the emotionally void, assembly-line mentality of consumer society and cannibalistic, machine-like zombies. The motion picture's setting, Monroeville Mall in suburban Pittsburgh, is visited by Arnie and Leigh at the turning point of their relationship. Afterward, Arnie's every act and motivation are determined entirely in response to his car; King suggests a fusion of man and machine, as if the implications of extreme materialism were coherence with the products by which we identify ourselves—and tapping what he described in *Danse Macabre* as "a deep, almost primitive unease about the cars we zip ourselves up in, thereby becoming anonymous . . . and perhaps homicidal."[15] Inevitably, only a larger machine—a septic tank truck itself personified with the nickname Petunia—is capable of defeating Christine, which is demolished at the precise moment that Arnie Cunningham dies in the crash of his parents' automobile, miles away in space, but allied in spirit with his mean machine.

In *Christine*, the metaphor for dehumanization coexists with an older, more primeval fear—that of internal evil: the upsurge of the animal, the repressed unconscious, the monster from the id; or, in this case, the monster from the fifties. In the placid suburban setting for *Christine*, Dennis Guilder's perfect fifties sit-com family, and the high school hoods that torment Arnie, we find a haunting sense of *déjà vu*—of a fifties mentality inhabiting a modern setting. And in Arnie's transformation—fifties rebel animating seventies wimp

—we find grim echoes of the blatantly allegorical American International exploitation film, *I Was a Teenage Werewolf* (1957).[16] King named his main character (in full, Arnold Richard Cunningham) specifically after the nostalgic seventies television glorification of the naive aspects of the fifties, "Happy Days," whose lead character, played by Ron Howard, was named Richie Cunningham, and whose principal setting was the local hangout "Arnold's." And he selected the 1958 Plymouth Fury as his mean machine precisely because it is almost totally forgotten today: "That car summed up the fifties—it was a very bland, ordinary, mass-produced car."[17]

By 1978, however, Christine is one-of-a-kind, violently colored, a heavy-metal nightmare as inapposite to the modern automobile as Arnie seems to the assembly line of modern life. Behind her steering wheel, the age-old conflict between the will to do evil and the will to deny evil is fought; Christine becomes a clear symbol of the duality of human nature—a rolling crazy quilt of order and anarchy, as telling as the two sides of Henry Jekyll's townhouse in the archetypal werewolf story, *Dr. Jekyll and Mr. Hyde* (1886), which bordered both a graceful Victorian street and a slumlike alley:

> *It was as if I had seen a snake that was almost ready to shed its old skin, that some of the old skin had already flaked away, revealing the glistening newness underneath . . . a newness just biding its time, waiting to be born.*[18]

And as Christine magically returns to street condition, Arnie also begins to change, at first for the better—his acne clearing, skinny body filling out, self-confidence growing—but then he matures beyond his years, a teenaged Jekyll rendered into a middle-aged Hyde, caught up in a masquerade where innocence peels away like burned rubber and death rides shotgun.

Dennis captures the image on the day that Christine is purchased:

> *I was surprised by a breathless choking panic that climbed up in my throat like dry fire. It was the first time a feeling like that came over me that year—that long, strange year—but not the last. . . . It had something to do with realizing that it was August 20th, 1978, that I was going to be a senior in high school in less than four weeks, and that when school started again it meant the end of a long, quiet phase of my life. I*

was getting ready to be a grown-up, and I saw that somehow. . . . And
I think I understood then that what really scares people about growing
up is that you stop trying on the life-mask and start trying on another
one. If being a kid is about learning how to live, then being a grown-up
is about learning how to die. [19]

Christine laments the coming of age, but it also serves as a dark
parable about the death of the American romance with the automo-
bile. It is not coincidence that Christine is reborn twenty, going on
twenty-one, years after her manufacture. The finned Plymouth is
the last of its breed—the costume-jeweled, chromed symbols of the
Eisenhower era, of a lost American dream of clean air and unlim-
ited gasoline, prosperity and peace. By 1978, the year in which
Christine is set, the Chrysler Corporation, the Plymouth's manufac-
turer, was near bankruptcy. Automobiles were no longer symbols of
success or freedom or youth; they were smaller, less powerful, less
comforting, and—if only because of catalytic converters—did not
smell the same. They were no longer named by their owners—
indeed, many were not even an American product. The automobile
had become just a means of transportation. At the novel's end,
Dennis thus describes the man whom Leigh eventually marries with
fitting irony: "Nice fellow," Dennis tells us. "Drove a Honda Civic.
No problem there." [20]

America, like the older, wiser Dennis Guilder who tells the story
of Christine, has come of age in the matter of the automobile, to its
loss as well as its gain. And *Christine*, perhaps, enacts the last gasp
of that romance.

In the final pages of *Christine*, Dennis describes two recurring
dreams that continue to haunt him four years after the events of the
novel. One dream flows logically from the narrative: Dennis revisits
Arnie's funeral, and the coffin springs open to disclose not Arnie,
but his predecessor, Roland D. LeBay. The second dream, how-
ever, is intuitive:

In the other dream—and this one is somehow worse—I've finished with
a class or proctoring a study hall at Norton Junior High, where I teach. I
pack my books back into my briefcase, stuff in my papers, and leave the
room for my next class. And there in the hall, packed in between the
industrial-gray lockers lining it, is Christine—brand new and sparkling,
sitting on four new whitewall tires, a chrome Winged Victory hood or-

nament tilting toward me. She is empty, but her engine guns and falls off . . . guns and falls off . . . guns and falls off. In some of the dreams the voice from the radio is the voice of Richie Valens, killed long ago in a plane crash with Buddy Holly and J. P. Richardson, The Big Bopper. Richie is screaming "La Bamba" to a Latin beat, and as Christine suddenly lunges toward me, laying rubber on the hall floor and tearing open locker doors on either side with her doorhandles, I see that there is a vanity plate on the front—a grinning white skull on a dead black field. Imprinted over the skull are the words ROCK AND ROLL WILL NEVER DIE. *Then I wake up—sometimes screaming. . . .*[21]

This dream is "somehow worse," not simply because it suggests, as does the novel's conclusion, that Christine may return, but because it reminds Dennis of his lost youth, and of his mortality. In the space of a few short years, Dennis has moved from teenager to adult, from student to teacher—but Christine remains, the apotheosis of the fifty rock-and-roll songs that King selected to introduce the chapters of the book—from Chuck Berry to Jan and Dean to Bruce Springsteen, anthems of the runaway American dream that belonged to men who belonged to cars.

For King, rock and roll is a kind of magic; "it was the beginning of life for me," he says:

The first record I ever owned was a 78-rpm of [Elvis Presley's] "Hound Dog" backed by "Don't Be Cruel," and when I listened to those tunes I felt about ten feet tall and I grinned so hard that it felt like the corners of my mouth would meet in the back and the top of my head would simply topple off.[22]

"When we were young enough to believe that rock'n'roll would live forever," he has written, "we believed the same of ourselves."[23] Perhaps rock and roll, the music of cars and love and death, will live forever; perhaps Christine, born to run, drives on in the night, its radio blaring "La Bamba"—the song of the young.

As for ourselves, we can only believe.

The archetype of the werewolf implicit in the transformation of Arnie Cunningham in *Christine* saw its first explicit use by Stephen King in *Cycle of the Werewolf* (1983).[24] This novelette, which King later adapted for the screen as *Silver Bullet* (1985),[25] was conceived in 1979 as a collaboration with artist Berni Wrightson. The original

intention was to produce a calendar with artwork by Wrightson, who also illustrated the comic book version of *Creepshow*, and a brief text by King. The final result, however, was a story written in twelve parts, each specific to a month of the year, with nearly sixty pages of illustrations and graphics, including twelve full-color plates.

The story is set in Tarker's Mills, Maine, another of King's insular, isolated Maine settings. In January of 1984, something more than a new year has begun:

> *Something inhuman has come to Tarker's Mills, as unseen as the full moon riding the night sky high above. It is the Werewolf, and there is no more reason for its coming now than there would be for the arrival of cancer, or a psychotic with murder on his mind, or a killer tornado. Its time is now, its place is here, in this little Maine town where baked bean church suppers are a weekly event, where small boys and girls still bring apples to their teachers, where the Nature Outings of the Senior Citizens' Club are religiously reported in the weekly paper. Next week there will be news of a darker variety. . . .*
>
> *The cycle of the Werewolf has begun.*[26]

Tarker's Mills, like Jerusalem's Lot, has its secrets—alcoholism, wife-beating . . . and a citizen who bears the Mark of the Beast. Each month, when the moon is full, the Werewolf kills; only one person, a ten-year-old handicapped boy, Marty Coslaw, looks upon its face and escapes. On the night of the Fourth of July, while wheelchair-bound Marty is enjoying a private fireworks celebration, the Werewolf attacks, but Marty flings firecrackers into its face, blinding one of its eyes. Not until Halloween, when Marty, disguised poignantly as Yoda from the "Star Wars" movie *Return of the Jedi*, visits the houses of the town, does he discover who now wears an eyepatch—the Beast disguised as a man. It is the Baptist minister, Reverend Lowe, whose fate is similar to that of Arnie Cunningham and of so many other King characters: *"This—whatever it is—is nothing I asked for. I wasn't bitten by a wolf or cursed by a gypsy. It just . . . happened."*[27]

The Reverend strives to perceive his dilemma in religious terms: *"I do good here, and if I sometimes do evil, why, men have done evil before me; evil also serves the will of God, or so the Book of Job teaches us; if I have been cursed from Outside, then God will bring*

me down in his time."[28] And indeed, the Werewolf's victims, more often than not, seem appropriately taken—except for Marty Coslaw; but the Beast has a rendezvous with Marty in dark December, when the cycle of the Werewolf draws to an end.

Pet Sematary

"He wanted to show that fate ruled people's lives, and that those who interfered with it did so to their sorrow."
— W. W. Jacobs

Over the past few years, rumors have circulated about a Stephen King novel that was too frightening to be published. The prospect was certainly enticing: what kind of story could possibly prove so terrifying as to stay the hand of the best-selling writer of horror fiction of all time? And although the truth of the matter proves something decidedly different, the novel in question, *Pet Sematary* (1983),[1] doubtless satisfies any reader's expectations of the delicious fear that King's formidable talent can evoke.

In early 1979, King was serving as writer-in-residence at his *alma mater*, the University of Maine at Orono, teaching courses that served as the proving grounds for much of *Danse Macabre*. His rented house, in nearby Orrington, bordered a major truck route— a road that seemed to consume stray dogs and cats; in the woods behind the house, up a small hill, local children had created an informal pet cemetery. One day, a neighbor called to inform King that a passing truck had killed his daughter's cat, Smucky. King was faced with the disconcerting tasks of burying the cat in the pet cemetery and then explaining to his daughter what had happened:

My impulse was to tell her that I hadn't seen him around; but Tabby said no, that she had to have that experience. So I told her, and she cried and cried. . . .

The next day . . . we heard her out in the garage. She was in there, jumping up and down, popping these plastic packing sheets and saying, "Let God have His own cat. I want my cat. I want my cat."[2]

It was on the third day after the burial, he reports rather ominously, that the idea for a novel came to him. What would happen, King wondered, if a young family were to lose their daughter's cat to a passing truck, and the father, rather than tell his daughter, were to bury the cat on a remote plot of land—something like a pet cemetery. And what would happen if the cat were to return the next day, alive but fundamentally different—fundamentally *wrong*. And then, if that family's two-year-old son were to fall victim to another passing truck. . . . The book would be a conscious retelling of W. W. Jacobs' "The Monkey's Paw" (1902), that enduring short story about parents who literally wish their son back from the dead:

When ideas come, they don't arrive with trumpets. They are quiet— there is no drama involved. I can remember crossing the road, and thinking that the cat had been killed in the road. . . . and [I thought], what if a kid died in that road? And we had had this experience with Owen running toward the road, where I had just grabbed him and pulled him back. And the two things just came together—on one side of this two-lane highway was the idea of what if the cat came back, and on the other side of the highway was what if the kid came back—so that when I reached the other side, I had been galvanized by the idea, but not in any melodramatic way. I knew immediately that it was a novel.[3]

That night King dreamed of a reanimated corpse walking up and down the road outside of the house[4]; he began to think about funerals and the modern customs surrounding death and burial: "I said to myself, 'If anybody else wanted to write about that, people would say that he's really morbid.' But I've got a reputation. I'm like a girl of easy virtue—one more won't hurt."[5]

But it did hurt. When King completed the first draft in May of 1979, the book he had come to call *Pet Sematary* (using a child's spelling) was put away. He did not wish to work on it further; the novel was tinged with anxieties about his youngest child, who it had been feared—fortunately, incorrectly—was hydrocephalic, and his

difficulties in coming to grips with the implications of the death of a child:

> *The book started off as a lark, but it didn't finish up that way. It stopped being a lark when I realized that the kid would have to die—and that I had never had to deal with the consequences of death on a rational level.*
>
> *I have always been aware of the things that I didn't want to write about. The death of a child is one—and the death of Tad Trenton at the end of* Cujo *was bad enough, but there I didn't have to deal with the aftermath. And I have always shied away from the entire funeral process—the aftermath of death. The funeral parlors, the burial, the grief, and, particularly where you are dealing with the death of a healthy child, the guilt—the feeling that you are somehow at fault. And for me, it was like looking through a window into something that could be.*
>
> *I decided that, if I was going to write this book, perhaps it would be good for me—in the Calvinist sense—to go through with it, to find out everything, and to see what would happen.*
>
> *But in trying to cope with these things, the book ceased being a novel to me, and became instead a gloomy exercise, like an endless marathon run. It never left my mind; it never ceased to trouble me. I was trying to teach school, and the boy was always there, the funeral home was always there, the mortician's room was always there.*
>
> *And when I finished, I put the book in a drawer.*[6]

In a television interview, King unwittingly sparked rumors that the book was too frightening to be published:

> *It was the first time I had ever been asked the question: "Did you ever write anything too horrible to be published?" And this book came immediately to mind; Tabby had finished reading it in tears, and I thought it was a nasty book—I still think that it is a nasty book. Twenty years ago,* Pet Sematary *would not have been a publishable novel . . . because of its subject matter and theme. Maybe I don't have the guts for that end of the business of horror fiction—for the final truths.*[7]

Whether the book would have been published entirely of King's volition is now a moot question. Fate intervened, in the form of a contractual dispute with his former hardcover publisher, Doubleday. Rewritten in 1982, *Pet Sematary* appeared in 1983 only as ransom for substantial money, earned by King's early novels, that had

been withheld from him. He allowed Doubleday, in its promotion of the book, to perpetuate the myth that had grown up around the novel; but he would not assist in the promotion of *Pet Sematary* or, indeed, talk with anyone about the book, save for the single interview on which this chapter is based:

> *About a year after the original manuscript was finished, one of my teachers, a lady who I loved almost as much as I loved my mother, died. And she had left a request that I read from* Proverbs *at her funeral. And although by then I was considered a "public figure," and I had spoken often on television and in public, I almost lost it. My voice was this sort of wild trembling and I could feel my pulse in my collar, the way you do when your tie is too tight, and the whole thing just seemed to come in on me and suffocate me.*
>
> *And it was all part of this book—because you open these doors; and that's why I don't want to talk about this book.*
>
> *So it hurts me to talk about it; it hurts me to think about it.* Pet Sematary *is the one book that I haven't reread—I never want to go back there again, because it is a* real *cemetery.*[8]

Precisely because of King's closeness to its subject matter, *Pet Sematary* is one of the most vivid, powerful, and disturbing tales he has written. His hallmarks—effortless, colloquial prose, and an unerring instinct for the visceral—are in evidence throughout, but this novel succeeds because of King's ability to produce characters so familiar that they may as well have lived next door for years.

Louis Creed, a young physician, has moved his family from Chicago to Ludlow, Maine (a thinly disguised Orrington), where he will manage a university infirmary. Creed is the most hardheaded of rationalists: "He had pronounced two dozen people dead in his career and had never once felt the passage of a soul."[9] His wife, Rachel, on the other hand, shrinks with preternatural fear from the very thought of death—as a child, she had witnessed the final agonies of a sister ravaged by spinal meningitis and, much as Stephen King had been alone when he discovered his grandmother's death, was left alone by her parents on the day that her sister died. When an elderly Downeaster, Jud Crandall, takes the Creeds to visit the "Pet Sematary" in the woods behind their rented house, their six-year-old daughter, Ellie, immediately fears for the life of her cat, Winston Churchill (wryly nicknamed "Church"):

[Creed] held her and rocked her, believing, rightly or wrongly, that Ellie wept for the very intractability of death, its imperviousness to argument or to a little girl's tears; that she wept over its cruel unpredictability; and that she wept because of the human being's wonderful, deadly ability to translate symbols into conclusions that were either fine and noble or blackly terrifying. If all those animals had died and been buried, then Church could die . . . and be buried; and if that could happen to Church, it could happen to her mother, her father, her baby brother. To herself. Death was a vague idea; the Pet Sematary was real. [10]

The reality of the Pet Sematary soon invades the life of Louis Creed. On his first day at work, a student dies in his arms after uttering a sybilic warning: "It's not the real cemetery." [11] That night, Creed's sleep is interrupted by an apparition of the dead student, which leads him back to the Pet Sematary: "Don't go beyond, no matter how much you feel you need to," it says. "The barrier was not made to be broken." [12]

Death follows death, as inexorably as a falling column of dominoes; and it strikes next in the Creed household. Fulfilling Ellie's dark apprehension at the sight of the Pet Sematary, Church is killed by a passing truck. King named Ellie's cat with a purpose; in the death of Church, he signals that the issue at the heart of *Pet Sematary* is that of the rational being's struggle with modern death—death without God, death without hope of salvation.

Aware of the pain that Church's death will cause Ellie, Jud Crandall initiates Creed into the secret that lies *beyond* the Pet Sematary—an ancient burial ground long abandoned by Indians. Creed is reminded of Stonehenge; there is a sensation of incredible age in the spiraling arrangement of cairns, a sensation reinforced when Crandall begins to speak of Indian legends of the Wendigo. He directs Creed to bury the cat there; and the cat, just like in the nursery rhyme, returns the very next day—awkward, loathsome to touch, stinking of sour earth, but *alive*—setting the stage for a haunting moral dilemma: whether, regardless of the cost, death should be cheated.

When two-year-old Gage, the book's most endearing character, is killed by another passing truck, Louis Creed's mourning is not that of a sentimental Pietà, but the driven ambition of a Faust. Should he take the corpse of his son beyond the Pet Sematary? "You do it

because it gets hold of you," Crandall warns. "You do it because that burial place is a secret place, and you want to share the secret. . . . You make up reasons . . . they seem like good reasons . . . but mostly you do it because you want to."[13]

In *Cujo*, for which *Pet Sematary* is a thematic bookend, the rabid dog becomes a symbol of nature, a literal embodiment of King's naturalistic stance—"free will was not a factor."[14] In *Pet Sematary*, he invokes a time-honored symbol of nature, the Wendigo.[15] This malevolent spirit-being of north country Indian folklore, an anthropomorphization of the cold and forbidding northern environment, is said to have polluted the once-hallowed burial ground, disturbing the sleep of the dead. In the symbol of the Wendigo, whose overshadowing presence Creed may have glimpsed on his journey to bury Gage, King confirms the purpose of the fakir in "The Monkey's Paw": "He wanted to show that fate ruled people's lives, and that those who interfered with it did so to their sorrow." ("Which," King notes, "I suppose is a comfort.")[16]

Pet Sematary is, then, an inward-looking narrative, focused upon the question of moral responsibility for interference with the natural order. Creed, like Church, is named with intention; his creed—rationality—is the flaw that pushes him along the path to destruction. He has apparently acquired the ultimate skill of his profession as a physician—the ability to return the dead to life—and he cannot help but use it. King comments:

> *He never ceases to be the rational man. Everything is plotted out—this is what can happen, this is what can't happen. But nothing that he thinks can happen is eventually what does happen.*
>
> *The book is very Christian in that sense, because it is a book about what happens when you attempt miracles without informing them with any sense of real soul. When you attempt mechanistic miracles—abracadabra, pigeon and pie, the monkey's paw—you destroy everything.*[17]

In the rational order of things, fathers do not bury their sons. The death of a child is the ultimate horror of every parent, an outrage against humanity; and the reanimated Gage is precisely that horror made flesh, savaging and literally eating away at his mourning family. The lesson King offers is that which he reluctantly taught his daughter when her cat died—the lesson that Dick Hallorann, the

surrogate father of *The Shining*, taught Danny Torrance: "You grieve for your daddy. . . . That's what a good son has to do. But see that you get on. That's your job in this hard world, to keep your love alive and see that you get on, no matter what. Pull your act together and just go on."[18] Death is a part of the natural order of things; and, as another surrogate father, Jud Crandall, tells Louis Creed: "Sometimes dead is better."[19]

Creed thus finds no consolation in his acts—only an abyss, the dark hole of death. In acceptance of death, he could have kept his love alive through memories of his son, but the "miracles" from beyond the Pet Sematary only confirm his rationalist world view, crushing his memories through a vision of a mindless chaos—indeed, malevolence—awaiting at the end of life. Yet he returns again to the burial ground with the body of his wife, and as the novel ends, waits alone for her return. "What this novel says," King holds, "is that it is worth *everything*, even your own soul." ("But would you do it?" I ask him. "Knowing what Louis Creed knows at the end of the book, would you do it?" He smiles for a moment, then looks at me with confident self-knowledge: "No.")[20]

Louis Creed's quest is carried out in secrecy—he arrogates the power over death unto himself, his rational mind in triumph over the emotion of his heart; as Jud Crandall observes:

> *"[T]he things that are in a man's heart . . . are secret things. Women are supposed to be the ones good at keeping secrets, and I guess they do keep a few, but any woman who knows anything at all would tell you she has never really seen into any man's heart. The soil of a man's heart is stonier, Louis—like the soil up there in the old Micmac burying ground. Bedrock's close. A man grows what he can . . . and he tends it."*[21]

Secrets are the dark undercurrent of *Pet Sematary:* not simply the secrets that divide man and woman, husband and wife—such as the moments of unfaithfulness to their wives that both Creed and Crandall hold locked in their stony hearts; or the secrets of the mortician's room, to whose door King takes us, yet whose contents we never see; or, of course, the secrets of the burial place that lies beyond the Pet Sematary. The ultimate secret, the impenetrable bedrock beneath the stony soil, is that of death, which King aptly symbolizes as Oz the Great and Terrible ("Tewwible," in the words

of Rachel Creed's dying sister, again a child's usage)—the unknow-able overlord whose masquerade we cannot pierce . . . until we die.

"Death is a mystery, and burial is a secret,"[22] King tells us here, and in those few words pinpoints the key to his popularity and the abiding lure of the uncanny for writers and readers alike. As a committed writer of horror fiction, Stephen King works, by choice, in a *genre* responsible for countless films and paperback potboilers whose sole concern is the shock value of make-believe mayhem. But as *Pet Sematary* makes clear, the horror story—at its most penetrating, important moments, those of the immaculate clarity of insight which we call art—is not about make-believe at all. It is a literature whose essence is our single certainty—that, in Hamlet's words, "all that live must die."

What lies in wait for us, down the dark hole of death?
Do the dead sing?
We began this exploration of the night journeys of Stephen King with the story of Stella Flanders, which asked the question explicitly—and answered in the affirmative. For although death awaits Stella Flanders at the far side of the Reach, it is a gentle, lovely death—hand-in-hand with friends who have passed before her, singing hymns of grace. Her journey through darkness, like the journeys of *The Stand*, *The Dead Zone*, and *Firestarter*, emerges to light, renewing Doctor Van Helsing's observation in *Dracula*: "We must go through bitter waters before we taste the sweet."[23] Her journey's end is indeed different from that of the "small animals" down the dark hole of *Cujo*, and from the song greeting Carrie White at the finale of *Carrie*: "that last lighted thought carried swiftly down the black tunnel of eternity, followed by the blank, idiot hum of prosaic electricity."[24] Or from the fates of Father Callahan in *'Salem's Lot* and David Drayton in "The Mist," doomed as eternal fugitives in night journeys that may never end.

As these disparate destinies suggest, the question—"Do the dead sing?"—must go unanswered, at least for the moment. Like Louis Creed, waiting for his wife's return from beyond the Pet Sematary, and like Stella Flanders' son, left on this side of the Reach, we can only conjecture until it is our time to know. "We fall from womb to tomb, from one blackness toward another," King has written, "remembering little of the one and knowing nothing of the other . . . except through faith."[25] But in the tale of horror, we may exper-

ience that fall, the journey into night, yet live again; thus in King's "The Last Rung on the Ladder," two Nebraska farm children play a game of falling from the loft of a barn into stacks of new-mown hay below—an apt metaphor for the horror story: "[Y]ou'd come to rest in that smell of reborn summer with your stomach left behind you way up there in the air, and you'd feel . . . well, you'd feel like Lazarus must have felt . . . fresh and new, like a baby."[26] Always lurking, whether sought or simply found in these night journeys, is the other side of our self and our existence—the elusive phantom of life. And the darkness, the night, the eternal negation of the grave, give us access to truths that we might not otherwise obtain. In "Ad Astram," William Faulkner wrote a fitting credo for horror fiction: "A man sees further looking out of the dark upon the light than a man does in the light and looking out upon the light."

Death, destruction, and destiny await us all at the end of the journey—in life as in horror fiction. And the writer of horror stories serves as the boatman who ferries people across that Reach known as the River Styx—offering us a full dress rehearsal of death, while returning us momentarily to our youth. The Reach *was* wider in those days. And even as we read these words, the Reach is shortening, and the future beckons us even as the ghosts of our past are calling us home. In the horror fiction of Stephen King, we can embark upon the night journey, make the descent down the dark hole, cross that narrowing Reach, and return again in safety to the surface—to the near shore of the river of death.

For our boatman has a master's hand.

The Talisman

"But I reckon I got to light out for the Territory ahead of the rest, because Aunt Sally she's going to adopt me and sivilize me and I can't stand it. I been there before."
— *Huckleberry Finn*

On September 15, 1981, a boy named Jack Sawyer stands at Arcadia Beach on the seacoast of New Hampshire, "where the water and land come together. . . . He was twelve years old and tall for his age. The sea breeze swept back his brown hair, probably too long, from a fine, clear brow. . . . His life seemed as shifting, as uncontrolled, as the heaving water before him."[1] Although he now only senses something ominous, Jack Sawyer will soon light out on an epic quest—a long walk from coast to coast—whose outcome may dictate the fate of this earth . . . and of other lands. His story is the modern American myth of *The Talisman* (1984), the collaboration of horror fiction's two leading writers, Stephen King and Peter Straub.

If Stephen King is the heart of contemporary horror fiction—the life-force that has sustained its popularity in the 1970s and 1980s—then Peter Straub must be considered its head; his supernatural novels *Julia* (1975), *If You Could See Me Now* (1977), *Ghost Story* (1979), *Shadowland* (1980), and *Floating Dragon* (1983)[2] have established him as the premier stylist and aesthetic conscience of the modern horror field. In contrast to Stephen King's seemingly intuitive and colloquial storyteller's prose, the fiction of Peter Straub is deliberate, structurally complex, and above all, styled; he

writes what Stephen King calls "the good prose"—"prose which is almost always structurally correct. . . . It is not flashy, gaudy prose, but each sentence is as tight as a time-lock, as unobtrusively strong as the good (but hidden) joists in a fine Victorian house that will last for three hundred years."[3] King's endorsement of Straub's horror fiction is unequivocal:

> *He is, simply, the best writer of supernatural tales that I know. He has built upon things he has already done . . . but he has never repeated himself; could, for instance, any two books be more different in style than* If You Could See Me Now, *with its Chandleresque first-person narrative, and* Ghost Story, *with its Jamesian diction? His ambition seems boundless, something the reader might also be grateful for. . . . [It] is a rare and startling gift. . . .*
>
> *Peter Straub's books smack neither of tired academic ennui or foolish self-indulgence. Instead there is the clean enthusiasm of the authentic crazy human being—the sort of dudes who staggered back from the wilderness with the skin around their eyes blasted black by the sun of visions and a scorpion or two crawling in their hair. And I don't suppose it matters if the prophet in question came back from those lonely places where ordinary people are afraid to go in a lice-infested robe or a suit from Paul Stuart. The look is the same, the intelligence just as mind-popping.*[4]

The collaboration of these two distinct and exceptional talents had been planned since 1977; it was perhaps the inevitable result of a friendship that began that year when the writers first met in London. Neither writer had even heard of the other until two years earlier, when King read Straub's *Julia* at the request of its publisher and wrote a short comment for the book's dust jacket. It was "easily the most insightful" of the comments received by the publisher, recalls Straub, who was then living in England. "[H]e had a sort of immediate perception of my goals."[5] When King's *The Shining* and Straub's *If You Could See Me Now* were published in 1977, the writers, living on opposite sides of the Atlantic and still not in direct communication, nevertheless began to sense a remarkable affinity through reading each other's works. Straub comments:

> *[I]t was clear that if I had an ideal reader anywhere in the world, it was probably Stephen King; and it was also clear to me that the reason for this was that his aims and ambitions were very close to my own. . . .*

[T]he experience of first reading King was like that of suddenly discovering a long-lost family member—of finding a brother, really—and that is no exaggeration.[6]

The writers began to correspond. At about the same time, the King family prepared for an extended vacation in England. After the difficulties of completing *The Dead Zone* and *Firestarter*, King found the writing of his next novel much smoother going; upon the birth of his third child in the late summer of 1977, with the novel well underway, the move was made. (As a result, one of King's most insular and Maine-oriented novels, *Cujo*, would be completed, ironically, in England.)

The Kings soon decided that England was not for them—a planned one-year stay was shortened to three months, as they returned to Maine in December, purchasing a home in Center Lovell—but the friendship between King and Straub was swiftly sealed. Its literary fruits were immediate. King's first effort to meet Straub was frustrated when, on a rainy day, he could not find a taxi to take him to Straub's home in the Crouch End section of London, and the experience was memorialized in a short story, "Crouch End."[7] After the writers finally met over drinks at Brown's Hotel, King suggested to Straub that they collaborate on a novel. Straub agreed; but their respective obligations on forthcoming books precluded work on the project for several years.

A storyline was not developed until 1980, when Peter Straub returned to the United States after a ten-year absence, taking up residence in Connecticut in the wake of the enormous popular success of *Ghost Story*. "Whenever we saw each other," he notes, "we would try to cook up an idea or two, to see where things were going."[8] One day, while Straub and his family were visiting the Kings, a "comic series of misadventures" involving a videotape caused the two writers to drive the nearly fifty miles between Center Lovell and Portland, Maine, several times. "There were millions of beer cans rattling around the King vehicle," Straub recalls, "and we managed to work out a lot of the essential matter of the book."[9] The premise of *The Talisman* was conceived by King, but he attributes the book's vitality to Straub:

[I]t's an idea that I had when I was in college. I must have been nineteen or twenty, originally, when it occurred to me to write a story about a

The "Boogeyman" as a baby: four-month-old Stephen Edwin King flashes a devilish grin at his proud mother, Nellie Ruth King, in early 1948.

The King family (from left to right): Brother David King, 7, Stephen, 5, and Nellie on the fair grounds of Fort Wayne, Indiana, to celebrate Independence Day, 1952.

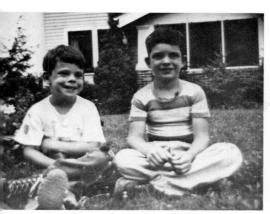

Stephen and David in their yard.

A boy and his dog; Stephen, 9, and Queenie.

Portrait of the artist at work: King following the publication in 1967 of "The Glass Floor," the first short story for which he was paid. It appeared in *Startling Mystery Stories*.

King clowns around with his wife, Tabitha, to whom he dedicated his first published novel, *Carrie*, in 1974. Steve met "Tabby" in 1969 while working in the library at the University of Maine at Orono, and they married two years later. (Photo by Raeanne Rubenstein/PEOPLE WEEKLY © 1981 Time Inc.)

King seeks eerie inspiration for future novels in condemned buildings, haunted houses, abandoned watertowers, and lonely graveyards. (Photo by Raeanne Rubenstein/PEOPLE WEEKLY © 1981 Time Inc.)

King, the family man: standing from left to right on the porch of their Bangor, Maine, home are daughter Naomi Rachel King, son Owen Philip King, wife Tabitha, Stephen, and son Joe Hill King. (Photo by Raeanne Rubenstein/ **PEOPLE WEEKLY** © 1981 Time Inc.)

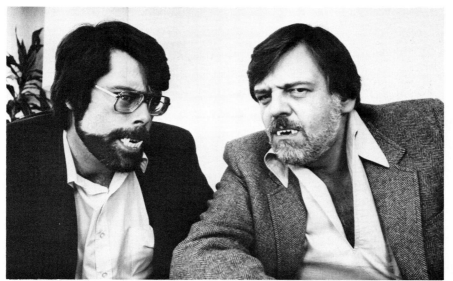

Two wild and crazy ghouls? King and Director/Writer George A. Romero. Although King made a cameo appearance in Romero's film *Knightriders* in 1980, the two did not officially team up until the filming of *Creepshow*. (Photo by Jack Vartoogian/PEOPLE WEEKLY © 1982 Time Inc.)

King, Producer Richard P. Rubinstein, and Director Romero on the set of *Knightriders,* the film in which King made his acting debut. (© 1981 Laurel-Knights, Ltd.)

King receives constructive criticism from Director Romero on the set of *Creepshow*. King portrayed a country-bumpkin-turned-moss-monster in the segment entitled "Lonesome Death of Jordy Verrill." (© 1982 Laurel-Show, Inc.)

King as Jordy Verrill in mind-transformation. (© 1982 Laurel-Show, Inc.)

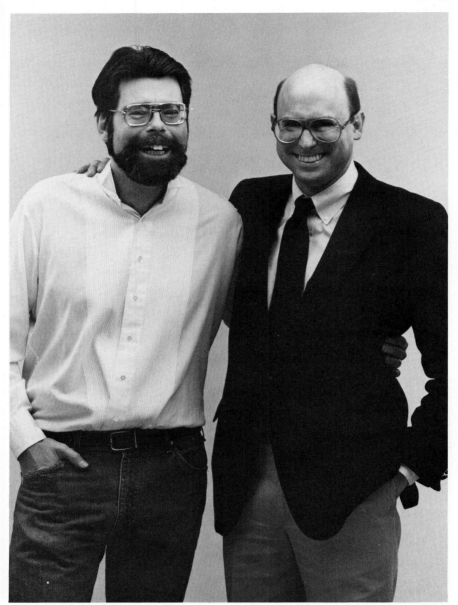

The Terrifying Twosome: horror masters King and Peter Straub, bestselling author of *Ghost Story*. King and Straub combined both their talents and word processors to produce *The Talisman*. (Photo by Andrew T. Unangst)

King and the leading lady in his 1983 bestseller, *Christine*, which was later made into a feature film, directed by John Carpenter of *Halloween* fame. (Photo by Andrew T. Unangst)

From left to right: Veteran movie mogul Dino De Laurentiis, nine-year-old actress Drew Barrymore, Northeast COMBAT Executive Director John Supranovich, and King gathered in front of King's sprawling Victorian mansion in Bangor before attending the world premiere of *Firestarter*, May 9, 1984, which served as a fundraiser to benefit COMBAT, a Maine-based consumer-protection organization. (Photo courtesy of the *Bangor Daily News*)

woman who is a failed actress and her young son, living in a deserted resort area on the Atlantic coast while she waited to die, and what it would be like. And it occurred to me that the kid would try to find something that would save her.

I started a piece—it was called "Verona Beach"—and then I simply dropped it, because I wasn't capable of handling it at that time. So I brought it up while we were kicking ideas around, and it was the one that Peter responded to. His modifications seemed to really inject vitality into the thing—enough vitality to make it roll. So in that sense, it's probably more his book than it is mine.[10]

An outline of the book was developed in 1981, and the writing began in the spring of 1982; almost immediately, the writers faced the intriguing interplay of their distinctly disparate styles: Straub's "good prose" and King's "plain"—or, in his words, "Big Mac and a large fries"—style. Straub comments:

[W]e had [an] extremely intense but comradely period, in which we wrote the first couple of chapters on my machine. Then we knew that everything was going to work, because there was no problem with tone, and there was no problem working together—our styles seemed to melt together. The book has its own sound; it doesn't sound like me and it doesn't sound like Steve. And that's nice—that's what we wanted.

I don't think it's possible, really, for anybody to tell who wrote what. There were times when I deliberately imitated Steve's style and there were times when he deliberately, playfully, imitated mine.[11]

His views are echoed by King:

We both agreed that it would be nice to make the book seamless—it shouldn't seem like a game to the readers to try to figure out who wrote what. . . . When I worked on my half of the copy editing, I went through large chunks of the manuscript unsure myself who had written what. . . . In fact, there were several times when I was reading through the thing that I thought I really did a good job, and it turned out it was Peter. And the only way I could tell was the typing style. He will double space after periods and between dashes, and I don't do that. He also misspells different words than I do. . . . At one point, we have an Uzi machine gun, and Peter was spelling the word "Uzzi." And I said, "Peter, that's really funny, the way you are spelling 'Uzi.'" He said, "Look at the way you spell 'cemetery.'"[12]

The book was written sequentially, from start to finish; the writers assigned each other sections, each one picking up where the other had left off. The self-assignments did not depend upon character or setting, or even chapters or subchapters; in the words of Peter Straub:

> It was totally at random. When one of us took it, usually he went on until he reached a point at which he was comfortable dropping it. So we pretty much ignored our assignments and went on until a natural break. By and large, we started off writing it rigidly, and ended up doing it instinctively, which was by far the better of the two ways.[13]

Pages were exchanged electronically, by telephone modem communication between their respective word processing computers. "It was a little bit like playing tennis," says King:

> He would send what he had done, and then I would work for three or four weeks and send the stuff back to him. . . . And it was wonderful—the book would grow without me doing anything. . . . But it was also a little bit like the old days, when I got the Saturday Evening Post with its serial stories. When Peter said he was going to send something, I would get excited because I was going to get to read some more of the story.[14]

Not until the book was completed did either writer change or edit what the other had written. "When we actually rewrote the other's stuff," Straub reflects, "it was a wonderful and profound experience, and something very few writers ever get the chance to have. It's like having an X-ray of someone's mind when you review his material that way."[15]

The book as finally written represents approximately one fourth of the original conception. "It would have been a four thousand page novel," Straub laughs. "And Steve and I would both be dead, if we were still trying to write that thing."[16] On Thanksgiving of 1982, the two families met in Boston. That night, after their wives and children had gone to bed, Straub and King stayed up, drinking, and undertook "the great Thanksgiving putsch," in which the book was radically streamlined to its published structure and length.

As a collaboration, The Talisman must, of necessity, be considered a unique element in the writings of either Stephen King or

Peter Straub. "As Casey Stengel used to say," King notes, "you've got to put an asterisk by it."[17] Although the writing of the novel involved the reconciliation of two separate personalities and two separate aesthetics, at its center is the very affinity that brought King and Straub together: *The Talisman* is, first and foremost, a tale well told, but it also revisits a recurrent theme of its authors' fiction—the coming of age in a time when the assembly-line mentality of the rational world seems to hold sway over instinct and imagination.

The Talisman begins just after Jack Sawyer has been brought to Arcadia Beach by his mother, Lily Cavanaugh, "queen of two decades' worth of B movies." Dying of cancer, she has abruptly closed their house on Rodeo Drive in Los Angeles—first to rent an apartment on Central Park West, then to retreat even further to a quiet resort hotel, the Alhambra Inn, on the New Hampshire coast. The hotel is curiously named: not only is it Californian, obviously displaced on the Atlantic seaboard; it harkens to the original Alhambra—the hill in Granada, Spain, on which stand the ruins of a once-proud castle. Upon their arrival, Jack thought he saw a rainbow over the hotel's gambrel roof: "A sign of sorts, a promise of better things. But there had been no rainbow."[18] His mother's condition only worsens, sped on by the hounding of his late father's greedy, scheming business partner, Morgan Sloat, who seems intent upon draining Lily of not only her money, but her life. Only the rainbow dreams of an Oz-like land offer hope for Jack and his mother.

The great American novel of boyhood, Mark Twain's *The Adventures of Huckleberry Finn* (first published in 1884, exactly one hundred years before *The Talisman*), ends with Huck pointed west, ready to light out for the territory he had sought, but never found, in his travels with Nigger Jim down the Mississippi. Jack Sawyer, who will take that westward journey, is, as his name implies, an amalgam of such fictional boyhood adventurers, at once steeped in their traditions and yet a wholly new and modern character—despite his last name, we are told at the outset that "Uncle Tommy was dead."[19] In a deserted funfair on Arcadia Beach, Jack finds his Nigger Jim—the aged but ageless Speedy Parker, who calls him "Travellin' Jack," the very nickname given him by his late father. Prefigured by Dick Hallorann of *The Shining* and Bud Copeland of *Shadowland*, Speedy, like Twain's black avatar, embodies the wilderness of instinct and primitive terror which Jack, the outcast

paleface boy, must confront. The daydreams of Jack's youth are real, Parker reveals. With a drink of juice from a cheap wine bottle, Jack may "flip"—catapult himself into another world called the Territories, an "innately good" land enmeshed in a medieval, agrarian past: the time-honored realm of fantasy. A journey through that world, Jack learns, will lead to something called the Talisman—the sole hope for his mother's survival.

The dualities implicit in King's first epic quest novel, *The Stand*, are made explicit in *The Talisman*, as King and Straub conjure reality as a magical hall of mirrors. The Territories are a parallel world in the truest sense: people, places, even events are duplicated there, and reflect back upon us; cause and effect are seemingly displaced—thus, World War Two may have originated in a Territories palace revolt, while nuclear testing in Nevada and Utah may have rendered the western realms of the Territories into the ravaged, apocalyptic "Blasted Lands."

Jack finds that most people have a mirror-image—a "Twinner" —in the Territories. His mother, the B-movie queen, is twinned with Laura DeLoessian, the literal Queen of that fantastic otherland, now fallen prey to a strange sleeping sickness. The evil Morgan Sloat—as slothful and bloated as his name implies—is doubled by Morgan of Orris, clubfooted pretender to the Territories throne. But Jack Sawyer has no alternate self; his Twinner, who died in infancy, was called Jason—harkening not only to the mythic quest for the talismanic Golden Fleece, but soon revealed as the Territories name for Jesus. Although Jason was apparently murdered in his sleep by Morgan, he lives again in Jack; "guys like Jason had a way of coming back," Jack realizes, and his Jason-side is the embodiment of the classical heroic mythology that King and Straub evoke throughout *The Talisman*.[20]

Jack Sawyer's quest for the Talisman finds little solace in either our world or the Territories; life on the road is a nightmarish moralizing experience. King comments:

> There is never a feeling of Huck looking around at the world and saying, "My, this sure is fine." Jack is never glad to be going. Most of what he sees does not cause his heart to rise up—the only time that he feels really good about his trip, it seems to me, is during a couple of his experiences in the Territories, when he is overwhelmed with beauty and good feeling.[21]

Those fleeting moments of enchantment in the Territories find dark contrasts in modern America, where "Travellin' Jack" must live at the edge of civilization, surviving in the nomadic subsociety of what King calls "Reagan's America": "the ebb and flow of an underclass, the dregs of society, the roadies who are put upon by other people, the unhomed and homeless drifting just below everybody's sight."[22] When Jack leaves peaceful New England, signaled by his frightening passage through the Oatley Tunnel in upstate New York, the world itself constricts, tunnel-like. Jack learns the importance not only of life, but of freedom, experiencing firsthand society's dehumanizing power over the individual. He is trapped and exploited— first in the Oatley Tap and then in the orphanage of midwestern fundamentalist minister Sunlight Gardener, the right hand of Morgan Sloat; but Jack is also imprisoned by the growing responsibilities of his sudden rush toward adulthood.

In keeping with the mirror-like structure of the book, King and Straub produce two companions for Jack Sawyer (who, a Freudian would suggest, represent Jack's competing id and ego, joined at the book's conclusion when his quest is fulfilled). Sloat's relentless pursuit of Jack causes him to "flip" back to our world with his first companion in hand: Wolf, a slow-witted and decidedly hairy sixteen-year-old boy from the Territories. As his incessant cry of "Right here and now!" confirms, Wolf is a creature of immediacy and chaos; indeed, he is a werewolf who runs with the full moon, the noble beast who cannot survive in our technology-poisoned world. Inevitably, he is slain by the forces of order when, to save Jack, he rebels against the mad authoritarian theocracy of Sunlight Gardener.

Wolf's successor is Richard Sloat, a creature of pure rationality, effectively orphaned by his father, Morgan, to the confines of Thayer School, a bastion of preppy sensibilities as short-sighted and ultimately dungeonlike as Gardener's religious mania. The death of Wolf pairs Jack with the werewolf's opposite, "Rational Richard," who, in reaction to a frightening childhood glimpse of the Territories, has turned his mind from fantasy, embracing a mechanistic world view. Earlier in their youth, Jack had challenged Richard's perspective, unaware that, but a few years later, he would offer concrete proof of its falsity:

"Do you know what you want, Richard? You always say you want to be a research chemist," Jack said. "Why do you say that? What does it mean? . . . Do you think you'll cure cancer and save millions of people's lives?"

". . . I don't think I'll ever cure cancer, no. But that's not even the point. The point is finding out how things work. The point is that things actually really do work in an orderly way, in spite of how it looks. . . ."

. . . Jack grinned. "You're going to think I'm crazy. I'd like to find something that makes all this—all these rich guys chasing golfballs and yelling into telephones—that makes all this look sick."

"It already looks sick," Richard said, with no intention of being funny.[23]

Jack's arrival at Thayer School triggers a surreal siege in which that staid citadel of rep ties and reason succumbs to chaos from without and within—its faculty and students rendered into gibbering shapeshifters and its very walls oozing with putrefaction. When Richard makes his disbelieving escape with Jack into the Territories, his rational world view is seemingly externalized in reaction to the realm of fantasy—ravaged like a victim of radiation poisoning, he becomes walking confirmation of his wry observation that the result of our trust in technology and reason "looks sick." Jack becomes his caretaker, his foster father, literally shouldering the responsibility for Richard as part of his growth into manhood:

Carrying Richard seemed to be no problem at all, and not just because Richard had lost weight. Jack had been running kegs of beer, carrying cartons, picking apples. He had spent time picking rocks in Sunlight Gardener's Far Field, can you gimme hallelujah. It had toughened him, all of that. But the toughening went deeper into the fiber of his essential self than something as simple and mindless as physical exercise could go. Nor was all of it a simple function of flipping back and forth between the two worlds like an acrobat, or that other world—gorgeous as it could be—rubbing off on him like wet paint. Jack recognized in a dim sort of way that he had been trying to do more than simply save his mother's life; from the very beginning he had been trying to do something greater than that. He had been trying to do a good work, and his dim realization now was that such mad enterprises must always be toughening.[24]

In depicting Jack's relationships with Wolf and Richard, *The Talisman* consciously invokes critic Leslie Fiedler's controversial es-

say, "Come Back to the Raft Ag'in, Huck Honey!" (1948),[25] which
first explored the undercurrent of homosexuality in *The Adventures
of Huckleberry Finn* and other classic American novels. Jack takes
the hand of both Wolf and Richard, and tells them baldly of his love
for them—a love that is reciprocated. An immaculate bond is
sealed—boy to boy, man to man—offering a sentimental vision
(and perhaps, for some readers, a nervous one) of primal, pre-
Freudian intimacy. Arrayed against these acts of love are the moral
rhetoric of Morgan Sloat and Sunlight Gardener, denouncing the
benign aspects of homosexuality (such as that of Jack's late uncle),
and the moral degradation of the darkly homosexual Elroy, the
boogeyman of the Oatley Tap, and of endless highway drivers anx-
ious to press their desires upon Jack when he is alone on the road. In
these counterpoints we see society's dangerous suppression—indeed,
perversion—of man's natural and healthy instincts of love for fellow
man. Despite Sunlight Gardener's raving insistence that "all boys
are bad—it's axiomatic," the child, like the land, is innately good.
The love shared by Jack and his companions is, like Jack's love for
his mother, not simply innocent—it is a symbol of innocence itself.

As Queen DeLoessian's name (from the German *löss*, effectively
"of the earth") suggests, the healing of Jack's mother is not the sole
purpose of his quest—the implicit mother figure of *The Talisman* is
Mother Earth, defiled by the cancerlike spread of modern civiliza-
tion. When Jack and Richard set out on their exploration of the
"Blasted Lands," they ride upon a railroad train brought to the Ter-
ritories by Morgan Sloat. The image has a unique duality: for the
boys, the railroad, like Twain's steamboat, is the symbol of an
older, lost America, supplanted by even greater machines; but in
the Territories, it is a symbol of the new order of a secular,
technological culture. Morgan Sloat, upon learning the secrets of
the Territories from Jack's father, has sought to bend its people and
its land to his will. He has imported the black magic of modern tech-
nology—not simply the train, but automatic weapons and explo-
sives; more important, he has infected the land and its people with
the diseased world view of sterile rationality. The romance and en-
chantment of the Territories are waning as rapidly as the health of
its sleeping Queen; Sloat and the cancerous engines of "progress"
are superseding the old wisdoms, the intimacies between humanity
and its environment.

The journey of redemption that Jack Sawyer and his companions

must undertake is inevitably a westward one, the selfsame path taken by Stella Flanders of "Do the Dead Sing?" and the survivors of *The Stand*. Jack's travels in the Territories reenact the American experience, beginning as a pilgrimage into an uncharted wilderness, crossing a great frontier with a vision of manifest destiny, viewing the colonialist encroachments of Morgan Sloat—the taming and enslavement of the land—and finally confronting the fact of America's geographical limits. His goal lies always to the west; but for Jack, as for Stephen King and Peter Straub—and indeed, for all Americans—the west is as much a dream as a fact. Its locale is never entirely geographical, but is, in the words of Archibald MacLeish, "a country in the mind." The Territories represent that most American of mythical landscapes, and in its fading beauty, we experience a recovered sense of what America, in its rush to wealth and technology, has lost—and what remains, even today, our nation's richest legacy: what Robinson Jeffers called the dignity of room, the value of rareness.[26]

Ever west is Jack's journey, but he looks longingly backward, to his mother—to the east. Jack's coast-to-coast trek brings him, appropriately, to a California landscape that mirrors the New England where his journey began. "This is how it should be," he realizes. "I'm coming back to the place I left behind."[27] For Jack, California represents a place even more primitive than the Territories, a place that glances eastward toward the ruined castle of the Hotel Alhambra, and the aptly named Arcadia Beach—it is a neo-Eden, the great good place of childhood from which we are cast out as we grow older; thus, both Jack and Richard yearn for earlier days: "[N]othing was so grown-up back then . . . when we all lived in California, and nobody lived anywhere else."[28]

The quest of Jack Sawyer is that mythical descent into the underworld that pervades the novels of Stephen King, a life-giving immersion in darkness, filled with imagery of death and rebirth. It haunts not only the fiction of Stephen King, but that of Peter Straub—and of Charles Brockden Brown, Nathaniel Hawthorne, Edgar Allan Poe, Herman Melville, H. P. Lovecraft, Ray Bradbury, and so many other writers in the rich American art of darkness. It is the search for meaning in our adult lives that can compare with that known in the lost innocence of childhood—a meaning for our lives that, once left behind, may be found only in death, in the

night journey across the River Styx that we rehearse in the fiction of horror.

At the end of Jack Sawyer's quest, he regains that meaning, if only for a moment, in the Talisman. On the California coast, where the water and the land again come together, stands the Hotel Agincourt, a black double of the Hotel Alhambra, named, appropriately, after the site of the medieval battle that ended the age of chivalry. Inside the black hotel, Jack must confront the vampiric spirits of five guardian knights; but the true conflict at the climax of *The Talisman* is fought within himself. He must overcome the dark despair, the will toward nothingness, that is the evil within each of us—an evil infinitely more powerful and enduring than that of the likes of Morgan Sloat—and his victory brings the Talisman into his arms:

> It was a crystal globe perhaps three feet in circumference—the corona of its glow was so brilliant it was impossible to tell exactly how big it was. Gracefully curving lines seemed to groove its surface, like lines of longitude and latitude . . . and why not? Jack thought, still in a deep daze of awe and enchantment. It is the world—ALL worlds—in microcosm. More; it is the axis of all possible worlds.
>
> Singing; turning; blazing.
>
> He stood beneath it, bathed in its warmth and clear sense of well-meant force; he stood in a dream, feeling that force flow into him like the clear spring rain which awakens the hidden power in a billion tiny seeds. He felt a terrible joy lift through his conscious mind like a rocket, and Jack Sawyer lifted both hands over his upturned face, laughing, both in response to that joy and in imitation of its rise.
>
> "Come to me, then!" he shouted. . . .[29]

The Talisman is Jack's rainbow, a symbol of redemption and fertile creativity—and above all, of the white, that fragile, delicate thing that we call good. It sends forth a beacon of light so powerful as to blot out the dark lives of Morgan Sloat and Sunlight Gardener, and its very touch heals Richard Sloat and Speedy Parker—and finally, Jack's mother. It is a round globe—a world, "the axis of all possible worlds"—and the sentient embodiment of the divine mystery at the heart of our universe: the unknowable, known for an instant, and understood to be good.

The Talisman is possessed only for a momentary interlude of salvation—then it is gone. As Jim told Huck Finn, "It's too good for

true, Honey. It's too good for true." No story is complete, and neither good nor evil reigns eternal, at least in this world. Life, like the Talisman itself, moves on. Lily Cavanaugh's first moment of rebirth also brings her a moment closer to death. And although Jack Sawyer has taken the long walk from childhood to adulthood, turning age thirteen on the final day of the novel, only part of his story has been told—as the novel's epigraph, from *The Adventures of Tom Sawyer*, notes: "It being strictly a history of a *boy*, it must stop here; the story could not go much further without becoming the history of a *man*." For Jack Sawyer—and for his creators—other stories and other worlds await.[30]

·16·

Night Shift, Skeleton Crew, and Other Short Stories

"The only two useful artforms are religion and stories."
— *Gordon Lachance*

This is what happened . . .

Simple words, direct and unassuming. A no-nonsense invitation to hunker down, pull the tab on another can of beer, and join the circle of friends around the campfire.

Storytelling words. Stephen King words.

After a brief hiatus in his publishing schedule for a collaboration with Peter Straub, *The Talisman,* and the pseudonymous "Richard Bachman" thriller, *Thinner,* Stephen King returned with a book that was unequivocally his own: the short-story omnibus *Skeleton Crew* (1985).[1] He had never been far away. Over the decade since the publication of *Carrie,* his prolific pen and seemingly boundless imagination had accounted for fifteen published novels, almost fifty short stories, two fiction collections, a nonfiction survey of contemporary horror, and three filmed screenplays. No less than eleven motion picture adaptations of his work were in theatrical release. As *Skeleton Crew* reached bookstore shelves in the spring of 1985, King was preparing to direct his first motion picture, *Overdrive,* before returning to the ranks of publishing with four new novels that would be released in the fourteen months from September 1986 to November 1987.

Skeleton Crew, when read with its predecessor, *Night Shift* (1978),[2] offers a unique retrospective of Stephen King's staggeringly successful career, collecting forty short stories and two poems that range over seventeen years—from his earliest publications in college literary magazines and horror pulps to his most recent work in such upmarket venues as *Playboy* and *Ladies' Home Journal*. The dated selections are not mere historical curiosities; although King's style has matured over the years, his vision has remained consistent and remarkably content. Despite fame, fortune, and their appurtenant distractions, Stephen King has never lost perspective on the chosen business of his life: telling stories.

This is what happened . . .

These words introduce the cornerstone of *Skeleton Crew*, "The Mist,"[3] a short novel that represents King at his most colloquial, taking a first-person ramble through the imagery of apocalypse (see Chapter 9). Its opening line is, for King, "the essence of all story, a kind of Zen incantation."[4] There is one goal of horror fiction that he holds above all others:

> *It must tell a tale that holds the reader or the listener spellbound for a little while, lost in a world that never was, never could be. It must be like the wedding guest that stoppeth one of three. All my life as a writer I have been committed to the idea that in fiction the story value holds dominance over every other facet of the writer's craft; characterization, theme, mood, none of those things is anything if the story is dull. And if the story does hold you, all else can be forgiven.*[5]

"The Mist" holds the reader by what King calls a "cheery cheesiness"[6]; it is *Dawn of the Dead* as scripted by H. P. Lovecraft and filmed on a shoestring budget by Roger Corman. When its desperate narrator, trapped in a small-town supermarket by an ominous mist and an increasingly nasty array of monsters, speaks of spaghetti sauce splattering like gouts of blood, we find the world ending with neither bang nor whimper, but a crazed and yet oddly reassuring laughter.

This tone of black but ultimately good-natured comedy animates the best stories of Stephen King, quickening the sense of the avuncular—and the expectation that he, like Rod Serling of the *Twilight Zone* television program, can (and will) set foot on stage at any time. (Indeed, in "The Blue Air Compressor,"[7] King is featured as

his own character.) It is virtually impossible to read these stories without recognizing—in their energy, wide-eyed honesty, and utter lack of inhibition—that they are the product of an inner necessity (or, as King writes in his introduction to *Skeleton Crew*, "because not to do it is suicide"[8]). That fact, coupled with King's plain-faced style and eager willingness to laugh and scream along with his readers, goes a long way toward explaining why his stories are, in turn, so compulsively readable.

The unwashed may wonder aloud about the likeability of a fiction devoted, in King's terms, "to death, destruction, and destiny"—and the guest lists of *Night Shift* and *Skeleton Crew* indeed include, along with the traditional allotment of ghosts, ghouls, and gremlins, a contingent of grue and gore. But King's oft-publicized penchant for the "gross-out" is, as faithful readers know, an exaggeration. There is no escaping his endearingly insistent vulgarity (he notes wryly that one of his stories, "Mrs. Todd's Shortcut," was rejected by two leading women's magazines "because of that line about how a woman will pee down her own leg if she doesn't squat"[9]), but only two of his published short stories venture into realms that are taboo on the evening news . . . at least for this week.

One is "Survivor Type,"[10] a tale that became something of a legend when King announced, in a footnote to *Danse Macabre*, that apparently no publisher would touch this "chance to really grab people by the gag reflex and throttle them."[11] It is a stunningly crafted, if one-note, story about a shipwrecked, starving surgeon who asks "Where's the beef?" and finds the answer close at hand. And foot. But concept aside, "Survivor Type" is (heh-heh) tasteful when compared with "The Raft,"[12] a compelling exercise in *grand guignol* in which King sends four teenagers out for a swim into the watery domain of a floating, carnivorous blob with only a rickety wooden raft as sanctuary. The horrors here are unflinching and relentlessly graphic, yet the result is a thinking person's answer to the *Friday the 13th* "splatter" films, with the water-borne stain as latent with symbolism as Melville's white whale.

As these stories suggest, Stephen King's fiction is often obsessed with the isolated, the abandoned, the lost; his aesthetics link horror with the absence of love, and his characters are repeatedly rendered as lonely, loveless pariahs at the mercy of an intractable fate. The epigraph of *Skeleton Crew*—"Do you love?"—is asked tauntingly of

King's characters in at least two of his stories, "Nona" and "The Raft"; it is implicit in most others. "I Know What You Need,"[13] a psychic college student tells the woman he pursues, offering to fulfill her every desire—save that for true love. "The Man Who Would Not Shake Hands"[14] must suffer the curse of an obscure Indian shaman that everything he touches will die; like the tortured souls who look into the mirror that reflects "The Reaper's Image,"[15] he must hasten into exile from the land of the loving—and the living.

Those who are fortunate enough to find love learn that it is the most fragile of emotions, one by which we, like the children of "The Last Rung on the Ladder,"[16] dangle precariously above the mundane realities of our adult lives . . . and our inevitable deaths. Love is also the most dangerous of emotions. For some, like the narrator of "Dolan's Cadillac,"[17] it becomes the source of vengeance; when his wife is murdered by a Las Vegas hood, only a mad poetic justice—burying the hood alive in his luxury car—will provide recompense. For others, the loss of love is beyond justice; in "The Woman in the Room,"[18] a young man must contemplate killing his paralyzed mother rather than watch her suffer the slow death of cancer. And love itself kills in "The Man Who Loved Flowers,"[19] taking the guise of a man who randomly stalks women on the streets of New York City.

Rare are the King characters whose fate is of their own choosing. In "Cain Rose Up,"[20] a grim retelling of Charles Whitman's "Texas Tower" murders, humanity is merely a series of targets for a college student who peers Godlike down the telescopic sight of his hunting rifle. "The Monkey,"[21] a genuine classic of short horror fiction, vivifies King's naturalist stance: a windup toy monkey becomes a modern-day banshee, each clash of its clockwork cymbals a signal of death to the owner's nearest and dearest.

But rarer still are the King characters who can stop, let alone slow, those clockwork cymbals of fate. In "Weeds,"[22] a meteor plummets onto the land of a backward New Hampshire farmer, spawning a weedlike greenery that relentlessly consumes him—until suicide is the only solution. Thus "Word Processor of the Gods"[23] is something of a departure, a story in which fate is foiled without apparent repercussion. Written by King soon after acquiring his first word processing computer, this story of a modern monkey's paw, complete with serial ports and disk drives, is as unsettling

in its optimistic ending as W. W. Jacobs' original—adapted by King in *Pet Sematary*—was in its pessimism.

Those who would tempt fate in King's stories more often find themselves with an unhealthy, if not fatal, reward. "The Jaunt,"[24] like "The Mist," is part of King's continuing series of cautionary tales (soon to culminate in a novel, *The Tommyknockers*) that use the trappings of science fiction to warn of indiscriminate interference with the nature of things. Similarly, the perils of wishful thinking are the true evil of "Gramma,"[25] which, like "The Monkey," is based upon events in King's childhood. An eleven-year-old boy, like the young Stephen King, is left alone with the corpse of his grandmother. Her agonizing physical and mental deterioration had caused the boy to wish her dead—but she returns, with an undeniable hunger.

The naturalistic impulse of King's writing has always been tempered by an unabashed enthusiasm for the irrational (and often hilariously nutty) response. While H. P. Lovecraft's eldritch creatures capered and gibbered long into the night, it is King's protagonists who are more likely to indulge in mad antics. In "Beachworld,"[26] a survivor of a wrecked spaceship stares wild-eyed across a planet made entirely of sand, singing songs by the Beach Boys as the dunes begin to ripple with life. In "Nona,"[27] a reprise of the Charles Starkweather killing spree, a mass murderer demurs when the police claim that he acted alone, telling of the beautiful girl who egged him on: "True love will never die,"[28] he whispers, after capture in a graveyard with her long-dead corpse in his arms. In "The Ballad of the Flexible Bullet,"[29] a writer's demented insistence that a tiny creature called a Fornit inhabits his typewriter proves as infectious as laughter, driving both him and his editor toward suicide.

Given the insanity of our times, King asks, do we still possess the ability to go insane? Or are we already there? His answer is found in two linked set-pieces of surrealism, both drawn from an aborted novel, *Milkman*. "Morning Deliveries"[30] finds our neighborhood milkman on his everyday rounds, leaving a quart of milk here, some yogurt there, a tarantula for Mrs. McCarthy, some bottled cyanide for the Kincaids. In "Big Wheels: A Tale of the Laundry Game,"[31] which is certainly King's strangest story and one of his very best, two drinking buddies on a Halloween joyride tap into a blue-collar nightmare, reality slipping from drunken hallucination into the seemingly supernatural with chilling logic. You may never drink

Iron City again . . . but if you should, beware the fate of Richie Grenadine, whose penchant for cheap beer reduces him to a mass of "Gray Matter."[32]

In the nightmare worlds of Stephen King, we learn that nothing is quite what it seems. "Here There Be Tygers,"[33] proclaims one of King's early stories, revealing that a region uncharted in adulthood—a grade-school boys' room—offers mortal dangers for explorers. "Crouch End,"[34] where Peter Straub lived during his years in London writing *Ghost Story*, becomes the portal from our world to a darker, malevolent plane.

As King's seminal short story "The Boogeyman"[35] discloses (see Chapter 1), persons as well as places are deceptive. When "Strawberry Spring"[36] comes to New England—"a false spring, a lying spring"—even the most mild-mannered of men may wear the werewolf face of Mr. Hyde. In "Suffer the Little Children,"[37] a disciplinarian schoolteacher begins to wonder about the true identities of her third graders; while on "The Night of the Tiger,"[38] a young roustabout with a traveling circus witnesses shape-shifting terrors.

And then there are the stories that confirm that reality itself is no solace. In King's first professionally published fiction, character after character is drawn to the room with "The Glass Floor,"[39] where they peer into a mirror of the soul whose darkness knows no depth. It is a fitting prelude for such nonsupernatural stories as "The Fifth Quarter,"[40] "Man with a Belly,"[41] and "The Wedding Gig,"[42] in which King probes the horrors of humanity, fostering his own canon of tales of the criminal underworld—an element intrinsic to two of his "Richard Bachman" novels, with their memorable characters Sal Magliore (*Roadwork*) and Richard Ginelli (*Thinner*). Inevitably, some of these stories have contrasted the criminal underworld with a darkly fantastic otherworld. In "Battleground,"[43] a syndicate hitman who terminates the owner of a toy company is besieged by an army of miniature soldiers; another assassin, hired by a sickly millionaire to kill "The Cat from Hell,"[44] meets his match in a creature with something more than nine lives.

King adapted two of his best criminal suspense stories for the motion picture *Cat's Eye* (1985),[45] which linked *Night Shift* entries "Quitters, Inc."[46] and "The Ledge"[47] with an original screen story, "The General." *Cat's Eye* was conceived in 1983 when producer Dino DeLaurentiis asked King to script a vehicle for child star Drew Barrymore, who had recently played the role of Charlie McGee in

Mark Lester's tepid film rendition of *Firestarter*. King's screenplay embellished the anthology format that he had used in *Creepshow*, linking three story segments with the escapades of a vagabond cat on a mysterious quest.

The film begins as the feline, later nicknamed the General, encounters a rabid Saint Bernard—the first of several in-jokes, acknowledging the fact that *Cat's Eye* director Lewis Teague also brought King's *Cujo* to the screen. General travels to Manhattan on a tobacco truck, but is captured by Dr. Donatti (played by Alan King), the operator of the rather unorthodox stop-smoking facility of the first episode, "Quitters, Inc." Donatti's newest client, Dick Morrison (James Woods), soon learns that the facility, founded by a Mafia kingpin, favors pragmatic solutions: Morrison will be kept under strict surveillance, and each surrender to the craving to smoke will be met with escalating sanctions, beginning with electric shocks to his wife.

As Morrison reluctantly accepts his cure, General moves south to Atlantic City, the setting of "The Ledge." There, casino owner Cressner (Kenneth McMillan) has discovered tennis pro Norris (Robert Hays) in a tryst with Cressner's young wife. Norris is trapped and forced to accept a unique wager: his freedom and Cressner's wife if he navigates a five-inch ledge around Cressner's high-rise penthouse apartment. Perched some forty-three stories in the air, Norris manages to survive crosswinds and seemingly demonic pigeons only to learn that Cressner has double-crossed him. He gains the upper hand and offers his own wager: the ledge against Cressner's life.

In the final episode, "The General," the wayfaring cat paws into the North Carolina home of young Amanda (Drew Barrymore), much to the chagrin of her parents (James Naughton and Candy Clark). It has arrived in response to an unconscious summons; inside the walls of the house lurks danger—a mischievous and malevolent troll who emerges at night to steal Amanda's breath.[48] Amanda's parents deliver General to the pound; but he escapes the clutches of a dullard animal keeper (a role that King originally intended to play) and charges back to save Amanda from the beastly invader.

A writer of horror fiction is expected to dwell upon such monsters, and Stephen King has proved no exception. His first published short story, "I Was a Teenage Grave Robber,"[49] climaxed in a battle

with giant maggots, and his earliest professional success came with the sale of several "creature feature" stories to *Cavalier*, many of which were collected in *Night Shift*. In "Graveyard Shift,"[50] laborers descend into a subterranean labyrinth to confront a hideous army of rats. "I Am the Doorway,"[51] warns a crippled astronaut, his body infested with murderous alien parasites. The ghosts of teenage toughs from the fifties haunt a schoolteacher who knows that "Sometimes They Come Back."[52] But King's most memorable monsters are those that possess a chilling familiarity—from the siege of driverless "Trucks"[53] to the demonic laundry machine known as "The Mangler"[54] and the hungry garden tool of "The Lawnmower Man,"[55] he turns our own creations against us, finding terror in our jobs, our shopping malls, our neighborhoods, and even in the house next door.

It is not surprising, then, that King's best stories are set right next door—in rural Maine settings, flavored with laid-back Downeast dialogue and a bittersweet sentimentality that may surprise those expecting the foreboding landscapes of *'Salem's Lot*. Over the past several years, King has charted a fictional geography that mirrors the region surrounding his summer home in southwestern Maine. In addition to the Lot, featured in the short stories "Jerusalem's Lot"[56] and "One for the Road,"[57] several other towns deserve detours should you stray in their direction. Tarker's Mills is hostage to *The Cycle of the Werewolf*, while in Harlow, the Newall House is under construction again—as one after another of the townspeople die, "It Grows on You."[58] The residents of Haven, with Tommyknockers knocking at their door, learn "The Revelations of 'Becka Paulson."[59] But the prominent locale of King's alternate geography is the small town of Castle Rock, modeled vaguely on Norway-South Paris, Maine, and featured in *The Dead Zone, Cujo, Different Seasons*, and an ever-growing number of short stories.

Somewhere in this landscape lies "Mrs. Todd's Shortcut,"[60] a route fixed firmly in King's imagination when he became amused by his wife's persistent search for the shortest route between their summer and winter homes. The story is a delightful fantasy, told with great irony (given its focus upon speed) as a series of pass-the-time conversations between two aging locals. Mrs. Todd, it seems, has become so obsessed with finding ever-shorter routes on her trips to Bangor that her forays onto obscure back roads begin to bend both time and distance.

One of those back roads is marked today by the abandoned hulk of a truck, its nose pointed toward a tiny shack some fifty yards distant. It is the inspiration for "Uncle Otto's Truck,"[61] the latest rendition of King's undying passion for finding life in the inanimate. In the tradition of *Christine*, this wheeled monstrosity moves with a vengeance, meting out justice for a crime committed thirty years before.

The beauty and terror of the Maine landscape are at the heart of King's tour de force—and, appropriately, the final story of *Skeleton Crew*. Originally published in the small Maine magazine *Yankee*, "The Reach"[62] is a hauntingly beautiful elegy to one of his most memorable characters, ninety-five-year-old Stella Flanders, who has spent the entirety of her life on a small island off the coast of Maine. Dying of cancer, she decides to walk across the frozen ocean waters of the Reach to the mainland, seeking the answer to a single question: "Do the dead sing?" Her story, examined in detail in Chapter 1, is the finest that King has written—and, indeed, it won the World Fantasy Award for best short fiction of 1981.

In *Night Shift* and *Skeleton Crew*, we see Stephen King firmly in his element, the campfire storyteller on a roll, spinning tale after tale after tale, reveling in his horrors and, along the way, working a special magic on his readers. At their finest moments—and there are many—these short stories offer the reader the rare exhilaration of being scared within the safe limits of art, and the opportunity to exercise our need, as rational beings, to laugh and to cry about the fact of our mortality. In a time when violence and confusion seem to hold reign over our daily lives, it is little wonder that millions of readers have embraced the imaginative talents of Stephen King. No one writing today better deserves the title of America's storyteller.

. . . Always More Tales

> ". . . sooner or later, it always comes back to the guy who is awake in the night and hears something getting closer and closer."
>
> —Stephen King

The year 1984 marked Stephen King's twentieth year as a published writer and tenth year as a published novelist. Since the release of *Carrie* in 1974, his life has changed radically—from his desperate hours as a private school teacher in rural Maine, barely able to meet his bills, struggling to produce a publishable first novel, to his present status as a financially secure, bestselling writer whose books have captivated the readers (as well as the publishers and motion picture producers) of America. His fiction has been translated into more than a dozen languages and has been adapted repeatedly for the motion picture screen. King has traveled across the world, and looked closely at New York and Colorado and even England as a home before deciding that he would rather live in his native Maine. His wife, Tabitha, has also established herself convincingly as a novelist of the first rank; and he has seen his children begin to reach their teenage years even as he nears age forty. Not surprisingly, King has called the decade after *Carrie* "the longest ten years of my life"; but for him, the thing that started it all—the fear—has not relented:

> In the ten years since Carrie was published, I have entered heart attack country—but nothing really changes inside, in the sense that I still feel vulnerable. Sometimes the objects of my fear change, and sometimes

the quality of my fear changes—but I find too much fear, in a way. I wish I could get away from horror for a while, and I do—or I think I do, and then suddenly I discover that I'm like the guy in the poem by Auden who runs and runs and finally ends up in a cheap, one-night hotel. He goes down a hallway and opens a door, and there he meets himself sitting under a naked light bulb, writing.

I can't go to sleep in a hotel without thinking, "Who is in the room underneath me, dead drunk and smoking a cigarette and about to fall asleep so that the room catches fire? When was the last time that they changed the batteries in the smoke detector?"

And that's the way it's always been with me. If I try to write something else, sooner or later, it always comes back to the guy who is awake in the night and hears something getting closer and closer. I guess it's just my fate.[1]

Stephen King is now in demand not simply as a novelist but as a screenwriter, lecturer and, indeed, media personality—his work has been reviewed by *Time* magazine, to his chagrin, under the heading "Show Business." He has said that he hopes "to push away from the typewriter a little bit and let the well fill back up again":

I don't feel tired in the sense of writing. I feel tired in the sense of having to be a writer.

The commitments to things other than writing just keep growing . . . and it's a while before you see it as something less than benign. You justify things on the basis of your career: "It's good for the career." Or maybe, deep inside yourself, you say, "Wow, think of that! They want me on TV, or they want me to make a speech at this thing." And if you're young, or if you're not somehow freakish, with huge bumps growing out of your head, the celebrity machinery goes to work.

But there is a real sense here of having to be careful that you're not eaten alive, because I sense more and more, particularly in the wake of things like the death of John Belushi, that celebrity is a little bit like being a turkey that's being fattened up in the pen for something you'd rather not contemplate—which might be front-page headlines for The National Enquirer.[2]

But King's long-sought sabbatical from writing—and, more important, its business obligations—has never occurred. Late in 1984, his screenwriting work for Dino DeLaurentiis on *Cat's Eye* and *Silver Bullet* brought him an opportunity that could not be refused: the offer to write and direct a motion picture of one of his favorite

stories, "Trucks." In 1985, with King working hard on the film, soon to be known as *Overdrive*, his secret otherlife as "Richard Bachman" became public knowledge. The subsequent sales success of *Thinner* despite its close proximity to the publication dates of *The Talisman* and *Skeleton Crew* convinced both King and his publishers that his forthcoming books could be scheduled at a pace that matched that of his prolific writing. In a fourteen-month period beginning in September of 1986, no less than four new King novels will see print—while still other projects wait in the wings—and as the following preview reveals, the years 1986 and 1987 will prove active ones for both King and his ever-growing audience.

Overdrive

In the summer of 1986, MGM/UA released the thirteenth motion picture adapted from the fiction of Stephen King—a suitable number to mark the first film directed by the man whose name has become synonymous with modern horror. *Overdrive*,[3] the tale of an industrial counterrevolution, is the ultimate expression of King's passion for the monster in the machine, climaxing the natural progression from such short stories as "The Mangler" and "Uncle Otto's Truck" to the novels *Christine* and *The Tommyknockers*. It is a story that begins, like the 1950s science-fictional horror films that it echoes, in outer space:

FADE IN ON:
1 EXT. THE PLANET EARTH, FROM SPACE

It hangs in the center of the screen, enveloped in a gauzy film of atmosphere. Beyond that, nothing but black unwelcoming space.
These words appear:
"On June 19th, 1987, at 9:47 A.M. EST, the Earth passed into the extraordinarily diffuse tail of Rhea-M, a rogue comet."
And although the darkness of space does not change, the envelope of atmosphere surrounding the earth begins to glow very faintly.
"According to astronomical calculations, the planet would remain in the tail of the comet for the next eight days, five hours, twenty-nine minutes, and twenty-three seconds."[4]

Overdrive is based upon the early King short story "Trucks,"[5] which depicted a roadside cafe besieged by an army of driverless but

somehow sentient trucks. The premise is embellished strikingly for film; in the eight-plus days of the comet's broomlike sweep of our planet, every mechanical device imaginable—including electronic bank tellers, crossing lights, lawnmowers, even a drawbridge— takes on a bizarre and utterly antihuman life. The result is an existential horror-comedy that breeds the surreal side of King's fiction with the "Living Dead" films of his friend (and *Creepshow* director) George A. Romero.

The focus of action is the "Dixie-Boy Truck Stop," whose decidedly Southern greasy-spoon atmosphere is presided over by Hendershot (played by Pat Hingle). The manager, notes King's script, is "a fat cigar-smoker with a face which is simultaneously hard and sneaky-smooth. He looks like the kind of guy who could simultaneously pick your pocket, feel up your wife, and steal your silverware."[6] Hendershot looks on helplessly as, one by one, the truck stop's mechanical contrivances run awry—first a spurting gasoline pump, then a "rabid" electric knife and exploding video games—until the trucks come roaring to life, without drivers but with very clear intentions: the destruction of all human life.

A band of survivors, led by one of Hendershot's employees, parolee Billy Robertson (Emilio Estevez) and a young hitchhiker, Brett Brooks (Laura Harrington), barricade themselves within the truckstop diner and attempt to battle the invaders. But their every move is haunted with a disbelieving sense of betrayal; as the Dixie-Boy waitress, Wanda June, screams incessantly at the circling trucks: "We made you! Don't you understand? You can't do this, we made you!"[7]

They soon realize that the beeping of truck horns is not cacophony, but the first of several messages in Morse Code, demanding that the humans refuel the thirsty machines. As their final signal reveals, however, the trucks thirst for more than mere gasoline: "Bleed. It said they know all about us they need to know. We bleed."[8] And the machines finally move in force against their makers:

395 EXT. AND INT. THE ATTACK
OF THE KILLER BULLDOZERS

They crash into the restaurant portion of the building, moving with the perfectly coordinated rhythms of a first-class drill team. The long show-

window crashes inward, spraying glass. The PATRONS draw back,
shielding their faces; WANDA JUNE is shrieking.
The booths that were by the windows are shoved across the floor, splin-
tering and breaking. We see tread-marks on the flooring. Boards snap
under the weight of the 'dozers. The 'dozers withdraw, then come
again. They push over support beams and part of the roof comes down
with a crash.
All of this will be done in a number of shots; the director will know what
he wants.[9]

In *Overdrive*, the director also knew, for the very first time, what
Stephen King truly wants from a film adaptation of his fiction. But
in translating the written words of "Trucks" to the screen visions of
Overdrive, King has not signaled a departure from fiction for the
realm of motion pictures. "I've got a family to take care of," he says.
"I can imagine myself doing it again, but I can't imagine myself
doing it again very soon."

IT

In the fall of 1986, Stephen King's next new novel, *IT*,[10] will be
published. Although it is certainly premature to talk of a *magnum
opus* for a writer of King's age, no better description for *IT* is avail-
able. A multilevel, multiple-viewpoint novel told in two different
timestreams, the first draft of *IT*, completed in 1980 after a year of
writing, totaled more than eleven hundred manuscript pages. "The
book is a summation of everything I have learned and done in my
whole life to this point," King says. "And it's like a monster rally—
everything is in this book, every monster you could think of."[11]

The theme of *IT* was first expressed in King's short story "The
Boogeyman": "[M]aybe if you think of a thing long enough, and be-
lieve in it, it gets real. Maybe all the monsters we were scared of
when we were kids, Frankenstein and Wolfman and Mummy,
maybe they were real. Real enough to kill the kids who were sup-
posed to have fallen into gravel pits or drowned in lakes or were just
never found."[12] King comments:

It's nothing but the Biblical idea that faith can move mountains and
that faith proveth all things. So when this kid in IT believes that he is
seeing the Mummy coming toward him across the ice of a frozen river, it
really is the Mummy.

He is coming home late from school—he has helped the teacher put away the books. The sun is going down, and it is very cold, and the shadows seem blue on the snow. Because he's late and it's cold, he decides to cross the river on the ice. And when he looks around, he sees this figure far away; the wind is blowing in his direction and he can smell something like bad spices. He falls down on the ice and bumps his head. When he gets up, the thing is getting closer and closer; finally he can see all the rags streaming out behind it and the dark holes where its eyes were—and it doesn't cast a shadow. And he knows what it is, because he has just seen the movies on TV; then he realizes that it is real, *that he is really seeing the Mummy, and he tries to run, but keeps falling down on the ice. . . .*

It was wonderful—it gave me the creeps to write that.[13]

The nemesis of the novel's title is a creature that inhabits the sewers of Derry, Maine (which roughly parallels Bangor, but which is situated geographically to the south of Bangor, near Newport, Maine). Six adults return to the town, where they grew up, and learn that they have forgotten much of their childhood. As youngsters in 1958, they had, in an act of faith, descended into the sewers to confront and wound "It." The monster had allowed them to escape, intending to deal with them when they were older. And twenty-five years later, they must face It again:

None of these things had to be said, perhaps, and the reason why they didn't have to be said had already been stated: they all still loved one another. Things had changed over the last twenty-five years, but that, miraculously, hadn't. It was their only hope.

The only thing that really remained was to finish going through it, to complete the job of catching up, of stapling past to present so that the strip of experience formed some half-assed kind of wheel. . . . The job is to make the wheel tonight; tomorrow we can see if it still turns. . . .[14]

The novel promises to be a further turning point in King's writing —its theme of completing the wheel, previewed in his autobiographical novella "The Body" in *Different Seasons*, concerns a relinquishing of childhood by reexperiencing younger days from a mature perspective:

I've written the book in two parallel lines: the story of what they did as kids and the story of what they're doing as grownups. . . . I'm inter-

*ested in the notion of finishing off one's childhood as one completes
making a wheel. The idea is to go back and confront your childhood, in
a sense relive it if you can, so that you can be whole.*[15]

After Stephen King completed the massive first draft of *IT*, his
typewriter fell silent:

It was like the aftermath of The Stand. *I wasn't able to complete any-
thing for a while after* IT. . . . *For a period of about two years, I really
didn't finish anything except for some short stories.* Creepshow *inter-
vened, of course. But I worked on a book called* The Cannibals—*I
had started it about five years before, but it was called* Under the Dome
then. It didn't get finished either time.

 That's why, when Peter and I had made our way through The Talis-
man, *and I began work on* The Tommyknockers *and* The Napkins, *I
was so knocked over to learn that there was indeed life after* IT.[16]

The novels that Stephen King has written in the wake of *IT* are
significant departures from the supernatural horrors for which he is
known—a tale of psychological terror, *Misery*, and two imaginative
fables, *The Eyes of the Dragon* and *The Tommyknockers*, which
stretch the normally realistic bounds of his fiction to the realms of
fantasy and science fiction.

Misery

What is the price of a writer's fame and fortune?
 Stephen King speaks rarely of the dark side of his success—the
overeager fans, the genuine crazies, the never-private life, the
omnipresent specter of exploitation—but in the late summer of
1984, laboring beneath the weight of constant screenplay revisions
and ever-increasing demands for his time, a short novel exploded
from him, nearly final in its very first draft, that plumbed the
depths of a celebrity's ultimate fear.
 Misery (1987)[17] is the story of writer Paul Sheldon and his
number-one fan, Annie Wilkes. Sheldon has found international
fame through a series of historical romance novels about Misery
Chastain, a young Victorian adventuress; but what he considers to
be his "serious" work—mainstream novels written at length be-
tween the tales of Misery—has never gained critical or commercial
favor. After he decides to kill his famous heroine at the conclusion of

her latest adventure, he is freed to create a contemporary novel that transcends everything he has written before. But as he departs Boulder, Colorado, heading for the airport with the manuscript in hand and a bottle of Dom Perignon under his belt, a sudden snowstorm spins his automobile off the road, carrying Sheldon and his novel into an inferno presided over by his "number-one fan."

Sheldon awakens in a bed, his legs horribly crushed; but the nurse who stands over him is not from a hospital—not any longer, at least, for Annie Wilkes has stood trial because of the curious number of patients who died under her care. Her face is that of a dark goddess, an African idol carved of stone:

> . . . *Paul was frightened by what he saw on her face, because what he saw was nothing; the black nothing of a crevasse folded into an alpine meadow, a blackness where no flowers grew and into which the drop might be long. It was the face of a woman who has become momentarily untethered from all of the vital positions and landmarks of her life, a woman who has forgotten not only the memory she was in the process of recounting but memory itself. He had once toured a mental asylum— this was years ago, when he had been researching* Misery—*and he had seen this look . . . or, more precisely, this unlook. The word which defined it was catatonia, but what frightened him had no such precise word—it was, rather, a vague comparison; in that moment he thought that her thoughts had become much as he had imagined her physical self: solid, fibrous, unchanneled, with no places of hiatus.*[18]

Annie Wilkes, living out her days in the seclusion of a backroads farm, is the ultimate fan—indeed, she is a fanatic, to the point of naming her pig after Sheldon's Victorian heroine. She cares less for Sheldon than for her own twisted concept of what befits the creator of Misery; when she reads his new novel, she screams with rage, for her trap is but a microcosm of that constructed by Sheldon's Misery:

> *And while the woman might be crazy, was she so different in her evaluation of his work from the hundreds of thousands of other people across the country . . . who could barely wait for each new five-hundred-page episode in the turbulent life of the foundling who had risen to marry a peer of the realm? No, of course she was not. They wanted Misery, Misery, Misery. Each time he had taken a year or two off to write one of the other novels—what he thought of as his "serious" work with what was at first certainty and had then become hope and had finally*

transmuted itself into a species of grim determination—he had received a flood of protesting letters from these women, many of whom signed themselves "your number-one fan." The tone of these letters varied from bewilderment (that always hurt the most, somehow) to reproach, to outright anger, but the message was always the same: it wasn't what I expected, it wasn't what I wanted. Please go back to Misery. . . . He could write a modern Under the Volcano, Tess of the D'Urbervilles, The Sound and the Fury; *it wouldn't matter. They would still want* Misery.[19]

Annie Wilkes will not accept the blasphemy of Sheldon's decision to kill Misery; she forces Sheldon to write a novel just for her, bringing new life to his heroine—and the bedridden, helpless author soon realizes that when the book is completed, she will create the ultimate collector's edition . . . by killing him and binding the book in his skin. She is, after all, his "number-one fan."

Misery is a brilliantly sustained exercise in psychological suspense, set almost entirely in the single farmhouse room where its doomed writer is held prisoner. Paul Sheldon becomes a modern Scheherezade, realizing that his whole life hinges on Misery—that if there is an escape, a way back from his prison, it must come through his writing; for, as Montaigne said, "writing does not *cause* misery, it is born of misery."

The Eyes of the Dragon

During the final stages of Stephen King's collaboration with Peter Straub, *The Talisman*, King turned to writing something of a lark: a fairy tale for his daughter, Naomi, and Peter Straub's son, Ben. The story, originally titled *The Napkins*, soon grew into a short novel that King self-published in a limited edition of one thousand copies in 1984, well in advance of its mid-1987 trade publication.

The Eyes of the Dragon[20] is set in the Territories, the parallel world of *The Talisman*—that mythical, medieval land of kings and queens, two-headed parrots, and magic—although it occurs in a different place and time than Jack Sawyer's quest. Subtitled "The Two Princes," it is written in the style of the traditional fairy tale: "Once, in a kingdom called Delain, there was a King with two sons."[21] *The Eyes of the Dragon* is the story of Peter and Thomas, sons of Roland, the great king of Delain. Although Roland is old—

aged somewhere over seventy years—his sons are young, children of his autumnal marriage to his queen, Sasha.

When Sasha dies giving birth to Thomas, Roland, alone and lonely, falls beneath the spell of his closest adviser—the magician Flagg, who is indeed the same dark man who haunted the ruined America of *The Stand*. "He likes to go back and forth from our world to theirs—and to others as well," King says. "There are a lot of worlds out there, according to *The Talisman*, at least."[22]

King Roland's heart is failing; he will die soon—in a year or three, certainly no later than five—and "everyone in the Kingdom, from the richest baron and the most foppishly dressed courtier to the poorest serf and his ragged wife, thought and talked about the King in waiting, Roland's eldest son, Peter."[23]

But one man "thought and planned and brooded on something else: how to make sure that Roland's younger son, Thomas, should be crowned King instead. This man was Flagg, the King's magician."[24] His plot succeeds, toppling the King and placing Thomas— a cat's paw to Flagg's will—upon the throne; and Peter, accused of the murder of his father, is imprisoned in a cell at the tip of the tower-like Needle. But all is not lost, for Peter has received a strange legacy from his late mother—a lesson she had taught to him after a state dinner when he was but five years old:

Because she was a good mother, she first complimented him lovingly on his behavior and manners—and this was right, because for the most part his manners had been exemplary. In a five-year-old they had been almost eerie. But she knew that no one would correct him where he went wrong unless she did it herself, and she knew she must do it now, in these few years when he idolized her. So when she was finished complimenting him, she said:

"You did one thing wrong, Pete, and I never want to see you do it again."

Peter lay in his bed, his dark blue eyes looking at her solemnly. "What was that, Mother?"

"You didn't use your napkin," said she.[25]

The Tommyknockers

Late last night and the night before, Tommyknockers, Tommyknockers, knocking at the door . . .

Stephen King's *The Tommyknockers* (1987)[26] is a satirical inversion of the ultrapragmatic "hard" science fiction, which seemingly worships the technological solution over human emotion. The novel is focused upon people who play with things that they do not understand; it is intended to serve as a direct allegory for what we, as a nation, are doing with our collective lives:

> The Tommyknockers *is a gadget novel—it's about our obsession with gadgets. That's what our nuclear weapons, our Sidewinder missiles, all of those other tools of destruction are—just gadgets.*
>
> *Our technology has outraced our morality. And I don't think it's possible to stick the devil back in the box.*
>
> *Every day, when I wake up and turn on the news, I wait for someone to say that Paris was obliterated last night . . . by a gadget. It's only the grace of God that has kept it from happening so far.*[27]

In the novel, a peculiar madness descends upon the small town of Haven, Maine, after a reclusive novelist, Bobby Anderson, begins secretly digging up a piece of metal—soon revealed as the tip of an alien spacecraft—that is lodged in the earth outside of his farmhouse. Anderson is joined by his only friend, a hard-drinking, suicidal poet and sometime antinuclear demonstrator, Jim Gardener; but Gardener is somehow immune to the forces that have rendered Anderson and the other inhabitants of Haven into telepathic, intuitive geniuses, capable of extreme technological marvels. And only Gardener senses a dark side to the knowledge that the spacecraft offers:

> *That the ship in the earth was a font of wonderful, unbelievable creation was undeniable . . . but it was also the wrecked craft of an alien, unknowable species from somewhere out in the blackness—creatures whose minds might be as different from human minds as human minds were from the minds of spiders or scorpions. It was a marvellous, improbable artifact shining in the hazy sunlight of this Sunday morning . . . but it was also a haunted house where demons might still live between the walls and under the floors and in the spaces between.*[28]

There are indeed demons within the ship in the earth: "They accepted no absolute command; Tommyknockers was a name they accepted as casually as any other, but they were really interstellar gypsies with no king."[29] Their legacy, like that of our own science, is

offered without moral judgment; and the human animal is drawn irresistibly to taste of its fruits, regardless of the consequences:

> Bobby laughed softly. "Man, the idea that whether or not to dig something like that up is a function of free will . . . you might be able to slip that in at a high school debate, but we're sitting out on the porch, Gard. You don't really think a person chooses about something like that, do you? Do you think a person can choose to put away knowledge once he's seen its edge?"
>
> "I have been picketing the nuclear power plants on that assumption, yes," Gardener said slowly.
>
> Bobby waved this away. "Societies may choose whether or not to implement ideas, but individual people seeing something sticking out of the ground and saying, 'Well, it might be bad. Guess I'll leave it alone'? I don't think so."
>
> "And you didn't have the slightest inkling that there would be . . ." Fallout was the word that came to mind. He didn't think it was a word Bobby would like. [30]

One of the townspeople is intent upon ridding his property of woodchucks; he jerry-rigs an old record player to create a harmonic vibration that will drive the woodchucks up from the earth. What he fails to consider is the fact that, once the vibration is set in motion, it could destroy the entire planet. Another character, suspicious that a friend has been cheating at a weekly poker game, decides to be rid of him. As King explains, his actions vividly distill the book's message:

> He soups up a boogie-suitcase radio with a bunch of batteries and diodes from a "Simon" toy, and just sends him to Altair -4. He turns the thing on, and just blows him right out of the universe to this place that's like an interstellar attic, where you store the useless junk of the planets.
>
> And that's what I'm talking about in this book—a guy who doesn't know what he's doing, yet who creates something capable of just blowing someone else away. [31]

. . . Always More Tales

In the years to come, other long-anticipated King projects are likely to see print. One is the unexpurgated edition of *The Stand*, which will restore substantial portions of King's original manuscript

that were deleted from the version published in 1978 because of its massive length. The uncut edition will include, among other things, a prologue and epilogue; a long interlude involving the Trashcan Man's trek across the country to Las Vegas, in which he meets "the Kid," a reincarnation of Charles Starkweather; and Stephen King's "future shock" version of capital punishment. Publication of the unexpurgated *Stand* has hinged upon King's former hardcover publisher, Doubleday, whose ownership of certain contract rights proved a temporary roadblock, with the result that the book will not see print until late in this decade.

King also intends to complete the next installment of *The Dark Tower*, a five-story cycle titled *The Drawing of the Three*,[32] with plans for a limited edition book in 1987. Both he and his wife have contemplated sequels to *'Salem's Lot*,[33] but neither has committed their ideas to paper. And then there are the myriad afternoon projects—what King likes to call his "toys"—that he "plays" with after each morning of "serious" writing work:

> *I almost never think of an audience. I've got things so ridiculous that I can't be thinking of an audience. They amuse me and I don't have any idea whether they would amuse anyone else or not.*[34]

One example is *The Cannibals*, which King wrote in longhand during the filming of *Creepshow*, inspired by his living quarters in Monroeville, Pennsylvania:

> *I've got about four-hundred-and-fifty pages done and it is all about these people who are trapped in an apartment building. Worst thing I could think of. And I thought, wouldn't it be funny if they all ended up eating each other? It's very, very bizarre because it's all on one note. And who knows whether it will be published or not?*[35]

To Stephen King, it really does not matter if *The Cannibals* ever sees print. The question continually posed to him—"Why do you write this stuff?"—has a simple answer: *"Why do you assume that I have a choice?"*[36] Stephen King writes for himself, and that is enough. His obsession has proved marketable beyond his wildest dreams; yet despite the millions of people who have read his books, and the dollars that have been paid to publish them and to produce

them as motion pictures, it is the stories that remain important. As he wrote in *Different Seasons:* "It is the tale, not he who tells it."

And even as you read these pages, new tales are unfolding from the man who, in the 1980s, best deserves the title of America's storyteller. In the words of his namesake "Stevens" of "The Breathing Method," bidding a farewell to the visitor to the brownstone house at 249B East Thirty-fifth Street:

"Here, sir, there are *always* more tales."

APPENDIX A

The Bachman Books

"You were starting to sound a little like a Stephen King novel . . ."

— *Richard Bachman*

Late on the night of January 14, 1984, Stephen King and I huddled before a wood-stove fire, watching in silence as a terrifying blizzard descended upon Bangor, Maine. After a time, he handed me a manuscript entitled *Gypsy Pie*. His eyes were suddenly alight with sardonic humor.

"Dicky Bachman is back from the grave," he said. "I thought that the brain tumor had gotten him . . . but he's back again."

Some months before, King had started a new short story about a man who could not stop losing weight; the idea soon blossomed into a novel. Although he initially wished to publish the book—later called *Thinner*—under his own name, he had decided instead to resurrect an old friend whose true identity was known only to a select few: Mr. Richard Bachman.

The publishing world has long operated under the premise that readers will accept only one new novel from a "major" writer each year. By 1984, Stephen King had seriously challenged that assumption by producing an average of two bestselling books a year for several years. In fact, the prolific pace of his writing had consistently exceeded the artificial limits that marketing placed upon him. At the time that *Thinner* was written, *The Talisman* and *Skeleton Crew* were in production, three complete novels—*IT*, *The Eyes of the Dragon*, and *The Tommyknockers*—waited on his shelf, and other book-length works were in progress. Under publishing's ground rules, *Thinner* might not see print for four to five years as a novel by Stephen King.

Enter Richard Bachman, a pseudonym created in 1977 when King, riding the wave of his early bestselling successes, decided to again attempt to find a publisher for the pre-*Carrie* novel *Getting It On.* He contacted editor Elaine Koster at his paperback house, New American Library, which quickly agreed to issue *Getting It On,* without publicity, under an assumed name; indeed, only a few people at NAL were privy to the author's true identity. Retitled *Rage,* the book appeared in 1977 to the collective yawn of the mass market. Over the ensuing five years, three other Bachman paperbacks would be published by New American Library—*The Long Walk* (1979), *Roadwork* (1981), and *The Running Man* (1982)—but no one seemed to notice.

Bachman's original name was Guy Pillsbury (who was, in fact, King's maternal grandfather); but NAL, allegedly wary of a leak, requested a change. When King took the telephone call, he was listening to a song by the Canadian rock band Bachman-Turner Overdrive; on his desk was one of Donald Westlake's pseudonymous "Richard Stark" novels. The rest, as they say, is history.

Over the years, a bogus biography evolved: Richard Bachman was born in New York City in the early 1940s. Upon graduation from high school, he joined the Coast Guard, then sailed with the merchant marine for some ten years. He finally settled in rural New Hampshire, dividing his time between writing novels and tending to a small dairy farm. He and his wife, Claudia Inez (to whom *Thinner* is dedicated), had a single child, but the boy died at age six, drowned accidentally in a well. A variety of excuses were offered for Bachman's reclusiveness—his wife's illness, a cancer-ravaged face, and ultimately, a raving insistence that he was Stephen King. Then, after Bachman's fourth novel, *The Running Man,* appeared in 1982, doctors discovered the near-fatal brain tumor. Remarkably, he seemed quite normal in his first public photograph, which was displayed prominently on the dust jacket of *Thinner,* via a picture of Richard Manuel, a Minnesota homebuilder and friend of King's literary agent, Kirby McCauley.

King made no special effort to cloak the fact of his authorship of the Bachman books. With the exception of *Thinner,* the books were dedicated to persons associated with his early years of writing (such as teachers Charlotte Littlefield, Burton Hatlen, and Ted Holmes), and the copyright forms on each book, publicly available at the Library of Congress, bore the names of either King or his agent. Clues to Bachman's identity are scattered throughout the books—not simply in their repeated use of Maine settings, but also in specific King locations: the Blue Ribbon Laundry of the short story "The Mangler" is present in *Roadwork,* as is the fictitious town of Derry, which appears in several King stories. Indeed, the Stephen King-Peter Straub collaboration *The Talisman* playfully named one of its land-

marks as Bachman, Ohio. No one reading the Bachman books carefully could escape some suspicion of King's authorship, and by 1984, it was a persistent rumor within most quarters of the horror and fantasy community that Richard Bachman was indeed Stephen King.

The situation was, for King, at once pleasing and yet oddly disappointing. He had fulfilled his desire to have his early books published and read without the terrible burden of being identified with horror fiction's "brand name." It was the only way, he notes, "to publish stuff when I didn't want to be Stephen King. Paul McCartney used to talk about the idea of the Beatles going around to small clubs, playing gigs in masks or something—anything but as the Beatles. That's what Richard Bachman tried to do."[1]

But with the appearance of *Thinner*, it was only a matter of time before the secret was out. The book was different from its predecessors: a new work, not one that had gone unpublished, its textures matched readers' expectations of what a Stephen King novel should be (and indeed, a *Literary Guild* reader described *Thinner* as "what Stephen King would write like if Stephen King could really write"). With its publication in hardcover, backed by a major advertising campaign, *Thinner* was Richard Bachman's shot at bestsellerdom; but it also proved his downfall, for as interest in Bachman heightened, the rumors about his identity emerged in force.

It was a calculated risk. King, hamstrung by his two-book-per-year publishing schedule, wanted *Thinner* in print; but he also wanted more—an answer to a question that has haunted his incredible popular success:

> *You try to make sense of your life. Everybody tries to do that, I think, and part of making sense of things is trying to find reasons . . . or constants . . . things that don't fluctuate.*
>
> *Everyone does it, but perhaps people who have extraordinarily lucky or unlucky lives do it a little more. Part of you wants to think—or must at least speculate—that you got whopped with the cancer stick because you were one of the bad guys (or one of the good ones, if you believe Durocher's Law). Part of you wants to think that you must have been one hardworking S.O.B. or a real prince or maybe even one of the Sainted Multitude if you end up riding high in a world where people are starving, shooting each other, burning out, bumming out, getting loaded, getting 'Luded.*
>
> *But there's another part that suggests that it's all a lottery, a real-life game show not much different from "Wheel of Fortune" or "The New Price is Right" (two of the Bachman books, incidentally, are about game-show-type competitions). It is for some reason depressing to think*

it was all—or even mostly—an accident. So maybe you try to find out if you could do it again.
 Or, in my case, if Bachman *could do it again.*[2]

Unfortunately, Stephen King was unable to learn if Richard Bachman could repeat his success: "He died with that question—is it work that takes you to the top or is it all just a lottery?—still unanswered."[3] In February of 1985, beleaguered by inquiries from fans and the media, King publicly acknowledged Richard Bachman's true identity in a release to his hometown newspaper, the *Bangor Daily News. Thinner* had sold a respectable 28,000 hardcover copies as a Bachman book; but when labels were attached proclaiming "Stephen King writing as Richard Bachman," sales skyrocketed to more than 300,000 copies. By the fall of 1985, both the paperback edition of *Thinner* and a one-volume omnibus collection of the first four paperback novels, *The Bachman Books*, had topped the bestseller lists under the name of Stephen King.

Richard Bachman was dead. The cause, in King's words, was "cancer of the pseudonym."[4] His legacy was a quintet of novels that chart the development of a powerful young writer—and that answer definitively the question whether Stephen King can write anything other than horror fiction.

Rage (1977)

The first Bachman book was, in fact, the first mature novel written by Stephen King. *Rage*[5] was conceived in 1966, while King was a high school senior, and written over the following summer; a few years later, he found the manuscript, then known as *Getting It On*, moldering in the cellar of his mother's house. He rewrote the book in 1971, and its submission to Doubleday that year brought him to the attention of editor Bill Thompson, who would later purchase *Carrie* for that publisher. *Rage*, a mainstream testament of the horrors of adolescence, also proved a thematic precursor to King's breakthrough novel.

Charlie Decker, a senior in a small-town high school in Placerville, Maine, has been pushed too hard by life. He has crossed the border into the nightland of chaos: "There must be a line in all of us, a very clear one, just like the line that divides the light side of a planet from the dark. I think they call that line the terminator. That's a very good word for it."[6] After clobbering his chemistry teacher with a pipe wrench, he is expelled from school; but rather than leave, he literally becomes the terminator. He takes his father's pistol to Classroom 16, where he kills the algebra teacher, Mrs. Underwood, with a single shot to the head. Then he shuts the door, replacing her at the front of the class. As a different form of education begins its

session, Charlie announces his world view, the naturalistic perspective that would haunt many of Stephen King's later novels:

You can go through your whole life telling yourself that life is logical, life is prosaic, life is sane. Above all, sane. And I think it is. I've had a lot of time to think about that. And what I keep coming back to is Mrs. Underwood's dying declaration: So you understand that when we increase the number of variables, the axioms themselves never change.

I really believe that.

I think; therefore I am. There are hairs on my face; therefore I shave. My wife and child have been critically injured in a car crash; therefore I pray. It's all logical, it's all sane. We live in the best of all possible worlds, so hand me a Kent for my left, a Bud for my right, turn on Starsky and Hutch, *and listen to that soft, harmonious note that is the universe turning smoothly on its celestial gyros. Logic and sanity. Like Coca-Cola, it's the real thing.*

But as Warner Brothers, John D. MacDonald, and Long Island Dragway know so well, there's a Mr. Hyde for every happy Jekyll face, a dark face on the other side of the mirror. The brain behind that face never heard of razors, prayers, or the logic of the universe. You turn the mirror sideways and see your face reflected with a sinister lefthand twist, half mad and half sane. . . .

The other side says that the universe has all the logic of a little kid in a Halloween cowboy suit with his guts and his trick-or-treat candy spread all over a mile of Interstate 95. This is the logic of napalm, paranoia, suitcase bombs carried by happy Arabs, random carcinoma. This logic eats itself. It says life is a monkey on a stick, it says life spins as hysterically and erratically as the penny you flick to see who buys lunch. . . .

It's a roulette wheel, but anybody who says the game is rigged is whining. No matter how many numbers there are, the principle of that little white jittering ball never changes. Don't say it's crazy. It's all so cool and sane.[7]

Charlie finds solace in such a world, for there he is perfectly sane—although he admits wryly that he has "one slightly crooked wheel upstairs."[8] That spinning wheel of misfortune has shown him the cool logic of violent solutions, the only apparent means of making his classmates realize that their lives, too, are but part of a game. "I'm the sane one," Charlie insists: "I'm the croupier, I'm the guy who spins the ball against the spin of the wheel. The guy who lays his money on odd/even, the girl who lays her money on black/red . . . what about *them?*"[9]

Charlie holds his classmates hostage, challenging them to wager some-

thing more than the odd/even, black/red "push" of conformity. "I'm out of your filing cabinet now," he proclaims to the school principal—and to the world. "I'm not just a record you can lock up at three in the afternoon."[10] As the remainder of the school is evacuated and police SWAT teams lay their deadly siege, Charlie and his classmates begin "getting it on"—a perverse show-and-tell time that vents the rage that has collected within each of them: rage against the caste system of high school society, rage against the inequalities of fortune, rage against the seeming inevitability of their young lives. And true to Mrs. Underwood's word, as the variables change—student after student joining Charlie's mad endeavor—the axioms never change:

> At times I was almost tempted to feel (foolish conceit) that I was holding them myself, by sheer willpower. Now I know, of course, that nothing could have been further from the truth. I had one real hostage that day, and his name was Ted Jones.[11]

That hostage personifies the facades of superiority and of pandering to adult expectations; beneath the surface of Ted Jones, a seemingly All-American student—football quarterback, Student Council president, son of a bank officer—is corruption. As Charlie watches, his pistol rendered meaningless, the class turns its rage upon Jones, finally assaulting him with tribal ferocity. Charlie looks upon his works with despair, and glimpses the certain fate of oncoming adulthood:

> I closed my eyes and put my face in my hands. All I saw was gray. Nothing but gray. Not even a flash of white light. For no reason at all, I thought of New Year's Eve, when all those people crowd into Times Square and scream like jackals as the lighted ball slides down the pole, ready to shed its thin party glare on three hundred and sixty-five new days in this best of all possible worlds. I have always wondered what it would be like to be caught in one of those crowds, screaming and not able to hear your own voice, your individuality momentarily wiped out and replaced with the blind emphatic overslop of the crowd's lurching, angry anticipation, hip to hip and shoulder to shoulder with no one in particular.
> I began to cry.[12]

The Long Walk (1979)

At another time and in another place, another group of teenagers is attending a different kind of school. The second Bachman book, *The Long*

Walk,[13] depicts the ultimate rite of passage: a marathon test of endurance in which one hundred teenage boys march south from Maine's border with Canada. There is no stopping; each boy must maintain a constant speed of four miles per hour, with warnings issued when he falters. After three warnings, the contestant is eliminated—by rifle shots to the head. The sole survivor is granted a single wish as his reward.

The most direly pessimistic of Stephen King's novels, *The Long Walk* was written during his freshman year of college and later submitted to the Bennett Cerf/Random House first-novel competition. After its rejection via an anonymous, printed form, King decided not to offer the book for publication, showing it only to Burton Hatlen and other of his English professors at the University of Maine. *The Long Walk*, certainly the best of King's pre-*Carrie* novels, thus waited for ten years to be published, until King's editor at New American Library asked if Richard Bachman would have a follow-up to *Rage*.

The setting of *The Long Walk* is a bleak, science-fictional mirror of contemporary America in which World War Two extended into the 1950s and government has passed into the hands of the military. The Long Walk has become this brave new world's premier sporting event; held annually for a worldwide television audience, it draws an ever-eager host of contestants and billions of dollars in wagers. King laces the novel with game-show references—each chapter is prefaced by quotations from the likes of Bob Barker, Chuck Barris, and Art Fleming—and its military flavor evokes the draft lottery of the Vietnam era. When Ray Garraty, the novel's sixteen-year-old protagonist, first confronts the mentor of the Long Walk, he sees an imposing but curiously faceless figure; known only as the Major, he is masked by reflecting sunglasses and an endless litany of slogans:

> *"You're in the army now," Olson whispered with a grin, but Garraty ignored it. You couldn't help admiring the Major. Garraty's father, before the squads took him away, had been fond of calling the Major the rarest and most dangerous monster any nation can produce, a society-supported sociopath.*[14]

Garraty, like most of his companions, has joined the Walk impulsively, drawn by a sense of glory and the vague expectation of adventure. As the marathon begins, he is seemingly oblivious to the agony of the Walk—and to its one certainty, death. Garraty holds no real hope of victory; he simply trudges toward an aptly named goal—Freeport, Maine—where his mother and girlfriend wait for him. But as the road and its rifle-bearing enforcers take their toll of the marchers, his quest shifts focus, from mileposts to meaning:

Somewhere up ahead was Freeport. Not tonight or tomorrow, though. Lots of steps. Long way to go. He found himself still with too many questions and not enough answers. The whole Walk seemed nothing but one looming question mark. He told himself that a thing like this must have some deep meaning. Surely it was so. A thing like this must provide an answer to every question; it was just a matter of keeping your foot on the throttle. Now if he could only—

He put his foot down in a puddle of water and started fully awake again.[15]

Each further step on the Long Walk is a descent into the cold and muddy water of reality, an awakening to the forced march of life. Garraty and his companions recount their short years in tales of lost adolescence, and he slowly recognizes the true horror of the Walk:

Garraty licked his lips, wanting to express himself and not knowing just how. "Did you ever hear that bit about a drowning man's life passing before his eyes?"

"I think I read it once. Or heard someone say it in a movie."

"Have you ever thought that might happen to us? On the Walk?"

McVries pretended to shudder. "Christ, I hope not."

Garraty was silent for a moment and then said, "Do you think . . . Do you think we could live the rest of our lives on this road? That's what I meant. The part we would have had"[16]

Indeed, each of the walkers ages along the road; as the Walk moves from the backroads of Maine onto highways packed with spectators, it becomes a surreal allegory for life—Charlie Decker's version of life, with its wheel of fortune randomness and cruel inevitability. The odds-on favorite, probably the best physical specimen, ironically falls ill; the crowds surge to the roadsides to watch the massacre of the innocents, wagering maniacally on its outcome; and all the while, the shepherding soldiers watch impassively, delivering their warnings and death with mechanistic indifference. And as Garraty learns when he passes the last of his fellow competitors, dead on the pavement, there is no victory, no finish line. The Walk, and the road of life, goes on; its answers, if any, lie only with the dark figure of death:

Garraty stepped aside. He was not alone. The dark figure was . . . up ahead, not far, beckoning. He knew that figure. If he could get a little closer, he could make out the features. Which one hadn't he walked down? . . .

A hand on his shoulder. Garraty shook if off impatiently. The dark figure beckoned, beckoned in the rain, beckoned for him to come and

walk, to come and play the game. And it was time to get started. There was still so far to walk.

Eyes blind, supplicating hands held out before him as if for alms, Garraty walked toward the dark figure.

And when the hand touched his shoulder again, he somehow found the strength to run.[17]

Roadwork (1981)

In 1974, after completing *'Salem's Lot*, Stephen King turned again to an attempt to write a "straight" novel: "I was also young enough in those days to worry about that casual cocktail-party question, 'Yes, but when are you going to do something *serious*?' "[18] The result, *Roadwork*,[19] was relegated to a drawer of King's desk, destined to become Richard Bachman's third novel; it had touched something deep within him:

> *I think it was also an effort to make some sense of my mother's painful death the year before—a lingering cancer had taken her off inch by painful inch. Following this death I was left both grieving and shaking by the apparent senselessness of it all. I suspect* Roadwork *is probably the worst of the [Bachman books] simply because it tries so hard to be good and to find some answers to the conundrum of human pain.*[20]

Roadwork is the story of Barton George Dawes, an executive with a large industrial laundry who, in the winter of 1973, finds himself standing on the border of insanity: "He kept doing things without letting himself think about them. Safer that way. It was like having a circuit breaker in his head, and it thumped into place every time part of him tried to ask: *But why are you doing this?*"[21]

Bart Dawes walks, numbed, through a world that seems to act without asking that question. His life was once the seeming archetype of suburban contentment—he had worked his way up from high school laborer to manager, married a loving woman, fathered a lovely child—but it has fallen to pieces following the death of that child, a victim of cancer. He no longer wishes to think about asking the question "Why?", for he fears the answer:

> *. . . [I]f a collection of bad cells no bigger than a walnut could destroy all those things, those things that are so personal that they can never be properly articulated, so personal you hardly dared admit their existence to yourself, what did that leave? How could you ever trust life again? How could you see it as anything more meaningful than a Saturday night demolition derby?*

. . . [A]nd if the world was only a demo derby, wouldn't one be justified in stepping out of his car? But what after that? Life seemed only a preparation for hell.[22]

When the senseless construction of a new highway extension at the height of 1973's "energy crisis" demands the demolition of both the laundry and Dawes' home, his mental circuit breaker thumps into place for the final time. Dawes sabotages the suburban relocation of the laundry and refuses to purchase a new home, losing first his job, then his wife. Alone in his house, the sole remaining occupant of an entire neighborhood slated for destruction, Dawes plots a guerrilla war against the engines of progress— and their roadwork, which is nothing but a memorial to mindlessness:

> *"What do you think of it?" he asked her.*
> *"Am I supposed to think something?" She was fencing, trying to figure this out.*
> *"You must think something," he said.*
> *She shrugged. "It's roadwork, so what? They're building a road in a city I'll probably never be in again. What am I supposed to think?"*[23]

His fellow laundry employees, his neighbors, his wife—even the young hitchhiker he meets and loves for a night—all are on the run. Bart Dawes has decided to make his stand; like Charlie Decker, his seeming insanity may be a sign that he is truly sane. As Charlie says, "What must it be like for a suicide coming down from a high ledge? I'm sure it must be a very sane feeling. That's why they scream all the way down."[24] Dawes wires his home with explosives and waits, rifle in hand, for the authorities to attempt to evict him—and for the news cameras to record the results, with the hope that once, just once, people will think.

But their reaction is inevitable: "It's roadwork, so what?" And roadwork, as Dawes knows too well, never ends.

The Running Man (1982)

In many ways the least of the Bachman books, *The Running Man*[25] nevertheless is one of Stephen King's favorite novels. Although published in 1982, it had been written more than a decade earlier, in the dark days of 1971 following Doubleday's rejection of *Getting It On*. Completed in a blind heat—*The Running Man* was written in a mere seventy-two hours—it was declined by at least two New York publishers before consignment to the desk drawer that would later spawn four Bachman novels. "[I]t's nothing but story," says King. "[I]t moves with the goofy speed of a

silent movie, and anything which is *not* story is cheerfully thrown over the side."[26]

The Running Man is set in a dystopian America of the year 2025, where most of the population—unemployed, impoverished, and ravaged with the diseases of environmental neglect—sit dull-eyed in the wash of Free-Vee, a blackly comic exaggeration of contemporary television. Its entertainments include such game shows as "Treadmill to Bucks," in which chronic heart, liver, and lung patients risk death by walking an ever-speeding treadmill while answering trivia questions for cash.

Ben Richards lives among the forgotten masses in the confines of Co-Op City, a highrise urban wasteland. Jobless, he stares at the Free-Vee with growing desperation; his infant daughter's untreated influenza has forced his wife to work the streets as a prostitute. Richards seems perfect fodder for the Free-Vee Network's highest-rated program, "The Running Man." Its rules are simple: to win its prize of one billion dollars, a contestant must survive for thirty days, eluding a team of trained killers whose hunt, aired nightly on Free-Vee, is aided and abetted by citizens eager for cash rewards. This high-tech version of "The Most Dangerous Game" has never been won; indeed, the longest life span of a running man is eight days. But Richards is a different kind of contestant; something at once dreadful and compelling burns within him:

> He turned on her, grim and humorless, clutching something that set him apart, an invisible something for which the Network had ruthlessly calculated. He was a dinosaur in this time. Not a big one, but still a throwback, an embarrassment. Perhaps a danger.[27]

Ben Richards proves more than simply a danger to the game; he challenges the very society on which it is based. In escaping the hunters and besting their leader, he turns the rules of the game upon themselves. He is the antithesis of a running man—one who, like Bart Dawes and other King characters, has come to take his stand.

Told in one hundred short scenes stripped almost to the bare essentials of narrative, *The Running Man* is paced much like the early horrific pursuit novels of King's friend David Morrell, *First Blood* (1972) and *Testament* (1975). It is thus not surprising that its cinematic adaptation, produced in 1986 with Arnold Schwarzenegger in the title role, should be overseen by George Pan Cosmatos, the director of *Rambo: First Blood II* (1985).

Despite its emphasis upon action, *The Running Man* pursues several of King's persistent thematic concerns. "How could morality be an issue," Richards asks, "to a man cut loose and drifting?"[28] Richards is driven to violent solutions—there seems no other choice in a game-show world—but morality is, in the final trumps, the *only* issue. Richards' ambition is not

simply to beat the system; he wishes its total destruction, and brings it in a rain of holy fire, "lighting up the night like the wrath of God."[29]

Thinner (1984)

Stephen King's final outing in the guise of Richard Bachman was, appropriately, the only one of the books that could be categorized as a traditional horror novel. *Thinner*,[30] written some nine years after *Roadwork*, shows a decided maturation in King's style and a leavening of the pessimistic world view of the earlier Bachman books. Its protagonist, William Halleck, is an obvious departure from his predecessors in the Bachman canon: he is neither outcast nor questing man-child, but a fortyish, upper-middle-class lawyer from the Connecticut suburbs, engrossed in the rituals of luxury cars and country clubs. His life has gained a sense of comfortable balance; yet its fruits—partnership in a Manhattan law firm and a satisfying marriage that has produced, in turn, a beautiful teenage daughter—are linked inexorably with a single apparent vice. For Billy Halleck literally wears the sign of his idle prosperity; he is thoroughly and neglectfully overweight.

Then a caravan of Gypsies passes through town, and Billy Halleck, like so many King characters, falls victim to "the Krazy Glue of Inevitability"[32]: while driving one day, he is distracted by his wife's sudden sexual overtures and fails to see an elderly woman step into the path of his car. The woman is killed, but Halleck's white suburban prosperity assures that her death will be ignored by the institutions of justice: the police investigation is a lax whitewash, the judge is Halleck's golfing and poker buddy, and the victim was, after all, nothing but an itinerant Gypsy. When Halleck leaves the courthouse, charges of vehicular manslaughter conveniently dismissed, an ancient Gypsy man steps before him:

> *"Thinner," the old Gypsy man with the rotting nose whispers to William Halleck. . . . Just that one word, sent on the wafting, cloying sweetness of his breath. "Thinner." And before Halleck can jerk away, the old Gypsy reaches out and caresses his cheek with one twisted finger. His lips spread open like a wound, showing a few tombstone stumps poking out of his gums. They are black and green. His tongue squirms between them and then slides out to slick his grinning, bitter lips.*
> *Thinner.*[32]

That single word terrifies Halleck—that word, and the face of the ancient Gypsy: "Taduz Lemke . . . was the very eyes of age. In those eyes Billy saw a deep knowledge that made all the twentieth century a shadow, and he trembled."[33] Lemke, aged more than one hundred years, is the fa-

ther of the woman killed by Halleck. His single word is apparently a curse—and Halleck's weight, just over 250 pounds, begins to plummet dramatically despite his usual excesses. His physicians are stymied, offering endless explanations but no solutions, while his wife shrinks from his increasingly cadaverous frame with horror—and her own gnawing sense of guilt.

Thinner was inspired by Stephen King's own campaign to lose weight, triggered by his doctor's ominous advice to both reduce a ballooning waistline and stop smoking. He notes: "After I started really losing weight, I couldn't help but feel attached to it. There's a line in the book about how our version of reality depends a lot on how we see our physical size. I began to think about just what would happen if someone who began to lose weight found he couldn't stop."[34]

Halleck's reaction to the Gypsy's curse is surprisingly moderate when compared with the violent pathways of other Bachman characters. It is a view of age from Stephen King's own eyes:

> *It's easy to blame, easy to want revenge. But when you look at things closely, you start to see that every event is locked onto every other event; that sometimes things happen just because they happen. None of us likes to think that's so, because then we can never strike out at someone to ease the pain; we have to find another way, and none of the other ways are so simple, or so satisfying.*[35]

Halleck traces the Gypsy caravan to an encampment in Maine, intent on finding Lemke and attempting to explain the accident, but more than anything else, on simply apologizing. When he confronts Lemke, however, another glance into the Gypsy's face convinces him that contrition will not bring him peace: "The eyes of age, had he thought? They were something more than that . . . and something less. It was emptiness he saw in them; it was emptiness which was their fundamental truth. . . . Emptiness as deep and complete as the spaces which may lie between galaxies."[36]

Halleck had hoped to persuade Lemke to view the accident as a "push"—the result of an even wager at the high stakes roulette wheel of life. But Lemke disagrees; each of us, he says, must accept responsibility for our acts, regardless of our world view:

> *"What did you call it? A poosh. That what happened to my Susanna is no more your fault than my fault, or her fault, or God's fault. You tell yourself you can't be asked to pay for it—there is no blame, you say. It slides off you because your shoulders are broken. No blame, you say. You tell yourself and tell yourself and tell yourself. But there is no*

poosh, white man from town. Everybody pays, even for things they dint
do. No poosh. . . .
 "I feel a little sorry for you. . . . Once you might have been pokol—
strong. Now your shoulders are broken. Nothing is your fault . . . there
are reasons . . . you have friends." He smiled mirthlessly. "Why not eat
your own pie, white man from town?"[37]

Unable to convince the Gypsy, Halleck places his own curse upon him:
Richard Ginelli, a longtime friend known as "Richie the Hammer" in un-
derworld circles. Ginelli is a pragmatist—"I believe in only two things," he
says, "Guns and money"[38]—and although he indeed evens the odds,
Halleck cannot escape responsibility. He must literally eat his own pie—a
confection fashioned by Lemke and spiced with Halleck's blood . . . and
his guilt. For ultimately, as Taduz Lemke reminds us, "there *are* no curses,
only mirrors you hold up to the souls of men and women."[39]

When, with Richard Bachman unmasked, *Thinner* ascended onto the
bestseller charts, some people began to wonder: if there were one Stephen
King pseudonym, why not more?

Two rumors of other pseudonymous works, both of them spurious, have
circulated among readers and collectors of King's writing. The first began
early in 1985, when an overeager scholar claimed that the 1975 Laser pa-
perback *Invasion*, attributed to the admitted pseudonym "Aaron Wolfe,"
was written by King—ostensibly because this science-fiction novel hap-
pened to be set in Maine. It was soon revealed that *Invasion* was in fact au-
thored by another popular horror and science-fiction writer, Dean R.
Koontz. Then came a book review in a leading fantasy magazine of a
"deluxe hardcover edition" of the "John Wilson" porno novel *Love Les-*
sons, published originally in paperback by Bee-Line in 1968. The review,
which claimed that the book was actually written by Stephen King, was a
hoax perpetrated by science fiction's merry prankster, Charles Platt, upon
the book dealers and fans who obsessively collect King's books. When *Fan-*
tasy Review published the review without blinking, sternly worded letters
from King and his attorney were required to set the record straight.[40]

What few people knew was that Stephen King had indeed published one
other work under a pseudonym: "The Fifth Quarter," a crime story that
appeared in *Cavalier* magazine in the spring of 1972 under the by-line of
"John Swithen." "Even then," notes King with a rueful shake of the head,
"there was concern that I should be known as a writer of horror fiction."[41]

With the passing of Richard Bachman, these concerns—and the need for
further pseudonyms—may finally have ended. The sales success of *Thin-*
ner as a novel by Stephen King despite its release at roughly the same time
as *The Talisman* and *Skeleton Crew* persuaded King and his publishers to

embark upon the most ambitious publication schedule for a major author in decades, releasing four new novels in the space of only fourteen months between September 1986 and November 1987.

One of them, *Misery*, would have borne the name of the late—and for some of us, lamented—Richard Bachman.

Short Fiction

This appendix provides an alphabetically-ordered index to more than twenty years of short fiction published by Stephen King, from the self-published pamphlets of his teenage years, "People, Places, and Things" and "The Star Invaders," to his most recent story to date, "Popsy." Each entry in the index includes the story's title, the place and date of its first publication, and a brief plot synopsis (except in the case of longer works, such as "The Mist," that were discussed in detail in the text). The stories that appeared in the collections *Night Shift, The Dark Tower: The Gunslinger,* and *Skeleton Crew* are so identified. Interested readers may also wish to consult my primary bibliography to identify the anthologies where stories that were originally published in magazines and other ephemeral sources have been reprinted.

"Apt Pupil" (*Different Seasons*, 1982)
 See Chapter Eleven.

"The Ballad of the Flexible Bullet" (*The Magazine of Fantasy and Science Fiction*, June 1984; *Skeleton Crew*, 1985)
 Reg Thorpe, who has written a single bestselling novel before retreating into seclusion in suburban Omaha, sends his only other work of fiction, a story entitled "The Ballad of the Flexible Bullet," to a failing New York magazine. The story speaks profoundly of madness—the "flexible bullet"

or mental suicide to which the title refers—and the magazine's fiction editor soon learns of Thorpe's close acquaintance with the subject. Thorpe's letters claim that a creature called a "Fornit" lives in his typewriter; he warns, among other things, that the telephone system actually operates on radium and is responsible for the growing cancer rate. The editor, at the urging of Thorpe's wife, decides to humor Thorpe; but, fighting his own battle with alcoholism, he begins to experience the same madness that grips Thorpe. He becomes certain that a Fornit inhabits his typewriter; he loses his job, and nearly his sanity, until one day he receives a message from the Fornit that precipitates Thorpe's suicide and almost causes his death as well.

"Battleground" (*Cavalier*, September 1972; *Night Shift*, 1978)

Organization hit man John Renshaw has returned to his penthouse apartment after completing his most recent assignment: the termination of Hans Morris, founder and owner of the Morris Toy Company. A package is waiting for Renshaw, apparently sent by Morris's wife. Upon carefully opening the package, he finds inside a "G.I. Joe Vietnam Footlocker" manufactured by the Morris Toy Company; its contents—tiny toy infantrymen, helicopters, jeeps—are alive and ready for combat. Renshaw's apartment is rendered into a battleground by the plastic invaders; he fights back using his pistol, lighter fluid, anything available to him. Unable to overcome the miniature army, he walks the ledge between the windows of two rooms in order to outflank it; but the attackers have brought along superior firepower—a toy thermonuclear device—which provides, one could say, for an explosive ending.

"Beachworld" (*Weird Tales*, Fall 1984; *Skeleton Crew*, 1985)

In a distant science-fictional future, FedShip ASN/29 crashes on an alien world consisting only of sand: "It was a beach in no need of an ocean—it was its own ocean, a sculpted sea of sand, a black-and-white snapshot sea frozen forever in troughs and crests and more troughs and crests . . . Dunes and dunes and dunes, and they never end." As the two surviving crewmen wait doubtfully for help, their ship beyond repair, one of them, Rand, calls insanely for his Beach Boys tapes, claiming that the sand is alive. His partner, Shapiro, works feverishly to survive, but slowly begins to suspect that Rand is correct. When a trading ship arrives, bearing a motley crew of humans and androids in search of salvage, they find that the endless beach *is* alive, its rippling dunes forming into arms that beckon . . . and grasp. The traders rescue Shapiro, leaving Rand alone with the dunes, singing Beach Boys songs as he thrusts handful after handful of sand into his mouth.

"Before the Play" (*Whispers*, no. 17/18, August 1982)

Stephen King's novel *The Shining* was originally structured as a five-act Shakespearean tragedy, paralleling the play that Jack Torrance was at-

tempting to write at the Overlook Hotel; the original draft included a prologue and an epilogue—titled "Before the Play" and "After the Play" —that were deleted from the final version. The prologue, published in a special Stephen King issue of *Whispers* magazine, sets forth a sketchy history of the construction of the Overlook Hotel, and tells of a series of terrible events that would echo in the haunting of the Overlook, including the death of Boyd Watson, firstborn son of the hotel's builder, in a riding accident where the animal topiary would later stand; the night fears of a calculating society woman, whose honeymoon at the hotel eventually drives her to suicide; a masquerade party where the lackey—and former homosexual lover—of a Howard Hughes-like magnate mysteriously dies in a bathtub; and a brutal gangland slaying in the Presidential Suite. "The Overlook," its final line confirms, "was at home with the dead."

"Big Wheels: A Tale of the Laundry Game" (*New Terrors 2*, 1980; *Skeleton Crew*, 1985)

A segment of the aborted novel *Milkman*, "Big Wheels" recounts the drunken joyride of two laundry workers, Rocky and Leo, who set out one Halloween evening in search of a garage that will grant an inspection sticker to Rocky's wreck of an automobile. They come upon a service station owned by one of Rocky's old high school buddies. While they share a few beers, Leo rambles on about the large washing machines at the laundry—the "wheels" of the story's title—and suddenly claims that he has a hole in his back: that rainwater, leaking through the laundry's roof, has dripped onto his back so often as to cause a hole. Rocky later chastises Leo for telling about the hole: "Where am I gonna keep my rocks if you go around telling everybody?" Reality shifts from drunken hallucination to the seemingly supernatural with chilling logic in what Ramsey Campbell has properly called King's "strangest story."

"The Bird and the Album" (*A Fantasy Reader: The Seventh World Fantasy Convention Program Book*, 1981)

An excerpt from the novel *IT*.

"The Blue Air Compressor" (*Onan*, January 1971; revised version, *Heavy Metal*, July 1981)

In this most self-conscious of all King's stories (he even intrudes, by name, directly into the narrative, introducing himself and reminding us that "Rule One for all writers is that the teller is not worth a tin tinker's fart when compared to the listener"), we are introduced to Gerald Nately, a would-be writer who has rented a house from an enormous seventy-year-old woman, Mrs. Leighton. Nately decides to write a story about her; he shows her other manuscripts, but never her story. When she discovers the

manuscript, she laughs at it: "This is such a bad story. I don't blame you for using a pen name." (And the pen name is a "royal" one—perhaps King?) "I'm too big for you," she tells Nately. "Perhaps Poe, or Dostoevsky, or Melville . . . but not *you* Gerald." So Nately murders her, in fine E. C. Comics tradition, by stuffing the hose of a blue air compressor into her mouth and inflating her until she really *is* too big, whereupon she explodes. This story was directly inspired by an E. C. Comics tale.

"The Body" (*Different Seasons*, 1982)
See Chapter Eleven.

"The Boogeyman" (*Cavalier*, March 1973; *Night Shift*, 1978)
An important key to all of Stephen King's horror fiction, "The Boogeyman" offers the theme that would underlie his *magnum opus, IT:* "[M]aybe if you think of a thing long enough, and believe in it, it gets real." "I came to you because I want to tell my story," says Lester Billings, comfortably enthroned on the psychiatric couch of Dr. Harper. "All I did was kill my kids. One at a time. Killed them all." So begins Lester Billings' journey through the retrospective corridors of psychoanalysis. He quickly explains that he did not actually kill his three children, but that he is "responsible" for their deaths because he has left certain closet doors open at night, and "the boogeyman" has come out. A rational mind must reject such a confessional, and Billings is an abrasive personality—cold, insensitive, filled with hatred for the human condition. Immediately, we doubt his credibility and his sanity. By the story's close, Billings has made it clear that it is he who fears "the boogeyman," and the reader can only conclude that he has murdered his children. Dr. Harper states that therapy will be necessary, but when Billings returns to the psychiatrist's office, he notices that the closet door is open—first, just by a crack, but it quickly swings wide: " 'So nice,' the boogeyman said as it shambled out. It still held its Dr. Harper mask in one rotted, spade-claw hand."

"The Breathing Method" (*Different Seasons*, 1982)
See Chapter Eleven.

"Cain Rose Up" (*Ubris*, Spring 1968; *Skeleton Crew*, 1985)
"Cain Rose Up," a grim retelling of the murder spree of "Texas Tower" killer Charles Whitman, is one of King's earliest stories, and it remains one of his favorites. The school year has ended, and college student Curt Garrish has just completed his last examination. His dormitory seems barren and sterile; his roommate had departed two days earlier, and the remaining students seem dull, lifeless zombies. The day before, Garrish had surreptitiously brought his hunting rifle to his room. He calmly locks the door

and fondles the rifle; then he peers Godlike down its telescopic sight at the people on the mall below. And he begins to shoot.

"The Cat from Hell" (*Cavalier*, June 1977)

John Halston, a Syndicate hit man, is hired by a sickly millionaire to kill his household pet—a cat. The millionaire's fortune is based upon pharmaceuticals whose testing demanded the destruction of thousands of cats; he claims that his pet has murdered three members of his household in revenge, and intends to take his life next. Halston accepts the curious task, despite an immediate affinity with the cat: "They were the only animals he did like They got along on their own. God—if there was one—had made them into perfect, aloof killing machines. Cats were the hitters of the animal world, and Halston gave them his respect." The cat is indeed possessed with near-demonic power, and in the duel that follows, proves superior to Halston in the art of killing; the story climaxes in a grotesque stomach-bursting scene that predates a similar episode in the film *Alien* by two years.

"Children of the Corn" (*Penthouse*, March 1977; *Night Shift*, 1978)

This story, which was the first of Stephen King's short fiction to be adapted as a major motion picture, opens as Burt and Vicky Robeson are driving from Boston to California in a last-ditch effort to save their marriage. As they travel across deserted Nebraska backroads, an argument breaks out and Burt, distracted, apparently runs down a boy; when they examine the body, they find that the boy's throat has been slit. They drive to the nearby town of Gatlin to report the death, but it is seemingly deserted; Burt finds a series of curious clues: "Something happened in 1964. Something to do with religion, corn . . . and children." The children of Gatlin have killed their parents in the worship of something in the corn—"He Who Walks Behind The Rows," an unseen entity akin to "a pagan Christ that might slaughter his sheep for sacrifice instead of leading them." Indeed, the children sacrifice themselves to the corn when they reach their nineteenth birthdays. Burt and Vicky become the latest offering to their deity—who, says the nine-year-old seer and leader of the children, is nevertheless displeased . . . and who demands a lowering of the age of self-sacrifice to the eighteenth year.

"The Crate" (*Gallery*, July 1979)

Dexter Stanley, head of the Zoology Department at Horlicks University, is summoned to the basement of Amberson Hall one night to examine a crate that a janitor has discovered beneath the stairs. The coffinlike wooden box is dated 1834 and is marked with the imprint of an Arctic expedition. When Stanley, excited by the prospect of the contents, directs the

janitor to open the crate, he watches, horrified, as the janitor is ripped to shreds and apparently consumed by an unseen thing inside. A graduate student arrives; his disbelief of the shocked Stanley leads him to a similar doom. Stanley retreats to the house of his best friend and chess companion, English professor Henry Northrup, to tell of the horror and to enlist Northrup's aid. But Northrup is besieged by his own monster—his shrewish, castrating wife/mother, Wilma, who forever brays, "just call me Billie, everyone does." Northrup lures Wilma to the crate, forcing her upon the voracious creature inside; then he locks the crate and dumps it in a remote quarry, thus disposing of both monsters. This story was adapted by King as an episode of the motion picture *Creepshow*.

"Crouch End" (*New Tales of the Cthulhu Mythos*, 1980)
This story, especially written for a collection of tales inspired by the writings of H. P. Lovecraft, is essentially an in-joke; the Crouch End section of London was where Peter Straub lived when King first met him in 1977, when the story was written (see text at p. 140 above). At the outset of the story, a veteran police constable offers the Lovecraftian idea that "our whole world, everything we think of as nice and normal and sane, is like a big leather ball filled with air. Only in some places, the leather's scuffed down to almost nothing." Crouch End is one of those places, where our reality intersects with a darker, malevolent otherworld. An American couple, anxious to meet English friends who live in Crouch End, become lost—and find themselves on streets that do not appear on maps, streets whose occupants are distinctly inhospitable and ultimately monstrous. Soon the husband is lost; "Gone to Him Who Waits," a little boy tells the wife. And the policeman to whom she tells the story follows in his path.

"Cycle of the Werewolf" (1983)
See Chapter Thirteen. This novelette was adapted by King for the motion picture *Silver Bullet*.

"Do the Dead Sing?" (*Yankee*, November 1981; *Skeleton Crew*, 1985)
Stella Flanders, the oldest resident of Goat Island, Maine, is ninety-five years old and dying of cancer. In the midst of a bitter winter, when the Reach—the narrow waterway between Goat Island and the mainland—is frozen over for the first time in forty years, Stella has decided to leave Goat Island for the first time in her life, by walking across the Reach. She has begun to see ghosts from her past—memories of friends and of her childhood. And as she walks into a raging storm over the dark, frozen waters of the Reach, she meets those who have passed before her, standing hand-in-hand, singing hymns of grace. One of Stephen King's favorite and most highly symbolic stories, "Do the Dead Sing?" (published in *Skeleton Crew*

as "The Reach") won the World Fantasy Award for best short fiction of 1981. See Chapter One for a more detailed discussion of this story.

"Dolan's Cadillac" (*Castle Rock*, nos. 2 through 6, February through June, 1985)

Dolan, a high-priced hoodlum, is known for the silver-gray Cadillac Sedan de Ville by which he commutes from Las Vegas to Los Angeles on Route 71. The narrator, a grade school teacher, embarks upon a mad scheme to avenge Dolan's murder of his wife. He talks his way into a summer job with a Las Vegas road crew, gaining the experience needed for his ironic justice: he wants to bury Dolan and his Cadillac in the middle of Route 71. He waits for a suitable time and location—a holiday weekend and the beginning of roadwork—then digs a massive grave just beyond a detour sign. When Dolan's Cadillac finally appears in the distance, he shoves the sign away, and the car plummets into the trap. Dolan rages, bargains, screams—but as he echoes the words of Montresor, who succumbed to a similar fate in Poe's "The Cask of Amontillado," the narrator gleefully shovels a final spadeful of dirt over Dolan and his silver-gray coffin.

"The Fifth Quarter" (*Cavalier*, April 1972)

This hard-boiled crime story was written by King under the pseudonym John Swithen (even at that early date, *Cavalier* wished the King name to be identified solely with horror fiction). An anonymous narrator, described only as a young ex-convict, seeks revenge for the death of a friend who was double-crossed and executed after serving as the getaway driver for a Brinks truck robbery. The robbers, recognizing that the stolen money was new and its serial numbers recorded, had arranged for a trustworthy friend to hide the money on an island; his map, the sole evidence of the money's location, was divided into four quarters, one for each robber. But greed inevitably causes the partners to have a falling out, and the narrator's friend is the first casualty. The narrator becomes the "fifth quarter" of the story's title, bringing rough justice to the robbers, and collecting the pieces of the treasure map along the way.

"Firestarter" (*Omni*, July and August 1980)

An excerpt, in two parts, from the novel *Firestarter*.

"The Glass Floor" (*Startling Mystery Stories*, Fall 1967)

Stephen King's first professionally published story concerns the visit of Charles Wharton to the monstrous Victorian mansion of Anthony Reynard, in which his sister—Reynard's wife—has recently died. Wharton wishes to interrogate the aged Reynard about the rather unusual circumstances of his sister's death. She had fallen from a ladder while working in

an empty, abandoned room whose entire floor is a glass mirror—a room said to be accursed. Wharton insists upon an inspection of the room, which Reynard has had sealed off by a plaster wall; when the wall is torn down, Wharton enters the room alone. He stares, seemingly hypnotized, into the depths of the glass floor, and soon falls to his death, prey to the same strange fate that took his sister's life.

"Gramma" (*Weirdbook*, no. 19, Spring 1984; *Skeleton Crew*, 1985)

In this story, King drew upon a particularly frightening experience in his childhood—his discovery of the dead body of his grandmother. An eleven-year-old boy, George, is left alone to tend his grievously ill grandmother when his brother breaks a leg, requiring his mother to go to the hospital. Gramma has become an obscene parody of a human—blind, grossly overweight, senile, she simply lies in bed, a monstrous "fat slug" to George's eyes. As George nervously thinks of her, slumbering in the next room, we learn of the history of his family—including the fact that his grandmother could not bear children until she had read certain curious books, dabbling with the occult until driven out of the small town where she had lived by superstitious neighbors. As if fulfilling his darkest wish, George enters the sickroom to find that Gramma has apparently died; he places a mirror before her mouth, without results, as King had done at the death of his grandmother. But then she moves . . . and when she calls to him, "her voice was *dead*." This story was adapted by Harlan Ellison for the network television series *The Twilight Zone*.

"Graveyard Shift" (*Cavalier*, October 1970; *Night Shift*, 1978)

Hall, a drifter, has found his most recent job at a mill in Gates Falls, Maine—a mill infested with rats. He enjoys working the graveyard shift: "the hours from eleven to seven when the blood flow of the big mill was at it coolest." The foreman invites Hall to join a special crew that will clean the plant's basement, which has gone untouched for twelve years. The crew descends into a garbage-strewn, decayed landscape, confronting more rats—larger rats that "seemed to have forgotten all about men in their long stay under the mill." Soon, a subcellar is found. Hall and the foreman work their way into its depths, and find themselves in the midst of a literal army of mutated rats and bats; they force their way forward until they find the ultimate horror—a "huge and pulsating gray" rat "as big as a Holstein calf," but eyeless, without legs: "Their queen, then, the *magna mater*."

"Gray Matter" (*Cavalier*, October 1973; *Night Shift*, 1978)

The patrons of Henry's Nite-Owl know that Richie Grenadine has a taste for beer: "Usually he'd be by once a day to pick up a case of whatever beer

was going cheapest at that time, a big fat man with jowls like pork butts and ham-hock arms." After an injury at work, he simply stays at home, growing fatter and sending his son for his nightly case. But one day, his son arrives at the Nite-Owl with a frightening story: near Halloween, Richie drank a can of beer that wasn't right—afterward, his son saw gray dribble along its top. Richie keeps drinking his beer, but soon he insists that the apartment lights stay dark; then he begins hiding under a blanket. When his son finally sees him again, he is less a man than a mass of gray jelly—he demands that his beer be heated, and his appetite also grows decidedly strange. When a trio from the Nite-Owl decide to deliver the beer to Richie's apartment, they find a gray, protoplasmic monstrosity in the act of dividing in two.

"The Gunslinger" (*The Magazine of Fantasy and Science Fiction,* October 1978; *The Dark Tower: The Gunslinger,* 1982)

"The man in black fled across the desert, and the gunslinger followed." In the first "Gunslinger" story, we join Roland, the last gunslinger, in his pursuit of the man in black and the clues that he holds for Roland's quest for the Dark Tower. At a dusty oasis, Roland tells its lone inhabitant about his experience in the nearest town, Tull. Roland had arrived in Tull on the heels of the dark man, not realizing that a trap had been set. In the town's saloon, he is approached by a layabout who speaks the long-abandoned High Speech of royalty; he learns that the layabout had died, but had been raised back to life by the man in black. The dark man had also slept with the town's rabidly fundamentalist minister, convincing her that she was pregnant with an angel. On the Sunday after Roland arrives in Tull, she preaches against the gunslinger, calling him "the Interloper." Roland forces her to tell him the path taken by the man in black, but as he prepares to leave, he is set upon by the townspeople, who have been whipped into a religious frenzy, crucifying the once-dead layabout. Roland's guns speak for him; he must kill everyone in the town before he can escape and resume his search for the man in black. See Chapter Six.

"The Gunslinger and the Dark Man" (*The Magazine of Fantasy and Science Fiction,* November 1981; *The Dark Tower: The Gunslinger,* 1982)

In the fifth "Gunslinger" story, Roland, having sacrificed Jake in order to capture the man in black, is led by the dark man to an ancient killing ground. The man in black reads Roland's future using an unconventional tarot deck; then he offers him a vision of the place of this universe in the scheme of things—as an atom in a blade of grass . . . purple grass. Perhaps that blade has been cut down by a scythe: "We say the world has moved on; maybe we really mean that it has begun to dry up." The man in black reveals himself as a former member of Marten's entourage; and he identi-

fies his master, the magician Maerlyn, servant of the beast that is the Keeper of the Dark Tower. And as for the Tower: "Suppose that all worlds, all universes, met in a single nexus, a single pylon, a Tower. A stairway, perhaps, to the Godhead itself. Would you dare, gunslinger? Could it be that somewhere above all endless reality, there exists a room . . . ?" Roland sleeps. When he awakens, he has aged ten years; the man in black is a skeleton at his feet. And he walks on, toward the ocean— the last gunslinger, waiting for the next stanza in his quest for the Dark Tower. See Chapter Six.

"Here There Be Tygers" (*Ubris*, Spring 1968; *Skeleton Crew*, 1985)

Charles is a third-grader who desperately needs to go to the bathroom. His teacher, Miss Bird, embarrasses him before the class by noting this fact. She sends him on his way, but when Charles reaches the boys' room, he finds a hungry tiger sprawled on its floor. He retreats, confused but unwilling to incur Miss Bird's wrath by telling her about the tiger—she will surely dismiss it as a childish fantasy. Soon one of his tormentors, Kenny Griffen, is sent by Miss Bird to find him; Kenny laughs at Charles's belief that a tiger is in the bathroom, and enters. But he does not return; Charles steels himself and goes back inside, finding the tiger, now with a piece of torn shirt in its claws. Just as Charles finally relieves himself—in the wash basin nearest the door—Miss Bird walks in; he tries to explain, but she stalks to the place where the tiger waits. Charles leaves the boys' room and returns to his classroom, where he waits . . . and waits.

"Heroes for Hope" (*Heroes for Hope Starring the X-Men*, no. 1, December 1985)

Stephen King and illustrator Berni Wrightson, who had earlier collaborated on *Creepshow* and *Cycle of the Werewolf*, contributed a story-segment to this comic book, whose proceeds were donated to African famine relief and recovery. In the comic, the X-Men, a band of outcast, mutant superheroes, confront a world gone suddenly insane. When one of their number, Kitty Pryde, interrupts their musings with the seemingly mundane announcement that she wishes to eat, the King/Wrightson episode begins. A dark, hooded figure reaches from the shadows to touch her: "Dry hands settle over her face; its breath is rank with empty death. And yet she has never been so hungry . . ." Her body wastes away to a shriveled skeleton as he offers her a platter of swiftly rotting food. "I am," he says, "every hungry bloated belly, every dying eye, every picked bone drying in the desert. I am pestilence and desolation, Kitty . . . but my friends just call me *hungry*!"

"I Am the Doorway" (*Cavalier*, March 1971; *Night Shift*, 1978)

A manned orbital exploration of Venus ends in disaster when the returning spacecraft crashes into the ocean—one crewman is killed; the other, the story's narrator, Arthur, is crippled for life. Arthur takes up residence on Key Caroline, across the water from Cape Kennedy. Five years after the accident, his hands begin to itch; red welts appear on his fingers, and when he raises his hands to his face: "There were eyes peering up at me through splits in the flesh of my fingers But that is not what made me scream. I had looked into my own face and seen a monster." Arthur summons his friend Richard; he claims that he is the doorway for some alien intelligence, and that it has forced him to kill a boy. Richard doubts his friend's sanity, until he sees his hands, and then the things inhabiting Arthur have no choice but to kill Richard. Arthur thrusts his hands into a fire, effectively amputating them; but seven years later, the eyes return, now peering from his chest. This short story was the basis for the cover illustration of the initial paperback edition of *Night Shift*.

"I Know What You Need" (*Cosmopolitan*, September 1976; *Night Shift*, 1978)

One evening, while college student Elizabeth Rogan is studying in the Student Union, she is approached by a nondescript, strange boy who says, "I know what you need." He introduces himself as Ed Hamner, and he indeed somehow knows of Elizabeth's craving for an ice cream cone. They soon become friends; Elizabeth has never met anyone who "seemed to understand her moods and needs so completely or so wordlessly." When her boyfriend is killed, Ed is there to help heal the wounds; they become lovers. But Elizabeth's wealthy roommate, suspicious of a blatant lie told by Ed, arranges for a private detective to probe his background. She learns that Ed has known Elizabeth since the first grade; he was a nondescript stranger even then, but possessed of a singular ability of extrasensory perception that his father used to gain riches through gambling and the stock market. When Elizabeth confronts him, she sees him for the first time as he really is: "a little boy with a huge power crammed inside a dwarfed spirit." He knows what she needs; but "was she so small that she actually needed so little?" She walks away, alone, into the night.

"I Was a Teenage Grave Robber" (*Comics Review*, 1965)

Stephen King's first published story, written while King was in high school, appeared in a comic book fan magazine edited by Marv Wolfman (who would himself later gain some celebrity as a writer for both D. C. and Marvel Comics). It is the narrative of Danny Gerad, an orphaned and destitute teenager who is recruited to work as a grave robber for a mad scientist. While driving home one night, Danny rescues a girl from the

clutches of her drunken guardian, who also had worked for the scientist. Danny falls in love with her, but while they are on a date, he receives an urgent call to return to the laboratory. It is a shambles—the mad scientist has exposed the stolen corpses to radioactivity, which caused the maggots infesting the flesh to mutate, coalescing into three gigantic maggots. Danny manages to save his new girlfriend and to destroy the monsters, but only after the scientist is killed by his creations. Although clumsy and often unintentionally hilarious, this story demonstrates the strength of King's storytelling skills even at an early age.

"It Grows on You" (*Marshroots*, 1975; revised version, *Whispers*, no. 17/18, August 1982)

The Newall House in Harlow, Maine, was built in 1916. Painted white, enclosing twelve rooms, it "sprouted from many strange angles." The close-knit townspeople dislike the house, and they dislike its builder, rich outsider Joe Newall; but, as they often say, "It grows on you." A new wing is added to celebrate the pregnancy of Newall's wife, but the child is hideously deformed and expires within hours of its birth. Later, Newall's wife dies; then his farm animals die. Finally, he hangs himself inside the house. Nearly fifty years later, as the old men of the town—young when the Newall House was built—pass away, the house begins to grow again. Dana Roy dies, and a new wing is seen; Gary Paulson dies, and a new cupola starts to go up on the new wing. King has acknowledged the particular influence on this story of Davis Grubb—and specifically Grubb's classic horror story, "Where the Woodbine Twineth."

"The Jaunt" (*Twilight Zone Magazine*, April 1981; *Skeleton Crew*, 1985)

In the twenty-first century, long-distance travel occurs by a teleportation system known as "the Jaunt." Mark Oates takes his family along on an employment assignment to Mars, and in an effort to reassure his wife and two children, who are traveling by Jaunt for the first time, tells the story of the discovery of the system in the 1980s. Central to the story is the fact that no conscious life form has ever survived the Jaunt. The first human experiment saw its subject—a convicted murderer drafted for the task in lieu of capital punishment—emerge white-haired, drooling, to mutter "It's eternity in there," and then drop dead. Scientists speculate that, while the body moves instantaneously through the "warp" created by the Jaunt, the mind doesn't particulate—it remains whole and constant, moving slowly through the "warp." The solution is simple—travelers are sedated with anaesthetic gas, their minds sleeping through the journey. But after Oates finishes the story, his ever-inquisitive son holds his breath when given gas, feigning sleep. When the Jaunt concludes at Mars, he is "a creature older than time masquerading as a boy," gibbering madly and clawing at his

eyes. It is a haunting denouement that poses interesting parallels to *Pet Sematary*.

"Jerusalem's Lot" (*Night Shift*, 1978)

This story was written in 1967, as a course requirement during King's sophomore year in college. "There was a course in Gothic literature," he recalls, "and the final requirement was that we submit either a piece of short Gothic fiction or a term paper. The teacher was a crusty old bird . . . and he said, 'And I must warn you, ladies and gentlemen—if you choose to write fiction, my standards will be very high.' I got an 'A' on the story, but I didn't deserve it; the story wasn't so much Gothic as it was an outrageous Lovecraft pastiche." Told in epistolary style, "Blood calls to blood" is the story's refrain, and it recounts the journey of Charles Boone in 1850 to his ancestral home near the deserted Maine town of Jerusalem's Lot. Boone's interest in his heritage leads him to a desecrated church in the Lot; he finds evidence from sixty years before that leads him to believe that his ancestors' worship of faceless Lovecraftian entities has seen them taken in unholy bondage as *nosferatu* —the Undead. Boone returns to the church to destroy the cursed book by which his ancestors had opened the portals to the "Secret of the Worm"; and he realizes that he, as the last of the Boone blood, is now the gateway. "I go to the sea now," he writes, preparing for death. "My journey, like my story, is at an end."

"The Last Rung on the Ladder" (*Night Shift*, 1978)

An apt allegory for the rational being's battle with the fact of his or her mortality, this story concerns a childhood game played by brother and sister, Larry and Kitty, while growing up on a Nebraska farm. When their father was away, they would sneak into the barn and dive from a high loft into the hay stacked on the barn's floor: "[Y]ou'd come to rest in that smell of reborn summer with your stomach left behind you way up there in the middle of the air, and you'd feel . . . well, like Lazarus must have felt I remember Kitty telling me once that after diving into the hay she felt fresh and new, like a baby." But one day, the children have grown too old—the ladder to the loft collapses beneath their weight, and Kitty hangs precariously from a beam until Larry is able to scoop hay beneath her so that she may drop in safety. Years later, after they have reached adulthood and moved to different coasts, Kitty has soured on life and becomes a call girl in Los Angeles. She writes to Larry to come to her, but he is preoccupied with his work as an attorney. He receives her last plea too late; she commits suicide by diving from the roof of a building: "She was the one who always knew the hay would be there."

"The Lawnmower Man" (*Cavalier*, May 1975; *Night Shift*, 1978)

Harold Parkette's lawn is desperately in need of mowing. He had sold his Lawnboy the previous summer after a neighbor's dog chased a cat into its blades; and this year, he has put off hiring a local boy for the job. When, in late July, he sees a woodchuck on the overgrown back walk, he finally consults the classified advertisements and calls a number listed in the part-time help column. The lawnmower man arrives—grossly fat, with an aged red power mower in tow—and when he goes to work, the mower seems to run of its own volition, with the lawnmower man crawling behind it, stark naked and eating the cut grass. Parkette watches, aghast, as the mower veers to run down a mole and the lawnmower man gobbles up its remains. When he protests, the lawnmower man tells him that he works for Pan (a Greek god linked with fertility), and that a sacrifice is necessary. Parkette attempts to call the police, but the lawnmower tears through the house after him; when the police finally arrive, they find that Parkette has become the sacrifice.

"The Ledge" (*Penthouse*, July 1976; *Night Shift*, 1978)

Wealthy Organization overlord Cressner traps Norris, a tennis pro who has fallen in love with Cressner's young, attractive wife, and offers him a unique wager. If Norris can successfully navigate the ledge around Cressner's penthouse apartment, Norris will have twenty thousand dollars, freedom, and Cressner's wife. Norris has no real alternative—if he refuses, Cressner will alert the police to the heroin that has been conveniently planted in his car. Norris reluctantly steps out onto the five-inch-wide concrete ledge, perched some forty-three stories in the air. He manages to survive the perilous circumnavigation despite dangerous crosswinds and an attack by a seemingly demonic pigeon. Cressner does not welsh on his wager; but he reveals that his wife, whom Norris is free to have, is now but a dead body in the morgue. Norris overcomes Cressner's bodyguard and, brandishing a pistol, offers Cressner a bet: the ledge against Cressner's life. This story was adapted by King in his screenplay for the motion picture *Cat's Eye.*

"The Man Who Loved Flowers" (*Gallery*, August 1977; *Night Shift*, 1978)

A handsome young man walks down a New York City street on a soft and beautiful May evening. He passes a flower stand, hesitates, and thinks: "He would bring her some flowers, that would please her." He buys a bouquet, then walks on; everyone on the streets seems to notice him, and to notice that he is obviously in love. When he seemingly reaches his destination, a dark and shadowed lane, a girl walks toward him. He calls for her—"Norma!"—but she says that he is mistaken, that that is not her name; and as he hands her the flowers, he too realizes that she is not

Norma—that Norma has been dead for ten years. He kills the girl with a hammer, just as he has killed so many others before her—"her name had not been Norma but he knew what his name was. It was . . . *Love*." As he walks on in the moonlight, a woman sees him and thinks: "[I]f there were anything more beautiful than springtime, it was young love."

"The Man Who Would Not Shake Hands" (*Shadows 4*, 1981; revised version, *Skeleton Crew*, 1985)
This Kiplingesque story is structured as a tale told before the hearth at a private men's club; it begins as an elderly, normally closed-mouthed member of the club says: "I once saw a man murdered right in this room . . . although no juror would have convicted the killer." He proceeds to tell of the single visit to the club, more than fifty years before, of one Henry Brower, a man who would not shake hands—and the peculiar poker game that ensued. The loser of the climactic hand of poker, which Brower takes with a straight flush, peevishly grabs and shakes Brower's hand; Brower runs screaming into the night. It is later learned that Brower, while visiting India, had accidentally caused the death of the son of an obscure holy man. The wallah had placed a curse upon Brower—that any living thing he touches with his hands will die. Believing the curse, he becomes an outcast; his visit to the men's club is a last attempt to find understanding companionship. But the club member who shakes his hand indeed dies; the others learn that Brower has committed suicide. "I've seen all kinds," says the innkeeper who finds his body, "but he's the only one I ever seen that died shakin' his own hand."

"Man with a Belly" (*Cavalier*, December 1978)
John Bracken, a Syndicate hit man, is hired by aged Don Vito Correzente to make an unusual hit: the brutal rape of Correzente's young, elegant wife, a rich society girl who married Correzente in order to support her compulsive gambling. The Don, cuckolded by his own wealth, is called a "man with a belly" in Sicilian argot—he wears his pride outwardly, and is never afraid to show an iron fist. But his object lesson backfires when Bracken, after making the "hit," is hired by the wife to gain revenge—by impregnating her. And the circle turns again: the wife tells the Don that she wishes to bear his child, and his repeated efforts to impregnate her precipitate a stroke, from which he ultimately dies—but only after his wife dies in childbirth. The Don calls Bracken to his deathbed, apparently to hire Bracken to "hit" the baby. But Bracken, too, is a "man with a belly"—he will not "take of his own leavings."

"The Mangler" (*Cavalier*, December 1972; *Night Shift*, 1978)
Based upon King's experience as a laborer in an industrial laundry, this story involves an electric speed ironer and folder that seemingly takes on a

life of its own, maiming and killing laundry workers. John Hunton, the police officer who investigates the latest "accident," begins to suspect that more than misfortune is involved. He learns that the problems with the machine began when a high school girl—a virgin—cut her hand on the device. Hunton enlists the aid of his friend, an English professor with an interest in the supernatural; they decide that the machine must be possessed by some form of demon. But when they attempt an exorcism, Hunton is "swept with a bone-freezing terror, a sudden vivid feeling that it had gone wrong, that the machine had called their bluff—and was stronger." The mangler tears itself from the floor, killing the professor and then stalking out into the streets in search of prey.

"The Mist" (*Dark Forces*, 1980; revised version, *Skeleton Crew*, 1985)
 See Chapter Nine.

"The Monkey" (*Gallery*, November 1980; *Skeleton Crew*, 1985)
 When Hal Shelburn's elderly aunt suddenly dies, he travels with his family to Maine for the funeral. His older son finds a broken toy—a wind-up, cymbal-clapping monkey—in the attic of her house. Hal looks at the monkey in horror; it is the same toy that, twenty-five years before, he had thrown down a dried-up well behind the house. As a boy (like Stephen King), he had discovered boxes containing possessions of his long-departed merchant mariner father; inside one carton was the monkey. Because of its broken clockwork, it would not clap its cymbals—unless, Hal learned, it wanted to. And the clap of its cymbals omens, or indeed causes, death in close proximity to Hal—after its first sound, his babysitter is murdered; again, and his brother's best friend is killed by a car that just misses his brother; again, and his mother dies of a brain embolism. And now the monkey has returned, offering its grim fascination to Hal's children. The monkey becomes a symbol for outside, predestinate evil: "It might be . . . that some evil—maybe even most evil—isn't even sentient and aware of what it is . . . like a monkey full of clockwork." With his younger son, a seeming mirror-image of himself as a child, Hal casts the monkey into the deepest part of a nearby lake; but its evil does not die.

"The Monster in the Closet" (*Ladies' Home Journal*, October 1981)
 An excerpt from the novel *Cujo*.

"Morning Deliveries" (*Skeleton Crew*, 1985)
 As dawn breaks on Culver Street, a sound grows quietly from the silence: "the decorously muffled motor of a milk truck." Across the truck's side are the letters CRAMERS DAIRY and MORNING DELIVERIES OUR SPECIALTY. But as the milkman—named, with some irony, Spike—

makes his rounds, the deliveries prove more and more curious. At the Mackenzies' house, he leaves milk, juice, and cream; at the McCarthy's house, a carton of chocolate milk, empty but for a tarantula; at the Webbers', a bottle of all-purpose cream, filled with an acid gel. On he moves, dropping off milk here, yogurt there, a little eggnog laced with belladonna, a bottle containing cyanide. Finally, the milkman reaches the Mertons' house, only to find a note that reads "Cancel." He opens their door; inside, he finds a house stripped not only of its furniture, but also its wallpaper—its blank walls are now decorated with a huge splash of dried blood, bones, and hair. A surreal vignette from the uncompleted novel *Milkman*.

"Mrs. Todd's Shortcut" (*Redbook*, May 1984; *Skeleton Crew*, 1985)

"A woman wants what a man wants," Ophelia Todd tells her caretaker, Homer Buckland. "[A] woman wants to *drive*." Ophelia is fond of driving her convertible Mercedes sports car—and she is seemingly obsessed with finding shortcuts on the Maine backroads outside of Castle Rock. When Homer rides with Ophelia, she seems to look like the goddess Diana, driving the moon across the sky—faster, ever faster. The roads she travels are often unknown to him, and frighteningly so: one features huts with thatched roofs, while on another, the branches of trees seem to reach toward the car. Ophelia tells Homer that she has found a route to Bangor that is shorter than straight-line mileage on a map; after she drives that route, Homer finds, beneath the front bumper of her car, the remains of a type of animal he has never seen before. Then one day, Ophelia disappears; ten years pass before she returns—younger, looking even more like a goddess. And this time, Homer Buckland rides off with her, into the night.

"The Night of the Tiger" (*The Magazine of Fantasy and Science Fiction*, February 1978)

Jason Indrasil, the lion tamer for a traveling circus, fears only two things: the circus's huge tiger, called Green Terror, and the mysterious Mr. Legere, who for nearly twenty years has followed the circus from town to town on its midwest swing, standing and watching silently at the cage that holds Green Terror. The narrator, a young roustabout spending his first summer with the circus, tells of the strange, silent battle of wills between Indrasil and Legere—a battle that reaches a climax one night in Oklahoma when a heat wave breaks in the frenzy of a tornado. In the midst of the storm, with the roustabout as the sole witness, Indrasil and Legere face off, Legere loosing Green Terror from its cage, seemingly controlling it with his mind, while Indrasil's body strangely shifts into the form of a tiger.

"Night Surf" (*Ubris*, Spring 1969; revised version, *Cavalier*, August 1974; *Night Shift*, 1978)

This story, in which King first used the "superflu" that would play an important role in *The Stand*, concerns a group of teenagers and their grim frolic along the resort beaches of southern Maine as they wait for seemingly inevitable death from the superflu "Captain Trips." Bernie, the narrator, tells of how the teenagers offer up a sacrifice, burning a diseased man whom they find in an automobile. He tells of how one of the group has become infected; and he tells of the night surf, rolling implacably in to shore, as unstoppable as "Captain Trips." But primarily, he tells about himself—not simply by what he says, but by what he chooses to say. His story is of the tragicomedy of regret: a childhood—and a world—that he cannot regain, buried beneath the ironic epitaph "Just the flu." In the revised version of this story which appeared in *Night Shift*, the source of the superflu is said to be Southeast Asia; there are elements of allegory relative to America's war in Vietnam and intriguing parallels with "Children of the Corn."

"Nona" (*Shadows*, 1978; *Skeleton Crew*, 1985)

The narrator, a hitchhiking college dropout, befriends a beautiful girl—Nona—at an interstate truck stop. They seem somehow linked in spirit: "It wasn't love . . ." the narrator tells us. "I wouldn't dirty that word with whatever we had—not after what we did, not after Blainesville, not after the dreams." They hijack a car and, seemingly at her bidding, set out on a murder spree; their story intermingles the true story of Charles Starkweather, with whom King has long had a fascination, with the American folk tale of the "vanishing hitchhiker." The path of their violence leads to Blainesville, Maine, the home town of the narrator, where Nona leads him to the graveyard, and one particular grave—that of "his girl," an oblique reference to his long-dead mother (who may, indeed, be Nona—although King never tells us so). When the police arrive, Nona is gone—the authorities claim that he alone committed murder after murder on the highways. But he demurs: "She was with me, she was real, I love her. True love will never die."

"One for the Road" (*Maine*, March/April 1977; *Night Shift*, 1978)

In the midst of a brutal Maine blizzard, Herb Tooklander begins to close down Tookey's Bar for the night, offering his only customer, Booth, a last drink—"one for the road." The door bursts open, and a man staggers in; his car has gone off the road, and he has left his wife and daughter, walking six miles to find help. Tooklander and Booth pale as he mentions the site of the accident—near the town of Jerusalem's Lot. They drive him back to rescue his family, warning of the strange fate that has befallen 'Salem's Lot, but he ignores them—just as he ignores them when he sees his

wife, floating over the snow toward them: "She was a dead thing somehow come back to life in this black howling storm." As Tooklander and Booth retreat to their truck, Booth sees a little seven-year-old girl in the snow. "I want to give you a kiss," she says; but Tooklander hurls a Bible at her, and she recoils in horror. "Whatever you do, don't go up that road to 'Salem's Lot," Booth tells us. "Especially not after dark."

"The Oracle and the Mountains" (*The Magazine of Fantasy and Science Fiction*, February 1981; *The Dark Tower: The Gunslinger*, 1982)

In the third "Gunslinger" story, the gunslinger Roland and his young companion, Jake, continue "the endless hunt for the man in black through a world with neither map nor memory." Exhausted, they camp in a grassy oasis, and as the gunslinger sleeps, he suffers a nightmare of death and destruction. Snapping awake, he realizes that Jake is gone; the boy has walked in his sleep to a circle of stones, drawn by an invisible succubus: "A demon with no shape, only a kind of unformed sexual glare with an eye of prophecy." Roland rescues him, then returns alone, demanding a prophecy; the oracle responds: *"Three. This is the number of your fate The boy is your gateway to the man in black. The man in black is your gate to the three. The three are your way to the Dark Tower."* Roland and Jake journey onward, crossing a cyclopean mountain range, climbing ever higher until confronted by an insurmountable wall of granite— where, above them, the man in black appears. The gunslinger's eager pistol shots miss his target; the man in black taunts him, but says, "On the other side we will hold much council." And he looks to the boy, and adds: "Just the two of us." See Chapter Six.

"People, Places, and Things—Volume I" (1963)

Young Steve King and his friend Chris Chesley printed this pamphlet in 1963, collecting a series of eighteen one-page short stories they had written between 1960 and 1963. It is the earliest surviving document of King's creative writing, and is devoted entirely to tales of horror and black irony; as its introduction states: "We warn you . . . the next time you lie in bed and hear an unreasonable creak or thump, you can try to explain it away . . . but try Steve King's and Chris Chesley's explanation: People, Places, and Things." In "The Hotel at the End of the Road," two criminals seek sanctuary in a backroads hotel but find themselves living mummies in an outré museum. "I've Got to Get Away!" laments a futuristic factory worker, unaware that he is a robot. A spoiled brat gets his comeuppance from "The Thing at the Bottom of the Well." Two space explorers on "The Cursed Expedition" are doomed to face something very much like King's "Beachworld." In the pamphlet's only collaboration, King and Chesley warn "Never Look Behind You," and tell of the fate of the man who did just

that. Other King stories included here are "The Dimension Warp," "The Stranger," "I'm Falling," and "The Other Side of the Fog."

"The Plant" (1982-1983, 1985-)

Beginning in 1982, Stephen King has circulated Christmas greetings to his friends in the form of self-published episodes of a comic horror novel-in-progress. "The Plant," told in epistolary style, is the story of John Kenton, an editor at Zenith House, a down-at-the-heels New York paperback publisher. Kenton receives a book manuscript called *True Tales of Demon Infestations* from one Carlos Detweiller, an employee at the Central Falls, Rhode Island, House of Flowers. Included in the package are photographs of an apparently authentic human sacrifice. But when Kenton alerts the police, their investigation finds the "victim" alive and well and working at the House of Flowers. Detweiller quits his job and disappears; then Kenton receives a mysterious plant, obviously sent by Detweiller. . . .

"Popsy" (*Masques II*, 1987)

Briggs Sheridan, a compulsive gambler unable to pay his mounting debts, takes on a desperate occupation: kidnaping children for hire. One day, he snatches a small boy from the Cousintown shopping mall, after finding him lost and teary-eyed, in search of his "Popsy." Sheridan lures the boy to his van, and although the child fights—and bites—he is finally overcome, handcuffed, and made ready for delivery to Sheridan's nefarious employer. "You'll be sorry," the boy says as they drive across the countryside. "He'll find me," he warns. "He can smell me . . . My Popsy can fly." And indeed the disbelieving Sheridan soon hears the flapping of wings overhead; then he sees a billowing cape. Popsy's hand—"more like a talon than a real hand"—smashes through the window, and Sheridan, the hunter, becomes the prey; for both Popsy and his grandson are thirsty.

"Quitters, Inc." (*Night Shift*, 1978)

Jimmy McCann introduces a business acquaintance, Dick Morrison, to Quitters, Inc.—the ultimate system for ending the smoking habit. Morrison does not learn its methods, however, until after he has signed the contract. Founded by the bequest of a Mafia kingpin who died of lung cancer, Quitters, Inc. believes that "a pragmatic problem demands pragmatic solutions." Its clients must stop smoking immediately; they are kept under constant surveillance, and each instance of surrender to the craving to smoke is met with escalating sanctions: from electric shocks to the client's wife for the first "offense" to termination, with prejudice, of the ten-time offender. "[E]ven the unregenerate two percent never smoke again," Morrison is told. "We guarantee it." This story was adapted by King in his screenplay for the motion picture *Cat's Eye*.

"The Raft" (*Gallery*, November 1982; *Skeleton Crew*, 1985)

Set in the same fictional suburban Pittsburgh as "The Crate" and *Christine*, this story serves as a seasonal counterpoint to "Strawberry Spring." It is a graphically violent tale of the loss of innocence, following four Horlicks University students—two boy-girl couples—who, at the late October ending of a long Indian summer, decide to go for a swim at a remote lake. Their inspiration is the sighting of the wooden raft that floats on the lake during the summer; someone has forgotten to bring it in for storage. The raft becomes a symbol of unconscious resistance to the adulthood that each student must soon face—"summers seemed to last forever when she was a girl; but now . . . they got shorter every year." When the couples swim to the raft, they find, lurking nearby, an oddly circular black patch on the water, something like an oil slick. It is soon revealed as a carnivorous monstrosity that casts a hypnotic spell upon those who stare into its depths; and, one by one, it kills the students, literally assimilating them into its dark, wastelike mass. This story was adapted by George A. Romero in his screenplay for the motion picture *Creepshow II*.

"The Reach"

See "Do the Dead Sing?"

"The Reaper's Image" (*Startling Mystery Stories*, Spring 1969; *Skeleton Crew*, 1985)

Stephen King's second professionally published story concerns a rare antique mirror, in which certain chosen people allegedly see the black image of the Grim Reaper—and then walk away, never to be seen again. John Spangler, a disbelieving art afficionado, inspects the mirror, which has been placed in storage after the most recent incident. As the nervous caretaker looks on, Spangler sees a dark spot in the mirror, which he first insists is masking tape intended to cover a crack; but then he grows suddenly hot and nervous, and leaves to get a drink of water. The caretaker is left waiting, although he knows that, like the others who have seen the Reaper's image, Spangler will never return.

"The Return of Timmy Baterman" (*Satyricon II Program Book*, 1983)

An excerpt from the novel *Pet Sematary*.

"The Revelations of 'Becka Paulson" (*Rolling Stone*, July 19/August 2, 1984)

During her annual spring cleaning, 'Becka Paulson unearths a target pistol that her husband, Joe, had won years before in a raffle. Gun in hand, she stumbles off her stepladder: "As she fell, she realized she looked more like a woman bent on suicide than on cleaning." 'Becka awakens with a

hole in her head, but no memory of the gun; soon, a 3-D picture of Jesus that she keeps on the television set begins to impart scandalous revelations about her friends and neighbors . . . and her husband, who, Jesus correctly notes, is "putting the boots" to another woman. 'Becka "couldn't live with such an awful outpouring"; following Jesus's instructions, she wires the television to electrocute her wayward husband. As he dies, the television screen glows with pictures of her revelations—and finally, of her "fall" from the stepladder, "more like a woman bent on suicide. . . ." She joins her husband in death. An excerpt from the novel *The Tommyknockers*.

"The Revenge of Lard Ass Hogan" (*The Maine Review*, July 1975; revised version in "The Body," *Different Seasons*, 1982)

A thematic bookend to *Carrie*, "The Revenge of Lard Ass Hogan" is the story of a down-trodden junior-high-schooler, two-hundred–and-forty-pound David Hogan, better known as "Lard Ass." His revenge takes place at his small town's annual pie-eating contest (held, like the "Black Prom" of *Carrie*, in the school gymnasium). Hogan, who has finally been pushed too far by his schoolmates, his parents, his society, drinks a bottle of castor oil before the event, causing him to regurgitate the several pies he has voraciously consumed. He sets off a chain reaction of vomiting among the participants and the audience, including the school principal and other prominent citizens. Lard Ass Hogan surveys his handiwork, "at the apotheosis of his life," and, like the heroine of *Carrie*, returns home to make his vengeance complete. A revised version of this story was reprinted in "The Body" (*Different Seasons*), as a story purportedly published in *Cavalier* by Gordon Lachance.

"Rita Hayworth and Shawshank Redemption" (*Different Seasons*, 1982)

See Chapter Eleven.

"The Shining" (*Reflections*, June 1977)

An excerpt from the novel *The Shining*.

"Skybar" (*The Do-It-Yourself Bestseller*, 1982)

This five-paragraph fragment was King's contribution to a workbook in which well-known writers provided the beginning and closing segments of "novels"; the reader would then "collaborate" by completing the story—blank pages were even provided for this purpose. "Skybar," written with an obvious tongue-in-cheek, concerns the visit of grade-schoolers to an abandoned, haunted amusement park. "There were twelve of us when we went in that night," it begins, "but only two of us came out—my friend Kirby and me. And Kirby was insane."

"Slade" (*The Maine Campus*, June through August, 1970)

During his college years, King wrote a weekly opinion column, "King's Garbage Truck," for *The Maine Campus*, the newspaper of the University of Maine at Orono. His final column, written upon graduation, was a mock "birth announcement," marking his entry into the "real" world. Through the following summer, *The Maine Campus* published, in weekly installments, his comic western novelette, "Slade." Its hero, Jack Slade, is a legendary gunslinger of the wild west; he carries a .45 caliber pistol in each fist, puffs his famous Mexican cigars, and is dressed entirely in black. Some say that he mourns for his lost sweetheart, Miss Polly Peachtree of Paduka, but others claim that Slade is "the Grim Reaper's agent in the American Southwest—the devil's handyman." Slade is hired by Miss Sandra Dawson of Dead Steer Springs to take on the sinister Sam Columbine, who is trying to steal her Bar-T Ranch. Slade faces off against a slew of diabolical villains, from John "The Backshooter" Parkman, scourge of the Brass Cuspidor Saloon, to Hunchback Fred Agnew, purportedly the next Vice-President of the American Southwest. Needless to say, Slade triumphs and rides off into the sunset, in search of new adventures.

"The Slow Mutants" (*The Magazine of Fantasy and Science Fiction*, July 1981; *The Dark Tower: The Gunslinger*, 1982)

In the fourth "Gunslinger" story, Roland and Jake enter a cave in the massive mountain, into which the man in black had earlier disappeared. Soon they find an abandoned railroad line, and continue the chase using a handcar. To pass the time, Roland tells of his youth—of his father, "the last lord of light," and of his mother's affair with the enchanter Marten. Jake asks about Roland's coming of age, and Roland describes how he became the youngest gunslinger when, offended by Marten, he bested his tutor in hand-to-hand combat years before he should have even tried—but his victory came only by the sacrifice of his hawk, thrown at his opponent as a distraction. "It was a game, wasn't it?" Jake reacts. "Do any men grow up or do they only come of age?" In the depths of the cave, they are attacked by Slow Mutants, gruesome troglodytes with a semblance of humanity; they escape into the remains of a rail station, which leads, in turn, to a rotting trestle spanning the darkness over a river. As they walk gingerly across the path to sunlight, the man in black appears, waiting at the other side. The tracks collapse beneath Jake, and he dangles by one hand; Roland faces a terrible choice—whether to save Jake or pursue the man in black. He chooses the man in black. See Chapter Six.

"Sometimes They Come Back" (*Cavalier*, March 1974; *Night Shift*, 1978)

Jim Norman begins his first full-time job as a high school English teacher with a certain trepidation; he had earlier suffered a nervous breakdown while serving as a practice teacher during college. His nights are terrorized

by dreams of the fateful day, sixteen years before, when his older brother was knifed and killed by a gang of teenage hoods. The nightmare recurs in daylight as three students in his remedial reading class mysteriously die or disappear, only to be replaced by transfer students from Milford High School—students who look exactly like the gang members from his past. Norman learns that the only place named Milford in his home town is the cemetery, and that the three hoods who were suspected of killing his brother had died in a car crash six months later. When the ghostly toughs murder his wife, Norman confronts them at night in the high school corridors, raising the spirit of his dead brother against them.

"Squad D" (*The Last Dangerous Visions*, presently unpublished)

This story of Josh Bortman of Castle Rock, Maine, the sole survivor of a squad of American soldiers ambushed while on patrol in Vietnam, was written for Harlan Ellison's *The Last Dangerous Visions*; but that massive three-volume anthology, originally scheduled for publication in the late 1970s, has not yet seen print.

"The Star Invaders" (1964)

This self-published "AA Gas-Light Book," printed on David King's mimeograph machine, is the second-earliest "published" Stephen King story of which a record remains. It strongly echoes the motion picture *Earth vs. the Flying Saucers*, whose influence upon the young King is discussed in *Danse Macabre*. The "Star Invaders," robot-like aliens from an unnamed planet, have conquered the Earth. Only a tiny band of defiant humans remains, hidden in caves; among them is humanity's last hope, Jed Pierce, a scientist who has developed a counter-weapon that disrupts the power source of the Star Invaders' spacecraft. One freedom fighter, Jerry Hiken, is captured; the Star Invaders torture him with a device that determines each human's greatest fear—in Hiken's case, claustrophobia. He finally reveals Pierce's hiding place, but the Star Invaders arrive too late; the counter-weapon is operational, and Pierce decimates their attack fleet. The war for the Earth's freedom will continue . . . but that is another story.

"Strawberry Spring" (*Ubris*, Fall 1968; revised version, *Cavalier*, November 1975; *Night Shift*, 1978)

Stephen King created the original version of this story in roughly one-and-a-half hours, writing on napkins in a college lunchroom while suffering from an excruciating headache. "When I finished," he notes, "the headache was gone." In March of 1968, a "strawberry spring" comes to New England—"a false spring, a lying spring" that occurs every eight to ten years, said to omen that "the worst norther of the winter is still on the way." On the campus of New Sharon Teachers' College, the mist-blown

nights of the strawberry spring bring terror: mysterious murders by a knife-wielding maniac whom the news media term "Springheel Jack" after the 1800s killer, Dr. John Hawkins. Springheel Jack claims four victims, all of them female, before strawberry spring departs; and the murderer leaves with the fog. All is forgotten to the first-person narrator until, eight years later, when he is married and a father, the strawberry spring returns. A woman is murdered on the New Sharon Campus. The narrator's wife is upset because he did not return home that night: "She thinks I was with another woman last night," he tells us. "And oh dear God, I think so too."

"Stud City" (*Ubris*, Fall 1969; revised version in "The Body," *Different Seasons*, 1982)

His name is Edward May, but his friends at high school call him Chico. On a dirty March day, he takes the virginity of his girlfriend, then stares through a broken window to the highway below his parents' home. "Stud city," he says, watching the cars follow the highway out of town. Chico is trapped in self-despair; his love has seemingly died with his mother, victim of a complicated childbirth. His family has fallen apart, his father marrying a younger woman who taunts Chico with her sexuality, finally making love with him while his father is cutting a Christmas tree. Chico threatens to leave, setting out on the highway; as it all comes back to him, he pulls his beat-up car over and vomits at the side of the road. A new white Ford passes, spraying dirty fans of water and slush. "Stud city," Chico says. "In his new stud car." This story, heavily revised, was reprinted as part of "The Body" in *Different Seasons*, as an early story purportedly published by Gordon Lachance in *Greenspun Quarterly*. King/Lachance comments: "It ought to have THIS IS THE PRODUCT OF AN UNDERGRADUATE CREATIVE WRITING WORKSHOP stamped on every page . . . because that's just what it was, up to a certain point. It seems both painfully derivative and painfully sophomoric to me now; style by Hemingway . . . theme by Faulkner And yet it was the first story I ever wrote that felt like *my* story It was the first time I had ever really used the place I knew and the things I felt in a piece of fiction, and there was a kind of dreadful exhilaration in seeing things that had troubled me for years come out in a new form, *a form over which I had imposed control.*"

"Suffer the Little Children" (*Cavalier*, February 1972)

"Miss Sidley was her name, and teaching was her game." Graying, trussed in a brace to support her failing back, she teaches third grade with a sense of strict discipline. But early in a new school year, she begins to wonder about her students; from the corner of her eye, she thinks she glimpses their faces changing into something . . . different. When she confronts one troublesome student, Robert, he suggests that her students

have been taken over: "the *other* Robert . . . [h]e's still hiding 'way, 'way down in my head He wants me to let him out." And then he begins to change. Miss Sidley, ever in control, breaks down and runs screaming from the school; when she returns to work one month later, she is again calm and controlled—and carrying a pistol. And she takes her students, one by one, to the mimeograph room, where she kills as many as she can before being discovered by another teacher.

"Survivor Type" (*Terrors*, 1982; *Skeleton Crew*, 1985)

In a footnote to *Danse Macabre*, King mentioned that he had written a story about self-cannibalism that no one had been willing to publish. "Stories of ghouls and cannibalism venture into genuine taboo territory," he wrote. "[H]ere's a chance to really grab people by the gag reflex and throttle them." Upon reading this footnote, horror fiction's premier anthologist, Charles L. Grant, immediately asked King for the story. It is presented as the diary of Richard Pine, a discredited surgeon turned drug dealer who has been washed up on a tiny, deserted island after the accidental sinking of a cruise ship. Pine is a born fighter—he has clawed his way through life with seeming disdain for everyone, and believes only in his superiority: "The only thing to learn is how to survive. Any asshole knows how to die." With little more than a notebook and the two kilos of pure heroin that he was smuggling, Pine soon hungers; and nothing edible can be found on the island. He begins to eat himself, a piece at a time, in order to survive. "I was very careful," he writes in his diary after amputating his foot. "I washed it thoroughly before I ate it."

"Trucks" (*Cavalier*, June 1973; *Night Shift*, 1978)

This story, one of King's personal favorites, recounts the siege of an interstate truck stop by a growing horde of driverless trucks, animated by some form of supernatural puppetry. When the occupants of the truck stop speculate as to the cause of the attack, the narrator, prefiguring *Christine*, drolly says: "Maybe they're mad." The metaphor for the dehumanizing pall of the machine age is made clear as the trucks force the humans to refuel them; King offers the surreal scene of an endless line of trucks, hungrily waiting for gasoline. "But they're machines," the narrator thinks. "No matter what's happened to them, what mass consciousness we've given them, *they can't reproduce*" But his hopes for a better day are crushed by a troublesome vision: "[I]f I close my eyes I can see the production lines in Detroit and Dearborn and Youngstown and Mackinac, new trucks being put together by blue-collars who no longer even punch a clock but only drop and are replaced." This story was adapted by King for the motion picture *Overdrive*.

"Uncle Otto's Truck" (*Yankee*, October 1983; *Skeleton Crew*, 1985)

On the Black Henry Road between Stephen King's summer home in Center Lovell, Maine, and nearby Bridgton, the old hulk of a truck sits in an open field, the scenic White Mountains in the background; the truck points directly at a tiny, one-room house just across the road. King used this backroad landmark to create "Uncle Otto's Truck," positing that the truck had been left in the field years ago by two business partners after it had broken down. One of the partners, the narrator's Uncle Otto, later causes an "accident" in which his partner is killed when the truck falls off its blocks. As the years pass, Uncle Otto descends into a peculiar madness, building and then moving into a small, one-room house across the road from the abandoned truck. Soon he claims that the truck is slowly, year after year, creeping closer—until one day, it exacts its revenge.

"The Way Station" (*The Magazine of Fantasy and Science Fiction*, April 1980; *The Dark Tower: The Gunslinger*, 1982)

The second "Gunslinger" story finds Roland, the last gunslinger, staggering out of the desert into the oasis of a deserted way station. He finds a nine-year-old boy waiting there, alone—John Chambers, better known as Jake, who has somehow been torn from our world by the man in black and deposited in the path of the gunslinger. "There was a deadly feeling about him," Roland realizes, "and the stink of predestination." In the cellar of the way station, Roland is confronted by a Speaking-Demon, which utters an obscure prophecy; then Roland and the boy set out toward a distant mountain range, trailing the evanescent man in black. While they journey, Roland recalls a turning point in his youth, when he first glimpsed the face of evil in the treason of a cook, and the face of death in the hanging that followed. The gunslinger senses death in Jake—that the boy will become a sacrifice: "Again and again it ends this way. There are quests and roads that lead ever onward, and all of them end in the same place—upon the killing ground. Except, perhaps, the road to the Tower." Jake sights the man in black, a tiny speck of life high in the mountains above them—and the pursuit continues. See Chapter Six.

"The Wedding Gig" (*Ellery Queen's Mystery Magazine*, December 1, 1980; *Skeleton Crew*, 1985)

This is the story of a Dixieland jazz band in 1927—"when jazz was jazz, not noise"—and of the special gig that it is invited to play by small-time hood Mike Scollay: the wedding reception for his sister, a monstrous three-hundred-and-fifty-pound bride "as ugly as the serpent in the garden." Scollay is on the hit list of another hood known as the Greek, who taunts Scollay with the ugliness of his sister, causing Scollay to rush out of the wedding reception into the streets, where he is promptly ventilated with

bullets. The narrator—the bandleader—has been struck by the sweetness of Scollay's sister; he meets her one night after the murder, and thinks of offering her kind words, but does not. He tells how she later took over Scollay's two-bit organization, rubbing out the Greek and other rivals and building a Prohibition empire equal to that of Al Capone.

"Weeds" (*Cavalier*, May 1976)

Jordy Verrill, a backward New Hampshire farmer, finds a meteor on his property. His dreams of earning a fortune by selling the meteor to the university are dashed when he inadvertently breaks the sizzling hunk of rock; but soon he is rolling in another kind of green stuff. To his misfortune, he touches the white substance that leaks from the meteor's core. Fuzzy green tendrils, revealed ultimately as sentient alien plant life, sprout first from his hand, then spread over his body. Verrill becomes a shambling weedlike monster: "A monster in the true sense, nearly as ludicrous as it was terrifying." Finally, he commits suicide; but the weeds continue growing, toward town—and an entire planet, ripe for vegetation. This story was later revised and adapted by King as an episode of the motion picture *Creepshow* titled "The Lonesome Death of Jordy Verrill," in which King himself played the role of luckless Jordy.

"The Woman in the Room" (*Night Shift*, 1978)

"The question is: Can he do it?" Johnny's mother is paralyzed, dying of cancer in the Central Maine Hospital in Lewiston—a painful, ugly death; and Johnny begins to contemplate bringing her peace by feeding her an overdose of pills. He knows that it would be murder, but feels that perhaps her impending death is his fault anyway; his brother was adopted, so that he was "the only child to have been nurtured inside her And of course the cancer now in her began in the womb like a second child, his own darker twin. His life and her death began in the same place. Should he not do what the other is doing already, so slowly and clumsily?" His mother is awake, relatively alert, when he gives her the pills; she takes them without question, and says: "You've always been a good boy, Johnny." He kisses her, then leaves: "He feels no different, either good or bad." This intense story is one of King's most autobiographical pieces, an explicit writing out of his emotions at the death of his mother of cancer in 1974.

"Word Processor of the Gods" (*Playboy*, January 1983; *Skeleton Crew*, 1985)

Early in 1982, Stephen King began use of a word processing computer as his principal writing tool. One of the first pieces composed on the machine was "Word Processor of the Gods," which offers a thematic parallel to *Pet Sematary*. Richard Hagstrom, a high school teacher and struggling writer,

is the captive of a dead-end marriage dominated by an overweight, sullen wife and a dull, disappointing son. His anger and frustration come to bitter focus when his brother—"an utter shit"—kills the two people he really loves in a drunken automobile accident: his brother's wife, whom Hagstrom had once courted, and her son, Jon, a bright, industrious teenager. A posthumous birthday gift from Jon to Hagstrom arrives—the word processing computer Hagstrom has always dreamed about but could never afford, jerry-rigged by the inventive Jon from an improbable collection of parts. Hagstrom discovers that anything he types on the machine will come true—much as the mummified talisman of W. W. Jacobs' classic horror story, "The Monkey's Paw," would grant the fabled three wishes. Hagstrom decides to delete his wife and son from existence and to return his lost love and Jon to life as their replacements. This story was adapted by Michael McDowell for the syndicated television series *Tales from the Darkside*.

Motion Picture and Television Adaptations

No contemporary writer has captured the imagination of the American motion picture industry as strongly as Stephen King. By 1986, every one of King's published novels (as well as one of his "Richard Bachman" novels) had been adapted for the screen or was in some stage of production; eight works of short fiction had been translated into feature-length films; and four other short stories had been presented in half-hour productions on television or videocassette. Nearly every major director associated with the horror field has handled a Stephen King property, and Steven Spielberg is scheduled to direct the adaptation of the Stephen King–Peter Straub collaboration, *The Talisman*. King himself has written the scripts for *Silver Bullet* and two original film anthologies—*Creepshow* and *Cat's Eye*—each based upon both previously published short stories and new stories conceived especially for the screen. Most recently, he has written and directed *Overdrive*, an expansion of his short story "Trucks."

Despite the popular success of King's fiction, and the enthusiasm of filmmakers for bringing his works to the motion picture and television screens, the adaptations of his novels and stories to date have proved decidedly uneven. The first, and probably best, motion picture produced from Stephen King's fiction was Brian De Palma's *Carrie* (1976). The film not only provided a major boost to the careers of both King and De Palma, whose other films include *Sisters* (1973), *The Fury* (1978), *Dressed to Kill* (1980), *Scarface* (1983), and *Body Double* (1984); it also gained Academy

Award nominations for Sissy Spacek and Piper Laurie. *Carrie* was followed by the bland four-hour television miniseries *'Salem's Lot* (1979), directed by Tobe Hooper, architect of *The Texas Chainsaw Massacre* (1974) and later director of *Poltergeist* (1982) and *Lifeforce* (1985). Despite a teleplay by Paul Monash that successfully captured the spirit of King's novel, the production was seemingly doomed from the outset by the need to conform to standards and practices of commercial television.

The most controversial King adaptation is *The Shining* (1980), for which even Stephen King holds a certain ambivalence; in his view, it is one of the worst of the adaptations, but he also recognizes that it could be a "flawed masterpiece." Its director, Stanley Kubrick, whose other films include *Dr. Strangelove* (1963) and *2001: A Space Odyssey* (1968), seemingly committed a misguided act of hubris, attempting to transcend a genre that he did not understand. "It doesn't make sense, either in a literal fashion or in a metaphorical fashion," King says. "The production is beautifully mounted—and Kubrick produces all sorts of interesting effects, not just mechanical special effects like those of Tom Savini, but effects inside your mind. I simply do not agree with his apparent sensibility that that can be a pay-off for the hollowness at the center of his story."

Stephen King has termed the motion picture of *Cujo* (1983) his personal favorite of the adaptations to date. Directed by Lewis Teague—earlier responsible for the horror spoof *Alligator* (1980) and later director of Stephen King's *Cat's Eye*—its screenplay was credited to Don Carlos Dunaway and Lauren Currier (a pseudonym for Barbara Turner), who rewrote an original script by King. Filmed on a relatively small budget and a tight schedule, *Cujo* has, for King, "some of the scariest moments on film." It also adopts the ending proposed by King's screenplay, which repudiated the death of Tad Trenton at the climax of the novel.

Director David Cronenberg, the Canadian horror film genius behind *Rabid* (1977), *The Brood* (1979), *Scanners* (1981), and *Videodrome* (1982), took the helm for *The Dead Zone* (1983). Showing a reserved visual style relative to his earlier films, Cronenberg's adaptation of *The Dead Zone* downplays horrific elements in favor of an emotional involvement with its characters. King has reserved judgment on this motion picture, but time should prove it one of the most significant of the adaptations.

Christine (1983) arrived on-screen with incredible dispatch; its rights were purchased while the book was still in manuscript, and production began four days before the novel's publication date. Its director, John Carpenter, had earlier created *Assault on Precinct 13* (1976), the highly influential "mad slasher" film *Halloween* (1978), *Escape from New York* (1981), and *The Thing* (1982). "*Christine* is a good movie, and it's close to the spirit of the book," says King. "But the book carries the film, to a degree; there is, unfortunately, very little of John Carpenter there."

The first Stephen King short story to be adapted into a feature-length film was *Children of the Corn* (1984)—an occasionally inspired, but ultimately forgettable production directed by Fritz Kiersch. Filmed in less than a month on a very limited budget, it is the sole adaptation to date that can fairly be termed exploitative. "The best thing that I can say," reports King, "is that this is a movie by a lot of young people who will do better work."

King's favorite screenplay is that of Stanley Mann for *Firestarter* (1984), but its execution was disappointing. Directed by Mark Lester, whose credits include *Class of '84* (1982) and *Commando* (1985), *Firestarter* is visually exciting but suffers, as have many of the adaptations, from the compression required to render a four-hundred-page novel into ninety or so minutes of film.

No less than three Stephen King short stories appeared on the television screen in 1985. Two half-hour films, "The Woman in the Room" (1983) and "The Boogeyman" (1983), were packaged for direct videocassette distribution as *Two Mini-Features from . . . Stephen King's Night Shift Collection* (1985). Although essentially student films produced on limited budgets, their directors, Frank Darabont and Jeff Schiro, proved equal to the task of bringing these two disparate stories to the visual medium. George A. Romero's *Tales from the Nightside,* a syndicated television series that favored dark fantasy and ironic humor over pure horror, featured an adaptation of King's "The Word Processor of the Gods" among its first year of episodes. This story of a henpecked husband who inherits a magical computer was directed by Michael Gornick and scripted by King's friend and fellow horror writer Michael McDowell. In 1986 another short story proved the basis for the first original network television presentation of Stephen King since the 1979 made-for-TV movie of *'Salem's Lot.* Given the acknowledged influence of *Twilight Zone* screenwriter Richard Matheson on King's writing, it was fitting that the revival of the *Twilight Zone* series should include Harlan Ellison's adaptation of "Gramma" in its first season.

One of King's *Different Seasons* novellas, "The Body" began production as a motion picture in late 1985 under the direction of Rob Reiner, whose prior films include the comedic *This Is Spinal Tap* (1984) and *The Sure Thing* (1985). That year also saw work underway in Canada on the first motion picture adaptation of one of King's pseudonymous "Richard Bachman" novels, *The Running Man,* directed by George Pan Cosmatos and starring Arnold Schwarzenegger.

King's overall assessment of the motion picture and television adaptations of his work is one of relief; "I've been lucky," he says:

There isn't a truly bad one in the bunch. I've never been hurt the way, for example, James Herbert and Peter Straub have been—at least not

yet. The adaptation of horror fiction is not taken very seriously—all that the companies are looking for is the quick pay-off, hoping for a five-week run and then good sales to foreign markets and to television. With some of the films from my novels, you could easily say that the people were just looking for that kind of pay-off, knowing that as long as they stayed somewhere in the neighborhood of the book, they couldn't go too far wrong. I really don't believe that, since The Shining, *there has been any conscious effort to make the film adaptations any better than the books.*

To me, John Updike said it all. He said that the best possible situation you could have with Hollywood is when they pay you huge amounts of money for your books and never make the film. Unless, as with Creepshow, *I play an active part in the creative development of the film, I don't feel that I have any responsibility for what happens to a book when it goes on the screen. I send it off the way that I can imagine sending a child off to college. So the critical reaction to some of the films makes me feel a little bit like someone who has stumbled onto the scene of a murder and picked up a bloody knife, and the cops—in this case, the critics—come in. And I say, "No, I didn't do it! It wasn't me!"*

An interviewer of James M. Cain once bemoaned the fact that Hollywood had ruined all of Cain's books. And Cain looked over to his bookshelf and said, "No, they're all still right there." There is no movie that can ruin a book. They can embarrass a writer—sort of like showing up at a party with your fly open—but these things pass, while the books remain.

At this point, I can't even explain why it seems so attractive to me to sell the books to the movie industry—it sure isn't the money. It seems to be something almost like exhibitionism—the same reason why I want to publish books.

King's scripts for *The Shining* and *The Dead Zone* were rejected by the directors of those films, while his screenplays for *Cujo* and *Children of the Corn* were rewritten by other writers, who were given final on-screen credit. Although he has written screenplays for *The Stand* and *Pet Sematary*, both of which George A. Romero will direct, King has grown less enthusiastic about adapting his own novels for the screen. "It feels too much like eating leftovers," he says. "And time is the master of everything in film—I hate the feeling of trying to cram something I've already written into this compressed form. What I prefer are original screenplays, and I certainly will continue to write those."

Creepshow (1982), discussed in Chapter Twelve, was King's first original screenplay. Its success prompted the development of *Creepshow II*, whose screenplay was written by George Romero based upon one pub-

lished King story—"The Raft"—and four additional storylines written specifically for the film by King. King's second original screenplay, *The Shotgunners*, gained the attention of legendary director Sam Peckinpah, whose films include *The Wild Bunch* (1969) and *Straw Dogs;* preproduction work on the film was underway when Peckinpah died in December 1984.

At the request of Dino DeLaurentiis, who was interested in producing a vehicle for Drew Barrymore (the young actress who played Charlie McGee in *Firestarter*), King wrote the original screenplay for *Cat's Eye* (1985), based upon two published stories—"The Ledge" and "Quitters, Inc."—and an unpublished story idea, "The General." He then turned to reworking his novelette *Cycle of the Werewolf* for the screen as *Silver Bullet* (1985), directed by Daniel Attias and starring Gary Busey. King's association with DeLaurentiis on both *Cat's Eye* and *Silver Bullet* set the stage for his directorial debut in *Overdrive*, discussed in Chapter Seventeen.

The formal credits for the motion picture and television adaptations of the fiction of Stephen King are as follows:

Carrie (United Artists, 1976)
Producer ... Paul Monash
Director ... Brian De Palma
Screenwriter ... Lawrence D. Cohen
Music ... Pino Donaggio
Director of Photography ... Mario Tosi
Production Design William Kenney and Jack Fisk
Editor ... Paul Hirsch
Cast Sissy Spacek, Piper Laurie, Amy Irving, William Katt, Nancy Allen, John Travolta, Betty Buckley, P. J. Soles, Sydney Lassick, Stefan Gierasch, Priscilla Pointer

'Salem's Lot (Warner Brothers, 1979)
Producer ... Richard Kobritz
Executive Producer .. Stirling Silliphant
Director ... Tobe Hooper
Screenwriter ... Paul Monash
Music ... Harry Sukman
Director of Photography .. Jules Brenner
Production Design ... Mort Rabinowitz
Editors ... Carroll Sax and Tom Pryor

Cast David Soul, James Mason, Lance Kerwin, Bonnie Bedelia, Lew Ayres, Julie Cobb, Elisha Cook, George Dzundza, Ed Flanders, Clarissa Kaye, Geoffrey Lewis, Barney McFadden, Kenneth McMillan, Reggie Nalder, Fred Willard, Marie Windsor

The Shining (Warner Brothers, 1980)
Producer ... Stanley Kubrick
Executive Producer .. Jan Harlan
Director ... Stanley Kubrick
Screenwriters Stanley Kubrick and Diane Johnson
Music .. Wendy Carlos
Director of Photography ... John Alcott
Production Design .. Roy Walker
Editor ... Ray Lovejoy
Cast Jack Nicholson, Shelley Duvall, Danny Lloyd, Scatman Crothers, Barry Nelson, Philip Stone, Joe Turkel, Anne Jackson, Tony Burton

Creepshow (Warner Brothers, 1982)
Producer .. Richard P. Rubenstein
Executive Producer .. Salah M. Hassanein
Director ... George A. Romero
Screenwriter ... Stephen King
Music ... John Harrison
Director of Photography Michael Gornick
Makeup and Special Effects ... Tom Savini
Production Design ... Cletus Anderson
Editors .. Michael Spolan, Pasquale Buba, George A. Romero, Paul Hirsch
Cast Adrienne Barbeau, Hal Holbrook, Viveca Lindfors, E. G. Marshall, Leslie Nielsen, Carrie Nye, Fritz Weaver, Ted Danson, Robert Harper, Ed Harris, Don Keefer, Jon Lormer, Elizabeth Regan, Gaylen Ross, Warner Shook

Cujo (Warner Brothers, 1983)
Producers Daniel H. Blatt and Robert Singer
Director .. Lewis Teague

Screenwriters Don Carlos Dunaway and Lauren Currier
Music .. Charles Bernstein
Director of Photography .. Jan De Bont
Production Design .. Guy Comtois
Editor ... Neil Travis
Cast Dee Wallace, Danny Pintauro, Daniel Hugh-Kelly,
Christopher Stone, Ed Lauter, Kai-
ulani Lee, Mills Watson

The Dead Zone (Paramount Pictures, 1983)
Producer .. Debra Hill
Executive Producer .. Kirby McCauley
Director .. David Cronenberg
Screenwriter ... Jeffrey Boam
Music ... Michael Kamen
Director of Photography ... Mark Irwin
Special Effects .. Jon G. Belyeu
Production Design .. Carol Spier
Editor ... Ronald Sanders
Cast Christopher Walken, Brooke Adams, Tom Skerritt,
Herbert Lom, Martin Sheen, An-
thony Zerbe, Colleen Dewhurst,
Nicholas Campbell

Christine (Columbia Pictures, 1983)
Producer ... Richard Kobritz
Executive Producers Kirby McCauley and Mark Tarlov
Director .. John Carpenter
Screenwriter ... Bill Phillips
Music ... Various artists
Director of Photography Donald M. Morgan
Special Effects .. Roy Arbogast
Production Design .. Daniel Lomino
Editor ... Marion Rothman
Cast Keith Gordon, John Stockwell, Alexandra Paul,
Robert Prosky, Harry Dean Stanton

Children of the Corn (New World Pictures, 1984)
Producers Donald P. Borchers and Terrence Kirby
Executive Producers Earl Glick and Charles J. Weber
Director .. Fritz Kiersch

Screenwriter ... George Goldsmith
Music .. Jonathan Elias
Director of Photography .. Raoul Lomas
Production Design .. Craig Stearns
Editor ... Harry Keramidas
Cast Peter Horton, Linda Hamilton, R. G. Armstrong,
John Franklin, Courtney Gains,
Robby Kiger, AnneMarie McEvoy,
Julie Maddalena

Firestarter (Universal Pictures, 1984)
Producer .. Frank Capra, Jr.
Director ... Mark Lester
Screenwriter .. Stanley Mann
Music .. Tangerine Dream
Special Effects .. Mike Wood and Jeff Jarvis
Director of Photography Giuseppe Ruzzolini
Production Design .. Giorgio Postiglione
Editor ... David Rawlins
Cast David Keith, Drew Barrymore, Freddie Jones,
Heather Locklear, Martin Sheen,
George C. Scott, Art Carney, Lou-
ise Fletcher, Moses Gunn

Cat's Eye (MGM/United Artists, 1984)
Producer .. Martha Schumacher
Director ... Lewis Teague
Screenwriter ... Stephen King
Music .. Alan Silvestri
Special Effects .. Carlo Rambaldi
Director of Photography ... Jack Cardiff
Production Design .. Giorgio Postiglione
Editor ... Scott Conrad
Cast Drew Barrymore, Candy Clark, Joe Cortese,
Robert Hayes, Alan King, Patti Lu-
Pone, Kenneth McMillan, James
Naughton, James Woods

The Word Processor of the Gods (Laurel Entertainment, 1985)
Executive Producers Richard P. Rubinstein, George A. Romero,
Jerry Golod
Producer .. William Teitler
Director .. Michael Gornick

Screenwriter ... Michael McDowell
Cast ... Bruce Davison

Silver Bullet (Paramount, 1985)
Producer ... Martha Schumacher
Director .. Daniel Attias
Screenwriter .. Stephen King
Music ... Jay Chattaway
Special Effects Carlo Rambaldi
Director of Photography Armando Nannuzzi
Production Design ... Giorgio Postiglione
Editor ... Daniel Loewenthal
Cast Gary Busey, Everett McGill, Corey Haim, Megan Follows,
 Robin Groves, Leon Russom, Terry
 O'Quinn

Two Mini-Features from Stephen King's Night Shift Collection (Granite Entertainment, 1985)
"The Woman in the Room" (Darkwoods, 1983)
Executive Producer ... Douglas Venturelli
Producer ... Gregory Melton
Director .. Frank Darabont
Screenplay .. Frank Darabont
Director of Photography Juan Ruiz Anchia
Production Manager ... Gregory Melton
Editors ... Frank Darabont, Kevin Rock
Cast Michael Cornielson, Dee Croxton, Brian Libby

"The Boogeyman" (Tantalus, 1983)
Producer .. Jeffrey C. Schiro
Director .. Jeffrey C. Schiro
Screenplay .. Jeffrey C. Schiro
Music .. John Cote
Director of Photography Douglas Meltzer
Editor .. Jeffrey C. Schiro
Cast ... Michael Reid, Bert Linder

Gramma (CBS Entertainment Productions, 1986)
Executive Producer ... Philip DeGuere
Director .. Bradford May
Screenwriter .. Harlan Ellison

Music .. Mickey Hart
Art Director ... John Mansbridge
Editor ... Greg Wong
Cast Barret Oliver, Darlanne Fluegel, Frederick Lang

Overdrive (MGM/UA, 1986)
Producer .. Dino DeLaurentiis
Director .. Stephen King
Screenwriter ... Stephen King
Music .. AC/DC
Production Design ... Giorgio Postiglione
Cast Pat Hingle, Emilio Estevez, Laura Harrington

[Remaining production information unavailable at time of publication]

The Body (in production, 1986)
Director ... Rob Reiner

[Production information unavailable at time of publication]

The Running Man (in production, 1986)
Director .. George Pan Cosmatos

[Production information unavailable at time of publication]

Notes

ONE: Introduction: Do the Dead Sing?

1. *Yankee*, November 1981 (as "Do the Dead Sing?"); *Skeleton Crew* (New York: Putnam, 1985).
2. See Harry Levin, *The Power of Blackness* (New York: Alfred A. Knopf, 1958).
3. *Cavalier*, December 1972; *Night Shift* (Garden City, NY: Doubleday, 1978), p. 76.
4. D. H. Lawrence, *Studies in Classic American Literature* (New York: Penguin, 1977), p. 85.
5. Panel Discussion: "Horror in the Eighties: Still Alive and Well," moderated by Charles L. Grant, The Sixth World Fantasy Convention, Baltimore, MD, November 1, 1980.
6. *Gallery*, July 1979.
7. *Gallery*, November 1980; *Skeleton Crew*.
8. *The Magazine of Fantasy and Science Fiction*, June 1984; *Skeleton Crew*.
9. *Twilight Zone Magazine*, April 1981; *Skeleton Crew*.
10. Jack Sullivan, *Elegant Nightmares: The English Ghost Story from LeFanu to Blackwood* (Athens, OH: Ohio University Press, 1978), p. 134.
11. *Cavalier*, October 1973; *Night Shift*.
12. *Cavalier*, May 1975; *Night Shift*.
13. *Gallery*, August 1977; *Night Shift*.

14. Quoted in "Sleep: Perchance to Dream . . .," *Newsweek*, November 30, 1959, p. 104.

15. *Penthouse*, July 1976; *Night Shift*.

16. *Cavalier*, October 1970; *Night Shift*.

17. *Night Shift*, 1978.

18. In Charles L. Grant, ed., *Shadows 4* (Garden City, NY: Doubleday, 1981); revised version, *Skeleton Crew*.

19. *Ubris*, Fall 1968; revised version, *Cavalier*, November 1975; *Night Shift*.

20. In Charles L. Grant, ed., *Terrors* (New York: Playboy, 1982); *Skeleton Crew*.

21. *Cavalier*, February 1972.

22. *Cavalier*, March 1973; *Night Shift*.

23. *Night Shift*, p. 96.

24. Ibid., p. 107.

25. *The Shining* (Garden City, NY: Doubleday, 1977), p. 420.

26. "Do the Dead Sing?," p. 246.

27. Philip Van Doren Stern, "Introduction," *Great Ghost Stories* (New York: Washington Square, 1947), pp. xvi–xvii.

28. In King's words: "[W]e are the first generation forced to live almost entirely without romance and forced to find some kind of supernatural outlet for the romantic impulses that are in all of us. This is really sad in a way. Everybody goes out to horror movies, reads horror novels—and it's almost as though we're trying to preview the end." Quoted in Bob Spitz, "Penthouse Interview: Stephen King," *Penthouse*, April 1982, p. 122.

29. *'Salem's Lot* (Garden City, NY: Doubleday, 1975), p. 253. See James B. White, *The Legal Imagination* (Boston, MA: Little, Brown, 1973), pp. 245-46.

TWO: Notes Toward a Biography: Living with the Boogeyman

1. *Carrie* (Garden City, NY: Doubleday, 1974), p. 3.

2. For complete information on the motion picture adaptations of Stephen King's fiction, see Appendix C.

3. Richard Zoglin, "Giving Hollywood the Chills," *Time*, January 9, 1984, p. 56.

4. *Small World* (New York: Macmillan, 1981); *Caretakers* (New York: Macmillan, 1983); *The Trap* (New York: Macmillan, 1985).

5. "Foreword," *Night Shift* (Garden City, NY: Doubleday, 1978) p. xiii.

6. *Danse Macabre* (New York: Everest House, 1981), p. 90.

7. Speech before the International Conference on the Fantastic in the Arts, Boca Raton, FL, March 24, 1984.

8. Ibid.

9. Interview with Douglas E. Winter, May 3, 1982.

10. Interview with Douglas E. Winter, March 23, 1984.

11. Speech before the International Conference on the Fantastic in the Arts, Boca Raton, FL, March 24, 1984.

12. Ibid.

13. *Danse Macabre*, p. 24.

14. Interview with Douglas E. Winter, January 15, 1984.

15. Ibid.

16. *Weirdbook*, no. 19, Spring 1984; *Skeleton Crew* (New York: Putnam, 1985).

17. Interview with Douglas E. Winter, January 15, 1984.

18. Ibid.

19. Interview with Douglas E. Winter, May 3, 1982. A copy of the manuscript of this story, titled "Charlie," still exists.

20. *The Maine Review*, July 1975; revised version in "The Body," *Different Seasons* (New York: Viking Press, 1982).

21. Interview with Douglas E. Winter, January 15, 1984. Charles Starkweather's story is retold in King's "Nona," in Charles L. Grant, ed., *Shadows* (Garden City, NY: Doubleday, 1978); *Skeleton Crew*.

22. See *Danse Macabre*, pp. 99–102. This episode of King's childhood is recaptured, with a definite twist, in "The Monkey," *Gallery*, November 1980; *Skeleton Crew*.

23. Interview with Douglas E. Winter, March 23, 1984.

24. Interview with Douglas E. Winter, January 15, 1984.

25. Interview with Douglas E. Winter, May 3, 1982.

26. Interview with Douglas E. Winter, January 15, 1984.

27. *Comics Review*, 1965. See Appendix B.

28. Interview with Douglas E. Winter, May 3, 1982.

29. *Startling Mystery Stories*, Fall 1967.

30. "On Becoming a Brand Name," *Adelina*, February 1980, p. 41.

31. Interview with Douglas E. Winter, January 15, 1984.

32. Ibid.

33. Ibid. The characters of naturalist writers battle strenuously for something but are finally beaten down by overpowering forces, leaving them in despair and not fully aware of what has happened to them. "It is not the despair that we abstract to some universal value," John Gardner writes, "but the struggle." John Gardner, *The Art of Fiction* (New York: Alfred A. Knopf, 1984), p. 62.

34. Quoted in Erik Hedegaard (with Michael Schrage and David M.

Abramson), "Mentors," *Rolling Stone College Papers*, April 15, 1982, p. 52.

35. Interview with Douglas E. Winter, March 7, 1984. The book that King offered to Hatlen was *The Long Walk*, which was dedicated to Hatlen and Holmes upon its publication as a "Richard Bachman" novel in 1979.

36. Quoted in "Mentors," p. 57.

37. Interview with Douglas E. Winter, March 7, 1984.

38. *Ubris*, Fall 1968.

39. *Ubris*, Spring 1969.

40. Interview with Douglas E. Winter, April 4, 1984.

41. Ibid.

42. Ibid.

43. *The Maine Campus*, May 21, 1970.

44. "The Dark Tower: A Cautionary Tale," unpublished manuscript, p. 1.

45. See text at pp. 65–67 above.

46. *Cavalier*, October 1970; *Night Shift*.

47. *Cavalier*, December 1972; *Night Shift*.

48. In Ramsey Campbell, ed., *New Terrors 2* (London: Pan, 1980); *Skeleton Crew*.

49. Interview with Douglas E. Winter, April 4, 1984.

50. "On Becoming a Brand Name," p. 42.

51. Interview with Douglas E. Winter, January 15, 1984.

52. "On Becoming a Brand Name," p. 42.

53. Interview with Douglas E. Winter, May 3, 1982.

54. Interview with Douglas E. Winter, April 4, 1984.

55. "On Becoming a Brand Name," p. 42.

56. Interview with Douglas E. Winter, March 23, 1984.

57. *Night Shift*, 1978.

THREE: *Carrie*

1. *Carrie* (Garden City, NY: Doubleday, 1974).

2. The documentary portions of the book were added after the initial draft as King worked to expand the manuscript to novel length.

3. "Afterword," *Different Seasons* (New York: Viking Press, 1982), p. 524.

4. Interview with Douglas E. Winter, January 15, 1984.

5. *Danse Macabre* (New York: Everest House, 1981), p. 37.

6. Peter Straub, "Meeting Stevie," in Tim Underwood and Chuck Miller, eds., *Fear Itself: The Horror Fiction of Stephen King* (San Francisco, CA/Columbia, PA: Underwood-Miller, 1982), p. 10.

7. *Danse Macabre*, p. 169.

8. *Carrie*, p. 149.

9. Ibid.

10. See *Danse Macabre*, pp. 166–72.

11. Interview with Douglas E. Winter, January 15, 1984. King is astounded that his intent has been misunderstood: "Again and again, I read that both Carrie and Charlie McGee in *Firestarter* have something to do with evil—with the *Rosemary's Baby* type of evil. I just went through a thing in Wyoming where there was an attempt to ban *Firestarter* from the school library. The complaint, which came from fundamentalists, was basically that this was a novel about witchcraft. And that is a ridiculous idea. I saw them both as good people." Ibid.

12. *Penthouse*, March 1977; *Night Shift* (Garden City, NY: Doubleday, 1978).

13. *Cosmopolitan*, September 1976; *Night Shift*.

14. Charles L. Grant, "The Grey Arena," in *Fear Itself: The Horror Fiction of Stephen King*, p. 148.

15. *Carrie*, p. 37.

16. *Danse Macabre*, p. 170.

17. Interview with Douglas E. Winter, January 15, 1984.

18. *Carrie*, pp. 189–90.

19. *Danse Macabre*, p. 380.

20. "Afterword," *Different Seasons*, p. 519.

21. "Why I Was Bachman," *The Bachman Books* (New York: New American Library, NAL Books, 1985), pp. ix–x.

22. "Afterword," *Different Seasons*, p. 521.

FOUR: *'Salem's Lot*

1. *'Salem's Lot* (Garden City, NY: Doubleday, 1975).

2. Ibid., p. 22.

3. See, for example, Don Herron, "Horror Springs in the Fiction of Stephen King," in Tim Underwood and Chuck Miller, eds., *Fear Itself: The Horror Fiction of Stephen King* (San Francisco, CA/Columbia, PA: Underwood-Miller, 1982), pp. 63–69.

4. Several major contemporary horror novelists have written books under the acknowledged influence of *'Salem's Lot*, notably David Morrell (*The Totem*, New York: Evans, 1979), Peter Straub (*Ghost Story*, New York: Coward, McCann & Geoghegan, 1979), and Charles L. Grant (*The Nestling*, New York: Pocket Books, 1982).

5. "On Becoming a Brand Name," *Adelina*, February 1980, p. 44.

6. "Geographically speaking," King admits, "Jerusalem's Lot would be about ten feet underwater. Because the geography in the book suggests

that, to get there, you would have to drive off where the existing coast ends. But it lies between Falmouth and Cumberland, two towns that, on actual maps, are side by side—except that anyone who goes down there at the right time of day, just when the shadows turn in the other direction, can still find 'Salem's Lot. It's not a good place to go at night." Interview with Douglas E. Winter, January 16, 1984.

7. "On Becoming a Brand Name," p. 44.

8. *Whispers*, no. 17/18, August 1982, p. 59.

9. See Yi-Fu Tuan, *Landscapes of Fear* (New York: Pantheon, 1979), pp. 145–74.

10. Alan Ryan's *explication de texte*, "The Marsten House in *'Salem's Lot*," in *Fear Itself: The Horror Fiction of Stephen King*, details the strength of King's narrative technique in the context of Ben Mears's arrival in Jerusalem's Lot.

11. *'Salem's Lot*, pp. 219–23.

12. *Night Shift* (Garden City, NY: Doubleday, 1978). Although first published in the *Night Shift* collection, this story was written in 1967 as a course requirement during King's sophomore year in college. See Appendix B.

13. *'Salem's Lot*, p. 18. The Marsten House is a real house (albeit with a different name), located on the Deep Cut Road in Stephen King's home town of Durham, Maine. King discusses his childhood exploration of the house, which somewhat parallels Ben Mears's experience, in *Danse Macabre* (New York: Everest House, 1981), pp. 252–53.

14. *'Salem's Lot*, p. 131.

15. Ibid., p. 123.

16. "The Fright Report," *Oui*, January 1980, p. 108. Several commentators, including Leonard Wolf in *A Dream of Dracula* (New York: Popular Library, 1972), focus almost exclusively upon Stoker's *Dracula* and its progeny as blatant sexual allegory.

17. "The Fright Report," p. 108.

18. Ibid. These very words echo the particular fall from innocence experienced in those years, echoing Jack Finney's *Time and Again* (New York: Simon and Schuster, 1970), which King quotes in *Danse Macabre*:

I was . . . an ordinary person who long after he was grown retained the childhood assumption that the people who largely control our lives are somehow better informed than, and have judgment superior to, the rest of us; that they are more intelligent. Not until Vietnam did I finally realize that some of the most important decisions of all time can be made by men knowing really no more than most of the rest of us.

19. *'Salem's Lot*, p. 344.

20. "Introduction," in Jack Finney, *The Body Snatchers* (Boston: Gregg Press, 1976), p. ix.

21. Interview with Douglas E. Winter, May 3, 1982.

22. *Maine,* March/April 1977; *Night Shift.*

23. "One for the Road," *Night Shift,* pp. 311, 322.

24. Quoted in David McDonnell, "The Once and Future King," *Mediascene Prevue,* April/May 1982, p. 59.

FIVE: *The Shining*

1. *The Shining* (Garden City, NY: Doubleday, 1977).

2. "On Becoming a Brand Name," *Adelina,* February 1980, p. 45. The Stanley Hotel remains open today for visitors and overnight guests.

3. "On *The Shining* and Other Perpetrations," *Whispers,* no. 17/18, August 1982, p. 13. The novel was originally titled *The Shine,* after the chorus to John Lennon's "Instant Karma": "We all shine on, like the moon and the stars and the sun. . . ."

4. *Danse Macabre* (New York: Everest House, 1981), p. 255.

5. *The Shining,* pp. 303–04. Additional details of the Overlook Hotel's "unsavory history," including a sketchy history of the resort's construction, were set forth in a prologue, "Before the Play," which was cut from the published version of the novel. The prologue has since been published in *Whispers,* no. 17/18, August 1982. See Appendix B.

6. *The Shining,* p. 143.

7. "On Becoming a Brand Name," p. 45.

8. Interview with Douglas E. Winter, May 4, 1982. The lack of effective love of characters is an obvious shortcoming of Stanley Kubrick's film adaptation of *The Shining.* By focusing upon psychological climate and failing to present a Jack Torrance who is capable of sympathy and understanding, Kubrick lessened the frightening impact of the character's dissolution.

9. *The Shining,* p. 36.

10. Interview with Douglas E. Winter, May 4, 1982.

11. "On Becoming a Brand Name," p. 45.

12. *Danse Macabre,* p. 255.

13. *The Shining,* p. 15.

14. *Danse Macabre,* p. 253. Jack Cady, who has written of another massive haunted house in *The Well* (New York: Arbor House, 1980), echoes King's sentiments: "[M]uch of who we are comes from the past We are formed and directed by forgotten words, spoken by forgotten ancestors." Quoted in Douglas E. Winter, "Shadowings," *Fantasy Newsletter,* no. 50, August 1982, p. 17.

15. *The Shining,* p. 222.

16. *Danse Macabre,* p. 267.

17. References to Poe resound throughout the novel, and not simply in

its allusions to "The Masque of the Red Death." Most notable is Jack Torrance's ironic dismissal of Poe as "the Great American Hack" early in the book (p. 155) and the manner in which *The Shining* subliminally parallels the many stories spawned by Poe's dipsomania. In relating the writings of Nathaniel Hawthorne to *The Shining*, my analysis owes a great debt to John Updike's "On Hawthorne's Mind," *New York Review of Books*, March 19, 1981.

18. *The Shining*, p. 351.
19. Ibid., pp. 108–09.
20. Ibid., p. 106.
21. Ibid., p. 135.
22. Quoted in Bill Ott, "Stephen King's Reign of Terror," *Openers*, Fall 1981, p. 4.
23. *The Shining*, pp. 437–38.
24. *'Salem's Lot* (Garden City, NY: Doubleday, 1975), pp. 351, 423.
25. *The Stand* (Garden City, NY: Doubleday, 1978), p. 766.
26. *The Shining*, pp. 446–47.

SIX: *The Stand* ◆ *The Dark Tower: The Gunslinger*

1. *The Stand* (Garden City, NY: Doubleday, 1978).
2. *Danse Macabre* (New York: Everest House, 1981), p. 369.
3. Ibid., p. 371.
4. The original manuscript was cut substantially by Doubleday editorial staff because of the practical difficulties of publishing and successfully marketing a book of such length. An unexpurgated edition of *The Stand* has been stalled by contractual difficulties. See text at pp. 171–172 above.
5. *Ubris*, Spring 1969; revised version, *Cavalier*, August 1974; *Night Shift* (Garden City, NY: Doubleday, 1978). This short story suggests that the superflu came out of Southeast Asia, a premise not entirely inconsistent with that of *The Stand*.
6. See, for example, Masao Miyoshi, *The Divided Self* (New York: New York University Press, 1969); G. Richard Thompson, "Introduction: Gothic Fiction and the Romantic Age: Context and Mode," *Romantic Gothic Tales, 1790–1840* (New York: Harper & Row, 1979).
7. Conrad's source was the Gospel According to Matthew, 23:27, which itself aptly describes the Gothic duality: "Woe unto you, scribes and Pharisees, hypocrites! For ye are like whited sepulchers, which indeed appear beautiful outward, but are within full of dead men's bones, and of all uncleanness."
8. *Danse Macabre*, p. 372.

9. See James O. Robertson, *American Myth, American Reality* (New York: Hill and Wang, 1980).

10. *The Stand*, p. 50.

11. *Ubris*, Fall 1969.

12. Interview with Douglas E. Winter, January 16, 1984. See Colin Wilson, *The Outsider* (London: Victor Gollancz, 1956).

13. *The Stand*, p. 478.

14. Ibid., p. 749.

15. Ibid., p. 765. This description of Flagg strongly echoes that of Sauron in the final confrontation of *The Lord of the Rings*.

16. *The Stand*, p. 766.

17. Ibid., p. 767.

18. See Frederick S. Frank, "The Gothic Romance," in Marshall B. Tymn, ed., *Horror Literature* (New York: Bowker, 1981); Michael Sadleir, *The Northanger Novels: A Footnote to Jane Austen* (London and New York: Oxford University Press, 1927).

19. *Danse Macabre*, p. 373.

20. *The Stand*, pp. 259–60.

21. Quoted in Abe Peck, "Stephen King's Court of Horror," *Rolling Stone College Papers*, Winter 1980, p. 53.

22. *The Stand*, p. 361. See *Danse Macabre*, p. 313.

23. Quoted in Martha Thomases and John Robert Tebbel, "Interview: Stephen King," *High Times*, January 1981, p. 40. As Glen Bateman puts it: "That is the curse of the human race. Sociability. . . ." *The Stand*, p. 259. Mother Abagail is less cynical: "The curse and blessing of the human race was its chumminess." Ibid., p. 406.

24. Ibid., p. 816.

25. Walter M. Miller, Jr., *A Canticle for Leibowitz* (Philadelphia: J.B. Lippencott, 1960). This unanswerable question is also posed in King's dystopian quest novel *The Long Walk* by "Richard Bachman" (New York: New American Library, Signet, 1979).

26. *Danse Macabre*, p. 374.

27. Ibid.

28. "The Gunslinger," *The Magazine of Fantasy and Science Fiction*, October 1978, p. 52.

29. *The Dark Tower: The Gunslinger* (West Kingston, RI: Donald M. Grant, 1982). The original printing of this book was limited to a ten-thousand-copy first edition, plus a small deluxe, signed and slipcased edition; it went quietly and quickly out of print. When the book was listed along with Stephen King's other works in the front matter of *Pet Sematary*, Donald M. Grant, King, and all of King's publishers were besieged with letters and calls from readers attempting to obtain copies. The demand was so great that a special second edition was printed in 1984; it is now also

out of print. King has written about the experience in the as-yet unpublished essay "The Dark Tower: A Cautionary Tale."

30. The first drafts of the stories that constitute *The Dark Tower: The Gunslinger* were written late in King's senior year in college and just after he graduated in 1970. During the summer of 1970, *The Maine Campus*—the university newspaper which had published his "Garbage Truck" column during his college years—printed, in serial fashion, a humorous King western story, "Slade," whose main character was a gunslinger. See Appendix B.

31. "The Gunslinger," p. 73.

32. Ibid., p. 89.

33. *The Magazine of Fantasy and Science Fiction*, April 1980; *The Dark Tower: The Gunslinger*.

34. *The Magazine of Fantasy and Science Fiction*, February 1981; *The Dark Tower: The Gunslinger*.

35. *The Magazine of Fantasy and Science Fiction*, July 1981; *The Dark Tower: The Gunslinger*.

36. *The Magazine of Fantasy and Science Fiction*, November 1981; *The Dark Tower: The Gunslinger*.

37. *The Magazine of Fantasy and Science Fiction*, November 1981, p. 83.

38. "Anything you have to outline is a way of saying to yourself, 'I'm afraid I'll forget what I was doing.' And if you are going to forget what you're doing, you must not have been very interested in the first place." Interview with Douglas E. Winter, May 4, 1982.

SEVEN: *The Dead Zone*

1. *The Dead Zone* (New York: Viking Press, 1979).

2. See *Danse Macabre* (New York: Everest House, 1981), pp. 61–88.

3. Quoted in Tim Lucas, "The Elephant Man," *Cinefantastique*, Spring 1981, p. 46.

4. *The Dead Zone*, p. 14. This visage reemerges momentarily as the novel's climax approaches: "That red left eye—and the scar running up his neck—made that half of his face look sinister and unpleasant." Ibid., p. 384.

5. See text at pp. 61 and 80, above.

6. *The Dead Zone*, p. 318.

7. That Stillson's name is intentionally a conjunction of "still" and "Nixon" is a possibility not to be lightly ignored.

8. *Gallery*, October 1980, p. 75/25; *Skeleton Crew* (New York: Putnam, 1985). One of King's best short stories, "The Monkey" has been anthologized no less than four times as of this writing. See Bibliography.

9. *Cavalier*, October 1973; *Night Shift* (Garden City, NY: Doubleday, 1978).

10. Jack Sullivan, *Elegant Nightmares: The English Ghost Story from Le Fanu to Blackwood* (Athens, OH: Ohio University Press, 1978), p. 18. J. Sheridan Le Fanu's "Green Tea" is available in a number of anthologies currently in print, including Herbert A. Wise and Phyllis Fraser, eds., *Great Tales of Terror & the Supernatural* (New York: Modern Library, 1944), and Jack Sullivan, ed., *Lost Souls: A Collection of English Ghost Stories* (Athens, OH: Ohio University Press, 1983).

11. Interview with Douglas E. Winter, January 15, 1984.

12. *The Dead Zone*, p. 309.

13. Mother Abagail tells Andros: "God has put his finger on your heart. But He has more fingers than one, and there's others out there . . . and He's got a finger on them, too." *The Stand* (Garden City, NY: Doubleday, 1978), p. 342.

14. Ibid., p. 751.

15. *The Dead Zone*, pp. 180–81.

16. Ibid., p. 107.

17. Ibid., p. 425.

18. Ibid., p. 426.

19. Interviews with Douglas E. Winter, January 15 and 16, 1984.

EIGHT: *Firestarter*

1. *Firestarter* (New York: Viking Press, 1980).

2. Interview with Douglas E. Winter, January 15, 1984.

3. See Henry Kuttner, "Dr. Cyclops," *Thrilling Wonder Stories*, June 1940, and Kuttner's novelization under the pseudonym Will Garth, *Dr. Cyclops* (New York: Phoenix Press, 1940). Tabitha King's first novel, *Small World* (New York: Macmillan, 1981), updates the imagery of "Dr. Cyclops," providing an apt allegory for life under the microscope of the public eye.

4. Edith Hamilton, *Mythology* (New York: New American Library, Mentor, 1966), p. 82.

5. Interview with Douglas E. Winter, January 15, 1984. The Fredric Brown story described by King is "The Weapon." It has been reprinted recently in Fredric Brown, *Honeymoon in Hell* (New York: Bantam Books, 1982).

6. *Firestarter*, p. 87.

7. See Bruno Bettelheim, *The Uses of Enchantment* (New York: Alfred A. Knopf, Vintage, 1977), pp. 303–09.

8. Quoted in Bill Ott, "Stephen King's Reign of Terror," *Openers*, Fall 1981, p. 4.

9. See Albert J. Guerard, *Conrad the Novelist* (Cambridge, MA: Harvard University Press, 1958), pp. 14–16.

10. It has been suggested that the classical myths of night journey began as allegorical explanations of the process of sowing and harvesting corn, then inevitably were extended to serve as allegories of human immortality or rebirth after death. See John MacQueen, *Allegory* (London: Methuen, 1970), pp. 1–2.

11. Russell Kirk, "A Cautionary Note on the Ghostly Tale," *The Surly Sullen Bell* (New York: Fleet, 1962), p. 239. This usage has precedent at least as early as the address to light at the beginning of Book III of Milton's *Paradise Lost* (1764): "Taught by the heav'nly muse to venture down/The dark descent, and up to reascend. . . ."

12. See Barton Levi St. Armand, *The Roots of Horror in the Fiction of H. P. Lovecraft* (Elizabethtown, NY: Dragon Press, 1977).

13. *The Dead Zone* (New York: Viking Press, 1979), pp. 99–101.

14. *Firestarter*, p. 263.

15. Interview with Douglas E. Winter, January 15, 1984.

16. Quoted in Martha Thomases and John Robert Tebbel, "Interview: Stephen King," *High Times*, January 1981, p. 96. These are the sentiments of Father Callahan in *'Salem's Lot* (Garden City, NY: Doubleday, 1975), p. 164: "At moments like this he suspected that Hitler had been nothing but a harried bureaucrat and Satan himself a mental defective with a rudimentary sense of humor. . . ."

17. Interview with Douglas E. Winter, January 15, 1984. *Firestarter*'s decidedly sympathetic portrayal of Charlie McGee (whose name is notably similar to Carrie) may also stem from King's concern about reader and viewer ambivalence toward Carrie White, the telekinetic high schooler of King's first published novel. See pages 31–32 and 231 above.

18. Interview with Douglas E. Winter, January 15, 1984. King's forthcoming sociopolitical allegory *The Tommyknockers* is discussed at pages 169–171 above.

NINE: *The Mist*

1. Stephen King, "The Mist," in Kirby McCauley, ed., *Dark Forces* (New York: Viking Press, 1980); revised version, *Skeleton Crew* (New York: Putnam, 1985).

2. John Cawelti, *Adventure, Mystery and Romance* (Chicago: University of Chicago Press, 1976), p. 49.

3. See, for example, Philip Van Doren Stern, "Introduction," *Great Ghost Stories* (New York: Washington Square, 1947), pp. xvi–xvii.

4. Charles L. Grant, "Introduction," *Shadows* (Garden City, NY: Doubleday, 1978), p. 1.

5. *Comics Review*, 1965. See Appendix B.

6. "The Mist," p. 425.

7. Ibid., p. 432.

8. Ibid., p. 449.

9. Ibid., p. 538.

10. In 1979, Stephen King termed *Dawn of the Dead* "the finest horror film of the year, perhaps of the decade":

> *In Romero's films (and most notably in* Dawn of the Dead*), there is a feeling of utter madness. He gives us total chaos, and somehow, in the context of our own lives, it makes sense. . . . Even as we look ahead into the confused and frightening final years of the twentieth century, Romero invites us to look back with him and cackle madly over a society that is literally feeding on itself.*

Stephen King, "The Horrors of '79," *Rolling Stone*, December 27, 1979/ January 10, 1980, p. 19. King and Romero would, of course, later collaborate on the motion picture *Creepshow* (1982) and, as of this writing, were working together on *Creepshow II* and screen adaptations of *The Stand* and *Pet Sematary.*

11. *Filmmakers Newsletter*, quoted in Danny Peary, *Cult Movies* (New York: Delta, 1981), p. 227.

12. Quoted in Paul R. Gagne, "Stephen King," *Cinefantastique*, Spring 1981, p. 9.

13. *Ubris*, Spring 1969; revised version, *Cavalier*, August 1974; *Night Shift* (Garden City, NY: Doubleday, 1978).

14. "The Mist," p. 505.

15. Ibid., p. 530.

16. See David Punter, *The Literature of Terror* (London: Longman, 1980), p. 355.

17. "The Mist," p. 549.

18. Russell Kirk, "A Cautionary Note on the Ghostly Tale," *The Surly Sullen Bell* (New York: Fleet, 1962), pp. 238–39.

19. Stephen King, "Introduction," in Bill Pronzini, Barry Malzberg, and Martin H. Greenberg, comps., *The Arbor House Treasury of Horror and the Supernatural* (New York: Arbor House, 1981), p. 18.

TEN: *Cujo*

1. *Cujo* (New York: Viking Press, 1981).

2. Castle Rock has since become a prominent location in King's fiction; it is the setting for "The Body" in *Different Seasons* (New York: Viking Press, 1982), and for a number of short stories, including "Mrs. Todd's

Shortcut," *Redbook*, May 1984; *Skeleton Crew* (New York: Putnam, 1985). King comments:

> *Castle Rock began as a fictionalized version of—and this is going to wipe out anyone who is from there—Norway-South Paris, Maine. . . . Little by little, it became its own place; and now, in my mind, Castle Rock is not like Norway-South Paris at all. It's a much prettier, touristy sort of place. But it's in about the same location.*

Interview with Douglas E. Winter, January 16, 1984.

3. "Wolfe was under the impression that 'Cujo' meant 'sweet one,' " King notes. "The people who made the motion picture of *Cujo* claimed that it meant 'unstoppable evil,' but I think that is hype. You won't find the word in a Spanish dictionary. And one of the things I've always liked is the impenetrability of that word." Interview with Douglas E. Winter, January 15, 1984.

4. Interview with Douglas E. Winter, May 4, 1982.

5. Ibid.

6. *Cujo*, p. 318.

7. See Burton Hatlen, "The Mad Dog and Maine," in Douglas E. Winter, ed., *Shadowings: The Reader's Guide to Horror Fiction, 1981–82* (Mercer Island, WA: Starmont House, 1983).

8. *Cujo*, p. 136.

9. Ibid., p. 161.

10. Ibid., p. 207.

11. Ibid., p. 11.

12. "The Mist," in Kirby McCauley, ed., *Dark Forces* (New York: Viking Press, 1980), p. 533; *Skeleton Crew*.

13. Stephen King, "Why We Crave Horror Movies," *Playboy*, January 1981, p. 264.

14. Letter from Stephen King to Douglas E. Winter, December 24, 1980. Copyright ©1982, 1984 by Stephen King.

15. *Cujo*, p. 214.

16. Stephen King, "Introduction," in Bill Pronzini, Barry Malzberg, and Martin H. Greenberg, comps., *The Arbor House Treasury of Horror and the Supernatural* (New York: Arbor House, 1981), p. 13.

17. H. P. Lovecraft, *Supernatural Horror in Literature* (New York: Dover, 1973), p. 82.

18. This aesthetic is used to exceptional effect in what Ramsey Campbell properly calls King's "strangest" story, "Big Wheels: A Tale of the Laundry Game," in Ramsey Campbell, ed., *New Terrors 2* (London: Pan, 1980) and *Skeleton Crew*, whose perspective shifts from everyday reality to drunken confusion to the uncanny with chilling logic.

19. *Cujo*, p. 208.

20. Ibid., pp. 81–82.

21. Interview with Douglas E. Winter, May 4, 1982.

ELEVEN: *Different Seasons*

1. *Different Seasons* (New York: Viking Press, 1982).

2. Ibid., p. 471.

3. Somewhat contrary to the recollection reflected in the "Afterword" to *Different Seasons*, it now appears that the four novellas were written by King in the following sequence: "The Body" upon completing the first draft of *'Salem's Lot;* "Apt Pupil" upon finishing the first draft of *The Shining;* "Rita Hayworth and Shawshank Redemption" after the first draft of *The Stand;* and "The Breathing Method" following the first draft of *Cujo.*

4. *Different Seasons*, p. 522.

5. Ibid., p. 3.

6. Ibid., p. 29. The implicit metaphor for the act of creative writing should not be ignored. One feels the same awe when considering the history of Stephen King's writing efforts.

7. Ibid., p. 100.

8. Ibid., p. 105.

9. Ibid., p. 124.

10. Dussander's alias, Denker, is also the name of the professor in Jack Torrance's failed play, "The Little Schoolhouse," in *The Shining* (Garden City, NY: Doubleday, 1977). Even more notable is the fact that, in German, the word *Tod* means death.

11. *Different Seasons*, p. 296.

12. Ibid., p. 288.

13. Ibid., p. 335. The observation is not inappropriate. See, for example, Curt Suplee, "Stricken à la King," *Washington Post*, August 26, 1980. As a result of money-oriented reviews, King sold the North American publication rights for *Christine* (1983) to Viking Press and New American Library in the spring of 1982 for an advance on royalties of one dollar from each publisher: "I'll take the royalties, if the book makes royalties, but I don't want to hear any more about Stephen King's monster advances." Interview with Douglas E. Winter, May 3, 1982.

14. *Danse Macabre* (New York: Everest House, 1981), p. 90. See text at p. 14 above.

15. "Stud City," *Ubris*, Fall 1969; "The Revenge of Lard Ass Hogan," *The Maine Review*, July 1975. Both stories were revised for publication in *Different Seasons*.

16. *Different Seasons*, p. 411.

17. Interview with Douglas E. Winter, May 4, 1982. This theme serves as the underpinning of King's forthcoming novel *IT*. See pp. 164–166.
18. *Different Seasons*, p. 301.
19. Ibid., p. 406.
20. Ibid., p. 470.
21. See Douglas E. Winter, "Shadowings," *Fantasy Review*, no. 65, March 1984, p. 8.
22. *Different Seasons*, pp. 517–18.
23. Ibid., p. 415.
24. Ibid., p. 514.
25. Interviews with Douglas E. Winter, May 3 and 4, 1982.
26. John D. MacDonald, "Introduction," in *Night Shift* (Garden City, NY: Doubleday, 1978), p. ix.
27. Interview with Douglas E. Winter, May 4, 1982.

TWELVE: *Creepshow*

1. *Creepshow* (Warner Brothers, 1982). See Appendix C for formal motion picture credits.
2. *Creepshow* (New York: New American Library, Plume, 1982).
3. *Tales from the Crypt*, no. 46, February/March 1955.
4. Ibid. The talented staff of E. C. Comics went on to found *Mad* magazine, a somewhat less extravagant and fundamentally adolescent approach to fantasy.
5. *Milwaukee Journal*, November 27, 1981, November 30, 1981, and June 2, 1982.
6. The early King story "The Blue Air Compressor," *Onan*, January 1971, for example, is an admitted retelling of an E. C. Comics story. See also *Danse Macabre* (New York: Everest House, 1981), pp. 29–59.
7. Stephen King, *Creepshow* (unpublished screenplay, 1979), pp. 1–2.
8. *Cavalier*, May 1976.
9. In the original screenplay, Richard commits suicide before his burial, leaving him awash in twin tides of blood and water.
10. *Gallery*, July 1979.
11. *Creepshow* screenplay, p. 45. This segment obviously parodies Edward Albee's *Who's Afraid of Virginia Woolf?*
12. *Creepshow* screenplay, p. 122.
13. Throughout *Creepshow*, authority figures are identified with the power of censorship; as the framing story's father observes after tossing the "Creepshow" comic book into the garbage:

"Did you see that crap? That horror crap? Things coming out of crates and eating people . . . and dead people coming back to life? . . .

"All right, then. I took care of it. That's why God made fathers, babe. That's why God made fathers."

Creepshow screenplay, p. 4.

14. Interview with Douglas E. Winter, May 3, 1982.

15. The success of *Creepshow* has prompted the development of a sequel, *Creepshow II*, with an original screenplay by George A. Romero based upon one of Stephen King's published stories, "The Raft," *Gallery*, November 1982, and four other story ideas by King. See Appendix C.

THIRTEEN: *Christine* ♦ *Cycle of the Werewolf*

1. *Christine* (New York: Viking Press, 1983), p. 1.

2. Interview with Douglas E. Winter, January 16, 1984. Lewis Padgett was a pseudonym for horror and science fiction writer Henry Kuttner. "The Twonky," which was produced as a motion picture by Arch Oboler in 1953, concerned a television set that threatened to take over its viewers.

3. Interview with Douglas E. Winter, January 16, 1984.

4. Originally, *Christine* was to be written entirely as the first-person narrative of Dennis Guilder, but the technical problem of presenting the subject matter of the middle third of the book through Dennis's eyes proved insurmountable.

5. *Christine*, p. 1.

6. Ibid., p. 94. George LeBay's observations seemingly take on a life of their own in King's short story "The Man Who Loved Flowers," *Gallery*, August 1977; *Night Shift* (Garden City, NY: Doubleday, 1978). George LeBay, it should be noted, hails from Paradise Falls, Ohio, the fictitious setting of several novels by one of King's favorite writers, Don Robertson.

7. *Cavalier*, December 1972; *Night Shift*.

8. *Gallery*, November 1980; *Skeleton Crew* (New York: Putnam, 1985).

9. *Cavalier*, September 1972; *Night Shift*.

10. *Yankee*, October 1983; *Skeleton Crew*.

11. *Cavalier*, June 1973; *Night Shift*.

12. Interview with Douglas E. Winter, January 16, 1984.

13. *Christine*, p. 64.

14. Interview with Douglas E. Winter, January 16, 1984.

15. *Danse Macabre* (New York: Everest House, 1981), pp. 162–63.

16. See *Danse Macabre*, pp. 51–56.

17. Interview with Douglas E. Winter, January 16, 1984.

18. *Christine*, p. 50.

19. Ibid., pp. 46–47. A more literal enactment of these sentiments occurs in "The Raft," *Gallery*, November 1982, and *Skeleton Crew*, which is set in the same fictional suburban Pittsburgh as *Christine*.

20. *Christine*, p. 521.

21. Ibid., p. 524. The imagery is also comparable to King's short story of a haunting from the fifties, "Sometimes They Come Back," *Cavalier*, March 1974; *Night Shift*.

22. Interview with Douglas E. Winter, January 16, 1984; Letter to *TV Guide*, April 30/May 6, 1983, p. A–3. Indeed, in 1983 King purchased AM radio station WACZ, Bangor, Maine (now retitled WZON), one of the few hard-driving rock-and-roll stations in the country remaining on the AM band. See Joel Denver, "Stephen King Takes a Stand for Radio," *Radio & Records*, February 24, 1984.

23. "Between Rock and a Soft Place," *Playboy*, January 1982, p. 242.

24. *Cycle of the Werewolf* (Westland, MI: Land of Enchantment, 1983; New York: New American Library, Plume, 1985).

25. *Silver Bullet* (New York: New American Library, Plume, 1986).

26. Ibid., pp. 11–12.

27. Ibid., p. 96.

28. Ibid., p. 97.

FOURTEEN: *Pet Sematary*

1. *Pet Sematary* (Garden City, NY: Doubleday, 1983).

2. Interview with Douglas E. Winter, January 15, 1984. Naomi King's reaction, as well as almost every other event surrounding the death of her cat, Smucky, is incorporated in *Pet Sematary*. Even Smucky is memorialized by name in the book, when the Creed family discovers its grave in the pet cemetery.

3. Interview with Douglas E. Winter, January 15, 1984.

4. This dream is used in the novel as part of Jud Crandall's story of the return of Timmy Baterman from the dead.

5. Quoted in Abe Peck, "Stephen King's Court of Horror," *Rolling Stone College Papers*, Winter 1980, p. 54.

6. Interview with Douglas E. Winter, January 15, 1984. King's difficulties also seem apparent in the narrative structure of *Pet Sematary*, whose point of view, initially exclusive to Louis Creed, disperses with the return of Gage Creed from the dead.

7. Interviews with Douglas E. Winter, May 3, 1982, and January 15, 1984.

8. Interview with Douglas E. Winter, January 15, 1984. Although King had initially indicated that there would be no motion picture adaptation of *Pet Sematary*, he has agreed to a production directed by George A. Romero, for which King will write the screenplay and have substantial creative control.

9. *Pet Sematary*, p. 22.

10. Ibid., p. 37.

11. Ibid., p. 58.

12. Ibid., p. 70.

13. Ibid., p. 146.

14. *Cujo* (New York: Viking Press, 1981), p. 318.

15. King's principal source for the mythology of the Wendigo (also spelled "Windigo") was *Where the Chill Came From: Cree Windigo Tales and Journeys,* gathered and translated by Howard Norman (San Francisco, CA: North Point Press, 1982). An early usage of Wendigo legendry was Algernon Blackwood's classic horror story, "The Wendigo" (1910).

16. Interview with Douglas E. Winter, January 15, 1984.

17. Ibid.

18. *The Shining* (Garden City, NY: Doubleday, 1977), pp. 446–47.

19. *Pet Sematary,* p. 144.

20. Interview with Douglas E. Winter, January 15, 1984. King's short story "The Word Processor of the Gods," *Playboy,* January 1983 and *Skeleton Crew* (New York: Putnam, 1985), offers an interesting counterpoint to *Pet Sematary,* in which a computerized version of the monkey's paw produces a happy ending for a frustrated writer.

21. *Pet Sematary,* pp. 120–21.

22. Ibid., p. 1.

23. This observation is the sole quotation from *Dracula* in King's vampire novel, *'Salem's Lot* (Garden City, NY: Doubleday, 1975).

24. *Carrie* (Garden City, NY, Doubleday, 1974), pp. 189–90.

25. *Danse Macabre* (New York: Everest House, 1981), p. 380.

26. *Night Shift* (Garden City, NY: Doubleday, 1978), p. 290–91.

FIFTEEN: *The Talisman*

1. *The Talisman* (New York: Viking Press and Putnam, 1984), p. 3. The date selected for the beginning of *The Talisman* has no precise significance, although the novel is intentionally set in the autumn. The dating of the events in the novel confirms King's commitment to writing fiction about his times. See text at pp. 84–85 above.

2. *Julia* (New York: Coward, McCann & Geoghegan, 1975); *If You Could See Me Now* (New York: Coward, McCann & Geoghegan, 1977); *Ghost Story* (New York: Coward, McCann & Geoghegan, 1979); *Shadowland* (New York: Coward, McCann & Geoghegan, 1980); *Floating Dragon* (New York: Putnam, 1983). Peter Straub's first novel, *Marriages* (New York: Coward, McCann & Geoghegan, 1973), was not horror fiction.

3. "Peter Straub: An Informal Appreciation," in Kennedy Poyser, ed., *World Fantasy Convention '82* (New Haven, CT: The Eighth World Fan-

tasy Convention, 1982), p. 30. Compare Peter Straub's assessment of King's writing style, quoted at p. 29 above.

 4. Ibid., p. 31.

 5. Peter Straub, "Meeting Stevie," in Tim Underwood and Chuck Miller, eds., *Fear Itself: The Horror Fiction of Stephen King* (San Francisco, CA/Columbia PA: Underwood-Miller, 1982), p. 7.

 6. Ibid., p. 9.

 7. In Ramsey Campbell, ed., *New Tales of the Cthulhu Mythos* (Sauk City, WI: Arkham House, 1980).

 8. Interview with Douglas E. Winter, February 28, 1984.

 9. Ibid.

 10. Interview with Douglas E. Winter, May 4, 1982.

 11. Interview with Douglas E. Winter, February 28, 1984. Unlike most of the novels written by either author, a rough outline was developed for *The Talisman*. Peter Straub comments:

> *I had finished two-thirds of* Floating Dragon, *and Steve came here in the spring. We stayed in my office for about three days, talking about what would actually happen at the beginning of the book. It was a very, very intense period. And then he came down again, after I had finished* Floating Dragon, *and we started writing it on my word processor. We were just shooting arrows into the dark, trying to figure out where our story was going. Steve surprised me one night by typing up our notes and putting them in an organized, more coherent form. I did the same thing for the rest of our outline; the result was a long elaborate plan for the first half of the book—about twenty-five or thirty pages long, which was our original working outline. It was actually unwieldy because there was far too much in it, as it turned out. It's exciting to read, though; it indicates that these two guys were full of ambition.*

 12. Interviews with Douglas E. Winter, March 8 and 23, 1984. Because of the writers' views, I have not here attempted to attribute particular passages to either writer, but have instead sought only to place the novel within the developing thematic context of Stephen King's other fiction. The playful element of the novel's writing involved not simply the mimicking of each other's style. Internal jokes abound in *The Talisman*, from place names (such as the Rainbird Towers, after the one-eyed assassin of *Firestarter*) to an *hommage* to fellow horror fiction writer Michael McDowell in a glimpse of the female were-alligator from his six-volume novel, *Blackwater* (New York: Avon, 1983). See also note 19 below.

 13. Interview with Douglas E. Winter, February 28, 1984.

 14. Interview with Douglas E. Winter, March 8, 1984.

15. Interview with Douglas E. Winter, February 28, 1984.
16. Ibid.
17. Interview with Douglas E. Winter, January 15, 1984.
18. *The Talisman*, p. 3.
19. Ibid, p. 8. Jack Sawyer's name was intended as a combination of the boy adventurers of *Treasure Island* and *The Adventures of Tom Sawyer*, but faulty memory recalled the hero of the former book as Jack Hawkins, when in fact his first name is Jim. As discussed in the text, King and Straub named other characters with intent—and in two cases, with a vengeance; the evil Smokey Updike and Sunlight Gardener were titled after mainstream writers John Updike and John Gardner.
20. King comments:

> *We were interested in the concept of the hero in literature. We talked about the hero in terms of the quest, the mythicization of the hero, and the return of the hero to a lesser being when the quest is completed. Huckleberry Finn is a picaresque novel that doesn't have a specific object for its quest; so we focused instead on things like the story of Jesus, the story of King Arthur, Sir Gawain and the Green Knight. We talked about those things, and when we wrote the book, it filtered down like sediment.*

Interview with Douglas E. Winter, March 8, 1984.
21. Ibid.
22. Ibid.
23. *The Talisman*, p. 386.
24. Ibid, p. 503.
25. *Partisan Review*, June 1948; in *The Collected Essays of Leslie Fiedler*, vol. 1 (New York: Stein and Day, 1971). See also Leslie Fiedler, *Love and Death in the American Novel*, Part Two: Achievement and Frustration (New York: Stein and Day, 1960). As of this writing, Steven Spielberg, director of the motion picture adaptation of *The Talisman*, has indicated that one of the lead child characters will be played by a girl; the change suggests, perhaps, the very anxiety concerning the notion of innocent love between males that the novel sought to reject.
26. Robinson Jeffers, "November Surf," in *The Selected Poetry of Robinson Jeffers* (New York: Random House, 1938), p. 238.
27. *The Talisman* (original manuscript).
28. *The Talisman*, p. 510.
29. Ibid, p. 581.
30. Despite the suggestiveness of the novel's epigraph, there are no current plans for a sequel to *The Talisman* or, indeed, a further collaboration

of any kind between King and Straub. The Territories will be revisited by King, however, in the forthcoming novel *The Eyes of the Dragon*. See text at pp. 168–169 above.

SIXTEEN: *Night Shift, Skeleton Crew, and* Other Short Stories

1. *Skeleton Crew* (New York: Putnam, 1985).
2. *Night Shift* (Garden City, NY: Doubleday, 1978).
3. In Kirby McCauley, ed., *Dark Forces* (New York: Viking Press, 1980); revised version, *Skeleton Crew*.
4. *Skeleton Crew*, p. 508. As King readily admits, this line is "simply stole[n] from Douglas Fairbairn's brilliant novel *Shoot*." Ibid.
5. *Night Shift*, p. xx–xxi.
6. *Skeleton Crew*, p. 508.
7. *Onan*, January 1971; revised version, *Heavy Metal*, July 1981.
8. *Skeleton Crew*, p. 15.
9. Ibid., p. 509.
10. In Charles L. Grant, ed., *Terrors* (New York: Playboy, 1982); *Skeleton Crew*.
11. *Danse Macabre* (New York: Everest House, 1981), p. 334.
12. *Gallery*, November 1982; revised version, *Skeleton Crew*.
13. *Cosmopolitan*, September 1976; *Night Shift*.
14. In Charles L. Grant., ed., *Shadows 4* (Garden City, NY: Doubleday, 1981); revised version, *Skeleton Crew*.
15. *Startling Mystery Stories*, Spring 1969; *Skeleton Crew*.
16. *Night Shift*.
17. *Castle Rock*, February through June 1985.
18. *Night Shift*.
19. *Gallery*, August 1977; *Skeleton Crew*.
20. *Ubris*, Spring 1968; *Skeleton Crew*.
21. *Gallery*, November 1980; *Skeleton Crew*.
22. *Cavalier*, May 1976. This story was revised as the segment of *Creepshow* entitled "The Lonesome Death of Jordy Verrill."
23. *Playboy*, January 1983 (as "The Word Processor"); *Skeleton Crew*.
24. *Twilight Zone Magazine*, April 1981; *Skeleton Crew*.
25. *Weirdbook*, no. 19, Spring 1984; *Skeleton Crew*.
26. *Weird Tales*, Fall 1984; *Skeleton Crew*.
27. In Charles L. Grant, ed., *Shadows* (Garden City, NY: Doubleday, 1978); *Skeleton Crew*.
28. *Shadows*, p. 182.
29. *The Magazine of Fantasy and Science Fiction*, June 1984; *Skeleton Crew*.

30. *Skeleton Crew*, 1985.

31. In Ramsey Campbell, ed., *New Terrors 2* (London: Pan, 1980); *Skeleton Crew*.

32. *Cavalier*, October 1973; *Night Shift*.

33. *Ubris*, Spring 1968; *Skeleton Crew*.

34. In Ramsey Campbell, ed., *New Tales of the Cthulhu Mythos* (Sauk City, WI: Arkham House, 1980).

35. *Cavalier*, March 1973; *Night Shift*.

36. *Ubris*, Fall 1968; revised version, *Cavalier*, November 1975; *Night Shift*.

37. *Cavalier*, February 1972.

38. *The Magazine of Fantasy and Science Fiction*, February 1978.

39. *Startling Mystery Stories*, Fall 1967.

40. *Cavalier*, April 1972 (published under the pseudonym "John Swithen").

41. *Cavalier*, December 1978.

42. *Ellery Queen's Mystery Magazine*, December 1, 1980; *Skeleton Crew*.

43. *Cavalier*, September 1972; *Night Shift*.

44. *Cavalier*, June 1977.

45. *Cat's Eye* (MGM/UA, 1985). See Appendix C for formal motion picture credits.

46. *Night Shift*, 1978.

47. *Penthouse*, July 1976; *Night Shift*.

48. The troll was created by special effects wizard Carlo Rambaldi from the following description in King's script:

Exactly what is it? A gremlin or an elf of some sort, I suppose. . . . He's about five inches high, humanoid, wearing a breechclout or a loincloth. He has yellow eyes and an ugly expression—but it's not a stupid expression, oh no. On his head is a cap of bells, like a court jester's cap. . . . He's carrying a strange crooked knife in one hand. . . . He CHITTERS. This might be laughter. Yeah, he sounds like he's laughing. This is one very mean little being.

Cat's Eye (unpublished screenplay, third draft, 1984), p. 92.

49. *Comics Review*, 1965.

50. *Cavalier*, October 1970; *Night Shift*.

51. *Cavalier*, March 1971; *Night Shift*.

52. *Cavalier*, March 1974; *Night Shift*.

53. *Cavalier*, June 1973; *Night Shift*.

54. *Cavalier*, December 1972; *Night Shift*.

55. *Cavalier*, May 1975; *Night Shift*.

56. *Night Shift*, 1978.
57. *Maine*, March/April 1977; *Night Shift*.
58. *Marshroots*, 1975; revised version, *Whispers*, no. 17/18, August 1982.
59. *Rolling Stone*, July 19/August 2, 1984.
60. *Redbook*, May 1984; *Skeleton Crew*.
61. *Yankee*, October 1983; *Skeleton Crew*.
62. *Yankee*, November 1981 (as "Do the Dead Sing?"); *Skeleton Crew*.

SEVENTEEN: . . . *Always More Tales*

1. Interview with Douglas E. Winter, January 16, 1984. The poem by W. H. Auden that King refers to is "Nones," *Nones* (New York: Random House, 1950).
2. Interview with Douglas E. Winter, May 4, 1982.
3. *Overdrive* (MGM/UA, 1986). See Appendix C for formal motion picture credits.
4. *Overdrive* (unpublished screenplay, 1985), p. 1.
5. *Cavalier*, June 1973; *Night Shift* (Garden City, NY: Doubleday, 1978).
6. *Overdrive* screenplay, p. 7.
7. Ibid., p. 77.
8. Ibid., p. 81.
9. Ibid., p. 74.
10. *IT* (New York: Viking Press, 1986) (read in manuscript).
11. Interview with Douglas E. Winter, January 16, 1984.
12. "The Boogeyman," *Cavalier*, March 1973; *Night Shift*, p. 96.
13. Interview with Douglas E. Winter, January 16, 1984.
14. "The Bird and the Album," Jeff Frane and Jack Rems, eds., *A Fantasy Reader: The Seventh World Fantasy Convention Program Book* (Berkeley, CA: The Seventh World Fantasy Convention, 1981) (excerpt from first draft of *IT*, Chapter 13, Parts 1 and 2).
15. Quoted in Michael J. Bandler, "The King of the Macabre at Home," *Parents Magazine*, January 1982, p. 71.
16. Interview with Douglas E. Winter, January 16, 1984.
17. *Misery* (New York: Viking Press, 1987) (read in manuscript).
18. Ibid.
19. Ibid.
20. *The Eyes of the Dragon* (Bangor, ME: Philtrum Press, 1984; New York: Viking Press, 1987).
21. Ibid., p. 7.
22. Interview with Douglas E. Winter, January 16, 1984.
23. *The Eyes of the Dragon*, p. 7.

24. Ibid.

25. Ibid., pp. 16–17.

26. *The Tommyknockers* (New York: Putnam, 1987) (read in manuscript).

27. Interview with Douglas E. Winter, January 15, 1984.

28. *The Tommyknockers* (read in manuscript).

29. Ibid.

30. Ibid.

31. Interview with Douglas E. Winter, January 16, 1984.

32. See text at pp. 65–67 above.

33. See text at pp. 43–44 above.

34. Interview with Douglas E. Winter, May 3, 1982.

35. Ibid.

36. *Night Shift*, p. xii.

APPENDIX A: *The Bachman Books*

1. Interview with Douglas E. Winter, January 15, 1984.

2. "Why I Was Bachman," *The Bachman Books* (New York: New American Library, NAL Books, 1985), p. viii.

3. Ibid., p. ix.

4. Ibid.

5. *Rage* (New York: New American Library, Signet, 1977).

6. Ibid., p. 184.

7. Ibid., pp. 32–33.

8. Ibid., p. 34.

9. Ibid.

10. Ibid., p. 48.

11. Ibid., p. 151.

12. Ibid., pp. 202–03.

13. *The Long Walk* (New York: New American Library, Signet, 1979).

14. Ibid., p. 8.

15. Ibid., p. 36.

16. Ibid., p. 37.

17. Ibid., p. 244.

18. "Why I Was Bachman," p. ix.

19. *Roadwork* (New York: New American Library, Signet, 1981).

20. "Why I Was Bachman," pp. ix–x.

21. *Roadwork*, p. 7.

22. Ibid., pp. 169–70.

23. Ibid., pp. 104–05.

24. *Rage*, p. 35.

25. *The Running Man* (New York: New American Library, Signet, 1982).

26. "Why I Was Bachman," p. x.

27. *The Running Man*, p. 2.

28. Ibid., p. 202.

29. Ibid., p. 219.

30. *Thinner* (New York: New American Library, NAL Books, 1984).

31. Ibid., p. 20.

32. Ibid., p. 1.

33. Ibid., p. 162.

34. Interview with Douglas E. Winter, January 15, 1984.

35. *Thinner*, p. 153.

36. Ibid., p. 195.

37. Ibid., pp. 279, 282.

38. Ibid., p. 147.

39. Ibid., p. 267.

40. The hoax "review" by "Helen Purcell" appeared in *Fantasy Review*, no. 78, April 1985; responses from both Stephen King and his attorney followed in *Fantasy Review*, no. 79, May 1985.

41. Interview with Douglas E. Winter, January 15, 1984.

APPENDIX B: Short Fiction

All unattributed quotations of Stephen King are taken from interviews with the author.

APPENDIX C: Motion Picture and Television Adaptations

All quotations of Stephen King are taken from interviews with the author.

A Stephen King Bibliography

The primary bibliography that follows is intended to provide a checklist of the first appearances in print of Stephen King's fiction, as well as of most subsequent reprints; it also sets forth selected items of Stephen King's published nonfiction. The secondary bibliography of interviews, reviews, and criticism constitutes a small, but representative sampling of the rapidly expanding body of writing about Stephen King; the computer database from which it is drawn contains more than twenty times the number of items listed here. A definitive bibliographic accounting of the first twenty years of works by and about Stephen King has required the creation of an additional book—annotated and with commentary by and about Stephen King—that was designed specifically to serve as a companion to *The Art of Darkness*. Readers interested in this volume, *Stephen King: A Bibliography*, should contact Donald M. Grant, Publisher, West Kingston, Rhode Island 02892. Another useful reference tool is the official Stephen King newsletter, *Castle Rock*, published monthly by Stephen Leonard, P. O. Box 8131, Bangor, ME 04401.

Primary Bibliography

BOOKS

NOVELS

Carrie
 1. Garden City, NY: Doubleday, 1974 (hardcover).
 2. New York: New American Library, Signet, 1975 (paperback).
Christine
 1. West Kingston, RI: Donald M. Grant, 1983 (limited edition hardcover).
 2. New York: Viking Press, 1983 (hardcover).
 3. New York: New American Library, Signet, 1984 (paperback).
Cujo
 1. New York: The Mysterious Press, 1981 (limited edition hardcover).
 2. New York: Viking Press, 1981 (hardcover).
 3. New York: New American Library, Signet, 1982 (paperback).
Cycle of the Werewolf
 Illustrated by Berni Wrightson.
 1. Westland, MI: Land of Enchantment, 1983 (limited edition hardcover).
 2. New York: New American Library, Plume 1985 (trade paperback).
 As *Silver Bullet:*
 3. New York: New American Library, Plume 1986 (trade paperback).
The Dead Zone
 1. New York: Viking Press, 1979 (hardcover).
 2. New York: New American Library, Signet, 1980 (paperback).
The Eyes of the Dragon
 1. Bangor, ME: Philtrum Press, 1984 (limited edition hardcover).
 2. New York: Viking Press, 1987 (hardcover).
 3. New York: New American Library, 1988 (paperback).
IT
 1. New York: Viking Press, 1986 (hardcover).
 2. New York: New American Library, Signet, 1987 (paperback).
Firestarter
 1. Huntington Woods, MI: Phantasia Press, 1980 (limited edition hardcover).
 2. New York: Viking Press, 1980 (hardcover).
 3. New York: New American Library, Signet, 1981 (paperback).
The Long Walk (as Richard Bachman)
 New York: New American Library, Signet, 1979 (paperback).

Misery
1. New York: Viking Press, 1987 (hardcover).
2. New York: New American Library, Signet, 1988 (paperback)
Pet Sematary
1. Garden City, NY: Doubleday, 1983 (hardcover).
2. New York: New American Library, Signet, 1984 (paperback).
Rage (as Richard Bachman)
New York: New American Library, Signet, 1977 (paperback).
Roadwork (as Richard Bachman)
New York: New American Library, Signet, 1981 (paperback).
The Running Man (as Richard Bachman)
New York: New American Library, Signet, 1982 (paperback).
'Salem's Lot
1. Garden City, NY: Doubleday, 1975 (hardcover).
2. New York: New American Library, Signet, 1976 (paperback).
The Shining
1. Garden City, NY: Doubleday, 1977 (hardcover).
2. New York: New American Library, Signet, 1978 (paperback).
The Stand
1. Garden City, NY: Doubleday, 1978 (hardcover).
2. New York: New American Library, Signet, 1979 (paperback).
The Talisman (with Peter Straub).
1. West Kingston, RI: Donald M. Grant, 1984 (limited edition hardcover).
2. New York: Viking Press and Putnam, 1984 (hardcover).
3. New York: Berkley, 1985 (paperback).
Thinner (as Richard Bachman)
1. New York: New American Library, NAL Books, 1984 (hardcover).
2. New York: New American Library, Signet, 1985 (paperback).
The Tommyknockers
1. New York: Putnam, 1987 (hardcover).
2. New York: New American Library, Signet, 1988 (paperback).

COLLECTIONS

The Bachman Books
1. New York: New American Library, NAL Books, 1985 (hardcover).
2. New York: New American Library, Plume, 1985 (trade paperback).
Contents:
"Why I Was Bachman"
Rage
The Long Walk

Roadwork
The Running Man
Creepshow
 Comic book adaptation illustrated by Berni Wrightson.
 New York: New American Library, Plume, 1982 (trade paperback).
 Contents:
 "Father's Day"
 "The Lonesome Death of Jordy Verrill"
 "The Crate"
 "Something to Tide You Over"
 "They're Creeping Up on You"
The Dark Tower: The Gunslinger
 Illustrated by Michael Whelan.
 1. West Kingston, RI: Donald M. Grant, 1982 (limited edition hardcover).
 2. West Kingston, RI: Donald M. Grant, 1984 (limited edition hardcover).
 Contents:
 "The Gunslinger"
 "The Way Station"
 "The Oracle and the Mountains"
 "The Slow Mutants"
 "The Gunslinger and the Dark Man"
 "Afterword"
Different Seasons
 1. New York: Viking Press, 1982 (hardcover).
 2. New York: New American Library, Signet, 1983 (paperback).
 Contents:
 "Rita Hayworth and Shawshank Redemption"
 "Apt Pupil"
 "The Body"
 "The Breathing Method"
 "Afterword"
Night Shift
 1. Garden City, NY: Doubleday, 1978 (hardcover).
 2. New York: New American Library, Signet, 1979 (paperback).
 Contents:
 "Introduction" by John D. MacDonald
 "Foreword"
 "Jerusalem's Lot"
 "Graveyard Shift"
 "Night Surf"
 "I Am the Doorway"

"The Mangler"
"The Boogeyman"
"Gray Matter"
"Battleground"
"Trucks"
"Sometimes They Come Back"
"Strawberry Spring"
"The Ledge"
"The Lawnmower Man"
"Quitters, Inc."
"I Know What You Need"
"Children of the Corn"
"The Last Rung on the Ladder"
"The Man Who Loved Flowers"
"One for the Road"
"The Woman in the Room"

Skeleton Crew
1. Santa Cruz, CA: Scream/Press, 1985 (limited edition hardcover).
2. New York: Putnam, 1985 (hardcover).
3. New York: New American Library, Signet, 1986 (paperback).
 Contents:
 "Introduction"
 "The Mist"
 "Here There Be Tygers"
 "The Monkey"
 "Cain Rose Up"
 "Mrs. Todd's Shortcut"
 "The Jaunt"
 "The Wedding Gig"
 "Paranoid: A Chant"
 "The Raft"
 "Word Processor of the Gods"
 "The Man Who Would Not Shake Hands"
 "Beachworld"
 "The Reaper's Image"
 "Nona"
 "For Owen"
 "Survivor Type"
 "Uncle Otto's Truck"
 "Morning Deliveries (Milkman #1)"
 "Big Wheels: A Tale of the Laundry Game (Milkman #2)"
 "Gramma"
 "The Ballad of the Flexible Bullet"

"The Reach"
"Notes"
Stephen King
New York: William Heinemann, Inc. and Octopus Books, 1981 (hardcover).
Contents:
The Shining
'Salem's Lot
Night Shift
Carrie

NONFICTION

Danse Macabre
1. New York: Everest House, 1981 (limited edition hardcover).
2. New York: Everest House, 1981 (hardcover).
3. New York: Berkley, 1982 (trade paperback).
4. New York: Berkley, 1983 (paperback).

SHORT FICTION

"Apt Pupil"
Subtitle: "Summer of Corruption"
Different Seasons, 1982.
"The Ballad of the Flexible Bullet"
1. *The Magazine of Fantasy and Science Fiction*, June 1984.
2. *Skeleton Crew*, 1985.
"Battleground"
1. *Cavalier*, September 1972.
2. *Night Shift*, 1978.
"Beachworld"
1. *Weird Tales*, Fall 1984.
2. *Skeleton Crew*, 1985.
"Before the Play"
Previously unpublished prologue to *The Shining*.
Whispers, no. 17/18, August 1982.
"Big Wheels: A Tale of the Laundry Game"
1. In *New Terrors 2*. Ed. Ramsey Campbell. London: Pan, 1980 (paperback).
2. In *New Terrors*. Ed. Ramsey Campbell. New York: Pocket Books, 1982 (paperback).
3. *Skeleton Crew*, 1985.
"The Bird and the Album"
Excerpt from *IT*.

In *A Fantasy Reader: The Seventh World Fantasy Convention Program Book*. Eds. Jeff Frane and Jack Rems. Berkeley, CA: The Seventh World Fantasy Convention, 1981 (hardcover).

"The Blue Air Compressor"
1. *Onan*, January 1971.
Revised version:
2. *Heavy Metal*, July 1981.

"The Body"
Subtitle: "Fall from Innocence"
Includes "Stud City" and "The Revenge of Lard Ass Hogan."
Different Seasons, 1982.

"The Boogeyman"
1. *Cavalier*, March 1973.
2. *Gent*, December 1975.
3. *Night Shift*, 1978.
4. In *The 25th Pan Book of Horror Stories*. Ed. Herbert Van Thal. London: Pan, 1984 (paperback).

"The Breathing Method"
Subtitle: "A Winter's Tale"
Different Seasons, 1982.

"Cain Rose Up"
1. *Ubris*, Spring 1968.
2. *Skeleton Crew*, 1985.

"The Cat from Hell"
1. *Cavalier*, June 1977.
2. In *Tales of Unknown Horror*. Ed. Peter Haining. London: New English Library, 1978 (paperback).
3. In *The Year's Finest Fantasy*. Ed. Terry Carr. New York: Putnam, 1978 (hardcover); New York: Berkley, 1979 (paperback).
4. In *Magicats!* Eds. Jack Dann and Gardner Dozois. New York: Ace, 1984 (paperback).

"Children of the Corn"
1. *Penthouse*, March 1977.
2. *Night Shift*, 1978.
3. In *Cults! An Anthology of Societies, Sects, and the Supernatural*. Eds. Martin H. Greenberg and Charles G. Waugh. New York: Beaufort, 1983 (hardcover).

"The Crate"
1. *Gallery*, July 1979.
2. In *Fantasy Annual III*. Ed. Terry Carr. New York: Pocket Books, 1981 (paperback).

3. In *The Arbor House Treasury of Horror and the Supernatural*. Comps. Bill Pronzini, Barry N. Malzberg, and Martin H. Greenberg. New York: Arbor House, 1981 (hardcover); New York: Arbor House, Priam, 1981 (trade paperback).

Comic book adaptation illustrated by Berni Wrightson:

4. *Creepshow*, 1982.

"Crouch End"

In *New Tales of the Cthulhu Mythos*. Ed. Ramsey Campbell. Sauk City, WI: Arkham House, 1980 (hardcover).

"Cycle of the Werewolf"

Excerpt from *Cycle of the Werewolf*.

Heavy Metal, December 1983.

"Do the Dead Sing?"

1. *Yankee*, November 1981.

As "The Reach":

2. *Skeleton Crew*, 1985.

"Dolan's Cadillac"

Castle Rock, nos. 2–6, February through June, 1985.

"The Fifth Quarter"

Written as John Swithen.

1. *Cavalier*, April 1972.

2. *Twilight Zone Magazine*, February 1986.

"Firestarter"

Excerpt from *Firestarter*, in two parts:

Omni, July and August 1980.

"The Glass Floor"

Startling Mystery Stories, Fall 1967.

"Gramma"

1. *Weirdbook*, no. 19, Spring 1984.

2. *Skeleton Crew*, 1985.

"Graveyard Shift"

1. *Cavalier*, October 1970.

2. *Night Shift*, 1978.

3. In *The 21st Pan Book of Horror Stories*. Ed. Herbert Van Thal. London: Pan, 1980 (paperback).

"Gray Matter"

1. *Cavalier*, October 1973.

2. *Night Shift*, 1978.

3. In *The Arbor House Necropolis*. Ed. Bill Pronzini. New York: Arbor House, 1981 (hardcover); New York: Arbor House, Priam, 1981 (trade paperback).

"The Gunslinger"

1. *The Magazine of Fantasy and Science Fiction*, October 1978.

2. In *The Year's Finest Fantasy Volume Two*. Ed. Terry Carr. New York: Berkley 1980 (paperback).
3. *The Dark Tower: The Gunslinger*, 1982.

"The Gunslinger and the Dark Man"
1. *The Magazine of Fantasy and Science Fiction*, November 1981.
2. *The Dark Tower: The Gunslinger*, 1982.

"Here There Be Tygers"
1. *Ubris*, Spring 1968.
2. *Skeleton Crew*, 1985.

"I Am the Doorway"
1. *Cavalier*, March 1971.
2. *Night Shift*, 1978.

"I Know What You Need"
1. *Cosmopolitan*, September 1976.
2. *Night Shift*, 1978.
3. In *Isaac Asimov's Magical Worlds of Fantasy No. 4*. Eds. Isaac Asimov, Martin H. Greenberg, and Charles G. Waugh. New York: New American Library, Signet, 1985 (paperback).

"I Was a Teenage Grave Robber"
1. *Comics Review*, 1965.
As "In a Half-World of Terror":
2. *Stories of Suspense*, no. 2, 1966.

"It Grows on You"
1. *Marshroots*, 1975.
Revised version:
2. *Whispers*, no. 17/18, August 1982.
3. In *Death*. Ed. Stuart D. Schiff. New York: Playboy, 1982 (paperback).

"The Jaunt"
1. *Twilight Zone Magazine*, April 1981.
2. *Gallery*, December 1981 (special pull-out booklet).
3. In *Great Stories from Twilight Zone Magazine*, September 1982.
4. *Skeleton Crew*, 1985.

"Jerusalem's Lot"
1. *Night Shift*, 1978.
2. In *The World Fantasy Awards, Volume Two*. Eds. Stuart David Schiff and Fritz Leiber. Garden City, NY: Doubleday, 1980 (hardcover).

"The Last Rung on the Ladder"
 Night Shift, 1978.

"The Lawnmower Man"
1. *Cavalier*, May 1975.
2. *Night Shift*, 1978.
Comic book adaptation illustrated by Walter Simonson:
3. *Bizarre Adventures*, no. 29, December 1981.

"The Ledge"
1. *Penthouse*, July 1976.
2. *Night Shift*, 1978.

"The Man Who Loved Flowers"
1. *Gallery*, August 1977.
2. *Night Shift*, 1978.

"The Man Who Would Not Shake Hands"
1. In *Shadows 4*. Ed. Charles L. Grant. Garden City, NY: Doubleday, 1981 (hardcover); New York: Berkley, 1985 (paperback).
2. In *Fantasy Annual V*. Ed. Terry Carr. New York: Pocket Books, Timescape, 1982 (paperback).
Revised version:
3. *Skeleton Crew*, 1985.

"Man with a Belly"
1. *Cavalier*, December 1972.
2. *Gent*, November/December 1979.

"The Mangler"
1. *Cavalier*, December 1972.
2. *Night Shift*, 1978.
3. In *The 21st Pan Book of Horror Stories*. Ed. Herbert Van Thal. London: Pan, 1980 (paperback).
4. In *The Arbor House Celebrity Book of Horror Stories*. Eds. Martin H. Greenberg and Charles Waugh. New York: Arbor House, 1982 (hardcover); New York: Arbor House, Priam, 1982 (trade paperback).

"The Mist"
1. In *Dark Forces*. Ed. Kirby McCauley. New York: Viking Press, 1980 (hardcover); New York: Bantam, 1981 (paperback).
Revised version:
2. *Skeleton Crew*, 1985.

"The Monkey"
1. *Gallery*, November 1980 (special pull-out booklet).
2. In *Fantasy Annual IV*. Ed. Terry Carr. New York: Pocket Books, 1981 (paperback).
3. In *Horrors*. Ed. Charles L. Grant. New York: Playboy, 1981 (paperback).
4. In *Modern Masters of Horror*. Ed. Frank Coffey. New York: Coward, McCann & Geoghegan, 1981 (hardcover); New York: Ace, 1982 (paperback).
5. In *The Year's Best Horror Stories Series IX*. Ed. Karl Edward Wagner. New York: DAW, 1981 (paperback).
6. *Skeleton Crew*, 1985.

"The Monster in the Closet"
 Excerpt from *Cujo*.
 Ladies' Home Journal, October 1981.
"Morning Deliveries"
 Skeleton Crew, 1985.
"Mrs. Todd's Shortcut"
 1. *Redbook*, May 1984.
 2. *Skeleton Crew*, 1985.
"The Night of the Tiger"
 1. *The Magazine of Fantasy and Science Fiction*, February 1978.
 2. In *More Tales of Unknown Horror*. Ed. Peter Haining. London: New
 English Library, 1979 (paperback).
 3. In *The Year's Best Horror Stories Series VII*. Ed. Gerald W. Page.
 New York: DAW, 1979 (paperback).
"Night Surf"
 1. *Ubris*, Spring 1969.
 Revised version:
 2. *Cavalier*, August 1974.
 3. *Night Shift*, 1978.
"Nona"
 1. In *Shadows*. Ed. Charles L. Grant. Garden City, NY: Doubleday,
 1978 (hardcover); New York: Playboy, 1980 (paperback).
 2. In *The Dodd, Mead Gallery of Horror*. Ed. Charles L. Grant. New
 York: Dodd, Mead, 1983 (hardcover); New York: Dodd, Mead, 1983
 (trade paperback).
 3. *Skeleton Crew*, 1985.
"One for the Road"
 1. *Maine*, March/April 1977.
 2. *Night Shift*, 1978.
 3. In *Young Monsters*. Eds. Isaac Asimov, Martin H. Greenberg, and
 Charles G. Waugh. New York: Harper & Row, 1985 (hardcover).
"The Oracle and the Mountains"
 1. *The Magazine of Fantasy und Science Fiction*, February 1981.
 2. *The Dark Tower: The Gunslinger*, 1982.
"People, Places, and Things—Volume I"
 Self-published pamphlet.
 Durham, ME: Triad Publishing Company, 1963.
"The Plant"
 Self-published Christmas monograph.
 Bangor, ME: Philtrum Press, 1982, 1983, 1985.
"Quitters, Inc."
 1. *Night Shift*, 1978.
 2. In *Best Detective Stories of the Year*. Ed. Edward D. Hoch. New
 York: Dutton, 1979 (hardcover).

 3. In *The Science Fiction Weight-Loss Book*. Eds. Isaac Asimov, George R. R. Martin, and Martin H. Greenberg. New York: Crown, 1983 (hardcover).

"The Raft"

 1. *Gallery*, November 1982 (special pull-out booklet).

 2. *Twilight Zone Magazine*, May/June 1983.

 3. *Skeleton Crew*, 1985.

"The Reaper's Image"

 1. *Startling Mystery Stories*, Spring 1969.

 2. In *The 17th Fontana Book of Great Ghost Stories*. Ed. R. Chetwynd-Hayes. London: Fontana, 1981 (paperback).

 3. *Skeleton Crew*, 1985.

"The Return of Timmy Baterman"

Excerpt from *Pet Sematary*.

 In *Satyricon II Program Book*. Ed. Rusty Burke. Knoxville, TN: Satyricon II/DeepSouthCon XXI, 1983.

"The Revelations of 'Becka Paulson"

Excerpt from *The Tommyknckers*.

Rolling Stone, July 19/August 2, 1984.

"The Revenge of Lard Ass Hogan"

 1. *The Maine Review*, July 1975.

Revised version included in "The Body":

 2. *Different Seasons*, 1982.

"Rita Hayworth and Shawshank Redemption"

Subtitle: "Hope Springs Eternal"

Different Seasons, 1982.

"The Shining"

Excerpt from *The Shining*.

Reflections, June 1977.

"Skybar"

Beginning and conclusion of a "novel."

 In *The Do-It-Yourself Bestseller*. Eds. Tom Silberkleit and Jerry Biederman. New York: Doubleday, Dolphin, 1982 (trade paperback).

"Slade"

The Maine Campus, June through August, 1970.

"The Slow Mutants"

 1. *The Magazine of Fantasy and Science Fiction*, July 1981.

 2. *The Dark Tower: The Gunslinger*, 1982.

"Sometimes They Come Back"

 1. *Cavalier*, March 1974.

 2. *Night Shift*, 1978.

"Squad D"
> In *The Last Dangerous Visions*. Ed. Harlan Ellison. Currently un-published.

"The Star Invaders"
> Self-published pamphlet.
> > Durham, ME: Triad, Inc. and Gaslight Books, 1964.

"Strawberry Spring"
> 1. *Ubris*, Fall 1968.
> Revised version:
> 2. *Cavalier*, November 1975.
> 3. *Gent*, February 1977.
> 4. *Night Shift*, 1978.
> 5. In *An International Treasury of Mystery and Suspense*. Ed. Marie R. Reno. New York: Doubleday, 1983 (hardcover).

"Stud City"
> 1. *Ubris*, Fall 1969.
> Revised version included in "The Body":
> 2. *Different Seasons*, 1982.

"Suffer the Little Children"
> 1. *Cavalier*, February 1972.
> 2. In *Nightmares*. Ed. Charles L. Grant. New York: Playboy, 1979 (paperback).
> 3. In *The Evil Image: Two Centuries of Gothic Short Fiction and Poetry*. Eds. Patricia L. Skarda and Nora Crow Jaffe. New York: New American Library, Meridian, 1981 (trade paperback).
> 4. In *65 Great Spine Chillers*. Ed. Mary Danby. London: Octopus, 1982 (hardcover).

"Survivor Type"
> 1. In *Terrors*. Ed. Charles L. Grant. New York: Playboy, 1982 (paper-back).
> 2. *Skeleton Crew*, 1985.

"Trucks"
> 1. *Cavalier*, June 1973.
> 2. *Night Shift*, 1978.

"Uncle Otto's Truck"
> 1. *Yankee*, October 1983.
> 2. In *The Year's Best Horror Stories Series XII*. Ed. Karl Edward Wagner. New York: DAW, 1984 (paperback).

"The Way Station"
> 1. *The Magazine of Fantasy and Science Fiction*, April 1980.
> 2. *The Dark Tower: The Gunslinger*, 1982.

"The Wedding Gig"
1. *Ellery Queen's Mystery Magazine*, December 1, 1980.
2. *Skeleton Crew*, 1985.

"Weeds"
1. *Cavalier*, May 1976.
2. *Nugget*, April 1979.
Comic book adaptation illustrated by Berni Wrightson, as "The Lonesome Death of Jordy Verrill":
3. *Creepshow*, 1982.

"The Woman in the Room"
1. *Night Shift*, 1978.
2. In *The 25th Pan Book of Horror Stories*. Ed. Herbert Van Thal. London: Pan, 1984 (paperback).

"The Word Processor"/"Word Processor of The Gods"
1. *Playboy*, January 1983.
2. *Skeleton Crew*, 1985.

SELECTED SHORT NONFICTION

"Afterword"
 The Dark Tower: The Gunslinger, 1982.

"Afterword"
 Different Seasons, 1982.

"Afterword"
 Firestarter, 1981 (paperback edition only).

"Between Rock and a Soft Place"
 Playboy, January 1982.

"Books"
 Monthly book review column.
 Adelina, June through November 1980.

"The Cannibal and the Cop"
1. *Washington Post Book World*, November 1, 1981.
2. In *Shadowings: The Reader's Guide to Horror Fiction, 1981–82*. Ed. Douglas E. Winter. Mercer Island, WA: Starmont House, 1983 (hardcover and trade paperback).

"Childress Debut with 'World' Shows Uncanny Style and Eye for Detail"
 Atlanta Journal-Constitution, November 5, 1984.

"The Collected Stories of Ray Bradbury"
 Chicago Tribune Bookworld, October 10, 1980.

"Digging the Boogens"
 Twilight Zone Magazine, July 1982.

"The Doll Who Ate His Mother"
Whispers, no. 11/12, October 1978.

"The Evil Dead"
Twilight Zone Magazine, November 1982.

"Foreword"
Night Shift, 1978.

"Foreword"
Ellison, Harlan. *Stalking the Nightmare.* Huntington Woods, MI: Phantasia Press, 1982 (limited edition hardcover); New York: Berkley, 1984 (paperback).

"Foreword"
Grant, Charles L. *Tales from the Nightside.* Sauk City, WI: Arkham House, 1981 (hardcover).

"The Fright Report"
Oui, January 1978.

"Guilty Pleasures"
Film Comment, May/June 1981.

"The Horror Market Writer and the Ten Bears"
Writer's Digest, November 1973.

"Horrors!"
TV Guide, October 30/November 5, 1982.

"The Horrors of '79"
Rolling Stone, December 27, 1979/January 10, 1980.

"How to Scare a Woman to Death"
In *Murderess Ink.* Ed. Dilys Winn. New York: Bell, 1979 (hardcover); New York: Bell, 1980 (trade paperback).

"Imagery and the Third Eye"
 1. *The Writer*, October 1980.
 2. *Maine Alumnus*, December 1981.
 3. In *The Writer's Handbook.* Ed. Sylvia K. Burack. Boston, MA: The Writer, Inc., 1984.

"An Interview with Myself"
Writer's Digest, January 1979.

"Introduction"
Skeleton Crew, 1985.

"Introduction"
Brennan, Joseph Payne. *The Shapes of Midnight.* New York: Berkley, 1980 (paperback).

"Introduction"
Farris, John. *When Michael Calls.* New York: Pocket Books, 1981 (paperback).

"Introduction"
 Hunter, Evan. *The Blackboard Jungle*. New York: Arbor House, Library of Contemporary Americana, 1984 (trade paperback).
"Introduction"
 In *The Arbor House Treasury of Horror and the Supernatural*. Comps. Bill Pronzini, Barry Malzberg, and Martin H. Greenberg. New York: Arbor House, 1981 (hardcover); New York: Arbor House, Priam, 1981 (trade paperback).
"Introduction"
 In *Tales by Moonlight*. Ed. Jessica Amanda Salmonson. Chicago, IL: Robert T. Garcia, 1983 (hardcover); New York: Tor, 1984 (paperback).
"Introduction"
 Shelley, Mary, Stoker, Bram, and Stevenson, Robert Louis. *Frankenstein/Dracula/Dr. Jekyll and Mr. Hyde*. New York: New American Library, Signet, 1978 (paperback).
"Introduction: The Importance of Being Forry"
 Ackerman, Forrest J. *Mr. Monster's Movie Gold*. Virginia Beach/Norfolk, VA: Donning, 1982 (trade paperback).
"Introduction to the Marvel Edition of *Frankenstein*"
 Shelley, Mary Wollstonecraft (with illustrations by Berni Wrightson). *Frankenstein, or The Modern Prometheus*. New York: Dodd, Mead, 1983 (limited edition hardcover, hardcover, and trade paperback).
"The Irish King"
 New York Daily News, March 16, 1984.
"King's Garbage Truck"
 Weekly opinion column.
 The Maine Campus, February 1969 to May 1970.
"The Ludlum Attraction"
 Washington Post Book World, March 7, 1982.
"My High School Horrors"
 Sourcebook, 1982.
"My Say"
 Publishers Weekly, December 20, 1985.
"1984, a Bad Year If You Fear Friday the 13th"
 New York Times, April 12, 1984.
"Notes"
 Skeleton Crew, 1985.
"Notes on Horror"
 Quest, June 1982.
"On Becoming a Brand Name"
 1. *Adelina*, February 1980.

2. In *Fear Itself: The Horror Fiction of Stephen King*. Eds. Tim Underwood and Chuck Miller. San Francisco, CA/Columbia, PA: Underwood-Miller, 1982 (limited edition hardcover and hardcover); New York: New American Library, Plume, 1984 (trade paperback); New York: New American Library, Signet, 1985 (paperback).

"On *The Shining* and Other Perpetrations"
Whispers, no. 17/18, August 1982.

"Peter Straub: An Informal Appreciation"
In *World Fantasy Convention '82*. Ed. Kennedy Poyser. New Haven, CT: The Eighth World Fantasy Convention, 1982.

"A Pilgrim's Progress"
American Bookseller, January 1980.

"The Politics of Limited Editions"
Castle Rock, nos. 6–7, June and July, 1985.

"A Profile of Robert Bloch"
In *World Fantasy Convention 1983*. Ed. Robert Weinberg. Oak Forest, IL: Weird Tales Ltd., 1983.

"Ross Thomas Stirs the Pot"
Washington Post Book World, October 16, 1983.

"Special Make-Up Effects and the Writer"
Savini, Tom. *Grande Illusions*. Pittsburgh, PA: Imagine, Inc., 1983 (trade paperback); reprinted as *Bizarro*. New York: Crown, 1983 (trade paperback).

"Theodore Sturgeon (1918–1985)"
1. *Washington Post Book World*, May 26, 1985.
2. *SFWA Bulletin*, Summer 1985.
3. *Isaac Asimov's Science Fiction Magazine*, January 1986.

"Visit with an Endangered Species"
Playboy, January 1982.

"What Went Down When Magyk Went Up"
New York Times Book Review, February 10, 1985.

"When Is TV Too Scary for Children?"
TV Guide, June 13/19, 1981.

"Why I Am for Gary Hart"
The New Republic, June 4, 1984.

"Why I Was Bachman"
The Bachman Books, 1985.

"Why We Crave Horror Movies"
Playboy, January 1981.

"Writing a First Novel"
 The Writer, June 1975.
"You Gotta Put on the Gruesome Mask and Go Booga-Booga"
 TV Guide, December 5/11, 1981.

POETRY

"The Dark Man"
 1. *Ubris*, Fall 1969.
 2. In *Moth*. Ed. George MacLeod and Bruce Holsapple. Orono, ME:
 The Blanket Conspiracy, 1970.
"Donovan's Brain"
 In *Moth*. Ed. George MacLeod and Bruce Holsapple. Orono, ME:
 The Blanket Conspiracy, 1970.
"Harrison State Park '68."
 Ubris, Fall 1968.
"For Owen"
 Skeleton Crew, 1985.
"Paranoid: A Chant"
 Skeleton Crew, 1985.
"Silence"
 In *Moth*. Ed. George MacLeod and Bruce Holsapple. Orono, ME:
 The Blanket Conspiracy, 1970.
Untitled (opening line: "In the key-chords of dawn . . .")
 Onan, 1971.

SCREENPLAYS

Battleground (not produced).
Cat's Eye (produced, 1985).
Children of the Corn (not produced).
Creepshow (produced, 1982).
Cujo (not produced).
The Dead Zone (not produced).
Night Shift (not produced).
Overdrive (produced, 1986).
Pet Sematary (in development).
The Shotgunners (not produced).
The Shining (not produced).
Silver Bullet (produced, 1985).

Something Wicked This Way Comes (not produced).
The Stand (in development).

SELECTED MISCELLANEOUS PUBLICATIONS

"Basic Bread/Lunchtime Goop/Egg Puff"
 Recipes.
 In *The Famous New Englanders Cookbook.* Dublin, NH: Yankee
 Books, 1984.
"Dr. Seuss and the Two Faces of Fantasy"
 Text of speech before the International Conference on the Fantastic in
 the Arts, March 24, 1984.
 Fantasy Review, no. 68, June 1984.
"Don't Be Cruel"
 Letter to the editor.
 TV Guide, April 30/May 6, 1983.
"Favorite Films"
 Listing of five favorite motion pictures.
 Washington Post, June 24, 1982.
"Horrors!"
 A crossword puzzle clued by Stephen King.
 Games, October 1983.
"Lists That Matter (Number 7)"
 Listing of ten best movies of all time.
 Castle Rock, no. 8, August 1985.
"Lists That Matter (Number 8)"
 Listing of ten worst movies of all time.
 Castle Rock, no. 9, September 1985.
"Lists That Matter (Number 14)"
 Listing of ten greatest fears.
 Castle Rock, no. 10, October 1985.
"A Message from Stephen King to Waldenbooks People"
 Waldenbooks Booknotes, August 1983.
"Stephen King: His Creepiest Movies"
 USA Today, August 26, 1985.
"Stephen King's 10 Favorite Horror Books or Short Stories"
 In *The Book Of Lists #3.* Comps. Amy Wallace, David Wallechinsky,
 and Irving Wallace. New York: William Morrow, 1983 (trade
 paperback).
"Stephen King's Year of Fear: 1986"
 Calendar.
 New York: New American Library, 1985.

Untitled (opening line: "I don't have many dreams . . .")
 Description of a recurring dream.
 Dreamworks, Summer 1981.

Secondary Bibliography

SELECTED INTERVIEWS AND PROFILES

Allen, Mel. "The Man Who Writes Nightmares."
 Yankee, March 1979.
_____ "Witches and Aspirin."
 Writer's Digest, June 1977.
Ashley, Mike. "Stephen King."
 In *Who's Who in Horror and Fantasy Fiction*. New York: Taplinger,
 1977 (hardcover and trade paperback).
Baker, John F. "Stephen King."
 Publishers Weekly, January 17, 1977.
Bandler, Michael J. "A Journey into Fear with Stephen King."
 Chicago Tribune Book World, June 8, 1980.
_____ "The King of the Macabre at Home."
 Parents Magazine, January 1982.
Bhob (pseudonym of Robert Stewart). "Flix."
 In three parts:
 Heavy Metal, January, February, and March 1982.
Blue, Tyson. "S. K. Interviewed on *Overdrive* Movie Set."
 Castle Rock, no. 11, November 1985.
Brown, Stephen P. "Stephen King, Shining Through."
 Washington Post, April 9, 1985.
Cadigan, Pat, Ketchum, Marty, and Fenner, Arnie. "Has Success Spoiled
 Stephen King?"
 Shayol, Winter 1982.
Carmichael, Carrie. "Who's Afraid of Stephen (Carrie) King?"
 Family Weekly, January 6, 1980.
Chan, Mei-Mei. "King's Gruesome Ideas Are Dead Serious."
 USA Today, October 14, 1982.
Christensen, Dan. "Living in 'Constant, Deadly Terror.' "
 1. *Fangoria*, December 1979.
 2. *The Bloody Best of Fangoria*, 1982.
Chute, David. "The King of Horror Novels."
 Boston Phoenix, June 17, 1980.

_____ "King of the Night."
 Take One, January 1979.
Denver, Joel. "Stephen King Takes a Stand for Radio."
 Radio & Records, February 24, 1984.
de Pina, Eloise. "A Mania for the Macabre."
 Boston Globe, July 21, 1983.
Dewes, Joyce Lynch. "An Interview with Stephen King."
 Mystery, March 1981.
Donaldson, Stephen R. "Stephen King."
 Archon 6 Program Book, July 1982.
Dong, Stella. "Five Bestselling Writers Recall Their First Novels."
 Includes interviews with Stephen King and Peter Straub.
 Publishers Weekly, October 10, 1980.
Dudar, Helen. "King Keeps Writing and Bucks Keep Rolling In."
 1. *Chicago Tribune Bookworld,* August 22, 1982.
 As "Stephen King: The Horror Master Has Money Galore—Now He
 Wants Respect":
 2. *Detroit News,* September 5, 1982.
Duncan, David D., *et al.* "The Kings of Horror."
 Includes interviews with Stephen King and George A. Romero.
 Oui, August 1981.
Farren, Mick. "Stephen King."
 Andy Warhol's Interview, February 1986.
Fleischer, Leonore. "A Talk with Stephen King."
 Washington Post Book World, October 1, 1978.
Freff. "The Dark Beyond the Door."
 In two parts:
 Tomb of Dracula, no. 4, April 1980, and no. 5, June 1980.
Gagne, Paul R. " 'Salem's Lot."
 Famous Monsters of Filmland, no. 162, April 1980.
_____ "Stephen King."
 Cinefantastique, Spring 1981.
_____ "Stephen King."
 Cinefantastique, December 1983/January 1984.
Gareffa, Peter M. "King, Stephen (Edwin) 1947– ."
 In *Contemporary Authors New Revision Series,* vol. 1. Ed. Ann
 Evory. Detroit, MI: Gale Research, 1981 (hardcover).
Goldstein, Toby. "Stephen King's Scary Monsters Live Right Next Door."
 Creem, October 1982.
Goldstein, William. "A Coupl'a Authors Sittin' Around Talkin'."
 Joint interview of Stephen King and Peter Straub.
 Publishers Weekly, May 11, 1984.

Grant, Charles L. "Stephen King."
 In *The Fifth World Fantasy Convention Program Book*. Ed. Robert
 Booth. Providence, RI: The Fifth World Fantasy Convention,
 1979.
_____ "Stephen King: 'I Like to Go for the Jugular.' "
 Twilight Zone Magazine, April 1981.
Greeley, Andrew. "Stephen King's Horror Has a Healing Power."
 In *A Piece of My Mind . . . On Just About Everything*. Garden City,
 NY: Doubleday, 1983 (hardcover).
Hedegaard, Erik, with Michael Schrage and David M. Abramson. "Men-
 tors."
 Includes commentary by Stephen King on Burton Hatlen.
 Rolling Stone College Papers, April 15, 1982.
Hendrickson, Paul. "The Evil Worlds of Stephen King."
 1. *Washington Post*, August 30, 1979.
 As "The Stuff He Writes Even Scares HIM":
 2. *Detroit News*, September 26, 1979.
Janeczko, Paul. "An Interview with Stephen King."
 English Journal, February 1980.
Kilday, Gregg. "Reflections on Hollywood with Author Stephen King."
 Los Angeles Herald Examiner, Setpember 23, 1979.
Kilgore, Michael. "The Master of Modern Horror."
 Tampa Tribune, August 31, 1980.
King, Tabitha. "Living with the Boogeyman."
 In *Murderess Ink*. Ed. Dilys Winn. New York: Bell, 1979 (hardcover);
 New York: Bell, 1980 (trade paperback).
Lawson, Carol. "Behind the Best Sellers: Stephen King."
 New York Times Book Review, September 23, 1979.
Lofficier, Randy. "Stephen King Talks About *Christine*."
 Twilight Zone Magazine, January/February 1984.
Lowry, Lois. "King of the Occult."
 Down East Magazine, November 1977.
McDonnell, David. "The Once and Future King."
 Mediascene Prevue, May 1982.
McDowell, Edwin. "Behind the Best Sellers: Stephen King."
 New York Times Book Review, September 27, 1981.
Martin, Bob. "On (and Off) the Set of *Creepshow*."
 Fangoria, July 1982.
Matthews, Jack. "Novelist Loves His Nightmares."
 1. *Detroit Free Press*, November 12, 1982.
 As "Author Stephen King Has Terrible Dreams, But He Enjoys Them."
 2. *Baltimore Sun*, November 17, 1982.

Modderno, Craig. "I'd Really Like to Write a Rock 'n' Roll Novel."
 USA Today, May 10, 1985.
Norden, Eric. "Playboy Interview: Stephen King."
 Playboy, June 1983.
Ott, Bill. "Stephen King's Reign of Terror."
 Openers, Fall 1981.
Peck, Abe. "Stephen King's Court of Horror."
 Rolling Stone College Papers, Winter 1980.
Platt, Charles. "Stephen King."
 In *Dream Makers II*. New York: Berkley, 1983 (trade paperback).
Robertson, William. "Writer Stephen King: Horror in a Secular Age."
 Miami Herald, March 25, 1984.
Rolfe, John. "Tabitha King: Making It in Her Own Write."
 Maine Sunday Telegram, January 29, 1984.
Schumacher, Michael. "Straub and King Take A Double Fling."
 Interview with Peter Straub on *The Talisman*. *Milwaukee Journal*,
 September 30, 1984.
Shiner, Lewis; Ketchum, Marty; Cadigan, Pat; and Fenner, Arnie.
 "Shine of the Times: An Interview with Stephen King."
 Shayol, Summer 1979.
Spada, James. "Stephen King: Master of the Macabre."
 East/West, October 1980.
Spitz, Bob. "Penthouse Interview: Stephen King."
 Penthouse, April 1982.
Stein, Michael, and Horsting, Jessie. "Fantastic Films Interviews Stephen
 King."
 Fantastic Films, February 1983.
Stewart, Robert. "Filmedia: The Rest of King."
 Starship, Spring 1981.
Straub, Peter. "Snook Place."
 Archon 6 Program Book, July 1982.
Sullivan, Mark. "King of Terror in a World of Big Macs."
 Women's Wear Daily, August 23, 1982.
Thomases, Martha, and Tebbel, John Robert. "Interview: Stephen King."
 High Times, January 1981.
Thompson, Andrea. "The Thrills, Chills and Skills of Stephen King."
 McCall's, February 1983.
Unattributed. "King, Stephen (Edwin)."
 In *Current Biography Yearbook 1981*. Ed. Charles Moritz. New York:
 H.W. Wilson, 1982 (hardcover).
Unattributed. " 'King' of Horror . . ."
 Sidebar to "Imagery and the Third Eye."
 The Writer, October 1980.

Unattributed. "Random Notes . . . An Interview with Stephen King."
 Cavalier, August 1974.
Unattributed. "Stephen King's Ransom."
 Esquire, August 1983.
Weaver, Dan. "Interview . . . Stephen King."
 The Literary Guild Monthly Selection Magazine, December 1978.
Weller, Sheila. "The Healthy Power of a Good Scream."
 Purported "interview" based upon excerpts from *Danse Macabre*.
 Self, September 1981.
Wells, Jeffrey. "Stephen King Talks 'Creepshow', the 'Animal House' of
 Fright Pics."
 Film Journal, April 12, 1982.
Wiater, Stanley. "Stephen King and George Romero: Collaboration in
 Terror."
 1. *Fangoria*, June 1980.
 2. *The Bloody Best of Fangoria*, 1982.
Wilson, William. "Riding the Crest of the Horror Craze."
 New York Times Sunday Magazine, May 11, 1980.
Winter, Douglas E. "A Decade of Darkness."
 Fantasy Review, no. 71, September 1984.
——"Horror and the Limits of Violence."
 Includes commentary by Stephen King.
 In *Shadowings: The Reader's Guide to Horror Fiction, 1981–82*. Ed.
 Douglas E. Winter. Mercer Island, WA: Starmont House, 1983
 (hardcover and trade paperback).
—— "Interview: Stephen King."
 Gallery, January 1986.
—— "Some Words with Stephen King."
 Fantasy Newsletter, no. 56, February 1983.
—— "Stephen King."
 In *The Faces of Fear*. New York: Berkley, 1985 (trade paperback).
—— "Stephen King, Peter Straub, and the Quest for *The Talisman*."
 Twilight Zone Magazine, February 1985.
—— "Talking Terror with Stephen King."
 Twilight Zone Magazine, February, 1986.
Zoglin, Richard. "Giving Hollywood the Chills."
 Time, January 9, 1984.

SELECTED REVIEWS AND CRITICISM

Adams, Michael. *"Danse Macabre."*
 In *Magill's Literary Annual 1982*, vol. I. Ed. Frank N. Magill.
 Englewood Cliffs, NJ: Salem Press, 1982 (hardcover).

Alexander, Alex E. "Stephen King's *Carrie*—A Universal Fairytale."
Journal of Popular Culture, Fall 1979.

Atchity, Kenneth. "Stephen King: Making Burgers with the Best."
Los Angeles Times Book Review, August 29, 1982.

Bandler, Michael J. "The Horror Is As Much Political As Biological."
Newsday, October 19, 1980.

Barkham, John. "A Story Fired with Imagination, Protest."
Philadelphia Inquirer, August 31, 1980.

Barry, Dave. "*Christine* Is Demon for Punishment."
Philadelphia Inquirer, March 27, 1983.

Bishop, Michael. "Mad Dogs . . . and Englishmen."
Washington Post Book World, August 23, 1981.

Boonstra, John. "King of the Creeps."
Hartford Advocate, October 27, 1982.

Brandon, Jay. "Stephen King's Other Self."
Houston Chronicle, April 21, 1985.

Bryant, Edward. "The Future in Words."
Mile High Futures, May 1983.

_____ "The Future in Words."
Mile High Futures, January 1984.

Bryfonski, Dedria, and Senick, Gerard J., eds. "Stephen King, 1947– ."
In *Contemporary Literary Criticism*, vol. 12, Young Adult Literature.
Detroit, MI: Gale Research, 1980 (hardcover).

Budrys, Algis. "Books."
The Magazine of Fantasy and Science Fiction, February 1983.

_____ "Collaborating to Lay an Egg."
Chicago Sun-Times, November 11, 1984.

_____ "A Doggy New Novel from Stephen King."
Chicago Sun-Times, September 6, 1981.

_____ "King's 'Firestarter': It's Hot Stuff, All Right."
Chicago Sun-Times, September 21, 1980.

_____ "Stephen King's Car, Repossessed by the Devil."
Chicago Sun-Times Book Week, April 3, 1983.

_____ "The Wolf-Mask of Horror, As Lifted by Stephen King."
Chicago Sun-Times Book Week, May 3, 1981.

Callendar, Newgate. "Criminals at Large."
New York Times Book Review, May 26, 1974.

Canby, Vincent. "The Screen: *Cat's Eye*."
New York Times, April 12, 1985.

Cannon, Leslie. "Where the Conscious Meets the Subconscious."
Cincinnati Enquirer, April 2, 1978.

Chandler, Randy. "Horror Master Tells Motor-Vating Tale."
Atlanta Journal-Constitution, April 17, 1983.

Cheuse, Alan. "Horror Writer's Holiday."
 New York Times Book Review, August 29, 1982.
Childs, Mike, and Jones, Alan. "De Palma Has the Power."
 Cinefantastique, Summer 1977.
Chow, Dan. "*Locus* Looks at More Books."
 Locus, April 1983.
Chute, David. "Chilling Horror from Stephen King."
 Los Angeles Herald-Examiner, June 16, 1985.
_____ "King Gives Second-Best Horror Effort in *Cujo*."
 Los Angeles Herald Examiner, September 9, 1981.
_____ "Reign of Horror."
 Boston Phoenix, December 9, 1980.
Clark, Theresa J. "*The Talisman*."
 Saturday Review, November/December 1984.
Clayton, Bill, and Clayton, Debra. "Stephen King: King of the Beasties."
 Chillers, November 1981.
Cline, Edward. "Dark Doings in King Country."
 Wall Street Journal, October 28, 1983.
Cohen, Barney. "The Shockmeisters."
 Esquire, November 1984.
Collings, Michael R. *Stephen King as Richard Bachman*.
 Mercer Island, WA: Starmont House, 1985 (hardcover and trade paperback).
Collings, Michael R., and Engebretson, David. *The Shorter Works of Stephen King*.
 Mercer Island, WA: Starmont House, 1985 (hardcover and trade paperback).
Davis, L. J. "A Shabby Dog Story from Stephen King."
 Chicago Tribune Book World, August 16, 1981.
Demarest, Michael. "Hot Moppet."
 Time, September 15, 1980.
Disch, Thomas M. "Books."
 Twilight Zone Magazine, April 1984.
Egan, James. "Apocalypticism in the Fiction of Stephen King."
 Extrapolation, vol. 25, no. 3, Fall 1984.
Ellison, Harlan. "Harlan Ellison's Watching."
 The Magazine of Fantasy & Science Fiction, December 1984.
Ferguson, Mary. "*The Stand*."
 In *Survey of Modern Fantasy Literature*. Ed. Frank N. Magill. Englewood Cliffs, NJ: Salem Press, 1983.
Frane, Jeff. "*Locus* Looks at More Books."
 Locus, August 1982.

_____ "A Stunning Storyteller."
Seattle Times Magazine, February 4, 1979.

Gagne, Paul. "*Creepshow:* Five Jolting Tales of Horror! from Stephen King and George Romero."
Cinefantastique, April 1982.

_____ "*Creepshow:* Masters of the Macabre."
Cinefantastique, September/October 1982.

Gifford, Thomas. "Stephen King's Quartet."
Washington Post Book World, August 22, 1982.

Gorner, Peter. "King Drives at Horror with Less-Than-Usual Fury."
Chicago Tribune, April 6, 1983.

Graham, Mark. "Mouth Foaming for a Good Scare?"
Rocky Mountain News, September 6, 1981.

_____ "New King Novel Will Frighten You."
Rocky Mountain News, September 14, 1980.

_____ "Stephen King Shows Another Grisly Side."
Rocky Mountain News, September 19, 1982.

Granger, Bill. "Stephen King Strikes Again."
Chicago Tribune Book World, August 24, 1980.

Grant, Charles L.; Morrell, David; Ryan, Alan; and Winter, Douglas E. "Different Writers on *Different Seasons.*"
1. *Fantasy Newsletter*, no. 56, February 1983.
2. In *Shadowings: The Reader's Guide to Horror Fiction, 1981–82.* Ed. Douglas E. Winter. Mercer Island, WA: Starmont House, 1983 (hardcover and trade paperback).

Gray, Paul. "Master of Postliterate Prose."
Time, August 30, 1982.

Hall, Melissa Mia. "A Bestseller That Foams at the Mouth."
Fort Worth Star-Telegram, August 23, 1981.

Hansen, Ron. "*Creepshow:* The Dawn of a Living Horror Comedy."
Esquire, January 1981.

Hard, Annette. "King: Novellas from a Consummate Story Teller."
Houston Chronicle, September 12, 1982.

_____ "King: Sailing Uncharted Seas."
Houston Chronicle, October 7, 1979.

Harris, Robert R. "Brand-Name Horror."
New York Times Book Review, December 27, 1983.

Hatlen, Burton. "Alumnus Publishes Symbolic Novel, Shows Promise."
The Maine Campus, April 12, 1974.

_____ "The Mad Dog and Maine."
In *Shadowings: The Reader's Guide to Horror Fiction, 1981–82.* Ed.

Douglas E. Winter. Mercer Island, WA: Starmont House, 1983 (hardcover and trade paperback).

_____ " '*Salem's Lot* Critiques American Civilization."
The Maine Campus, December 12, 1975.

_____ "Steve King's *The Stand*."
Kennebec, April 1979.

_____ "Steve King's Third Novel Shines On."
The Maine Campus, April 1, 1977.

Herbert, Frank. "When Parallel Worlds Collide."
Washington Post Book World, October 14, 1984.

Hofsess, John. "Kubrick: Critics Be Damned."
Soho News, May 28, 1980.

Hogan, David J. "King and Cronenberg: It's the Best of Both Worlds."
Cinefantastique, December 1983/January 1984.

Horsting, Jessie. "*Cujo:* The Movie."
Fantastic Films, November 1983.

Kaveney, Roz. "The Consolations of Terror."
Books & Bookmen, November 1981.

Kelley, Bill. "John Carpenter's *Christine:* Bringing Stephen King's Best Seller to the Screen."
Cinefantastique, September 1983.

_____ "King's *Firestarter* Stretches Boundaries of Macabre Fiction."
Fort Lauderdale News/Sun Sentinel, September 28, 1980.

_____ " '*Salem's Lot:* Filming Horror for Television."
Cinefantastique, Winter 1979.

Kendrick, Walter. "Stephen King Gets Eminent."
Village Voice, April 29/May 5, 1981.

Kennedy, Harlan. "Kubrick Goes Gothic."
American Film, June 1980.

Kroll, Jack. "Stanley Kubrick's Horror Show."
Newsweek, May 26, 1980.

Lehmann-Haupt, Christopher. "Books of the Times."
New York Times, August 17, 1979.

_____ "Books of the Times."
New York Times, September 8, 1980.

_____ "Books of the Times."
New York Times, April 14, 1981.

_____ "Books of the Times."
New York Times, August 14, 1981.

_____ "Books of the Times."
New York Times, August 11, 1982.

_____ "Books of the Times."
 New York Times, April 12, 1983.
_____ "Books of the Times."
 New York Times, October 21, 1983.
_____ "Books of the Times."
 New York Times, November 8, 1984.
_____ "The Limits of a Novel's Point of View."
 New York Times, January 19, 1984.
Leiber, Fritz. "Fantasy Books."
 Locus, April 1980.
_____ "On Fantasy."
 Fantasy Newsletter, no. 39, August 1981.
_____ "Whispering in the Shadows."
 Washington Post Book World, April 12, 1981.
Levin, Martin. "Genre Items."
 New York Times Book Review, February 4, 1979.
Lingeman, Richard R. "Something Nasty in the Tub."
 New York Times, March 1, 1977.
Luciano, Dale. "*Danse Macabre:* Stephen King Surveys the Field of Horror."
 The Comics Journal, no. 72, May 1982.
_____ "E.C. Horror Stories Mistranslated into Film."
 The Comics Journal, no. 79, January 1983.
Lyons, Gene. "King of High-School Horror."
 Newsweek, May 2, 1983.
McDonnell, David and Sayers, John. "*Creepshow.*"
 Mediascene Prevue, May 1982.
McLellan, Joseph. "Vision of Holocaust: A Psychic's Dilemma."
 Washington Post, August 30, 1979.
Magistrale, Tony. "Inherited Haunts: Stephen King's Terrible Children."
 Extrapolation, vol. 26, no. 1, Spring 1985.
Manguel, Alberto. "Some Conversational Horrors from a Pair of Slick Writers."
 Toronto Globe and Mail, November 17, 1984.
Martin, Robert. "*Creepshow.*"
 Twilight Zone Magazine, September 1982.
_____ "Stephen King's Horror Show: From *Carrie* to *Cat's Eye.*"
 Home Viewer, December 1985.
Mewshaw, Michael. "Novels and Stories."
 New York Times Book Review, March 26, 1978.
Morrison, Michael A. "Pet Sematary: Opposing Views . . . Finest Horror Ever Written."
 Fantasy Review, no. 64, January 1984.

Naha, Ed. "Front-Row Seats at the *Creepshow*."
Twilight Zone Magazine, May 1982.
Neilson, Keith. *"The Dead Zone."*
In *Magill's Literary Annual 1980*, vol. I. Ed. Frank N. Magill.
Englewood Cliffs, NJ: Salem Press, 1980 (hardcover).
_____ *"Different Seasons."*
In *Magill's Literary Annual 1983*, vol. I. Ed. Frank N. Magill.
Englewood Cliffs, NJ: Salem Press, 1983 (hardcover).
Nicholls, Peter. *"Skeleton Crew."*
Washington Post Book World, June 16, 1985.
Oates, Joyce Carol. "Novel in Movieland."
Vogue, November 1984.
Osborne, Linda B. "The Supernatural Con Man vs. the Hymn-Singing
Mother."
Washington Post, November 23, 1978.
Patrouch, Jr., Joseph F. "Stephen King in Context."
In *Patterns of the Fantastic*. Ed. Donald M. Hassler. Mercer Island,
WA: Starmont House, 1983 (trade paperback).
Pettus, David. "Stephen King's *Silver Bullet*: A Review."
Castle Rock, December 1985.
Phippen, Sanford. "Stephen King's Appeal to Youth."
Maine Life, December 1980.
Podhoretz, John. "The Magnificent Revels of Stephen King."
Wall Street Journal, September 4, 1980.
Riggenbach, Jeff. "Suspense Accelerates in King's *Christine*."
San Jose Mercury News, May 1, 1983.
Rolfe, John. "Fitting Author Stephen King to the Charles Dickens Mold."
Maine Sunday Telegram, September 19, 1982.
Roraback, Dick. "Gift of Sight: Visions from a Nether World."
Los Angeles Times Book Review, August 26, 1979.
Rosenbaum, Mary Helene. "Pet Sematary."
Christian Century, March 21, 1984.
Ryan, Alan. "Ride Into Horror with *Christine*."
Cleveland Plain Dealer, April 17, 1983.
_____ "Stephen King Departs from Horror."
Cleveland Plain Dealer, September 26, 1982.
Salamon, Julie. "Horrormonger Stephen King on Screen."
Wall Street Journal, April 25, 1985.
Schow, David J. "Return of the Curse of the Son of Mr. King: Book Two."
Whispers, no. 17/18, August 1982.
Schweitzer, Darrell, ed. *Discovering Stephen King*.
Mercer Island, WA: Starmont House, 1985 (hardcover and trade pa-
perback)

Scott, Pete. "The Shadow Exploded."
Dark Horizons, Summer 1982.
See, Carolyn. "A Bumper Crop of Killing."
Los Angeles Times, May 8, 1983.
Seelye, John. "Wizard of Ooze with Four Novellas Makes Poe a Piker."
Chicago Tribune Bookworld, August 22, 1982.
Sherman, David. "Nightmare Library."
Fangoria, March 1984.
Shiner, Lewis. "A Collision of Good and Evil."
Dallas Morning News, November 26, 1978.
Shreffler, Philip A. "For Chills and Thrills."
St. Louis Post-Dispatch, October 5, 1980.
Skow, John. "Monstrous."
Time, November 5, 1984.
Slung, Michele. "A Master of the Macabre."
 1. *The New Republic*, February 21, 1981.
Expanded version: "In the Matter of Stephen King."
 2. *The Armchair Detective*, Spring 1981.
Stamm, Michael. "Pet Sematary: Opposing Views . . . Flawed, Unsatisfying."
Fantasy Review, no. 64, January 1984.
Stasio, Marilyn. "High Suspense."
Penthouse, July 1983.
Strouse, Jean. "Beware of the Dog."
Newsweek, August 31, 1981.
Sullivan, Jack. "Two Ways to Write a Gothic."
New York Times Book Review, February 20, 1977.
Suplee, Curt. "Stricken à la King."
Washington Post, August 26, 1980.
Thomas, Kevin. "A Sly Trio of Vignettes from a *Cat's Eye* View."
Los Angeles Times, April 12, 1985.
Thomas, Michael M. "The Holy Grail in Polypropelene."
Vanity Fair, November 1984.
Thompson, Thomas. "King's Latest a Shaggy Rabid Dog Story."
Los Angeles Times, September 6, 1981.
Underwood, Tim and Miller, Chuck, eds. *Fear Itself: The Horror Fiction of Stephen King*.
 1. San Francisco, CA/Columbia, PA: Underwood-Miller, 1982 (limited edition hardcover and hardcover).
 2. New York: New American Library, Plume, 1984 (trade paperback).
 3. New York: New American Library, Signet, 1985.
———, eds. Kingdom of Fear: The World of Stephen King.
 1. San Francisco, CA/Columbia, PA: Underwood-Miller, 1986 (hardcover).

2. New York: New American Library, Plume, 1987 (trade paperback).

Van Rjndt, Phillipe. "The Other Woman Was a Car."
New York Times Book Review, April 3, 1983.

Verniere, James. "Zeroing in on *The Dead Zone*."
Twilight Zone Magazine, November/December 1983.

Williams, Paul. "Fit for a King: Fascination with Horror Stories."
Los Angeles Times, May 10, 1981.

Winter, Douglas E. "The King of Storytelling Is Back Again."
1. *Philadelphia Inquirer*, June 30, 1985.
As "Winter Reviews *Skeleton Crew*":
2. *Castle Rock*, no. 9, September 1985.

_____ "*Pet Sematary*."
Washington Post Book World, November 13, 1983.

_____ *The Reader's Guide to Stephen King*.
Mercer Island, WA: Starmont House, 1982 (limited edition hardcover and trade paperback).

_____ "Shadowings: *Firestarter* by Stephen King."
Fantasy Newsletter, no. 30, November 1980.

_____ "Stephen King's *Christine*: '. . .where innocence peels away like burnt rubber and death rides shotgun.' "
Fantasy Newsletter, no. 56, February 1983.

_____ "Stephen King's *Cujo*: 'Nope, nothing wrong here.' "
Fantasy Newsletter, no. 42, November 1981.

_____ "Thoughts on *Creepshow* and E.C. Comics."
1. *Fantasy Newsletter*, no. 56, February 1983.
2. In *Shadowings: The Reader's Guide to Horror Fiction, 1981–82*. Ed. Douglas E. Winter. Mercer Island, WA: Starmont House, 1983 (hardcover and trade paperback).

Wood, Robin. "King Meets Cronenberg."
Canadian Forum, January 1984.

Woods, Larry D. "Stephen King Horrifies Again."
Nashville Tennessean, December 25, 1984.

Yardley, Jonathan. "Mean Machine."
Washington Post, March 23, 1983.

Zagorski, Edward J. *Teacher's Manual: The Novels of Stephen King*.
New York: New American Library, 1982 (pamphlet).

SELECTED MISCELLANEOUS MATERIALS

Bloom, John (writing as Joe Bob Briggs). "Stephen King Hits Town for Third Annual Drive-In Movie Fest."
Dallas Times Herald, October 27, 1984.

Bumiller, Elisabeth. "The Change of Hart: Looking to Win."
 Commentary on Gary Hart's presidential campaign.
 Washington Post, February 29, 1984.
Day, John S. "Campaign Is Eye-Opener for Stephen King."
 Commentary on Gary Hart's presidential campaign.
 Bangor Daily News, February 28, 1984.
Proch, Paul, and Kaufman, Charles. "Eggboiler."
 A parody.
 National Lampoon, May 1984.
Schneider, Peter. "Collecting the Works of Stephen King."
 Bookman's Weekly, October 24, 1983.
Winter, Douglas E. "Collecting King."
 Twilight Zone Magazine, February 1986.
Zieman, Mark. "When Buying Rare Books, Remember: Go for Stephen
 King, Not Galsworthy."
 Wall Street Journal, January 14, 1985.

Index